S0-BBY-006

MAR 1 0 1993
NOV 2 2 1993
Dec 6, 93
DEC 2 0 1993
JAN - 7 1994
OCT 2 5 1994
APR - 1 1996
April 15
JAN 3 1 1999
APR 1 0 2001
NOV 1 2 2003
NOV 2 6 2003
DEC 1 6 2003

Henri Rousseau

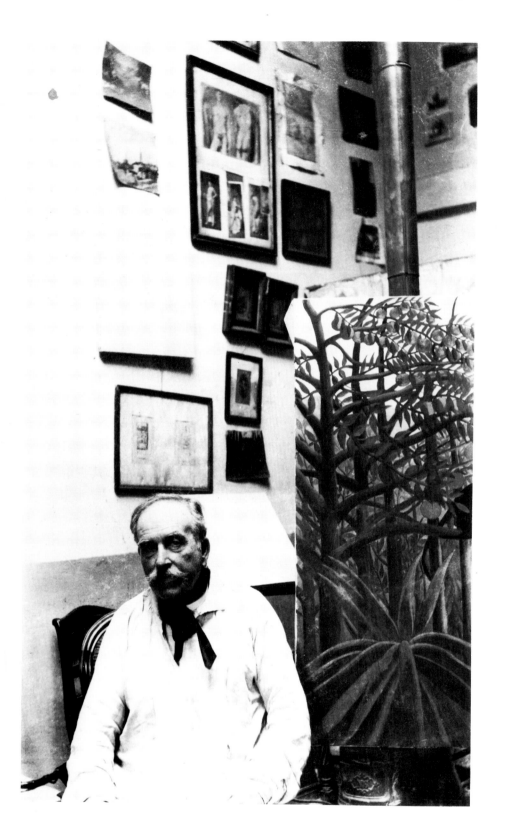

Henri Rousseau

Essays by
Roger Shattuck
Henri Béhar
Michel Hoog
Carolyn Lanchner and William Rubin

The Museum of Modern Art, New York
Distributed by New York Graphic Society Books
Little, Brown and Company, Boston

This exhibition at The Museum of Modern Art and its accompanying publication were made possible by a generous grant from PaineWebber Group Inc.

Additional support has been provided by the National Endowment for the Arts. An indemnity for the exhibition has been provided by the Federal Council on the Arts and Humanities

ERINDALE
COLLEGE
LIBRARY

The exhibition was organized by the Réunion des Musées Nationaux de France and The Museum of Modern Art, New York

Galeries Nationales du Grand Palais, Paris
September 14, 1984–January 7, 1985

The Museum of Modern Art, New York
February 21–June 4, 1985

Exhibition organized by

Michel Hoog, Conservateur, Musée de l'Orangerie, Paris
Chargé du Palais de Tokyo

Carolyn Lanchner
Curator, Department of Painting and Sculpture
The Museum of Modern Art, New York

William Rubin
Director, Department of Painting and Sculpture
The Museum of Modern Art, New York

First published in France, 1984
French edition Copyright © 1984
Réunion des Musées Nationaux de France
English-language edition published by
The Museum of Modern Art, New York, 1985
All rights reserved
Library of Congress Catalog Card Number 84-61967
Paperbound ISBN 0-87070-565-2
Clothbound ISBN 0-87070-564-4
Translations from the French by Richard Miller
Designed by Bruno Pfäffli
English-language edition designed by Thomas Kluepfel
Production supervised by Susan Schoenfeld
Type set by Concept Typographic Services, Inc., New York
Printed and bound by
Imprimerie Blanchard S.A., Le Plessis Robinson, France

The Museum of Modern Art
11 West 53 Street
New York, N.Y. 10019

Printed in France

This edition is distributed outside the United States and Canada by Thames and Hudson Ltd., London

Certain plates are covered by claims to copyright noted with Photo Credits, p. 270

Grateful acknowledgment is made to Roger Shattuck for permission to reprint sections from *The Banquet Years,* Copyright © 1955, 1957, 1958, 1968, and from the French edition, *Les Primitifs de l'avant-garde,* © 1974, Flammarion, Paris

Cover images :
Myself, Portrait-Landscape (detail), pl. 5
Forest Landscape with Setting Sun (detail), pl. 63

Frontispiece:
Rousseau in his studio. c. 1910

Acknowledgments

The preparation of this exhibition and catalogue has required the assistance and collaboration of many people. We have been most fortunate in the help we have received and the goodwill with which it has been given. Essential to the mounting of this exhibition has been the cosponsorship of the Réunion des Musées Nationaux de France. Neither institution acting alone could have presented an exhibition of this quality, drawing as it does on collections from around the world. Our primary, most profound thanks must go to the lenders, both public and private, who have so generously made their works available for this undertaking.

Foremost among our French colleagues to whom we owe a debt of gratitude are Hubert Landais, Director of the Musées de France, whose support was crucial to the realization of this exhibition, and Michel Hoog, with whom we have had the pleasure of codirecting it.

This project has required the assistance of many experts on both sides of the Atlantic. We are especially grateful to Françoise Callu, Henry Certigny, François Chapon, Isabelle Compin, Charles Delaunay, Yvonne Deslandres, Lola Faillant-Dumas, Richard Feigen, Steven Hahn, Claude Laugier, Yann Le Pichon, Colonel Neuville, Guy Pierrot, John Rewald, Alexandre Rosenberg, Monique Schneider-Maunaury, Eugene Thaw, M and Mme Christophe Tzara, Dora Vallier, Nicole Villa, François Woimant, and the Association des amis d'Alfred Jarry.

The realization of this exhibition and catalogue has involved staff time at both participating institutions. Irène Bizot, with whom it is always a pleasure to work, has brought her extraordinary gifts of efficiency and diplomacy to bear on behalf of this project. Members of her staff Mme Filhos-Petit and Mme Ute Collinet have demonstrated goodwill, patience, and skill in handling the many details of organization. With her customary expertise, Marguerite Rebois has overseen the often complicated logistics of transportation. Very particular thanks are also owed to Claire Béraud, Irène Elbaz, Paule Gillet, and Sylvie Maignan as well as to Bruno Pfäffli, who ably provided the design for the French edition of this catalogue.

Our deep thanks go to Richard E. Oldenburg, Director of the Museum, who has not only lent encouragement throughout the months this exhibition has been in preparation, but also been actively involved in securing certain loans.

Many colleagues at The Museum of Modern Art have given their support. Foremost among them is Marjorie Frankel Nathanson, whose research abilities and thoroughgoing professionalism have been essential to the realization of this undertaking. Alexandra Muzek handled the often onerous and difficult task of typing our manuscript and dealt with the multitude of details generated by this project with unfailing goodwill and skill. Her assistance has been invaluable.

To the Department of Publications, we owe a particular debt. Especially we should like to acknowledge the contribution of Jane Fluegel, who, recruited at the last moment, under the pressure of other work and the burden of an extremely tight schedule, managed the unusually complex task of editing this bilingual catalogue. Susan Schoenfeld guided it with consummate skill through all phases of production. Thomas Kluepfel brought his ingenuity and talent to bear on the difficult problems of design presented by this transatlantic coproduction. Frederic McCabe, Director of the Department, Harriet Schoenholz Bee, Managing Editor, and Nancy Kranz, Manager of Book Distribution, were actively helpful. Finally, our special thanks go to Richard Miller, whose translations have captured the spirit of our French colleagues' contributions.

Richard L. Palmer, the Museum's Coordinator of Exhibitions, has shown his customary patience and commitment during the preparation of this exhibition. Special thanks are owed the Department of the Registrar, particularly Kathy Hill, who admirably handled the logistics of assembly.

Many other members of the Museum staff have contributed in various ways. We should like to thank Albert Albano, Anny Aviram, Rosette Bakish, Mikki Carpenter, Fred Coxen, Kristin Hoermann, Susan Jackson, Frances Keech, Antoinette King, Terrence Mahon, Jerome Neuner, and Richard Tooke.

It is not possible to list all those who have given of their time and knowledge, but we should like here to register our deep appreciation for all such assistance.

Carolyn Lanchner
William Rubin
Codirectors for The Museum of Modern Art

Lenders to the Exhibition

Anonymous lenders
Sam Spiegel, New York
Mrs. John Hay Whitney, New York

Czechoslovakia
Prague National Gallery

France
Paris Musée du Louvre, Picasso Bequest
 Musée National d'Art Moderne, Centre
 Georges Pompidou
 Musée de l'Orangerie
 Musée d'Orsay, Galerie du Jeu de Paume

Germany
Frankfurt-am-Main Städelsches Kunstinstitut und Städtische Galerie
Hamburg Hamburger Kunsthalle

Great Britain
London National Gallery
 The Tate Gallery

Japan
Tokyo National Museum of Modern Art
 Bridgestone Museum of Art, Ishibashi Foundation

Switzerland
Basel Oeffentliche Kunstsammlung, Kunstmuseum
Winterthur Kunstmuseum
Zurich Kunsthaus Zurich

Union of Soviet Socialist Republics
Leningrad Hermitage State Museum
Moscow Pushkin State Museum of Fine Arts

United States
Buffalo Albright-Knox Art Gallery
Cleveland The Cleveland Museum of Art
New York The Solomon R. Guggenheim Museum
 The Metropolitan Museum of Art
Northhampton, Mass. Smith College Museum of Art
Philadelphia Philadelphia Museum of Art
Pittsburgh Museum of Art, Carnegie Institute
Richmond Virginia Museum of Fine Arts
Washington, D.C. National Gallery of Art
 The Phillips Collection

Contents

Object Lesson for Modern Art

The list of familiar tales on modern art runs from Van Gogh's severed ear to how Picasso could not paint a likeness of Gertrude Stein during eighty sittings—and then caught it months later from memory. But too few of these stories reveal, as Vasari's do for his time, the deepest aspirations and significance of art today. One of the most provoking of all modern legends is contained in the career of Henri Rousseau, called the Douanier. More fortunate than most, he attracted his Vasari in the person of Guillaume Apollinaire—less a biographer than an unexcelled forger of myth. "Rousseau had so strong a sense of reality that when he painted a fantastic subject, he sometimes took fright and, trembling all over, had to open the window" (*Il y a*).

Rousseau had *no aesthetic sophistication,* Apollinaire implies; yet he painted unaccountably *modern* works. The Cubists and Surrealists were both disturbed and reassured to find that so ingenuous a sensibility could produce paintings as revolutionary as their own. Furthermore, Rousseau's life is outstanding in the martyrology of the Banquet Years. In both his life and his work, we can examine him as an object lesson in modern art.

It is natural that the edges of the myth should blur into extravagance. Rousseau has been called everything from the most patent fraud ever perpetrated on a doltish public to the artist who restored angelic themes to modern painting. Even his sobriquet is a misnomer, for he was never a *douanier* (customs inspector), but a *gabelou* (employee of the municipal toll service). Most of the lingering falsehood stems from Apollinaire. In many articles he stated that Rousseau went to Mexico with troops sent by Napoleon III to support Maximilian, and that it is the memory of the "forbidden" tropical fruits in Central America that obsessed him in his Jungle paintings. Never sent to foreign parts during his military service, Rousseau found the tropics at the Jardin des Plantes in Paris. His great voyages of discovery took place in his imagination, in front of his paintings.

The most flamboyant of the Rousseau anecdotes attributes his entire career to a hoax perpetrated by Alfred Jarry. Crossing the Seine one morning on the Pont des Arts, Jarry is supposed to have found Rousseau at his post down on the quay. "My friend," Jarry told him earnestly, "I can see in your face that you're a painter. You must take up painting." Jarry immediately directed the composition of Rousseau's first canvas, *Adam and Eve,* and the escapade wound up in court with Rousseau, in tears, offering to do a portrait of the judge's "lady." A different version of this Pygmalion story has Paul Gauguin, on a wager, teaching Rousseau to paint; still another implicates Félicien Rops.

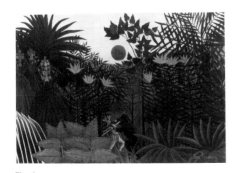

Fig. 1.
Rousseau. *Tropical Landscape: An American Indian Struggling with an Ape* (pl. 56). 1910

The truth is far different. *No one discovered Rousseau.* At the beginning of his self-chosen career as a painter, he earned a curious and paradoxical recognition to which neither Jarry nor Apollinaire contributed. It was only in later years that admirers like them tried to find a place of honor for this incorrigible genius.

Henri Rousseau was born on May 21, 1844, in Laval, a town in the northwest of France where Jarry was born thirty years later. The father, Julien Rousseau, earned a modest living as a tinsmith and hardware dealer. He had married the granddaughter of an infantry colonel under Napoleon. The family lived in one of the two towers of a fifteenth-century structure called the Beucheresse Gate. When Henri was about ten the father lost all his money trying to buy the building, and they had to move. Today the Beucheresse Gate carries a plaque commemorating the tinsmith's son who became a painter.

When the time came for him to draw his number for military service, Rousseau, now living in Angers, was given deferment. Then in December 1863 he enlisted for seven years in the infantry, an action whose explanation only recently came to light in the exhaustive biography by Henry Certigny. Working in an attorney's office, the young man was discovered in the petty theft of stamps and small sums totaling some 25 francs. By enlisting immediately and appearing at the trial in uniform, Rousseau apparently hoped to increase his chances for clemency. He received and served a month's sentence in the Pré Pigeon prison. Amazingly enough this early blot on his record was not unearthed when he was brought to trial forty years later on a similar charge. Once in the army, he was *not* (as Apollinaire reported) packed off as a regimental musician to Veracruz, nor did he become a sergeant in 1870 and "save the city of Dreux from the horrors of civil war." After four years of service in France between 1864 and 1868, Rousseau was discharged as a private.

In 1869 Rousseau married a girl from Saint-Germain-en-Laye and took a job as clerk in a lawyer's office in Paris. Soon after, he entered the Paris Municipal Toll Service, and now began his years as *gabelou*. The city of Paris imposed duties on many articles, and inspectors were required to control smuggling. The long tranquil hours took him to the quays along the Seine, to the city gates, and to the still-rural suburbs. He enjoyed the secure position of a minor functionary with already considerable seniority, because military service was counted toward retirement.

During these years, he had become a faithful "Sunday painter." Later in life he stated that he had always wanted to paint, but was long prevented from doing so by circumstances. His "Sunday" could fall on any day of the week, and beginning sometime in the seventies he devoted these days to painting in the suburbs and in his studio. The earliest of his dated works reads 1877. Eight years later when he exhibited his work for the first time, he had already developed a style enough his own to attract attention. After his wife's death, the daughter was sent to live with one of his brothers in Angers. Rousseau moved with his son into a studio he had rented three months earlier.

According to his own statements Rousseau received advice from several academic painters. He refers particularly to Félix Clément, a former Prix-de-Rome, who had succeeded well enough to build himself an elegant house in the rue de Sèvres next door to Rousseau. Clément, a butcher's son, was friendly and

encouraging and introduced his neighbor to the prominent figures Adolphe-William Bouguereau, Léon Bonnat, and J.-L. Gérôme. In 1884 Rousseau obtained an official permit to make copies in the Louvre; a mere customs employee would have needed solid recommendations. Being urged to "keep his naiveté" and copying in a museum do not add up to any kind of training. None of these circumstances detracts from Rousseau's status as a self-taught painter. It is clear that he would have preferred to be admitted to the official Salon among the academic painters he admired. But his work was refused, and it is the annual juryless salon of the Société des Artistes Indépendants, founded by Paul Signac and his friends, that probably saved Rousseau from oblivion. He became a regular member of the group that included Georges Seurat, Odilon Redon, and many unknowns like Rousseau. Paul Cézanne, Henri de Toulouse-Lautrec, Pierre-Auguste Renoir, Paul Gauguin, and Vincent Van Gogh joined a few years later.

Accordingly in August 1886 Rousseau trundled four paintings through the streets in a handcart and hung *A Carnival Evening* (pl. 1) among the 500 other works at the first major show of the Indépendants. In 1887 Rousseau hung three paintings and five drawings, five the next year, three the following year, and then an average of five a year except for banner years like 1891, 1895, 1896, and 1902, when he exhibited nine or ten. His career was launched.

After 1885 Rousseau's superiors were apparently understanding enough to assign him to posts where he could occasionally paint. But he still had to put in seventy hours of guard duty a week, with his saber in his belt. In 1893 he found enough confidence in himself to retire and try to live on his pension—1,019 francs per quarter. He never succeeded in paying off the bills he ran up at Foinet's for art supplies.

For several years he lived with his son in the studio on the avenue du Maine where there was only one bed. After his son's death in 1897, he found a cheaper place in the rue Vercingétorix. Then in 1899 he shaved off his black beard and married Joséphine Noury. She had been his mistress close to ten years, and her husband, a fiacre driver, had died three or four years earlier. They were both so poor that no marriage contract was required. Rousseau searched desperately for some source of income. The years 1899 and 1900 were the only ones when he failed to show anything at the Indépendants. He wrote a play, *The Revenge of a Russian Orphan,* and submitted it without success to the Châtelet Theater. He took part in two municipal competitions for decorative paintings. He had the idea of giving painting and music lessons and went out with his violin under his arm to teach a few students in the neighborhood. For a time a Paris newspaper employed him as inspector of sales and distribution. The couple moved to an even smaller apartment. Joséphine opened a stationery store, where she tried to sell his paintings. When she died in 1903 they were still in desperate straits. The writer Rémy de Gourmont spoke several times of meeting Rousseau playing the fiddle for his next meal. Yet it was known in his quarter that Rousseau was always willing to share what little food he had with any derelict who came hungry to his studio.

Despite his poverty, Rousseau contributed his talents to a new privately sponsored adult-education project called the Philotechnic Association. The city helped by lending classrooms in the evenings. Rousseau taught music and drawing, and after a few years he was decorated with the *Palmes académiques*

Fig. 2.
The Two Majesties. c. 1885
Engraving after Jean-Léon Gérôme

because of a confusion between his name and another Rousseau on the list. Though he soon learned of the error, Rousseau wore the little violet rosette in his lapel for the rest of his life and used the official wreath after his name. He gained enough prestige in his quarter to be commissioned to do a few portraits, principally of children and of formally composed family groups. But he remained miserably poor and asked very little for paintings over which he had labored several weeks.

Rousseau's works in the Salon des Indépendants were noticed favorably and watched from year to year. There is no evidence, except spurious legend, that the public maligned his work at this juncture. In his notebooks from 1886 on, Rousseau collected with great care the articles that discussed his work. During the first years, his painting received sympathetic attention as slightly out of the ordinary and worthy of encouragement. The adjectives "curious," "primitive," and "sincere" appear frequently, and other artists are accused of imitating his style.* In 1891 one critic stated bluntly that "the public has not yet reached the level of this genre." Yet at last the crowds were beginning to wonder or snicker, for that same year a dissident journalist cast the first stone: "Monsieur Rousseau paints with his feet with his eyes closed."

Not until 1894 did the punishment really begin. One article, printed in several papers, mentioned "the scoffing public"; Rousseau is called a "preprimitive" and criticized for painting hands without thumbs. From then on, the art critics began to revel in such readymade copy, and Rousseau became an "annual aberration," the victim they waited for from year to year, advising their readers to go and see his work if they wanted a good laugh. By 1902 he was a "celebrity"; one of his Jungle paintings was reproduced in a newspaper in the guise of a political cartoon. The scandal reached the point where some members of the Indépendants wanted to drop Rousseau. André Salmon reported that his cause was defended by Toulouse-Lautrec.

This neglected background clearly demonstrates that no one "discovered" Rousseau. He hung his work and it drew notice. Gustave Coquiot, one of the organizers of the Indépendants, maintained stoutly that, "Odilon Redon and I were, around 1888, the first to glorify Rousseau." Camille Pissarro admired his paintings, saying that "emotion takes the place of training." In 1891 in a Lausanne newspaper the Swiss painter Vallotton described one of Rousseau's tigers as "the alpha and omega of painting."

A year after his retirement Rousseau met Alfred Jarry, the most extravagant of his champions. At this time, Jarry was a precocious young poet scarcely twenty, charming but eccentric and not yet called up for military service. Rousseau was close to fifty, with a long life of wars and loves and losses already behind him. Hard as it is to imagine their friendship, they were close enough so that three years later Jarry stayed with Rousseau for several weeks when he was evicted from his own lodgings. Ten years passed before Rousseau knew anyone else in the literary or artistic world so well. In 1894 Rousseau painted Jarry's portrait with chameleon and parrot and exhibited it at the Indépendants with an inscription in verse that echoes Jarry's style. The portrait was mislabeled *Mme A. J.* because of Jarry's shoulder-length hair. That year, in his art chronicle, "Minutes d'art," Jarry devoted precious space to the huge composition *War* (pl. 9) and to his own portrait. "...some curious Henri Rousseaus: the spirit of war on the bristling

*In spite of a faint suggestion of irony, the most perceptive notice appeared in the *Journal des arts* (March 30, 1890): "But I am being slow in reaching M. Henri Rousseau whom I shall permit myself to call the 'cornerstone' [*clou*] of the Indépendants. M. Rousseau is an innovator in painting. It is he who invented the portrait-landscape, and I advise him to copyright his title, for there are unscrupulous characters who are capable of using it. But the misadventure would end there, and no one will appropriate M. Rousseau's manner. Before such vast compositions [*machines*] criticism is powerless."

horizontality of its frightened horse riding across the translucent corpses of axolotls; the portrait of a man with Chinese eyes and a little tuft of hair…" The two paintings have had contrasting histories. The Jarry portrait no longer exists. According to the several versions of the story, Jarry, having brought it to his room in the rue Cassette, either burned it accidentally, or cut away the background and kept only the head, or cut out the head and kept only the background. André Salmon supplies the final refinement: "He liked to say that, afraid of piercing himself [*i.e.,* the portrait] in an awkward flourish of his umbrella, he cut himself out carefully and kept himself rolled up in the 'long central drawer of our white-wood Colbert desk.'" Whatever its fate in Jarry's hands, the portrait has been lost. *War,* on the other hand, which had been lost, was found again in 1944. After its authenticity had been vehemently disputed by a few experts and the Surrealist André Breton, the Louvre acquired it and hung it prominently.

The year after the Jarry portrait, a ripple of recognition began to form around Rousseau. Jarry and Gourmont commissioned him to do a lithograph for their magazine, *L'Ymagier.* Both Gauguin, who met him through Jarry, and Pissarro publicly admired his use of black. The *Mercure de France* devoted a laudatory notice to him (by an unremembered critic, L. Roy), which stated unequivocally: "Only bad faith could lead one to believe that the man capable of suggesting such ideas to us is a bad artist." But the years brought no true success.

Not far from where Rousseau lived at this period, the composer William Molnard had a studio in the rue Vercingétorix. Gauguin, temporarily back from Tahiti, had his studio in the same street during the winter of 1894-95. Molnard and Gauguin entertained every Saturday. The Douanier frequently appeared with or without invitation and moved unabashedly among such guests as Hilaire-Germain-Edgar Degas, August Strindberg, and Stéphane Mallarmé. Sometimes he brought his fiddle and gave a short concert.

After the death of his second wife in 1903, Rousseau's figure comes into clearer outline. We begin to know how he lived, what his personality was, and (it is the key to true biography) how he spent his time. He had been a Sunday painter who lived only for his Sundays. By retiring, he had secured his dream: Sunday all week long. For certain solitary artisans and artists, every day holds a rare stillness and reverence which for the rest of the world comes only once a week. One of the haunting qualities in Rousseau's painting is that he conveys this Sabbath feeling of joyful rest. He never lived another weekday; he never painted a workaday picture. Living in a single-room studio in the rue Perrel over a plasterer's shop, he painted himself forever into his Sunday world. He said that he did not mind living in one room because when he woke up in the morning he could "smile a little at his paintings."

Poverty afflicted him as grievously as it did the laborers who were his neighbors. He always needed money for paint and canvas, and he tramped across Paris, his violin under his arm, to give music lessons. After the experience of teaching in the Philotechnic Association and with the prestige of his *Palmes académiques,* he hit upon a solution that suited his status as artist. He opened a school. In his doorway, hidden away in one of the lowliest streets of Paris, was displayed the sign, "Courses in Diction, Music, Painting, Solfeggio." For 8 francs a month, he instructed both the very young and the very old. Insubordination and doltishness

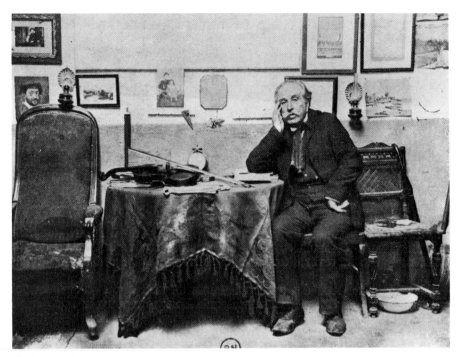

Fig. 3.
Rousseau in his studio. c. 1908

in his pupils did not ruffle him. His art students have never achieved fame, yet a nice paradox lurks in the fact that he should have earned at least a meager living teaching a subject supposed ignorance of which made him famous.

In appearance Rousseau was short and solidly built in his good years, with a full beard and a head of black hair. His complexion was light and his eyes a sparkling blue. He dressed in dark high-buttoned suits and carried a cane as he grew older. By preference, he wore a large artist's beret as the mark of his calling. With the years his hair turned white and he shaved off his beard, leaving only a fluffy white mustache. His steps became shorter and more puttering, yet his youthful spirit never left him.

In 1898 Rousseau wrote to the mayor of Laval to propose that his native city buy *The Sleeping Gypsy* (pl. 19) for 2,000 francs—a price more than ten times the top figure he had ever received. Was this innocence? bravado? slyness? It is hard to separate the strengths from the weaknesses in Rousseau's character. What usually showed itself as a kind of tranquil self-confidence sometimes took on the aspect of mulishness. When opposed, he could fall into frenzied moods like tantrums. Coquiot, who had frequent occasion to deal with him at the Indépendants, added this to his praises: "Rousseau could sometimes be as conceited and disagreeable as anyone...he was the kind of fellow who is insupportable some days, and then his beastliness beats anything...." Fernande Olivier, who knew Rousseau through Picasso and observed him better than most, described the same characteristic. "His face turned purple the minute he was thwarted or bothered. He generally acquiesced to everything people told him, but one had the feeling that he held back and did not dare say what he thought." Stubbornness

16

was his vice, his form of pride. Yet stubbornness was also the core of his genius, for without it he could never have started his singular career or persevered in it.

The tide began to turn in 1905. The Salon d'Automne, a new grouping of young and avant-garde artists formed two years before, accepted two of Rousseau's paintings. Works by Henri Matisse, André Derain, Georges Braque, Georges Rouault, Maurice Vlaminck, Othon Friesz, Raoul Dufy, and other unabashed colorists were assembled in a large central room with Rousseau's *The Hungry Lion* (pl. 31). After a jeering article by the critic Louis Vauxcelles, the room was christened the *cage aux fauves* (wild-animal cage)—terminology probably inspired in part by Rousseau's subject. Thus for a season Rousseau was associated with the Fauves and welcomed by them. The popular magazine *L'Illustration* (Nov. 4, 1905) published a two-page spread of reproductions of works in the Salon, and Rousseau's painting appears prominently with a Cézanne, a Guérin, a Vuillard, a Matisse, a Rouault, and a Derain. The caption states that Rousseau, previously ridiculed at the Indépendants' shows, has been given a place of honor and respect in the Salon d'Automne. The next year, the new Salon accepted one painting, in 1907 four, including two exotic landscapes and *The Snake Charmer* (pl. 36), now in the Louvre. Recognized and honored by the Salon d'Automne jury, Rousseau continued to send his work loyally every year to the Indépendants.

Apollinaire probably made Rousseau's acquaintance in 1907 through Jarry, who died that year. It is very much as if just at the moment that Jarry disappeared from the scene, Apollinaire appeared, equipped with vast promotional capacities. He had become one of the well-known figures in the artistic and literary world of Paris, writing poetry and criticism and enjoying enormous prestige for a young man of twenty-seven who had not yet published a book. His first critical mention of Rousseau was scarcely flattering, yet he gradually modified his tone. Rousseau kept a special notebook of clippings on Apollinaire, and through him rapidly made friends in new quarters. Unquestionably, Rousseau was "taken up," but he had been waiting for twenty years. He expected to be admired and sought after, just as he had expected a visit from Puvis de Chavannes. He met the artist Serge Férat, who became a loyal friend and began to buy a few of his paintings. He met Robert Delaunay, another painter who recognized and proclaimed Rousseau's talents and whose mother held a *salon* where Rousseau was welcomed. Ardengo Soffici, an Italian author and painter, paid his respects in person, bought some canvases, and in 1910 wrote the second full-length article on Rousseau. It appeared first in Rome and then in the *Mercure de France,* which had published the first article, L. Roy's, in 1895. Rousseau moved tranquilly in these new circles, his engaging manner unchanged.

Three dealers began buying his works: the German Wilhelm Uhde (who wrote the first book on Rousseau), Ambroise Vollard, and Joseph Brummer, a Hungarian, who later opened a successful gallery in New York. "Rousseau carried his canvases to Vollard's place," wrote Vlaminck, "the way a baker delivers his bread." None of them paid Rousseau very much for his paintings. Rousseau kept accounts in a notebook meant for laundry lists: "Sold to Madame la Baronne d'Oettingen, my self-portrait for 300 fr....Sold to Monsieur Delaunay, a lovely Mexican landscape, with monkeys, for 100 fr...." By 1910, when he had only a few months left to paint, he could write to Soffici, "I have orders on all sides, and I must make you wait."

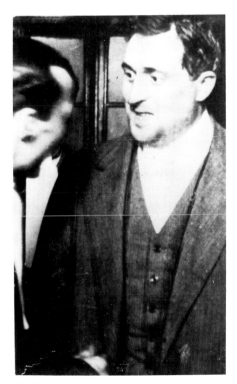

Fig. 4.
Guillaume Apollinaire

17

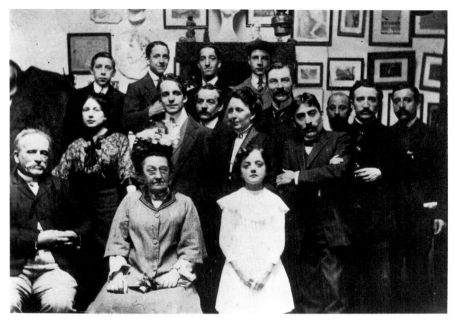

Fig. 5.
A gathering at Rousseau's studio *(soirée familiale et artistique)*. c. 1908

Not to be outdone by the hospitality of his new friends, Rousseau began about 1907 to hold his own *soirées familiales et artistiques*. He loved to gather around him friends and students and local tradespeople to celebrate any occasion that could be invented. He sent out formally phrased invitations to these Saturday parties and prepared his studio with great care. His bed was folded in a corner, the floor was swept and covered with the cheap rug he had secured in exchange for three of his pictures, bottles of wine stood on a table, and the chairs were rigidly lined up facing the "stage" at one end of the room. Rousseau, the rosette in his buttonhole, greeted the guests with a bow at the door, like an usher, and seated them in strict order of arrival. The proceedings were held up until everyone appeared.

For the organized part of the party, Rousseau reproduced in multicolored inks from gelatin plates lists of the evening's events. Drawn up carefully like theater programs, with date and address, they told what marches the orchestra would play, "followed by Madame Fisher with her repertory," and "Monsieur Rousseau (violin solo) with his works and creations." The stage was offered to any guest who felt the urge to perform, and on the back of the program there was always publicity for the Academy and Rousseau's private lessons.

The list of people who attended these affairs is staggering. One friend brought another, beginning with Apollinaire, Delaunay, Soffici, Férat, Baroness d'Oettingen. Soon half the young artists and writers in Paris were turning up: Picasso, Braque with his accordion, Max Jacob, Vlaminck, Georges Duhamel, Jules Romains, Constantin Brancusi, Marie Laurencin, Philippe Soupault, René Arcos, Charles Guérin, Félix Fénéon, Francis Carco, Maurice Cremnitz, André Warnod, and many more. What was there to draw them to these evenings, especially in view of the fact that most of them were thirty years younger than Rousseau?

Some of them undoubtedly saw a parody of their own lives and ambitions, and an almost Ubuesque version of the famous artist entertaining in style. But, more than this, there was Rousseau's personality, his desire to enjoy life to the full without the gaiety interfering with the seriousness of his work. This was the true spirit of the time, the spirit that associates Rousseau inseparably with the Banquet Years. In spite of all his troubles, his still-unrealized ambitions, and his sixty-five years, his youth was perennial and unforced. Furthermore, people were beginning genuinely to admire his work and to want to know more about the man who produced it. Whatever the explanation, few *salons* or cafés in the marginal history of painting have matched the simple exuberance of Rousseau's *soirées familiales et artistiques*.

At this period, the young American painter Max Weber was in Paris. He became a close friend of Rousseau (who called all foreigners "Americans"), and when Weber left in December 1908, Rousseau had a special soiree "in honor of the farewell to Monsieur Weber." Weber purchased as many Rousseau canvases as he could afford, and Rousseau gave him a number of drawings. These items made up the first one-man exhibition of Rousseau's work anywhere when they were put on display in 1910 in the Alfred Stieglitz gallery in New York. America and Germany vied for several years for leadership in appreciating Rousseau's work.

Weber's few published remarks on Rousseau make clear the immediate attraction people felt toward him. The two painters met at Madame Delaunay's *salon*. "...a round-shouldered genial old man, small of stature with a smiling face and bright eyes, carrying a cane, entered the room. He was warmly received, and one could see that he was pleased to find himself among so many friends and admirers." That day Weber walked back with Rousseau to his studio.

On my way home from this first visit, which I shall never forget as long as I live, I felt I had been favored by the gods to meet one of the most inspiring and precious personalities of all Paris.... "Here," I said to myself, "is a man, an artist, a poet whose friendship and advice I must cultivate and cherish."...By a sacred sense of privacy he was shielded from the snobbery, pretense, and sophistication which was rife in the art circles of the time. ...There is nothing chameleon about him (*Art News,* Feb. 15, 1942).

Rousseau's greatest moment—almost a transfiguration it seems to us now across the years, and it must have appeared so in the dizziness of that evening— came in 1908 at the *banquet Rousseau.* Its story, so often recounted, epitomizes the combination of festivity and conviction that characterized the period (see pages 66–71 in *The Banquet Years*). Picasso organized the banquet and decided to hold it in his own studio in the Bateau-Lavoir. The gathering has been interpreted by some as a lampooning of Rousseau, as a magnificent farce organized for everyone's enjoyment at Rousseau's expense. Delaunay refused to attend for that reason. It is more accurate to see the event as a celebration of unpredictable new resources in the arts, a spontaneous display of high spirits to greet ideas being unearthed every day by Picasso and Apollinaire, by Max Jacob and Braque, by everyone present at the gathering, including Rousseau. Taking Rousseau as a unique pretext, the banquet celebrated a whole epoch.

Rousseau's final years held a few such celebrations of the first magnitude, but they brought him only the most uncertain artistic recognition and no material security. In fact, the period began on a gloomy note despite the Bateau-Lavoir party. A few months before the banquet, Rousseau had been jailed on a forgery and embezzlement charge and then released to await trial. He was ultimately found guilty on incontrovertible evidence. The fault lay in Rousseau's guilelessness and his willingness to do a favor for one of his former pupils. By 1909 the newspapers knew that Rousseau made good copy, and his trial drew smiling attention from all sides. Recently it has provided the materials for a full-dress scholarly volume by Maurice Garçon.

Louis Sauvaget, whom Rousseau had met in a municipal orchestra, was an employee of the Meaux branch of the Bank of France. He had already embezzled 15,000 francs in 1903, but Rousseau knew nothing of his record. Sauvaget persuaded him to open an account at the Melun branch of the same bank under the name of Bailly and to have printed in Paris some false credit transfer forms. Sauvaget forged the signatures on a 21,000-franc transfer from Melun to Meaux. Rousseau, always helpful, consented to draw the money using forged identity papers which Sauvaget provided. Sauvaget let him have the odd thousand francs for his pains. Rousseau seems to have been quite unaware that he was doing anything more than obliging an acquaintance. A few days later the crime was detected, and Sauvaget acknowledged full responsibility. Rousseau was held for the month of December 1907 in La Santé prison; his imploring and eloquent letters to the *juge d'instruction* and to the *conseiller municipal* of his quarter secured his release until the trial in January 1909.

The defense had introduced two pieces of evidence to establish the innocence of Rousseau's character: his notebooks of press clippings with marginal comments, which, read aloud by the clerk, fulfilled the courtroom's expectations of entertainment; and one of his tropical paintings full of monkeys and bright oranges, which quickly set the jury grinning. Guilhermet, the defense lawyer, finished his summation with a swelling extra-legal coda. "This morning he [Rousseau] said to me: 'If I am condemned, it will not be an injustice for me, it will be a misfortune for art.' Well then, members of the jury, give Rousseau back to art; spare this exceptional creature. You do not have the right to condemn a primitive." After this plea, Rousseau leaned forward and said to Guilhermet in unhushed tones that everyone could hear, "Look, now that you've finished, can't I go along?" Afterward, he remained on friendly terms with Guilhermet, and with Ernest Raynaud, a lawyer-poet who had investigated the case. Both of them were frequent guests at his soirees.

As with the other misfortunes in his life, Rousseau makes little mention of the trial. His extant letters to friends, collected in a special number of Apollinaire's *Soirées de Paris* in 1914, say nothing of it; Apollinaire omits it entirely from his articles. Rousseau may never have understood that society considered his acts criminal, not charitable.

Fortunately, these disappointments could not distract Rousseau from his work. All through the dismal months of 1909 he was working feverishly, on, among other things, the double portrait of Marie Laurencin and Apollinaire called *The Muse Inspiring the Poet* (pl. 58). He began a lengthy one-sided correspondence

with Apollinaire, dealing mostly with hours for sittings and other arrangements. The letters reveal that the Douanier was troubled to the very last by grinding poverty. Letter after letter states that he has less than one franc left for dinner; can Apollinaire pay him something in advance for the portrait? He regrets having to set a price on the painting, "But I have had too many reverses to do otherwise. I have my pension, true enough; how would I do without it? But I have not been able to save anything unfortunately, and when I paint a picture which requires two or three months' work, I must live somehow and furnish my time and my own materials." The critics continued to ridicule his work, taking exceptional advantage of his trial. It came to the point where he appealed to Apollinaire. "You will avenge the harm which is being done me, won't you?" His troubles never ceased.

In 1909 at age sixty-four Rousseau fell madly in love with a widow of fifty-five named Léonie, a salesclerk in a Paris department store. He wrote her passionate letters and asked his friends to provide written testimonials of his professional standing. Léonie, protected by her ancient parents, turned a deaf ear to all his attentions. No one could console Rousseau; not even an automobile ride—the latest craze—could change his doleful expression. Yet his talent did not decline. In 1908 he had tried the new subject of men in motion which led to *The Football Players* (pl. 45); during 1910 he finished one of his boldest and most magnificent works, *The Dream* (pl. 66). In public he kept up his good spirits, acting as if one day would follow the next without end and allow him to realize all his projected paintings.

Rousseau's last soiree was held on July 14, 1910. It was on this occasion that he asked Uhde the question "Do you love peace?" When Uhde said that he did, Rousseau led him to the window and showed him the German flag waving among the others in the flag-bedecked streets. A month later he cut himself inadvertently in the leg and neglected the wound until blood poisoning set in. His eyes sunken and yellowing, he lay on his tiny bed without the strength to chase the flies from his face. One of his most recent actions had been to write Léonie, and he spoke tenaciously of getting back on his feet very soon. Finally, he was taken to the Necker Hospital in a near coma, and the only one of his friends still in Paris, Uhde, came to his bedside. The young German dealer held the hand of the sixty-six-year-old Frenchman who had waited forty years before he could retire and devote himself to painting. The hospital provided the final irony by diagnosing this innocent primitive as an "alcoholic." He died in the ward, alone, on September 4, 1910, when most Parisians had still not returned from their vacations. Rousseau, who knew no vacations, never had to leave the city to find his landscapes, his inspiration, or a place to die.

He was buried in a pauper's grave in the Bagneux Cemetery, where Jarry's body had lain for three years.

The following year, Robert Delaunay and Quéval (Rousseau's landlord), contributed to buy a thirty-year plot in the cemetery and to erect a small tombstone with a bronze medallion of Rousseau. Apollinaire wrote in chalk an epitaph which immortalizes the legend of the Douanier. Brancusi, the Romanian sculptor who until 1957 had his studio of enchantments not far from the rue Perrel in the impasse Ronsin, chiseled the lines into the stone in 1913.

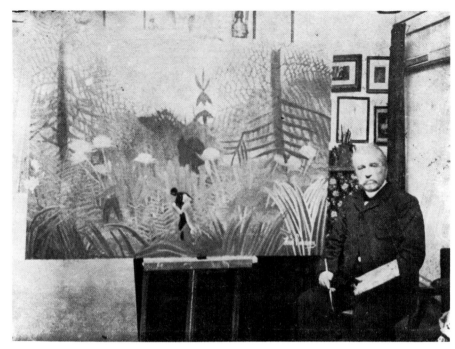

Fig. 6.
Rousseau in his studio in front of *Forest Landscape with Setting Sun* (pl. 63). 1910

We salute you
Gentle Rousseau you hear us
Delaunay his wife Monsieur Quéval and I
Let our baggage through free at heaven's gate
We shall bring you brushes, paints, and canvas
So that you can devote your sacred leisure in the light of truth
To painting the way you did my portrait
The face of the stars

In 1947 Rousseau's remains and the tombstone were moved to Laval, his native city, and placed in the Parc de la Perrin.

Part of his victory was over time. It is as if he grew younger during those long "months of Sundays." His world was the Paris he lived in and the luxuriant, dangerous, alluring jungle which grew behind the softness of his eyes. The miraculous nature of his accomplishment turned naturally into legend. It has been discovered that the owner of a sideshow in a traveling fair applied in 1930 to purchase the Douanier's mortal remains to show as a pious relic. But he was no angel and no saint. There was a simplicity about him which enabled him to express the most simple and heartrending yearnings of popular art. His vision carried him unerringly to the very center of the strictly disciplined yet exuberant strivings of twentieth-century art.

Roger Shattuck

22

Jarry, Rousseau, and Popular Tradition

Ever since artistic opinion enshrined Henri Rousseau as one of France's national glories, it has been said that Alfred Jarry discovered—or even invented—the painter. The more-or-less imaginary anecdotes Guillaume Apollinaire saw fit to set down about the two have been endlessly repeated. Most people neglect to mention that when Jarry first wrote articles promoting Rousseau, he had barely come of age and was making his fourth attempt to pass the Ecole Normale Supérieure entrance exam, for which he had been cramming at the Lycée Henri IV after passing the *baccalauréat*. That his praise for the Douanier might have been just a precocious schoolboy prank is, however, a judgment I am unwilling to make. The links between the beginning writer and the older painter were in part based on family connections (both were originally from Laval, their families did little favors for one another and, according to the records, Jarry's father and Rousseau had been schoolmates), but beyond that, Rousseau's painting would appear to have provided the solution in pictorial terms to problems that were preoccupying Jarry in his own aesthetic experiments. Although the poems and plays Jarry was attempting to publish in this period had none of the simplicity of Rousseau's works (quite the contrary!) they were nonetheless trying to make an equivalent representation of space-time by employing a particular popular tradition. *Ubu Roi* may be regarded as the transposition for an adult public of a marionette play viewed as timeless, as taking place in eternity and in Utopia (Poland, Nowhere). The scenery that Jarry imagined would realize his stage aesthetic is very like the painting of the Douanier Rousseau: "Scenery painted by someone who doesn't know how to paint comes very close to abstract scenery, presenting only the substance—simplified by taking advantage of happy accidents" ("De l'inutilité du théâtre au théâtre," *Mercure de France*, September 1896).

However, Jarry was not content with merely applauding the merits of various artistic solutions inspired by the simplicity of folklore or expressing his contempt for the classical canons of art. He joined Rémy de Gourmont in founding *L'Ymagier,* a magazine devoted to original graphic works, through which they intended to bring the treasures of folk art to the attention of rich art lovers and inspire contemporary artists to turn to and adapt the old traditions of woodcut and lithography. This artistic continuity was set forth by Gourmont in the first issue of *L'Ymagier:*

Next to and underlying printed literature runs the stream of oral tradition, tales, legends, folk songs. And there is also folk imagery, today synthesized in

Fig. 1.
Picasso. *Portrait of Alfred Jarry*
Published in *Soirées de Paris* (February 1914)

the Epinal workshop, yesterday to be found flourishing in some thirty towns, and above all in Troyes. In the form of leaflets or pamphlets, that imagery is known only to archaeologists or a few art lovers: it is our primordial subject here, and any other contents of *L'Ymagier* are only extras, ornaments, sources, objects for study or comparison.

Here, therefore, we shall profit from the old imagery and, through drawing, reflect the joy of those who, for only a bent *sou,* once decorated their humble dwellings with archangelical communications, the joy of a peasant—a Breton in this case—who discovers in a peddler's hut rude visages carved by Georgin, symbolic and piercèd hearts, Christs whose sorrow purifies our sufferings, miraculous Virgins and mysterious horsemen, King's messengers bearing the news of some great event—as well as legendary Saint Genevièves and powerful mitered Saints taller than steeples (October 1894).

Jarry broke with Gourmont for nonliterary reasons after the fifth issue and founded his own art magazine, *Perhinderion* (of which two issues appeared, in March and June 1896); he made more or less the same statement in his introduction to the first issues: "As peddlers used to bring rare images on appointed dates to moated public squares at the foot of sanctuaries, *Perhinderion* will six times a year resuscitate the old or bring forth the new...."

Rousseau's art is a more immediate response to a similar concern. Despite their differences, the young aesthete perhaps regarded the older painter as a turn-of-the-century Georgin (1801–1863), the printmaker who had supplied the Fabrique Pellerin d'Epinal with woodcuts celebrating Napoleonic legend (figs. 2, 3). Having struck an agreement with the Pellerin workshop to make new editions of Georgin's prints, Jarry also urged Gourmont to commission a lithograph of Rousseau's *War* (pls. 9, 10). He had noticed the painting at the 1894 Salon des Indépendants and wrote about it on two occasions in terms which, although they sacrificed rigor to symbolism, nonetheless expressed the deep impression the picture had made: "Of H. Rousseau there is above all 'War (terrifying, she passes...)'. With legs outstretched the horrorstruck steed stretches its neck with its dancer's head, black leaves inhabit the mauve clouds, and bits of débris fall like pine cones among the translucent corpses of axolotls attacked by bright-beaked crows" (*Essais d'art libre,* June-July 1894).

It was in this period that Rousseau began his portrait of Jarry, finally exhibiting it at the eleventh Salon des Indépendants. Although the Douanier did not devote to this portrait all the care his admirer might have hoped for, there can be no doubt about Jarry's fondness for the painter's manner. His flat colors and his deliberate disproportion, his contempt for perspective, his invention of the "portrait-landscape" suited the Symbolist taste for microcosm and macrocosm. Artistic affinity turned into camaraderie, and Rousseau put his young friend up in the single room of his avenue du Maine apartment from August to November 1897.

During this period, Jarry was writing his *Gestes et opinions du Docteur Faustroll, Pataphysicien,* in which he nominated "Monsieur Henri Rousseau, artist-painter-decorator, known as the Douanier, and so cited and decorated," for the administration of a "painting factory," intended to transform the monstrosities of the "national Storehouse"—otherwise known as the Musée du Luxembourg—and so endowed him with the descriptive nickname he still bears.

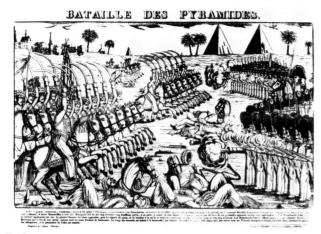

Fig. 2.
Georgin. *Battle of the Pyramids.* Image d'Epinal
Musée des Arts et Traditions Populaires, Paris
Published in *Ymagier* (January 1895)

Fig. 3.
Georgin. *The Railroad.* Image d'Epinal
Musée des Arts et Traditions Populaires, Paris
Published in *Perhinderion* (June 1896)

Thus Rousseau was the ideal "Ymagist" for a young writer eager to revive a declining folk art or, more precisely, to make it a part of contemporary life and to bring about a resurgence of that underground stream Gourmont evoked when discussing the oral tradition. As it happened, in the inscriptions or quatrains accompanying his pictures, Rousseau, too, was carrying forward the same tradition. For the same reason that *L'Ymagier* published old songs ("Au bois de Toulouse," "La Belle s'en est allée," "La Légende de Saint Nicolas," "Chanson pour la Toussaint," "La Triste Noce"), Jarry mingled folk elements and refrains in his most elaborate poems, added color to his novels with old ballads ("La Triste Noce" appears in *Le Surmâle,* for example) and, above all, continually cultivated in his plays what in French is called *l'esthétique du mirliton,* a kazoo aesthetic, a form of drama he quite rightly baptized *théâtre mirlitonesque,* or, one might say, theater for the masses. The writer enjoyed recalling folk songs such as this:

Three frogs cross over the brook,
My dear Olaine,
Bearing needles and a thimble
And a tiny bit of wool...

Trois grenouilles passèrent le gué,
 Ma mie Olaine,
Avec des aiguilles et un dé,
 Du fil de laine...

Jarry could not have been unaware of the inscription Rousseau composed for his own painting, *A Hundred Years of Independence* (1892): "The people dance round the two Republics, that of 1792 and that of 1892, holding hands, to the tune of 'Auprès de ma blonde qu'il fait bon fait bon dormir.'"

Similarly, the artistic transposition Jarry worked with regard to *War* demonstrates that he remembered Rousseau's inscription: "War (terrifying, she passes

by, leaving behind on all sides despair, tears and ruin)." There can be no doubt that he was sincerely moved by the Douanier's real sensitivity, by his kind and generous nature; Jarry described him as "the well-known philanthropist painter" in one of his articles in *La Revue blanche* (June 15, 1901), in which he tells of a guest, less well-mannered than he, who, not content with having been clothed, lodged, and fed by Rousseau for two months, fell upon his benefactor and accused him of having kept him prisoner.

Is there any reason to suppose that the quatrain attached to Jarry's portrait is not by the painter himself?

> Thou, Muses with dreaming foreheads forming lapidary triangles,
> Look upon this image that it might always please
> Those Readers who, with sincere spirits,
> Seek the agreeable pleasure light can provide.

The verses reveal the artist's high opinion of the young writer with whose friendship he was being favored. Of course, the style is more complex than that of other poems that decorate Rousseau's pictures but shares their elevated thought. For example, *The Present and the Past* (1890-99, fig. 4) strikes the following allegorical note:

> Separated one from the other
> [And] from those they had loved,
> Both remarried,
> Yet remained faithful in spirit.

The lost portrait *A Philosopher* (1896) bore the following inscription, one worthy of the anonymous captions that accompanied the *images d'Epinal,* the naive chromolithographs to which it makes reference:

> In the manner of the great philosopher Diogenes
> (Although not residing in a barrel),
> I am like the Wandering Jew on earth
> Who fears not storm nor water
> But jogs along smoking an old pipe
> Proudly braving thunder and lightning
> To earn a modest stipend
> Despite the rain soaking the ground,
> Bearing uncomplainingly on my back
> An advertisement for the independent newspaper *L'Eclair.*

Of course there is a huge gap between these irregular lines of verse, so totally lacking in metrical pretentions, and the almost excessively accomplished poems in Jarry's *Minutes de sable mémorial.* Yet are they really so different from the rhymed plays, *Le Moutardier du pape, Pantagruel, L'Objet aimé,* or *Par la taille,* which concludes thus:

> The little clock
> Rang in the depths of my incredulous hearing

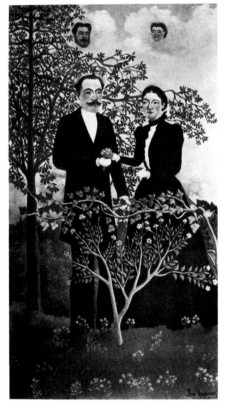

Fig. 4.
Rousseau. *The Present and the Past.* c. 1890–99
The Barnes Foundation, Merion, Pa.

26

Six o'clock, six in the evening!
I shall arrive at my Ministry
Behindtime,
O, despair!

La petite pendule
A sonné jusqu'au fond de mon ouïe incredule
Six heures, six heures du soir!
Je vais arriver à mon ministère
Retardataire
O désespoir!

We do not know whether during the time he lived with Rousseau—or even later—Jarry read the Douanier's plays, *The Merry Student, A Visit to the 1889 Fair,* and *The Revenge of a Russian Orphan.* In addition to finding technical solutions for the problem of simultaneous action and the unfolding of events (which are employed in the *Ubu* cycle, although we cannot in this respect speak of influence, considering the multifarious origins of those works), Jarry would have been drawn to their moral goodness and simplicity of effect, which he always sought in his own *théâtre mirlitonesque.*

The self-taught painter's freshness of imagination, the childlike vision he managed to preserve in all his works (both written and painted), were values Jarry fully appreciated, for he was himself at the time attempting to bring intact to the stage the adolescent genius of *Ubu* and was drawing upon the treasures of the folk tradition in constructing his verbal images. There can be no doubt that it was upon this ground that the encounter between Jarry and the kind-hearted Rousseau, whom the writer did his best to popularize, occurred.

Henri Béhar

27

Rousseau in His Time

Henceforth the wise man
Can witness the scenes of the World
And listen to the song of the wind....

He will go calmly and
Will pass through the ferocity of cities....

He will love the deep places, the fields,
Goodness, order, harmony....

Casting aside passion
And wary of
Worldly usages,
He will prefer landscape.

Le Sage peut, dorénavant
Assister aux scènes du Monde
Et suivre la chanson du vent....

Il ira, calme, et passera
Dans la férocité des villes....

Il aimera les creux, les champs
La bonté, l'ordre et l'harmonie....

Mais revenu des passions
Un peu méfiant des usages
A nos civilisations
Préfèrera les paysages.

—Verlaine

A problem persists with regard to the Douanier Rousseau. Admired by artists at the turn of the century (Pablo Picasso, Robert Delaunay, Wassily Kandinsky, Constantin Brancusi, and others), and defended by the same writers (led by Guillaume Apollinaire and Blaise Cendrars) who defended them, he is still difficult to fit into what we call modern art. Thus in 1918, after having cited the precursors of Cubism and modern painting, Amédée Ozenfant and C.-E. Jeanneret (who was not yet calling himself Le Corbusier) stated: "No need to include among [them] the Douanier Rousseau, one of the most charming painters of the period, for his art was purely traditional."[1] A similar judgment was handed down by Ribemont-Dessaignes, who was active in the Dada movement: "The emergence

of Rousseau is an isolated fact separate from the day-to-day development of art; Rousseau's painting is totally foreign to every contemporary school, whether old-fashioned or avant-garde."[2] And even Philippe Soupault, who was passionately devoted to Rousseau, refused to place his work in historical perspective. Tristan Tzara, however, equally devoted to the Douanier, was able to analyze his work more acutely and to understand the role it played in twentieth-century art.

Such an equivocal situation obviously arises out of the singularity of Rousseau's work and the lack of precedents for it.[3] Also responsible, perhaps, is Rousseau's ambiguous personality, to which we shall return. There persists even today an error in historical perspective regarding his precise chronological position: we tend to forget that Rousseau was not the contemporary of his admirers. Born in 1844, he was very little younger than Paul Cézanne, Claude Monet, and Odilon Redon; his contemporaries were L. O. Merson, B. Constant, and Fernand Cormon, all born in 1845. His true contemporary in pictorial adventure is Paul Gauguin, only four years his junior, who like him began as a Sunday painter and became an artist with a "belated vocation." Neither began painting in his personal style until sometime around 1885. Of course such a parallel cannot be drawn out indefinitely—Gauguin's artistic quest was more calculated, methodical, and rapid than was Rousseau's; however, innumerable relationships can be discerned between the two bodies of work. It has long been noted that Rousseau was indebted to Gauguin, whose canvases he had many opportunities to see.

Notwithstanding the misleading nature of some of his own statements, Rousseau's art cannot be defined by the greater or lesser degree of clumsiness with which he assimilated academic procedures. He did of course attempt to conquer Albertian perspective and to give an illusion of it, primarily in his urban landscapes. In the years around 1890, however, was that really the problem? If traditional perspective and modeling had been rejected, first by Edouard Manet and then by Cézanne, Monet, Georges Seurat, and Gauguin, it was because they realized that such procedures had reached a dead end. Unlike Rousseau, however, they had earlier served their apprenticeships; they had, to varying degrees, acquired the needed skills. Rousseau followed them and, consciously or not, he benefited from the work they had done. In the last years of the century, painters and the more enlightened critics realized that it was no longer necessary to master Albertian perspective to express themselves. The deed, of course, preceded the word, and theoretical writings on the subject are few and far between. However, why should Rousseau be excluded from this great purgative task, one that was not destructive in its effects but, rather, aimed at the elaboration of new languages to take the place of a dying tradition? As early as the first Jungle of 1891 (Surprise!, pl. 6) and in many of the portraits painted around 1900 (pls. 23, 24)[4] we can discern methods close to those of Gauguin and the Nabis. It is after 1900, however, and principally in his exotic compositions, that Rousseau evidences his mastery of a formal language that no longer owes anything to traditional methods. Many critics, even those not fond of Rousseau, have quite rightly evoked Persian, Japanese, or medieval models when writing of his Jungle pictures. Are those sumptuous vegetal décors, in which the spread of fantastic greenery is punctuated by marvelous, multicolored flowers, a reminiscence of the so-called mille fleurs tapestries of the late Middle Ages that he might have seen in his youth in Angers, or in Paris at the Musée de Cluny? Perhaps. Such vegetation, at once

1. Charles-Edouard Jeanneret, Après le cubisme, Paris, 1918, p. 13.

2. Georges Ribemont-Dessaignes, Déjà jadis, Paris, 1958, p. 23.

3. Similar cases do exist, however, the most applicable is that of the railway worker and Sunday painter Niko Pirosmanašvili (1863–1918), who was similarly "discovered" at the turn of the century by the young Russian painters Larionov and Iliazd. On Pirosmanašvili, see A. Devroye, exhibition catalogue, Nice, 1983.

4. There is still a great deal of uncertainty about the chronology of Rousseau's paintings, especially from 1900 on.

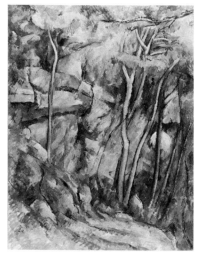

Fig. 1.
Cézanne. *In the Park at Château Noir.* c. 1898
Musée de l'Orangerie, Paris

Fig. 2.
Redon. *Day* (detail). 1910–11
Abbaye de Fontfroide, France

dense and without depth, with the thick foliage of the Barbizon school (although without the clever interspersal of vistas), and far removed from the Impressionists' airy landscapes, may not, however, be particular to Rousseau. A survey of pictorial production around 1900 would in fact reveal many other comparable examples—in Gauguin, of course, in late Cézanne, and in the younger generation, Picasso, Fernand Léger, and Raoul Dufy.

Around 1890, in and around Paris but most of all in the vicinity of Aix-en-Provence, Cézanne had begun to paint skyless, horizonless clearings in the woods (fig. 1). Monet's earliest Waterlilies, with their profuse, invasive vegetation, were exhibited in 1900. Although somewhat later, Redon's frescoes at the Abbaye de Fontfroide (1910–11, fig. 2) are in a way the logical extension of his earlier work. In all these examples—and confining ourselves to artists of Rousseau's own generation—we find painters expressing the same desire: to depart from nature to create a pictorial fact, leading them to the limits of the imagination, abandoning the problems of depth and perspective. Man is excluded, but the profusion, richness, and eternal springtime of their flora endows them with a pantheistic significance that is far different from the earthbound horizons of the Barbizon school or the dainty settings for Impressionist outings; this pantheistic feeling is especially powerful in the late Waterlilies and in Cézanne.

Outside France, in the work of Gustav Klimt (fig. 3) or Augusto Giacometti (fig. 4), for instance, it is possible to find other examples of flat vegetal décor that invades the entire surface of the painting. Nor should we overlook the achievements of Art Nouveau in the area of applied arts. Yet must we revive the somewhat tired notion of influence, fix exact dates, and verify opportunities for actually seeing works or photographs? Those might be useful pursuits were it a question of a particular borrowing, but is it necessary for a convergence of related phenomena? Rousseau could have seen such and such a work, particularly at the Salon des Indépendants where he showed regularly and at which he must have

Fig. 3.
Klimt. *Roses under Trees.* c. 1905
Musée d'Orsay, Paris

Fig. 4.
Augusto Giacometti. *Fantasy on a Potato Flower*
Cantonal Museum, Chur, Switzerland

5. As for the sources of these images, some are known from a publicity pamphlet for the Galeries Lafayette by Meisenbach and Riffart entitled *Bêtes sauvages.* The inventor of a new photogravure method, Meisenbach founded a company that specialized in the publication of art books (see R. Lecuyer, *Histoire de la photographie,* Paris, 1945, p. 248). Other sources can surely be discerned. A group of students from the Ecole du Louvre undertook an investigation, the results of which point up the *abundance* of material. There is no magazine of the period that did not publish illustrated accounts of voyages, explorations, religious missions, and colonial expeditions, to which must be added illustrated publications of fiction and botanical works. There are thus thousands of images that could underlie the Douanier's work.

been a sedulous visitor. Did he see the Cézanne exhibition at Vollard's in 1895; did he frequent Durand-Ruel or Bernheim-Jeune? For a man like Rousseau, alert to the visual world, a man whose entire output reveals an intense drive for renewal, the glimpse of a few works, the décor of a façade or designed paper, some engraving, any isolated impulse, could have sufficed to capture his attention and inspire a meditation, conscious or unconscious, on the problems of his craft.[5] There are more than twenty Jungle paintings, almost all of which are large in scale. Even taking into account the uncertainties of their chronology, most of them can still be dated post-1904; their production, interspersed with the execution of other, often large-scale, works, was thus something around four per year. Whether out of a process of slow ripening or sudden intuition, Rousseau found and at once mastered a landscape formula that enabled him fully to express himself and at the same time to resolve—or circumvent—technical problems that had hitherto held him back.

The profusion of tropical vegetation also reflects another of Rousseau's desires. This impecunious suburbanite, aware that he had led an unadventurous life, was through the evocation of the "incredible floridas" of Arthur Rimbaud's visions to satisfy his own need for dream, for escape—the same escape Rimbaud and Gauguin had sought in flight and revolt; that Pierre Loti (whose portrait Rousseau painted c. 1891, pl. 7) was to realize in the conformist career of naval officer and celebrated novelist; that Redon, Gustave Moreau, Fantin-Latour, and Stéphane Mallarmé would find by taking refuge in their inner worlds, Monet beside his pond, Cézanne opposite his mountain.

Nevertheless, in devoting the majority of his output during his last years to the depiction of an encroaching vegetal fairyland, Rousseau was in line with or anticipating the work of many of his contemporaries, whereas thirty or fifty years earlier such a landscape genre would have been totally unique. In the case of each artist, of course, the work represents the outcome of personal research: it would be as ridiculous to explicate the Jungles by reference to the Waterlilies as it would be to make Monet indebted to Rousseau. Both the Jungles and the Waterlilies are

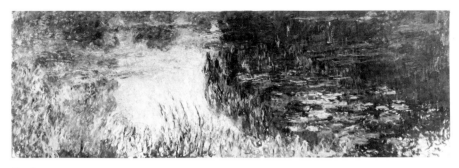

Fig. 5.
Monet. *Waterlilies* (detail). c. 1916–23
Musée de l'Orangerie, Paris

products of their period, and the phenomena of that period go far beyond the domain of painting. Its denizens are "tired of this antique world" and overwhelmed by "tentacled cities." The flower, age-old symbol of votive offering, love, or friendship, thus takes on broader meaning. A symbolic example? Two volumes by a writer who was highly typical of the period, Maurice Maeterlinck, frame the years of Rousseau's "floral" productions: they are *Serres chaudes (Greenhouses),* 1889, and *L'Intelligence des fleurs (Life and Flowers)* of 1907—the first privately published and circulated, the second enjoying an immediate success.

Although our image of the Douanier Rousseau is linked to his Jungles—now popularized even in song—his repertoire of subjects is much richer. At the end of the nineteenth century, when nearly every artist, whether academic or innovative, confined himself to a few subjects, Rousseau's work covered a broad range: still life, genre paintings, individual or group portraits, historical scenes. He even provided a strange collection of farm and domestic animals. Perhaps this should be regarded as another form of escape for a city dweller. In Rousseau's day there were still many farms in the Parisian suburbs. The painter showed an equal

Fig. 6.
Boecklin. *Under the Arbor*
Kunsthaus Zurich

Fig. 7.
Seurat. *The Eiffel Tower.* 1889
The Fine Arts Museums of
San Francisco

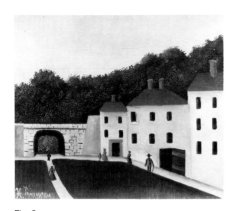

Fig. 8.
Rousseau. *Strollers in a Park.* 1907–08
Musée de l'Orangerie, Paris

originality in the sphere of portrait-landscapes, which he claimed to have invented: as in *The Muse Inspiring the Poet* (pl. 58), his portrait of Apollinaire and Marie Laurencin, flowers are detailed with a botanical care that is almost unique at this period (although Arnold Boecklin in *Under the Arbor,* fig. 6, shows a similar predilection for floral detail).

As for the city landscape, for Rousseau it forms a kind of counterpoint to the exotic landscape. After Charles Méryon and Gustave Caillebotte and at the same time as Camille Pissarro and Maximilien Luce, he was imbuing banal modern urban vistas with grace and poetry. He was also fond of colorless suburban neighborhoods, and he unhesitatingly used determinedly modern motifs in his pictures, for example factory chimneys in *Chair Factory* (c. 1897, pl. 18). In this he had few predecessors other than Seurat and Cézanne (in the Views of L'Estaque). But whereas Cézanne evidenced little taste for modernism and is said to have complained about the installation of streetlights and the "biped invasion" at L'Estaque, Seurat on several occasions used streetlights to give rhythm to his compositions, investigated artificial lighting, and painted *The Eiffel Tower* (fig. 7), the first—and for a long time the only—painter to dare do so. All these motifs, save for the artificial light, were to be taken up by Rousseau as well. And if Robert Delaunay chose the Eiffel Tower (*The City of Paris,* p. 44), still an object of loathing in some art circles, as his symbol of modernity and one of the bases for his experiments with form, he owed the idea in part to Rousseau (*Myself, Portrait-Landscape,*1890, pl. 5), of whom he was a great admirer. There are other examples of Rousseau's consistent taste for subjects that represented technological innovations, the most spectacular being his many paintings of airplanes and dirigibles, which he set in the Parisian sky (*The Quay of Ivry* and *The Fisherman and the Biplane,* pls. 42, 43); here, too, he was followed by Robert Delaunay, as well as by La Fresnaye.

There is a fundamental difference between the significations of the two categories of landscape. The Jungles almost always have the look of impenetrable grills, or screens, before which the conflict unrolls; whereas the pictures of city or suburb are open landscapes through which peaceful strollers promenade (fig. 8). Rousseau's landscapes are filled to an obsessive degree with means of communication: streets, country paths, bridges, vehicles, and, more original, balloons and airplanes. Rivers ("roads that move," as Victor Hugo, that great formulator of the commonplace, called them), nearly absent from the tropical landscapes, appear in almost all the suburban views of Paris. When he creates populated scenes he reconciles social classes (*A Hundred Years of Independence,*[6] 1892, *La Carmagnole,* 1898) or States (*Representative of Foreign Powers arriving to Hail the Republic as a Sign of Peace,* pl. 35). The repeated presence of two of Frédéric-Auguste Bartholdi's colossal sculptures, the Statue of Liberty and the Lion of Belfort, is surely not without significance (pls. 20, 32). Both statues had a precise political meaning: Liberty, in New York harbor, stressing the ideal community between the two Republics, France and America, at a time when most countries were living under monarchies, and the Lion, located in Paris, recalling the defense of Belfort, an heroic episode from the 1870 Franco-Prussian War. Similarly, there can be nothing fortuitous about the continual recurrence of the three national colors (and sometimes only the two, blue and red, of the City of Paris).

Contrary to popular belief, Rousseau was hardly uneducated; secondary stud-

6. The title of this picture, which is Rousseau's own, contains a lapsus, or at least an anomaly, that appears never to have been noted. In French history the year 1892 marks the hundredth anniversary of the proclamation of the Republic, but not of any Independence. Is it to be explained by a kind of accretion (traces of which can be found in the political vocabulary of the Third Republic) between "republic" (form of political régime) and "nation" (an entity that had been forced to defend its independence against the invader in 1792 and again in 1870)?

ies, even when uncompleted, were in his day the accomplishments of the minority. He ended his formal education filled with the zeal of a man believing in the virtues of science and progress. He filled his teaching post at the Philotechnic Association in the same spirit; we also know that he was interested in the political life of his *quartier* and that he was a Freemason. His two extant plays (the manuscript of the third appears to be lost) are written in an easy style. In short, Rousseau's level of education was higher than average for petty civil servants at the time and very much on a par with that of other artists—J.-F. Millet for example. Can we go further? The liberated fantasy of certain of his compositions, his unique expression of dream and the irrational, the pantheism of his Jungles, all recall trends of thought prevalent in his day. There is no question of turning Rousseau into a reader of Lautréamont, a disciple of Sar Péladân or Eliphas Lévy, or into a frequenter of Symbolist or Decadent cenacles. Did he even know the names of Mallarmé or Huysmans? We do not know, but on the other hand, why reject any coincidence between Rousseau's outlook and that of many other artists and writers (some of whom acted as critics at the Salons) who were opening windows to air out the stuffy prosiness of the period? He too was "tired of this antique world."

Once again we must face the problem of Rousseau's unique personality. Was he the simple naïf intoxicated by his belated success and the compliments of his admirers described for us by some of his earliest biographers? There can be no doubt that his behavior often evidenced a kind of naïveté, not to say obliviousness—for example, in the rash acts (the adjective is a mild one) that led him into the courtroom (see Shattuck, p. 20). However, on that occasion his very "naïveté" served him well in the outcome of his trial, and we may wonder whether he was not wisely playing the fool. In the end, our overriding impression is of a certain finesse, of a sometimes clumsy trickiness, but also of a stubborn courage in pursuing and "improving" his work, and, thus, of an indifference to anything that did not touch upon that work. His letters, which constitute the most serious testimony to his state of mind, are explicit in this regard. André Malraux noted in Rousseau "the type of childlike but cunning power that poets often have" and discerned the same quality in Verlaine. It was Verlaine, born only a few weeks earlier than Rousseau, who wrote: "He will go calmly through the ferocity of cities...Casting aside passion, And wary of worldly usages, He will prefer landscape."

Fig. 9.
Watteau. *Young Woman Seated* Musée du Louvre, Paris. Reproduction of this drawing hung in Rousseau's studio

Michel Hoog

Henri Rousseau and Modernism

But above all these, they are
to be commended who come to our
art through spontaneous love of
it and an innate refinement.

—Cennino Cennini

In 1895 Henri Rousseau composed a small autobiography in which he wrote with modest pride: "He continued to improve his mastery of the original genre he had developed."[1] Fifteen years later, and some four months before his death, his tone was sharper when he responded to a critic: "I cannot now change my style, which I acquired, as you can imagine, by dint of stubborn labor." And in the same letter he informed his correspondent: "If I have kept my naiveté, it is because Monsieur Gérôme...as well as Monsieur Clément...always told me to keep it; in the future you won't find it shocking any longer."[2] These statements would indicate that as real as the Douanier's now legendary ingenuousness may have been before the practical problems of life and in his initial approach to art, he was, nonetheless, highly conscious of the way he painted, of his style as such. There is no lack of self-awareness in his identification of "maintaining my naiveté," as a principal goal. Nor was his "primitive" stylization of forms simply an instinctive manner. Rousseau consciously imposed it upon images that in their earlier *bozzétto* stages were often more improvisational, more realistic, and more dependent upon immediate perception.

The "stubborn labor" of which Rousseau speaks began, insofar as we can document it, in the early 1880s and ended with his death in 1910 from the effects of an untreated gangrene infection. During those years, which coincide with the Post-Impressionist era and extend through Fauvism and into the development and elaboration of Analytic Cubism, artists became increasingly concerned with two principles that would be the hallmarks of modernism: conceptual or invented form as opposed to perceived form, and style as opposed to subject matter as the bearer of content. These were, indeed, the years most directly crucial to the development of art in our own century. For all that Rousseau is recognized as having made some of the most beautiful and powerful paintings of this era, his work is rarely perceived as integral to its epoch.

Rousseau is most often considered sui generis, a figure entirely apart, outside

1. Written July 10 for a proposed, but never published, book to be titled "Portraits du prochain siècle." Cited by Dora Vallier in *Tout l'oeuvre peint de Henri Rousseau,* rev. ed. (Paris: Flammarion, 1982), p. 84, and by Henry Certigny, *La Vérité sur le Douanier Rousseau* (Paris: Plon, 1961), p. 157. Rousseau's submission of this biography to the editors of the planned book was unsolicited and perhaps made at the instigation of Alfred Jarry.

2. Letter to André Dupont, cited in special Rousseau issue of *Les Soirées de Paris,* eds. Guillaume Apollinaire and Jean Cerusse, no. 20 (Jan. 15, 1914 [erroneously dated 1913]), p. 57.

the mainstream of his own generation. He tends to be valued in the twentieth century for the delight his pictures give us, but his art is thought to have had little impact on our own. At best he is regarded as a kind of happy accident; at worst—in his guise of "primitive"—as the founder of a school of twentieth-century naive painting. Although some critics, scholars, and artists have recognized in Rousseau's Symbolist, poetic preoccupations and his flat-lit, archaizing, decorative style his close ties with his own Post-Impressionist generation, standard reference works usually locate him under Primitive, often in association with such painters as Camille Bombois and Louis Vivin. As Carlo Carrà pointed out, "attempts to create the same legend about the bricklayer Bombois and the mechanic Boyer have had to be abandoned, because the discrepancy was so apparent;"[3] the quality of Rousseau's painting completely invalidates such comparisons.[4] The commonplace use of the word *primitive* is meaningful as applied to Rousseau only in that he was self-taught.

The term itself was probably first used with reference to Rousseau by the playwright and novelist Alfred Jarry.[5] Born in Laval as was Rousseau, Jarry was one of the artist's earliest defenders; although Jarry was undoubtedly drawn by Rousseau's eccentric, almost child-man personality, these were not the qualities that caused him to characterize a portrait by Rousseau as primitive. Rather, Rousseau's style made him think of the Italian and Flemish primitives; he specifically mentions Memling.[6] And Thadée Natanson, in *La Revue blanche,* wrote: "Above all mention must be made of Monsieur Henri Rousseau, whose *determined* naiveté manages to become a style and whose ingenuous and stubborn simplicity, relying solely upon our goodwill, manages to remind us of primitive works."[7] Natanson's "determined naiveté" reads as a mildly derisive echo of Rousseau's own "stubborn labor." That such single-mindedness should become style is more surprising for Natanson than for the artist. As Natanson uses the plural "primitives," we may assume that he had in mind late medieval/early Renaissance art, as had Jarry, rather than "Egyptian" or any other of the non-Western or pre-Renaissance arts that the word *primitive* was often used to describe in the late nineteenth century.[8]

From our present perspective, we need not, however, draw upon our "goodwill" to see the similarities between Rousseau's work and the art of the pre-Renaissance West. In both we find similarly flattened space and an absence of the complex devices of illusionist lighting and perspective that characterized the official art of Rousseau's day. That being said, Natanson's goodwill was probably called forth less by the formal similarities between Rousseau's work and pre-fifteenth-century Christian art than by their spiritual affinities. Rousseau's painting, as perhaps no other in the late nineteenth century, is infused by faith. A Freemason, Rousseau was almost aggressively anticlerical,[9] but he had an absolute quasi-religious belief in art.

The world he created has been described as "consistent and self-contained as a Hebrew prophet's, and for the same reason he believed in it."[10] Gustave Coquiot, who with Odilon Redon was perhaps the first notable figure in the artistic milieu of the day to notice Rousseau, later wrote: "[He] worshiped only Painting, lived for it alone." Coquiot is virtually the only person to have known Rousseau who has described him as having been other than long-suffering and patient to the point of saintliness—he goes so far as to report that there were times when his "beastliness beat anything." Yet, in reflecting further on Rousseau's art, he credits

3. Carlo Carrà, "Rousseau le Douanier and The Italian Tradition," *Magazine of Art,* vol. 44, no. 7 (Nov. 1951), p. 261.

4. André Salmon, one of the earliest and still most perceptive of the commentators on Rousseau, wrote of the modern naives vis-à-vis Rousseau: "They have absolutely nothing in common with Rousseau. On the contrary, the example of their half-success or half-failure, whichever, helps us to situate Rousseau more clearly, and in a truer light." Cited in *Henri Rousseau dit Le Douanier* (Paris: G. Crès, 1927), p. 22.

5. Certigny, p. 169.

6. Ibid., p. 137.

7. June 15, 1897; cited in ibid., p. 169.

8. For a discussion of the uses of the word *primitive,* see William Rubin, "Modernist Primitivism: An Introduction," in *"Primitivism" in 20th Century Art: Affinity of the Tribal and the Modern,* ed. Rubin (New York: The Museum of Modern Art, 1984).

9. See Certigny, pp. 194–95.

10. David L. Norton, "The Primitive Painter's 'Reality,'" *Post-Dispatch* (St. Louis, Mo.), Oct. 4, 1959.

him with "such style, such inventiveness, such a deployment of rare qualities: and above all he offers such a love, such personal generosity, such a gift of his naked heart, such absence of falsehood, of insincerity, that we can rightly speak of Rousseau's contribution to painting as both generous and unique."[11]

This all-consuming devotion to an ideal is in part responsible for the artist's reputation as a primitive. It was the basis for his unworldliness and for the profound sincerity that even he characterized as naive. Rousseau's obstinate struggle to express his own vision was the cultivation of his faith and the preservation of that naiveté which, in the last months of his life, he firmly proclaimed intact.

As an autodidact, Rousseau found his own way into painting. In 1886 while still working as a minor excise officer for the city of Paris,[12] he began to exhibit annually[13] in the Salon des Indépendants, and by the middle of the next decade—despite widespread critical scorn and ridicule—was known and admired by many of the major vanguard artists of his time. But he worked at his painting in isolation, untouched by the theoretical debates that engaged so many of his fellow exhibitors at the Indépendants. In formal terms, his solutions to many of his pictorial problems were demonstrably parallel to those of Paul Gauguin, Georges-Pierre Seurat, and other Post-Impressionist artists; yet his professed admiration was for the heroes of the Academy: Félix-Auguste Clément, Jean-Léon Gérôme, Léon Bonnat, and William-Adolphe Bouguereau. This apparent contradiction produces another contradiction if we attempt to resolve it by concluding that "in innocently following debased Academic practices he perverted their effects."[14] This solution, perhaps rightly, implies an accidental factor in the earliest stages of the formation of Rousseau's style, but it implies as well that Rousseau did not know what his pictures looked like. Rousseau's recorded testimony aside, it is impossible to imagine the painter of such magnificently controlled canvases as *War* (1894, pl. 9), *The Sleeping Gypsy* (1897, pl. 19), and *The Dream* (1910, pl. 66) to have been engaged in an innocent perversion over a twenty-year period. The disagreement here is not, however, with any assertion that "his ideal of finish was academic in origin,"[15] for we have every reason to believe that it was—indeed, high finish was what Rousseau seems to have most admired in official Salon painting.

Whenever Rousseau may have begun to paint in earnest, it was certainly while he was still an employee of the Octroi of Paris, unimaginably far removed from the cenacles of high art toward which he longed. His employment in the Octroi left little time either to paint or to look, so that high art was for him what he found in the Louvre and other museums of Paris and its suburbs (for which he had received a copyist's permit in 1884),[16] and, most immediate to him, the official Salon art of the time. The Ecole des Beaux-Arts and the Académie des Artistes Français were the consecrated temples of the faith that drew him. It is likely that he tried in his earliest paintings to emulate the achievements of its high priests, and, in working toward that ideal, rather than away from it as his contemporaries were doing, effected an unpremeditated reversal of its terms. But at some point, certainly prior to the execution of *Myself, Portrait-Landscape* (1890, pl. 5), he seems to have realized that the Gods could be served in more ways than one, and made his particular version of tight finish and concomitant surface treatment of flat, overlapping planes positive components of the style that he practiced without deviation for the rest of his career. As Fernand Léger was later to remark,

11. Gustave Coquiot, *Les Indépendants 1884–1920*, 4th ed. (Paris: Librairie Ollendorf, 1920), p. 133.

12. Although Rousseau was referred to as *Le Douanier* extensively during his life and to such a degree after his death that the term is virtually synonymous with his given name, he was, in fact, never a customs officer but one of the toll collectors formerly stationed at the gates of the city of Paris. These functionaries of the department of city government called L'Octroi were properly described by the word *gabelou*. The social station of a *gabelou* was considerably lower than that of a *douanier;* in fact, the pejorative term for a customs officer is *gabelou*.

13. Rousseau exhibited in every Salon des Indépendants except those of 1899 and 1900 through the year of his death in 1910.

14. John Elderfield, *European Master Paintings from Swiss Collections: Post-Impressionism to World War II* (New York: The Museum of Modern Art, 1976), p. 40.

15. Ibid. Although Rousseau's tight, economical finish was far from that of the Salon—as Elderfield points out, remarking that his "scrupulously detached treatment of surface composed of flat, juxtaposed and overlapping planes [is] closer...to a detailed version of Cézanne than to Bouguereau"—it was nonetheless considerably at odds with the more painterly handling that characterized modern art after Impressionism. A discussion of Picasso's contrasting within his own art the finish of Rousseau with the *nonfinito* of Cézanne follows in this essay.

16. The permit was probably obtained through the intercession of Félix-Auguste Clément, Rousseau's neighbor in the rue de Sèvres. See Vallier, *Tout l'oeuvre peint*, p. 83, and Certigny, p. 85.

Rousseau was a worker not an engineer.[17] His painting tended to become bolder over the years and capable of encompassing more fanciful subject matter, but it did not experiment with other modes; we know, however, from his studies, which are competent, even expert, impressionistic works, reflecting an immediate confrontation of the motif, that he was capable, when he wished, of painting in a very different manner from the one we see in his finished pictures (pls. 13, 14). For him, painting based on immediate sensation was only a preliminary stage in the realization of a more permanent concept of style.

Rousseau's constancy of manner is paralleled over the course of his career by a remarkably consistent level of realization in terms of quality. Whatever unevenness we find in his work is almost entirely confined to his small paintings, some of which were probably hastily done in an attempt to satisfy shopkeepers' bills, and about many of which the greatest doubts as to authorship exist. In assessing Rousseau's oeuvre, the question of authenticity is a major concern. So many paintings of problematic origin have been advanced in the literature (even from the very beginning) as well as on the market that the overall view of his work has become clouded. Criticisms of Rousseau's art as especially uneven are very much related to the confusion surrounding the extent of the artist's actual output. It is our hope that this intentionally restricted exhibition, providing, as it does, the opportunity to see some sixty paintings of unquestioned authorship that represent the artist from his beginnings at the Indépendants through his last finished work, *The Dream* (1910, pl. 66), will clarify the image of his style. By focusing on his most ambitious works, but including as well more modest endeavors, the exhibition will demonstrate that—contrary to the oft-cited unevenness—the *real,* the demonstrable Rousseau maintained an unusually consistent level of quality throughout his career.

A key painting in Rousseau's oeuvre both because it asserts the major elements of his style and because it announces his identity and place in the world as *artiste-peintre* is *Myself, Portrait-Landscape* (1890, pl. 5). What he painted about himself in this picture he writes of himself in his 1895 autobiography: "His appearance is notable because of his bushy beard and he has long been a member of the Indépendant group, believing as he does that complete freedom to produce must be granted to the innovator whose thought is elevated toward the beautiful and the good."[18] In this, the largest of the paintings he had yet made, Rousseau presents himself in monumental scale against a scene of Paris in which the Eiffel Tower and a hot-air balloon, symbols of the Exposition Universelle of 1889, announce the modern age. His timid identity as civil servant and Sunday painter is totally discarded, and his profession as *artiste-peintre* proclaimed.

The portrait-landscape as reinvented by Rousseau[19] explicates its subject, and none does so more fully than this self-portrait. Indispensable to the uniform of the artist in the nineteenth-century popular imagination was a large, floppy beret like the one worn by the painter on a poster for the 1889 exhibition (fig. 1). Rousseau's conspicuous adoption of this beret asserts his profession; just as the names of his two wives inscribed on his palette testify to the steadfastness of his affections,[20] the beret symbolizes his sense of the nobility of his calling and links him to its traditions. Unlike Bouguereau, who, hoping to block construction of the Eiffel Tower, signed a petition which claimed that "the Paris of the sublimely Gothic... will have become Paris of M. Eiffel,"[21] Rousseau, like the poster painter,

Fig. 1.
L. Gabillaud. *L'Exposition Universelle de Paris en 1889*
Musée d'Orsay, Paris

saw art allied to the new mechanical age heralded by the tower; art in all of its accumulated glory with the painter as its apostle would play its accustomed role, retaining its old subjects while exalting the new.

Rousseau was a frequent visitor at the 1889 Exposition Universelle, and even wrote a vaudeville play about it, *A Visit to the 1889 Fair,* which describes a kaleidoscopic walking tour of Paris as much as it treats the fair itself. Intended as a celebration of the 1789 Revolution, the fair was a great success, and thus was widely regarded as a victory for the Republic and republicanism; among its commercial benefits were large increases in the receipts of the Octroi of Paris.[22] For Rousseau, who was antimonarchist and a devoted patriot, it was an affirmative event closely linked to his daily life.[23]

In all of Rousseau's portrait-landscapes, the figures are delineated with great clarity against a ground plausibly appropriate to their particular personalities, situations, or occupations; in almost no other,[24] however, is there the absolute definition of ground and model that we see in the uncompromising black of the painter's image against Paris and the sky above. Rousseau's outsize figure, his head in the heavens, higher than the top of the mast of the flag-bedecked boat, the top of the Eiffel Tower, and the floating balloon, is superimposed on a view of Paris as painted by himself. As though in a photographer's studio, he is the carefully posed model "collaged" against an artificially lit backdrop. *Myself, Portrait-Landscape* is a picture of the artist and his subjects both seen and unseen, for he looks out of the painting with a fixity of vision that is pointed not at us but at the world of his imagination.

Roch Grey, who later owned *Myself* with her brother, Serge Férat, wrote of Rousseau's personality, "His simplicity borders on the aristocratic,"[25] and this indeed is the image we see of the man touchingly "dressed as an artist in a Rembrandt hat,"[26] *Palmes académiques* in his lapel, and immense paintbrush in hand. Rousseau's achievement in this painting could be described as Alfred H. Barr, Jr., described Cézanne's in his *Bather* of c. 1885, "adapting a landscape from another painting, [he] has again fumbled his naturalistic scale while achieving artistic grandeur."[27]

If Cézanne's scale were indeed "fumbled" in joining landscape and figure, the parallel distortion by Rousseau was almost surely deliberate. *Myself* is the first painting in which major elements of Rousseau's characteristic style are stated. While the liberties he takes with naturalistic scale and the flatness of his forms may have originated in his early problems with the rendering of perspective, they have become, by the time of *Myself,* coordinates of his own style. This pragmatic approach to making art was very different from the highly intellectual route of Seurat and his Neo-Impressionist followers, as it was also from the self-conscious, mystic, quasi-religious path of Gauguin and the Symbolists. The work itself, however, shares much with theirs, and contemporary criticism, in spite of the tendency then as now to put Rousseau in a special and isolated category, often derided their work for the same "faults" it found in Rousseau's.

Although the artists who are generally grouped as Post-Impressionists worked in a wide diversity of manners, their paintings are related by certain common characteristics. In their art they were all concerned with the expression of individual personality both in subject and style; rejecting the spatial norms of the Renaissance and conventions of official Academy art, they employed a variety of visual perceptions, while maintaining tightly structured compositions. Rousseau's

17. Fernand Léger, *Functions of Painting,* The Documents of 20-Century Art, ed. Edward F. Fry, trans. Alexandra Anderson (New York: Viking Press, 1973), p. 63 (first published as *Fonctions de la peinture* [Paris: Editions Gonthier, 1965]).

18. Cited in Vallier, *Tout l'oeuvre peint,* p. 84, and Certigny, p. 157.

19. See Rousseau's letter of Dec. 7, 1907; cited in Certigny, p. 300.

20. See Vallier, *Tout l'oeuvre peint,* p. 92, no. 32, for a discussion of Rousseau's painting and repainting of the palette.

21. Cited by Richard D. Mandell in *Paris 1900: The Great World's Fair* (Toronto: University of Toronto Press, 1967), p. 19.

22. Ibid., p. 22.

23. Certigny, p. 104, points out that a facsimile of a Senegalese village constructed on the Champs-de-Mars may have played a role in the later development of Rousseau's exotic imagery.

24. In *L'Enfant aux rochers* (Vallier, *Tout l'oeuvre peint,* no. 86), The National Gallery, Washington, D.C., the definition of figure against ground is as pronounced.

25. Roch Grey, *Henri Rousseau* (Rome: Edizione di Valori Plastici, 1922), p. 12. Roch Grey was the pen name of the Baroness Hélène d'Oettingen and Serge Férat was the name assumed by her brother Serge Jastrebzoff.

26. Pierre Courthion, "Henri J. Rousseau," *L'Oeil* (Lausanne), no. 46 (Oct. 1958), p. 27.

27. Alfred H. Barr, Jr., ed., *Masters of Modern Art* (New York: The Museum of Modern Art, 1954), p. 22.

painting shares all of these characteristics and clearly places him within the Post-Impressionist, Symbolist orbit.

While we can thus locate Rousseau, his ties to his own generation were largely of a formal order. What relates Rousseau's paintings to those of the Post-Impressionists, notably Gauguin and Seurat, are parallel structural qualities, and/or like subjects, and symbolistic poetic effects. But while his *poésie,* like his pictorial architecture, paralleled that of the Post-Impressionist and Symbolist vanguard, these affinities went unremarked at the time. It remained for the first generation of painters of the next century to see Rousseau's art as relevant to their own. Although Rousseau's appearances in the Salon des Indépendants were so regular and so faithful that it was later remarked by a critic, "...what would an exhibition of the Indépendants be without Monsieur Rousseau?"[28] his personal contact with his late nineteenth-century contemporaries was limited. What there was of it sometimes seems to have taken the form of practical jokes made irresistible to Rousseau's more sophisticated colleagues by his gullibility and unworldliness. More importantly, his work was noticed and admired—if sometimes patronizingly—by such elder statesmen of the avant-garde as Camille Pissarro, Pierre-Auguste Renoir, and Hilaire-Germain-Edgar Degas, and was even singled out by the deeply respected Puvis de Chavannes as well as by Redon, Gauguin, Toulouse-Lautrec, and Signac. But if his art had any influence on his fellow Indépendants, its operation was subliminal, with virtually no detectable effects.

The particular affinities of Rousseau's work with that of Gauguin and Seurat are worth examining in some detail as they tend to illuminate aspects of the Douanier's painting that have made it important to artists in our own century.

Visiting the Salon des Indépendants of 1890, in which Rousseau's self-portrait was hung, Gauguin is reported to have exclaimed in front of the Douanier's entries: "Now that is painting! It's the only thing that can be looked at here."[29] If, in fact, this scene did occur as reported, Gauguin may have spoken half in jest, half seriously. Rousseau's apparently naive style may have had the directness of feeling he himself sought and saw reflected in the art of Breton folk painters and Polynesian sculptors. But if Gauguin found conviction and sincerity in Rousseau's work, its literal side may have seemed comic to this very much less than innocent artist, so self-consciously endeavoring to return to the primitive. Like Rousseau, Gauguin had given up another career—although in Gauguin's case, it was the more elevated one of banker—to devote himself to art. But his subsequent experience was in some respects the very opposite of Rousseau's humble, lonely toil. Gauguin's forceful personality and freely articulated opinions, almost as much as his art, caused him to be seen as the unofficial *chef-d'école* of Symbolism, whereas Rousseau was regarded as no more than a simple eccentric. Nonetheless, Gauguin's professed desires to rejuvenate art by returning to pre-Renaissance and non-Western sources, "to primitive art that proceeds from the mind and uses nature,"[30] produced a highly decorative and emblematic oeuvre that has much in common with Rousseau's. Both are characterized by flat, juxtaposed areas of rich color that lie assertively on the surface, sharp patterns, avoidance of shadow and modeling, and the reduction of form to essential outlines. But Rousseau's work, proceeding from an imagination unfettered by preconceived theory, is—except in color—far bolder and surer. Even Gauguin must have seen some of this quality; his often cited admiration for Rousseau's use of black was probably a recognition of its daring, especially at a time when it had been

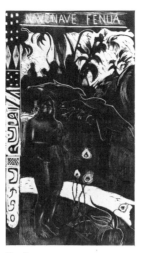

Fig. 2.
Gauguin. *Nave, Nave, Fenua.* c. 1895
The Art Institute of Chicago
The Clarence Buckingham Collection

Fig. 3.
Gauguin. *The Loss of Innocence.* 1890
The Chrysler Museum, Norfolk, Va.
Gift of Walter P. Chrysler, Jr.

banished from the vanguard palette by the Impressionists, Seurat, and Cézanne.

Gauguin's search for the unspoiled and instinctual led him first to Brittany and then to the South Seas, but he could not throw off the culture he carried with him, and in many of his paintings a synthesis of the varied elements of fin de siècle Symbolism and the fragments of non-Western art history often seems grafted onto his primitivized or exotic imagery in an inorganic way. Rousseau's equivalent to Gauguin's Breton peasants are the petite bourgeoisie of Paris and the suburbs, while his flight to the desert and the tropics was accomplished via the Jardin des Plantes and pictures he found in magazines and journals.[31] But his working-class subjects inhabit a Sunday world of Paris that is in its own way an image of a Golden Age seemingly as eternally ordained and as harmonious as the ancient dream of lost innocence; and in the fantasy kingdoms of desert and jungle his imagination delivers to us, we are in the realm of dream and at the heart of myth.

While many of Rousseau's iconographic sources are in popular imagery and Salon painting rather than in the work of his vanguard contemporaries, it is likely that he found inspiration for the imagery of *The Snake Charmer* (1907, pl. 36) in the Gauguin retrospective at the Salon d'Automne of 1906. Painted the following year, *The Snake Charmer* suggests certain of Gauguin's figures as, for instance, the woman in the colored woodcut *Nave, Nave Fenua* (c. 1895, fig. 2), which was shown in the retrospective. There may even be a tenuous relationship between Rousseau's *Eve* (pl. 29), probably painted sometime after 1904, and Gauguin's *The Loss of Innocence* (fig. 3).

If the manner of Rousseau and of Gauguin have much in common, their paintings are very different in feeling. By contrast, the pictures of Seurat, whose methodology and approach could not be further removed from Rousseau's, are often affectively quite close to the Douanier's. Although Rousseau and Gauguin were acquainted, there is little to suggest that Seurat and the Douanier ever met, even though they undoubtedly saw each other's pictures as fellow exhibitors in several of the Salons des Indépendants.[32] In 1886, the year Rousseau made his

28. Furetières, *Le Soleil,* April 1906; cited in Certigny, p. 261.

29. Cited by Pierre Descargues, *Le Douanier Rousseau* (Geneva: Skira, 1972), p. 11.

30. C. Morice, *Paul Gauguin* (Paris, 1920), pp. 25–29; cited by John Rewald, *Post-Impressionism: From van Gogh to Gauguin,* 3d ed. (New York: The Museum of Modern Art, 1978), p. 420.

31. For a good graphic presentation of Rousseau's sources, see Yann Le Pichon, *Le Monde du Douanier Rousseau* (Paris: Editions Robert Laffont, 1981).

32. Seurat and Rousseau were fellow exhibitors in every Indépendants from 1886 to 1891 and again in 1892, when a posthumous retrospective of Seurat's work was held. A retrospective of Seurat's work was also held in 1905 at the Indépendants.

Fig. 4.
Seurat. Study for *Sunday Afternoon on the Island of La Grande Jatte.* c. 1884–85
The Metropolitan Museum of Art, New York

Fig. 5.
Seurat. *Sunday Afternoon on the Island of La Grande Jatte.* 1884–86
The Art Institute of Chicago.

début in the Salon, Seurat's *Sunday Afternoon on the Island of La Grande Jatte* was the scandal of the exhibition, provoking both mirth and controversy. Although his fellow artists and many influential critics took Seurat's art very seriously indeed, it elicited reactions both favorable and unfavorable that parallel various receptions of the Douanier's work. One critic called *La Grande Jatte* "an error, a flat imitation of Miss Kate Greenaway."[33] And, with certain overtones of Natanson's remarks on Rousseau, the Belgian poet Emile Verhaeren wrote: "La Grande Jatte is painted with a primitive naiveté and honesty....As the old masters, risking rigidity, arranged their figures in hierarchic order, M. Seurat synthesizes attitudes, postures, gaits. What the masters did to express their time, he attempts for his, and with equal care for exactness, concentration, and sincerity."[34]

Seurat, fastidiously basing himself on the highly intellectualized, "scientific" theories he had developed, sought to found his art on the transcription of optical sensation, whereas Rousseau, doggedly and with artisanal scruple, often sought to project an inner vision. Ironically, the extreme artfulness of the one and the pragmatic artlessness of the other—each in its own way close to what Gauguin had in mind when he said that "truth in art" was "cerebral" and "primitive," proceeding "from the mind and using nature"[35]—produced art of similar poetic effects. Rousseau's and Seurat's depictions of working-class holiday life share a sense of quietude and stasis that imparts the fixity of eternal order to the banal subject matter.

Given the disparity of their mentalities and the fact that the only similarity (apart, of course, from their common rejection of traditional illusionism) between Seurat's method of carefully applying colored dots and Rousseau's equally meticulous layering of flat planes would seem to be a mutual conscientiousness, it may seem odd that their paintings have such similar affective qualities. But they share more than we might initially grasp. Even in what is seemingly most opposed, their factures, there is a parallel precision, directness, honesty, and immediate legibility. Rousseau's smooth surfaces are as candid about process as are Seurat's dots. And like Seurat, Rousseau had a very clear notion of finish; the sketches of both before the motif are impressionistic aides-mémoires intended to be transformed in the studio to stylized paintings (figs. 4, 5; pls. 59, 60).

Moreover, as pictorial composers, the two artists are quite often very close. Both treat the picture as a self-contained field organized by a bold architecture of

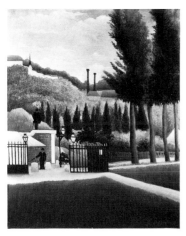

Fig. 6.
Rousseau. *L'Octroi*. c. 1890
Courtauld Institute Galleries, London

Fig. 7.
Seurat. *Port-en-Bessin*. 1888
The Minneapolis Institute of Arts

Fig. 8.
Seurat. *Invitation to the Sideshow (La Parade)*. 1887–88
The Metropolitan Museum of Art, New York
Bequest of Stephen C. Clark

33. F. Javel, "Les Impressionnistes," *L'Evénement*, May 16, 1886; cited in Rewald, p. 86.

34. Emile Verhaeren, "Le Salon des Vingt à Bruxelles," *La Vie moderne*, Feb. 26, 1887; cited in Rewald, p. 94.

35. See n. 30 above.

36. Ronald Alley, in *Portrait of a Primitive: The Art of Henri Rousseau* (Oxford: Phaidon, 1978), p. 28, has pointed out the resemblance of *L'Octroi* to work by Seurat.

37. Rousseau would have seen *La Parade* not only in the Indépendants of 1888, but again in the posthumous retrospective of 1892. He may also have seen it once more when it was shown in a Seurat retrospective at the Galerie Bernheim-Jeune (Dec. 14, 1908–Jan. 9, 1909).

38. Meyer Schapiro, "Seurat," in *Modern Art 19th and 20th Centuries: Selected Papers* (New York: Braziller, 1978), p. 108.

rigidly controlled verticals, horizontals, diagonals, and arabesques. Figures are often presented almost parallel with or at right angles to the picture plane, in a state of suspended animation as in a dream, and their postures as well as other compositional elements and patterns are often rhymed and echoed. While it may be necessary to analyze the paintings of Seurat and Rousseau closely to discover their similarities, certain of Rousseau's works, such as *The Octroi* (fig. 6), demonstrate a striking resemblance to Seurat as we see him in such works as *Port-en-Bessin* of 1888 (fig. 7).[36] No evidence exists to indicate that Rousseau was consciously influenced by Seurat, and it seems unlikely that pictures painted in a pointillist technique would have appealed to him. But if we allow for this possibility, we may also permit ourselves to wonder if, much later, when painting the dark musician of *The Dream*, Rousseau did not have some whispering memory of the trombone player from Seurat's *Invitation to the Sideshow (La Parade)* (fig. 8) before his mind's eye.[37]

Aside from the common characteristics of Rousseau's and Seurat's pictorial structures, what relates their pictures most is an unnatural and determinedly inconsistent light that accounts for much of their poetic resonance, or, as André Breton was to say of each, their "magic." Also evident in the work of both artists is their common interest in modernity as symbolized by the Eiffel Tower, iron bridges, and, later for Rousseau, the new airships. For Seurat, who was fifteen years younger than Rousseau and almost dispassionately intellectual, the new accomplishments of engineering may have held, as Meyer Schapiro observes, "deeper" meaning "as models of structure and achievement of the rational mind."[38] But, in incorporating the tower in his self-portrait and other paintings, as well as frequently depicting the new urban world, the Douanier goes beyond expressing a simple sense of wonder at new mechanical marvels and records his recognition of man—especially the artist—interacting with a transformed, constructed environment. He and Seurat were, in fact, the only nineteenth-century modernists to have celebrated the Eiffel Tower, and in their different ways were committed to an ideal of technological modernity.

Some twenty years after Rousseau's self-portrait of 1890 and Seurat's death in 1891, a new generation of painters in a new century began to celebrate man in his machine-made world. One of them was Robert Delaunay, now famous for his own versions of the Eiffel Tower. One of these, *The City of Paris* (fig. 9), incorporates an homage to Rousseau, quoting at its left edge the flag-bedecked boat from *Myself, Portrait-Landscape*. Delaunay met Rousseau in 1906 and became his friend, not only admiring but collecting his pictures. In 1920, reflecting on the Douanier's qualities, Delaunay wrote: "Rousseau takes his place alongside the masters who are the harbingers of modern art and sometimes overshadows them by his great faith, his naiveté and his sense of style.... Rousseau's style was pushed close to perfection. However, he had no theories at all...[and] while eschewing talk of style and tradition, Rousseau was more impregnated with them than the majority of the painters of his generation. For him the picture was a primal surface with which he had to deal physically to project his thought. But his thought consisted solely of plastic elements. If order and composition were basic to it, the *matière* was laid out as the work progressed. The picture was a unity. Everything in it was subject to the whole... to the relationships of surfaces on the primary surface of the canvas."[39]

When Delaunay writes, "his thought consisted solely of plastic elements," he is giving us an essential key to the understanding of Rousseau's painting, its genius and its inimitability. Rousseau's art is as stylized as any we can find—every bit as much so as Seurat's—and we know from Rousseau's own account as well as others' that it was almost as painstakingly executed.[40] Yet it has a feeling of spontaneity that high style and meticulous execution almost by definition preclude. This immediacy in Rousseau's work arises from his directness of transcription—conception and action are not separated by theory. Although Rousseau's style was not yet fully formulated in 1888, it must have been a quality of his peculiar freedom that led Degas, when brought to the Indépendants in that year to see work by Seurat, to turn to the paintings of the Douanier and exclaim, "Why shouldn't that be the painting of the future?"[41] The remark by Degas, impatient with explanations of theory, may have been made at least partially in exasperated jest.

Rhetorical as Degas's question might have been, we will take the liberty of possibly perverting his sense and respond seriously. Rousseau's painting was too intimately a part of himself to provide a model, and formulas were nonexistent outside his own creative powers. Hence his painting could be and was a fecund source of ideas, but his style as a totality could not be converted to the expressive needs of any other painter. By contrast, Seurat's codified style was more limited and therefore less rich in suggestion; and, personal though it was in Seurat's own hands, it could be adopted whole, which indeed it was by the entire coterie of Neo-Impressionist painters.

Rousseau's painting does not simply belong to Post-Impressionism; it is to some degree an unwitting synthesis of certain of its styles and subject matter, particularly those of Gauguin and Seurat, which were to be combined in the works of the Fauves between 1905 and 1907. But Fauvism, generally considered the first vanguard artistic movement in the new century, was even more a synthesis of late nineteenth-century ideas—the last struggle in the battle initiated by Manet to throw off the received conventions of post-Renaissance Western painting. Although all the major Fauve painters knew Rousseau's work well, they did not

Fig. 9.
Delaunay. *The City of Paris.* 1910–12
Musée National d'Art Moderne, Centre Georges Pompidou, Paris

39. Robert Delaunay, "Henri Rousseau le Douanier," *L'Amour de l'art* (Paris), no. 7 (Nov. 1920), pp. 228–29.

40. For an account of Rousseau's working methods, see Ardengo Soffici, *Trenta Artisti Moderni Italiani e Stranieri* (Florence: Vallecchi Editore, 1950); cited in Certigny, p. 411. In Rousseau's correspondence with Apollinaire concerning his work on *The Muse Inspiring the Poet,* he often refers to his slow, labored progress, mentioning in connection with his urgent need for money the difficulties of having to live on his pension alone "while I'm working on a picture that calls for two or three months work" (Apr. 28, 1909; cited in Rousseau issue, *Les Soirées de Paris,* p. 42).

41. Recounted by Ambroise Vollard, *Recollections of a Picture Dealer,* trans. Violet M. Macdonald (London: Constable, 1936), p. 196; cited in Certigny, p. 100.

42. Félix Vallotton, *Le Journal suisse,* March 25, 1891; cited in Certigny, p. 115.

43. Apr. 1906; cited in Certigny, p. 261.

44. Mar. 26, 1910.

45. Pierre Daix (in a letter to Rubin, Dec. 15, 1982) insists on Matisse's interest in the Douanier as early as 1905, and cites Alfred H. Barr, Jr., *Matisse: His Art and His Work* (New York: The Museum of Modern Art, 1951), p. 77, in regard to the possible association between Matisse's 1906 *Pink Onions* and the still lifes of Rousseau. The art of Rousseau played a certain role at least in the step toward simplification and reduction of means that marks Matisse's transition from Fauvism to his own personal style in late 1906 (the difference, essentially, between the two versions of *The Sailor*). This role was, however, subordinate to that of Gauguin, Cézanne, and the various so-called primitive arts Matisse was already collecting. The work that may best illustrate Matisse's generalized primitivism of the period around late 1906 is *Marguerite* (repr. in Barr, p. 332), which Picasso would select in an exchange of works between the two artists the following year.

46. See Sandra Leonard, *Henri Rousseau and Max Weber* (New York: Richard L. Feigen & Co., 1970), p. 48, n. 133, for Weber's version of Matisse's attitude toward Rousseau. Adolphe Basler, in *Henri Rousseau* (Paris: Librairie de France, 1927), p. 10, writes: "Max Weber led the Académie Matisse in his praise for the Douanier's work. He managed to infect the majority of the students with his impassioned belief; on the other hand, the Master remained cool, if not hostile, to such ingenuous painting"; cited in Certigny, p. 353.

47. Cited in *Les Soirées de Paris,* p. 68; recounted in Certigny, p. 438.

yet see in it the relevance it would later take on as the Fauve movement started to fade.

Rousseau's interaction with Fauvism was very much as it had been with Post-Impressionism. He painted and they painted, and what he painted and what they painted were all shown together at the Salon des Indépendants and the Salon d'Automne. As has often been suggested, the proximity of one of Rousseau's entries in the 1905 Salon d'Automne, the huge *The Hungry Lion* (1905, pl. 31), to the paintings of Henri Matisse, André Derain, Maurice de Vlaminck, and others may have unconsciously prompted the critic Louis Vauxcelles to use the term *fauves,* or wild beasts, to describe the new group—a term hardly warranted by their style—especially in 1905. Thus baptized, the new painting provoked strong reactions, and Rousseau benefited from the press coverage, especially when the conservative *L'Illustration* published a two-page spread featuring *The Hungry Lion,* along with reproductions of Fauve works, including those of Matisse and Derain, as well as paintings by Cézanne and Edouard Vuillard. Indeed, one wonders if the Fauve painters may have felt a little bit as Félix Vallotton had at the Indépendants of 1891 when his work was hung next to Rousseau's *Surprise!* (1891, pl. 6), and he wrote in the Swiss journal of which he was the Paris correspondent: "He is a terrible neighbor, since he crushes everything else."[42]

If he ever took any notice, Matisse cannot have been altogether pleased by occasions on which he met Rousseau in print. In 1906 a critic in the *Rénovation esthétique* wrote that the Salon des Indépendants could best be characterized by tricksters (*roublards*) like M Matisse and naifs like M Rousseau;[43] and in 1910 in *Gil Blas* the following commentary appeared: "I would be remiss were I to...neglect to mention the names of those who amuse the spectators and provide them, as they pass their droll entries, with a few seconds of real gaiety: Messrs. Duchamp, Ribemont-Dessaignes, Lhote, Misses Vassilief, Laurencin, and, master of them all, from Othon Friesz to Henri Matisse, the inspired Henri Rousseau, former customs man, a completely worthless but extraordinarily determined painter."[44]

Although Rousseau's work probably played a minor, perhaps unconsciously accepted role for Matisse in a gradual simplification of his painting in 1906–07, it can only be surmised, and is, in any case, subordinate to a generalized interest in primitivism current at that moment.[45]

If we accept the accounts of Max Weber, who was a student of Matisse and in close contact with the Douanier, and Weber's friend Adolphe Basler, Matisse alone among the pioneers of modernism, did not respond positively—at least in his recorded remarks—to Rousseau's work.[46] And, according to Roch Grey, Rousseau's friend and early collector, the only artist the Douanier himself couldn't stand was Matisse. When she and her brother, Serge (Férat) Jastrebzoff, would ask Rousseau what he thought about the work of other painters he would reply: "'I don't hate it, I don't hate it'; only Matisse made him angry, it was a kind of powerful contempt that he laughed about himself, 'If only it were amusing....But, my dear, it is sad, it's frightfully ugly!'"[47] Ironically, the "still, serene, sensuous world" that Matisse was painting during his Fauve period in such canvases as *Luxe, calme et volupté* (1904–5) and *Bonheur de vivre* (1905–6) was equally powerfully bodied forth by Rousseau in his *Snake Charmer* (1907).

The year that Rousseau painted the pacific image of his *Snake Charmer* was the year that Pablo Picasso painted his violently expressionistic *Les Demoiselles*

d'Avignon. While the two paintings have nothing in common except an equally subsumed relationship to Gauguin, the significance of the *Demoiselles* as the culminating work in Picasso's transition from a perceptual to a conceptual way of working and its effectiveness in obliterating the vestiges of nineteenth-century painting still operating in Fauvism make it obliquely important to the discovery of Rousseau by early modernist artists. For, with the waning of Fauvism, artists were increasingly influenced by Picasso, and in the two years immediately following the completion of the *Demoiselles* to the first paintings done in a fully realized Analytic Cubist mode, in June–July 1909, Picasso was actively testing out every received idea of painting; he successively looked to tribal art and Rousseau as well as returning to Cézanne in a new spirit. While Rousseau was not as fundamental to the redirection of Picasso's art as Cézanne, nor even as crucial as the tribal artists, he was initially, if briefly, important as a simplifying agent (largely in late 1908) and, subsequently, as a source of ideas and imagery. His work provided a landscape model for a reductively simplified image that complemented the figure model provided by *art nègre.*

But to understand the nature of Picasso's involvement with Rousseau, we must try to resolve the question of when he first saw the Douanier's work[48] and, second, of when he met the man. A number of authors have claimed that Picasso's first encounter with a Rousseau dates from his purchase in autumn 1908 of a large painting, *Portrait of a Woman* (c. 1895, pl. 12), by the Douanier which he found in the shop of the secondhand dealer Père Soulier.[49] On the evidence of Picasso's painting alone, this date is too late, for we first see traces of Rousseau's influence in Picasso's work in spring 1908, and it then becomes dominant in the Rue des Bois landscapes (figs. 10, 11) painted late in that summer. Moreover, since we have Picasso's word that up until the First World War he saw every Salon des Indépendants and Salon d'Automne that took place when he was in Paris,[50] we must assume that he very likely saw Rousseau's painting as early as 1901 and certainly no later than 1905.

In 1901 Picasso arrived in Paris in the spring in part to prepare his June show at Ambroise Vollard's gallery. We do not know his precise date of arrival, but Pierre

48. For a further discussion of this topic, see William Rubin, "From Narrative to 'Iconic' in Picasso: The Buried Allegory in 'Bread and Fruitdish on a Table' and the 'Role of Les Demoiselles d'Avignon,'" *The Art Bulletin*, vol. 65, no. 4 (Dec. 1983), pp. 620–22.

49. Most authors agree that Picasso's fortuitous acquisition of this large and magnificent portrait was the immediate inspiration for the Rousseau banquet (see p. 51), held, as all sources agree, in autumn 1908. Douglas Cooper dates Picasso's purchase of the portrait as 1907. Ignoring various witnesses (e.g., Max Weber, who speaks of it as having been acquired in autumn 1908), Cooper's undocumented assertion that "Picasso first became acquainted with the painting of Henri Rousseau through seeing and buying one of his finest works in a junk-shop in Montmartre in the winter of 1907" (*Cubist Epoch,* Los Angeles: Los Angeles County Museum of Art, and New York: The Metropolitan Museum of Art, 1970, p. 34) was probably made to accommodate the evident influence of Rousseau in Picasso's Rue des Bois landscapes of late summer 1908. Cooper gives no evidence for advancing Picasso's lucky acquisition by an entire year, and while his assertion provides a rationale for Rousseau's influence in the Rue des Bois landscapes, it not only makes it impossible for the banquet to have been occasioned by Picasso's find, but its proposed date of 1907 is, minimally, two years later than Picasso's first encounter with Rousseau's painting, as demonstrated here.

50. Rubin, "From Narrative to 'Iconic' in Picasso," p. 621.

51. Ambroise Vollard, *En écoutant Cézanne, Degas, Renoir* (Paris, 1938), reports that Renoir remarked of this painting: "It's odd, how people are repelled when they come upon a painter's qualities in a painting. There is one who must exasperate them more than anyone else: the Douanier Rousseau! This prehistoric scene with the hunter dressed in a suit from the Belle Jardinière right spang in the middle of it carrying a rifle....However, in the first place, can't we enjoy a canvas solely on the basis of agreeable colors? Do we need to understand the subject? And what a lovely hue this canvas of Rousseau's has! Do you remember, opposite the hunter, a female nude?...I feel sure that Ingres himself would not have disliked it!" Cited in Certigny, p. 208.

52. Rousseau probably met Apollinaire through Jarry either in 1906 or the following year. See Dora Vallier, *Henri Rousseau* (Cologne: DuMont Schauberg, 1961), p. 81. Certigny believes Rousseau and Apollinaire did not meet until 1907; see pp. 263 ff. and 279–81.

53. Rousseau, in a letter to Vollard, Sept. 26, 1909, wrote that he had hoped to sell this painting to the state. It probably passed from Vollard to Picasso in 1910, the year Picasso painted that dealer's portrait. Cited in Germain Viatte, "Henri Rousseau: Lettres inédites à A. Vollard," *Art de France* (Paris), no. 2 (1962), p. 333.

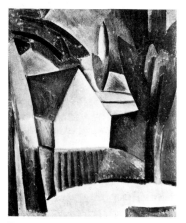

Fig. 10.
Picasso. *House in the Garden.* 1908
Hermitage State Museum, Leningrad

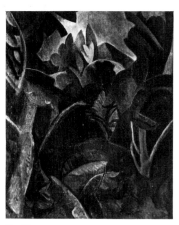

Fig. 11.
Picasso. *Landscape.* 1908
Collection Riccardo and Magda Jucker, Milan

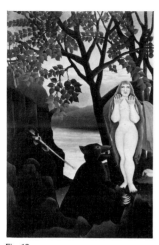

Fig. 12.
Rousseau. *Unwelcome Surprise.* c. 1901
The Barnes Foundation, Merion, Pa.

Daix suggests that it was early May. The Salon des Indépendants in which Rousseau showed seven pictures, including *The Unwelcome Surprise* (fig. 12),[51] closed on May 21. If Picasso was in Paris prior to this date there is little doubt that he would have seen the exhibition, especially since Coquiot, who was arranging Picasso's exhibition at Vollard's and writing its catalogue preface, was not only an official of the Indépendants but, as we have seen, a devoted admirer of the Douanier's. It is most unlikely that he would not have drawn Picasso's attention to this singular French artist; but Picasso's own painting at the time was such that Rousseau's work would have had little effect on him.

As Picasso was absent from Paris in the spring of 1902 and of 1903, his next opportunity to see Rousseau's painting may have been in 1904. As we know only that Picasso arrived in Paris in the "spring" of that year, we cannot be sure that he would have seen the Indépendants since it closed unusually early, on March 24. We can, however, be absolutely sure of the situation in 1905. We know that Picasso was in Paris during the entire run of both the Indépendants and the third Salon d'Automne, the first in which Rousseau exhibited. Even without Picasso's own testimony that he never missed a Salon d'Automne, we would have to assume that the notoriety surrounding this manifestation of the "wild beasts" would have attracted his attention. And we know that Rousseau's monumental *The Hungry Lion* (pl. 31) played no small role in the attention provoked by the new painting. Later, in March 1906, Vollard purchased *The Hungry Lion* from the Douanier and, at about the same time, "bought out" Picasso's studio. As Picasso was a frequent visitor to Vollard's celebrated *cave,* it is likely that after seeing *The Hungry Lion* in the Salon, he renewed acquaintance with it at Vollard's on more than one occasion before the end of 1908.

In the 1906 Indépendants, notable for the showing of Matisse's *Bonheur de vivre,* Rousseau exhibited five paintings; the following autumn, he exhibited *The Merry Jesters* (1906, pl. 33), a work whose foliage—with that of *The Jungle: Tiger Attacking a Buffalo* (1908, pl. 50), shown in spring 1908—anticipates more than other Rousseaus the decorative reductions of Picasso's Rue des Bois landscapes. By that time, however, it is possible that Picasso and Rousseau had already met through Guillaume Apollinaire or Jarry.[52] Thus, Picasso would have begun seeing the Douanier's work in the latter's studio, as well as attending his *soirées familiales et artistiques.* Rousseau's work was again on view in the spring Salons of 1907 and 1908 and the autumn Salon of 1907. Indeed, one of Rousseau's entries in the Indépendants of 1907 was *Representatives of Foreign Powers Arriving to Hail the Republic as a Sign of Peace* (1907, pl. 35), which Picasso would later acquire from Vollard.[53]

As we can securely date Picasso's familiarity with Rousseau's painting from 1905 at the very latest, and almost undoubtedly earlier, we may ask why the Douanier's influence is not felt in Picasso's painting until 1908. The answer lies, at least partially, in a general recapitulation of the course of painting in Paris, which parallels Picasso's own, from approximately 1900 until the period surrounding the execution of the *Demoiselles.* Prior to that time artists were recasting ideas received from the styles of the Impressionists and Post-Impressionists, which, with the partial exception of Gauguin's, were formulated to record sensation; however, as the younger painters moved through that process and out of Fauvism, their art began to shift toward modes based on conceptualization. By 1906–07 vanguard art had reached a transitional point that made it receptive to

the reductive possibilities proposed by African or tribal artifacts and the work of Rousseau, as well as to the structural simplifications of Cézanne.

Of the several influences operative in Picasso's art, the "African" tends to dominate for more than a year after the *Demoiselles*. It gives way in the Rue des Bois landscapes of late summer 1908 to combine with the briefly greater influence of Rousseau. Cézanne is less important than Rousseau and *art nègre* in the Rue des Bois paintings, but his role would overtake that of Rousseau in the autumn under the pressure of Braque's new appreciation of Cézanne in his first Cubist pictures from L'Estaque shown in November at Daniel-Henry Kahnweiler's gallery.

The subsequent influences of the two nineteenth-century artists in Picasso's work is nowhere more marked or more significant than in the monumental still life *Bread and Fruitdish on a Table* (fig. 13), begun in late autumn 1908 and completed in early 1909. The influence of Cézanne is manifest in the high viewpoint that blunts the orthogonals of the tabletop and tends to align them with the frame, in the displaced or discontinuous contour of the rear edge of the table, and in the *nonfinito* of the right side and bottom of the picture. The influence of Rousseau is visible primarily on the left side of the picture in the simplified forms and purged, unbroken contours of the compotier and fruit, as well as in their tightly painted, uniquely high finish, and in the ornamental leaflike pattern of subtle greens in the drapery that recalls the tonal nuancing of the greens in *Hungry Lion*.[54]

The reductive drawing of the compotier and fruit on the left of *Bread and Fruitdish*—more austere than that of the Rousseau-like "toy" houses and stylized trees of Picasso's Rue des Bois landscapes—suggests, as in the Douanier, a strictly conceptual type of image. The exploratory "unfinished" passages of the right side of *Bread and Fruitdish* recall, on the other hand, the searching, perceptual approach of Cézanne working before the motif. Indeed, the profound methodological and philosophical differences that separate Cézanne and Rousseau are nowhere better exemplified than in their notions of finish, surely the most obvious of the many stylistic differences that separate their work. It is not without significance that among Rousseau's few recorded observations about the Master of Aix was the suggestion that he "could finish" Cézanne's pictures.[55]

Picasso's amalgam of the alien styles of Rousseau and Cézanne in *Bread and Fruitdish* went beyond the terms of a formidable challenge to his own pictorial inventiveness and beyond an homage to the painterly achievements of the two older artists to the very nature of his own feelings about them. Cézanne and Rousseau were revered figures for Picasso, who admired them as paragons of conviction and integrity.[56] Of the same generation, and both "outsiders" even within the small world of vanguard painters, both were relatively hermetic in personality and maintained a quasi-religious attitude toward painting; both were sometimes scorned as incompetents. In such respects they were logical role models for the twenty-seven-year-old Picasso at a time when his own radical and seemingly "primitive" explorations had carried him beyond the understanding of those who had admired and collected his Blue- and Rose-period works.

It has long been recognized that Picasso is one of the most diaristic of artists. "I paint," he is quoted as saying, "the way some people write their autobiography."[57] But only with the publication of considerable material on Picasso's private life during the last two decades have we begun to realize just how direct and

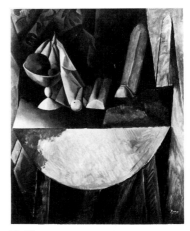

Fig. 13.
Picasso. *Bread and Fruitdish on a Table*.
1908–09
Oeffentliche Kunstsammlung,
Kunstmuseum Basel

54. Prior to the installation of the exhibition *European Master Paintings from Swiss Collections* at The Museum of Modern Art, New York (Dec. 1976–Mar. 1977), in which both paintings figured, *The Hungry Lion* and *Bread and Fruitdish* were placed side by side. The effect was astonishing in the proximities of tone and hue and in the similarity of facture between the Rousseau and the left side of the Picasso.

55. This remark of Rousseau's is quoted frequently in the literature and is difficult to trace to any one source. An unpublished memorandum by Max Weber (cited in Leonard, p. 23) describes a visit Weber made with Rousseau to the Cézanne Memorial Retrospective in 1907, where Rousseau suggested that he "could finish" the Wilstach *Bathers* (Philadelphia Museum of Art). Either Rousseau made such an observation more than once—which is probable—or Weber retailed the remark to others. In any case, Picasso recounted it to William Rubin in 1971 as something Rousseau had said to him.

56. The friendship of Picasso and Rousseau, and the latter's ubiquitousness in the Apollinaire circle, tend to make us forget that the Douanier, born in 1844, and Cézanne, born in 1839, were of the same generation. Both were considered strictly nineteenth-century painters by the artists and poets of the Cubist generation.

57. Françoise Gilot and Carleton Lake, *Life with Picasso* (New York, Toronto, London: McGraw-Hill, 1964), p. 123. The word "autobiography" used here by Gilot is not quite the proper one as it suggests that the painter recreates his life in retrospect. Considering the time that elapsed between Picasso's remark and Gilot's recounting it to Lake, it is perhaps permissible to think that her recollection is not completely accurate and that Picasso—who was very precise in his choice of words—said rather that he painted the way other people wrote their "diaries."

58. For an extended discussion of this and an amplified examination of Rousseau's role in *Bread and Fruitdish,* see Rubin, "From Narrative to 'Iconic' in Picasso," pp. 615–49.

48

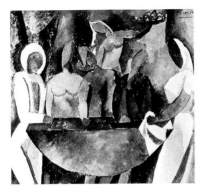

Fig. 14.
Picasso. *Study for Carnaval au bistrot*
(first state). Late 1908
Private collection

Fig. 15.
Picasso. *Sheet of Studies for Carnaval au bistrot*
(first state). Late 1908
Musée Picasso, Paris

specific are the private references in his paintings. They often constitute a distinct and consistent substratum of meaning distinguishable from, but interwoven with, the manifest subject matter. The larger, the more evolved a picture, the more multilayered its iconography is likely to be.

Bread and Fruitdish is, in fact, the culmination of a series of large early pictures, including *La Vie* (1903), *Family of Saltimbanques* (1905), *Les Demoiselles d'Avignon* (1907), and *Three Women* (1908), which underwent radical transformations during their execution, as Picasso veiled specifically autobiographical references. In each picture, narrative content was modified or, as in *Bread and Fruitdish,* replaced by stylistic differences that carry a deepened expression of meaning.[58]

It was first suggested by curators at the Basel Kunstmuseum and later demonstrated by Christian Geelhaar that the configuration of *Bread and Fruitdish* directly derives from studies for an unexecuted large picture, which depict Harlequin, Gilles, and several other figures dining at a drop-leaf table.[59] The first state of this image had been titled *Carnaval au bistrot* (fig. 14) by Christian Zervos—probably because of the presence of Gilles and Harlequin—although the static, symmetrical, and circular composition projects a religious rather than secular atmosphere. A later version (fig. 15) contains a sketch on the margin that closely resembles *Bread and Fruitdish;* and in subsequent states, a pencil drawing (fig. 16) and a gouache (fig. 17), we see the cast of characters reduced to four and the figure on the right given a Kronstadt hat. Comparison of the gouache banquet scene with *Bread and Fruitdish* reveals it as the immediate source of the still life's configuration, but a "transmigration" of forms has occurred; the shapes have remained constant but have passed to new identities. The arms of the man in the Kronstadt hat, for example, are recast as loaves of bread while his right hand has become an inverted teacup. Harlequin's left arm is also redefined as a loaf of bread, his right hand as a lemon, and the contours of his upper torso and hat more or less forced into a convoluted drapery pattern. In the large canvas only the legs under the table remain to confirm that *Bread and Fruitdish* was actually begun as

59. The idea was first discussed among the staff of the Basel Kunstmuseum, notably Carlo Huber and Dieter Koepplin, and was first published by the latter in the notes to the exhibition catalogue, *Kubismus: Zeichnungen und Druckgraphik aus dem Kupferstichkabinett Basel.* Christian Gaelhaar's article, "Pablo Picassos Stilleben 'Pains et compotier aux fruits sur une table': Metamorphosen einer Bildidee," *Pantheon,* vol. 28, no. 2, pp. 127–40, elaborates on the thesis.

Fig. 16.
Picasso. *Study for Carnaval au bistrot*
(second state). Winter 1908–09
Musée Picasso, Paris

Fig. 17.
Picasso. *Study for Carnaval au bistrot*
(second state). Winter 1908–09
Musée Picasso, Paris

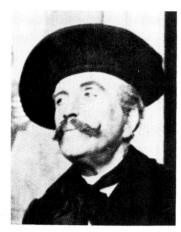

Henri Rousseau (detail of fig. 22)

Fig. 18.
Picasso. *At the Lapin Agile* (detail). 1905
Estate of Mrs. Joan Whitney Payson

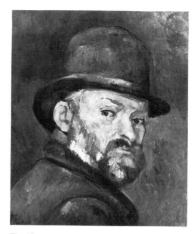

Fig. 19.
Cézanne. *Man in Bowler Hat.* 1883–85
Private collection

a commedia dell'arte dining scene. The autobiographic references of the original scene were not, however, abandoned with the shift in subject, but were recast in terms of style rather than commedia dell'arte allegory, and can be deciphered by identifying the symbolic personages of the original conceit.

The protagonists in *Carnaval au bistrot* reveal their hidden identities more or less readily. Most immediately we can identify Picasso himself, sitting at the center of the table dressed as Harlequin. Harlequin was not simply a favorite personage of Picasso; he has long been recognized as Picasso's persona, his alter ego,[60] as we see him in Harlequin's motley in *At the Lapin Agile* (1905, fig. 18). The woman with whom Picasso rubs shoulders in *Carnaval au bistrot,* and toward whom he inclines his head, may be identified through this pairing as his companion Fernande Olivier. The relationship of this couple—merged in the second-state gouache within a binding pyramidal silhouette—constitutes a subordinate theme within the allegorical iconography.[61]

The other figures at the table in *Carnaval au bistrot* reveal themselves less easily but no less securely. The man to the right of Harlequin/Picasso was intended from the start to be contemplative; and in the drawings (figs. 15, 16), he is shown clearly resting his head upon his hand, his other arm bent horizontal at the elbow in a posture Cézanne amateurs will recognize as almost a mirror image of the man mesmerized by several oranges in Cézanne's *Luncheon on the Grass.*[62] That Picasso's Contemplator was intended to represent Cézanne himself is confirmed in the second state (fig. 17), where he is given a Kronstadt hat. This is a type of hat Cézanne imaged frequently and, indeed, wore himself in some of his self-portraits (fig. 19). There can be no doubt as to the meaning here, for while Picasso was under way on this project, probably between the execution of the watercolor and the gouache, Georges Braque purchased a Kronstadt hat as an act of homage to Cézanne; Picasso was tremendously excited and took the hat to his studio where he featured it in a still life widely known as *Cézanne's Hat* (1909).

There are, of course, still other allusions to Cézanne in *Carnaval au bistrot,* among them the posture of the servant with the bowl of fruit, which was adapted from a comparable figure in Cézanne's *L'Après-midi à Naples.*[63] Moreover, while images of four-to-six figures sitting and standing around a table are very rare in

50

Picasso. *Study for Carnaval au bistrot* (fig. 14)

60. See Theodore Reff, "Harlequins, Saltimbanques, Clowns and Fools," *Artforum*, October 1971, pp. 30–41; and "Themes of Love and Death in Picasso's Early Work," in *Picasso in Retrospect* (New York and Washington: Praeger, 1973), pp. 11–47.

61. The stylistic dualism that expresses the primary theme celebrating Picasso's life as an artist simultaneously echoes the more private motif of the Picasso/Fernande relationship. The juxtaposition of the circular bowl of sumptuous fruit with hard, "phallic" *pains longs* (not unlike Harlequin's baton in form) of the final still life echoes the private motif of the Picasso/Fernande relationship within the general depersonalization of forms that took place between the original banquet scene and the ultimate still-life painting; see Rubin, "From Narrative to 'Iconic' in Picasso," pp. 639–42.

62. Venturi 107.

63. Venturi 224.

64. For a description of this banquet, see Fernande Olivier, *Picasso et ses amis* (Paris: Librairie Stock, 1933), pp. 78–83, and Roger Shattuck, *The Banquet Years: The Origins of the Avant-Garde in France: 1885 to World War I* (New York: Vintage Books, 1968), pp. 66–71 (1st ed. 1955).

65. The table legs with their baluster forms are more realistically represented than in *Bread and Fruitdish* in another still life of the period, *Loaves on a Table* in Christian Zervos, *Pablo Picasso,* vol. II (Paris: Cahiers d'art, 1942), no. 125.

Picasso's prior work, Cézanne's large *Card Players* would have provided a model, especially as Picasso had seen the huge version now at the Barnes Foundation (Merion, Pennsylvania) a year earlier in the Cézanne memorial retrospective, and was no doubt struck by Cézanne's audacity in making the legs under the table so monumental as to seem detached from their respective figures; he incorporated this autonomous "architectural" treatment of the legs in *Carnaval au bistrot,* and the association adds something to the significance (and perhaps logic) of his having retained their forms even after he had converted his canvas into a still life.

That the secret identity of Gilles, on the left in *Carnaval au bistrot,* is Henri Rousseau should hardly come as a surprise in a late 1908 work by Picasso that represents an artist's banquet. Certainly the theme of the image was suggested by the banquet in honor of Rousseau that Picasso held in his studio in November of that year,[64] at most weeks and perhaps just days before he began work on *Carnaval au bistrot.* The very table pictured in *Carnaval* would have been put to use for the Rousseau banquet, as it is a simplified version of the round drop-leaf table visible in a photograph of Picasso's studio of 1908 (fig. 20).[65] That event was, to be sure, a convivial, somewhat riotous one. *Carnaval au bistrot* is more its by-product than its representation. Picasso converted the celebration of the Douanier into a quasi-sacred allegory of communion among artists, in which he breaks bread seated between his two major nineteenth-century avatars—precisely the two painters on whom he was drawing most in his work of the moment.

The logic of Gilles as a "stand-in" for Rousseau begins with their commonality as sad entertainers, sad clowns. Rousseau was, to be sure, a somewhat inadvertent clown, whose singing and violin playing at his *soirées familiales et artistiques* and at Picasso's banquet were occasionally the butt of laughter—as was his serious, grave, and stately demeanor. Nor did his painting evade such derision, even among some of Picasso's friends. Yet Picasso was deeply moved by the unrelenting seriousness and the sense of sacred mission of the Douanier as regards not only his own work but that of all artists. At the Rousseau banquet, the

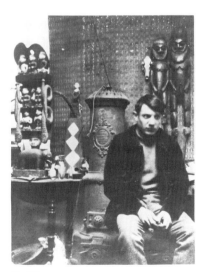

Fig. 20.
Picasso in his studio in the Bateau-Lavoir
Photographed for Gelett Burgess, 1908

Fig. 21.
Watteau. *Gilles.* c. 1719
Musée du Louvre, Paris

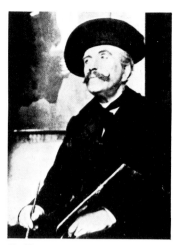

Fig. 22.
Henri Rousseau in his studio, rue Perrel
c. 1907

Douanier was elevated like a king or saint above the level of the other guests, seated as he was on a chair mounted on a packing box, which Fernande Olivier described "as a kind of throne." Imagine him there in all his gravity and for- mality—he sat unflinchingly "with great stoicism," Fernande tells us, despite the tallow that dripped onto his forehead from a hanging lantern—and we see why Picasso remembered him as being like a "Byzantine character." When the lantern later caught fire, Fernande recalls, "we made Rousseau think it was the final apotheosis."[66]

Given what Picasso recognized as Rousseau's almost saintly purity of character, his simplicity and generosity—quite apart from the Douanier's religious attitude toward painting—what better choice could the artist have made than to embody him as Gilles, especially as Gilles's round hat could be made, as Watteau had already shown (fig. 21), to imply a halo. Moreover, in so doing, Picasso was adapting a figure whose hat could be identified in its roundness with that worn by Rousseau himself. The Douanier's self-image was inseparable from that old- fashioned beret. Wearing it was, as we have seen, his way of asserting the nobility and tradition of his profession. Not only does he wear it in *Myself* but also in his official photograph as *artiste-peintre* (fig. 22), where it reads as a surrogate halo. Picasso knew this photograph well, for it hung, framed like a painting, on the wall of Rousseau's little studio where, according to Arsène Alexandre, Rousseau had also hung reproductions of work by Watteau.[67] Thus, the symbolism of all three male figures in the mutations of *Carnaval au bistrot* ultimately emerges as proverbial: "The Hat Makes the Man."

We have only to look at the final still life to see how Picasso came to "tell" the original story of *Carnaval au bistrot* by means of style itself. The left side of *Bread and Fruitdish* (where the Douanier, as Gilles, had sat in *Carnaval*) is executed in a Rousseau-like manner, unique in Picasso's early painting;[68] the right side (where Cézanne as Contemplator, had been seated) is comparably Cézannesque. But both stylistic tendencies are subsumed in a painting that is integrally Picasso's.

Finally, of course, the polarity of substyles in *Bread and Fruitdish* alludes to

Fig. 23.
Picasso. *Still Life with Fruit and Glass.* 1908
The Museum of Modern Art, New York
Estate of John Hay Whitney

Pl. 23.
Rousseau. *Portrait of the Artist*

divergencies and contradictions in human feeling that transcend the references to Rousseau and Cézanne reflected in them. The tension between concreteness and sensation, between closed and open systems, between conception and perception, and between certitude and doubt that these references embody fuels the interior drama of Picasso himself as he confronts the problems and possibilities of what is becoming Cubism.

Although probably not intended by Picasso, *Bread and Fruitdish* can be read as a temporary farewell to Rousseau, for the Douanier's influence does not surface in Picasso's work again until after the full period of Analytic Cubism and the development of collage. In any case, the Douanier's role in Picasso's work, as it was equally in Braque's in 1907–09, was less structural than catalytic, operating, as did *art nègre,* against *la fausse tradition*[69] as the two artists moved toward the creation of Cubism.

Picasso's experience of Rousseau during this time is largely reflected in the simplified drawing and predominantly green palette of his Rue des Bois landscapes. But his tendency toward frontal, iconic imagery and the sense of monumentality that informs even such small paintings as *Still Life with Fruit and Glass* (fig. 23) also owe something to Rousseau, whose own ability to endow a small canvas with immense presence is demonstrated in his *Portrait of the Artist* (1900–03, pl. 23) that Picasso would later own and was at the time either still with Rousseau or in the collection of Delaunay.

Picasso must also have been struck by Rousseau's distortions of scale, which paralleled his own manipulations of form. And, while such departures from natural proportion were executed by Picasso with virtuoso bravado and clearly for expressive purposes, in Rousseau's work they seem awkward and possibly unintended. But Rousseau was a careful composer of his pictures, and the sometimes surprising dimensions of his figures do not "work" just by accident. When Weber, watching Rousseau paint *Old Junier's Cart* (1908, pl. 39), asked him if the dog beneath the carriage would not be too big, Rousseau "looked musingly at the picture" and replied, "No, it must be that way."[70] (Weber could just as well have questioned him on the smallness of the dog at the right whose absurd

66. Olivier, p. 78.

67. *Comoedia,* Mar. 19, 1910; cited in Vallier, *Tout l'oeuvre peint,* p. 10.

68. In none of his other Rousseau-influenced paintings (such as figs. 10, 11) did Picasso opt for the very tight finish we see in the compotier and fruit of *Bread and Fruitdish.* His interest in creating the illusion of an almost glazed surface closely resembling that of Rousseau suggests his desire to focus this clue with the greatest precision possible.

69. See John Golding, *Cubism: A History and an Analysis 1907–1914* (London: Faber and Faber, 1968), p. 15 (1st ed. 1959).

70. Cited by Daniel Catton Rich, *Henri Rousseau,* 2d ed. rev. (New York: The Museum of Modern Art, and Chicago: Art Institute of Chicago, 1946), p. 52.

tininess acts to punctuate the large scale of the picture.) And when Marie Laurencin, who was quite thin, complained about her bulk in *The Muse Inspiring the Poet* (1909, pl. 58), Rousseau replied, "Guillaume is a great poet. He needs a fat muse."[71] For all her slightly comic character, Rousseau's Muse has the dignity and force of Romanesque sculpture—indeed brings to mind examples such as the eleventh-century *Apostle* in St. Sernin, Toulouse (fig. 24); and the impossible length of Laurencin's arm is needed not only to balance the composition but to emphasize her gesture, which seems to imply the blessing of divine authority.

The primal force of Rousseau's imagery clearly impressed Picasso. He said himself that the painting he found at Père Soulier's "obsessed me from the moment I saw it."[72] If Rousseau's work was temporarily not useful to Picasso in the highly finessed Cubism of 1910–12 that he shared with Braque, it was to become so again and possibly in a more structural way.

Clues regarding Rousseau's reemergence in Picasso's art are yielded by a consideration of the two versions of *Three Musicians* (in Philadelphia, fig. 25; in New York, fig. 26) executed in 1921, long after the close of the Analytic Cubist period, and, in fact, often regarded as the culmination of Picasso's Synthetic Cubism. Theodore Reff has convincingly demonstrated that *Three Musicians* has a hidden allegorical meaning;[73] in this sense it is not dissimilar to *Bread and Fruitdish*. Reff characterizes *Three Musicians* as an "elegy for [Picasso's] lost Bohemian youth, for the freedom of the Bateau-Lavoir days,"[74] and he persuasively identifies its three main characters as Apollinaire/Pierrot, Picasso/Harlequin, and Max Jacob/Monk. Picasso's art abounds with images that conflate identities; it is therefore not in the least incompatible with Reff's reading of *Three Musicians*—in fact it is an extension of his interpretation—to find evidence of Rousseau's presence in the paintings as well as that of Apollinaire.

Many of Reff's arguments for equating Pierrot with Apollinaire are just as valid if we pair the figure with Rousseau; while attributes specific to Apollinaire are balanced by attributes specific to Rousseau. In a scene commemorating the past and depicting commedia dell'arte figures at a table, evocations of Rousseau

Fig. 24.
Apostle. 1096. Stone
St. Sernin, Toulouse, France

Pl. 58.
Rousseau. *The Muse Inspiring the Poet*

Fig. 25.
Picasso. *Three Musicians*. 1921
The Philadelphia Museum of Art
The A.E. Gallatin Collection

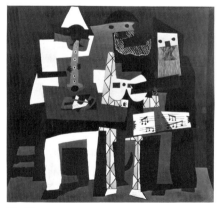

Fig. 26.
Picasso. *Three Musicians*. 1921
The Museum of Modern Art, New York
Mrs. Simon Guggenheim Fund

54

Fig. 8.
Seurat. *La Parade*
(detail). 1887–88

Pl. 66.
Rousseau.
The Dream (detail)

would have been as appropriate as those of Apollinaire, especially given the precedent of the Rousseau banquet and its subsequent role in the inspiration and elaboration of *Bread and Fruitdish*. Reff himself points out the relevance of *Carnaval au bistrot,* where we have already seen Rousseau as Pierrot, to the *Three Musicians*. Although agreeing with Reff that Apollinaire was for Picasso "a writer who is a clown like Pierrot,"[75] we also know that the word *painter* substituted for *writer* would give us one of Picasso's images of Rousseau. And, if Pierrot is for Picasso, as Reff says, a purely French character whose white costume in *Three Musicians* is "enhanced by a radiant French blue" appropriate because "he stands for one of the purest of French poets, Apollinaire,"[76] let us also consider Picasso's words on the portrait he owned by the Douanier, "A work of French insight of decision and clearness...one of the most revealing French psychological portraits."[77]

That Pierrot's playing of a wind instrument confirms his symbolic role as Apollinaire through associations with his poems, especially "Le Musicien de Saint-Merry," is convincingly demonstrated by Reff. But this identification does not exclude another. Nothing could be more apt than a Rousseau/Pierrot in a music-making setting. Rousseau gave music lessons and considered himself a professor of the art; his personality was associated by Picasso and his friends with the *soirées familiales et artistiques,* during which he and his pupils performed. On these occasions Rousseau almost always played "Clémence," the waltz for violin he had written for his wife; on the cover of its sheet music was an image of Pierrot. Rousseau played "Clémence" at the famous banquet held in his honor in Picasso's studio as well as at the farewell soiree held for Weber on December 19, 1908, which Picasso attended.

The wind instrument may seem specifically more appropriate to Apollinaire, but it seems less so if we compare the attitude and posture of Pierrot in *Three Musicians* with those of the mysterious figure playing a similar instrument in Rousseau's *The Dream* (1910, pl. 66), the last large picture the Douanier painted before his death. Reff himself points out the similarities between Picasso's Pierrot and Seurat's trombone player in *La Parade* (fig. 8), which, as we have seen, may well have played a role in the creation of Rousseau's image of the mysterious enchanter of *The Dream*.

Reff draws attention to the package of tobacco, clay pipe, and pouch on the table directly below Pierrot as the quintessential attributes of Apollinaire, especially as previously depicted by Picasso. And indeed they are Apollinaire's own. But, combined as they are with certain countervailing elements that belong exclusively to Rousseau, Pierrot's dual persona is thus only reinforced.

Before, however, discussing *Three Musicians* solely from the perspective of its allusions to Rousseau, let us consider what might have brought the Douanier to Picasso's mind in 1921. Reff has pointed out that Picasso, then in his fortieth year, radically changing his life-style to suit the bourgeois values of his wife Olga Koklova, was in a state of mind that would have inclined him to feel most keenly the loss of his youth, of "the golden age when everything was fresh and untarnished before he had conquered the world and then discovered that...the world had conquered him."[78] In this nostalgic mood, he had various immediate reasons to think of Apollinaire—as he had also to think of the Douanier. The previous November Delaunay, whose collection of Rousseaus Picasso knew well, published an article on the Douanier in *L'Amour de l'art.* On May 30, 1921, the Wilhelm

71. Cited in Vallier, *Tout l'oeuvre peint,* p. 112.

72. Cited by Dore Ashton, *Picasso on Art: A Selection of Views* (New York: The Viking Press, 1972), p. 164.

73. Theodore Reff, "Picasso's Three Musicians: Maskers, Artists and Friends," *Art in America,* Dec. 1980, pp. 124–42.

74. Ibid., p. 136.

75. Ibid., p. 132.

76. Ibid.

77. Cited in Ashton, pp. 164–65.

78. Françoise Gilot, cited in Reff, "Picasso's Three Musicians," p. 136.

Uhde collection, sequestered by the French government during the war, was sold, and two weeks later the first of the Kahnweiler auctions of similarly confiscated work was held. The sales themselves caused a scandal among the artists, who feared that a flood of their work let loose on the market would depress their prices; Braque, in fact, publicly slapped Léonce Rosenberg, one of the organizers of the auctions. For Picasso the sales would also have had a somber, symbolic side, underscoring the changes that had occurred in his life. The Uhde auction must have reminded him of the gentle old man who had died in poverty and whose work was now being sold with Picasso's own. Uhde, one of the first and very few to buy Rousseau's work during the artist's lifetime, had had his portrait painted by Picasso in 1910 only months before the Douanier's death. And, it was Uhde who published the first monograph on Rousseau in 1911; and the next year he organized the Rousseau memorial retrospective at Bernheim-Jeune.

Kahnweiler, the champion of Picasso in his youth, was no longer his dealer; it was Paul Rosenberg, whose interest in Rousseau went back at least as far as his purchase of the *Portrait of Pierre Loti* (c. 1891, pl. 7) in 1913 from Georges Courteline, who had collected Rousseaus as additions to his *musée des horreurs*. At the time of the Kahnweiler sale, Picasso was living in the fashionable rue de la Boétie next door to his new dealer, where he would often have encountered Rosenberg's holdings of the Douanier's work. The Kahnweiler sale must have stirred up old memories for Picasso and made him reflect (quite worriedly, one imagines) on his new life-style and the Douanier's rather unpredictable presence in it. Picasso's feelings about Rousseau must have been close to the surface as in the year following the execution of *Three Musicians;* the Russian poet Vladimir Maïakovski returned from France with the information that with Picasso, "like... the other artists I encountered," one finds "the same passion for the Douanier Rousseau."[79]

Apollinaire was of enormous importance to Picasso, his close friend and companion in a way that the old Douanier never could have been. But Rousseau had something in common with Picasso that Apollinaire did not. They were both painters. Thus Picasso could allude to Rousseau not only as he did to Apollinaire, through recognizable attributes, but, as in *Bread and Fruitdish,* in terms of style as well as borrowed image. And in *Three Musicians* all three of these allusive means are employed.

Reff believes, and we concur, that of the two versions of *Three Musicians,* the Philadelphia picture precedes the one now in New York. The Philadelphia painting is compositionally less tight, and there are far more *pentimenti,* especially in the area of Pierrot's and the monk's costumes, than in the New York version. It is also much more playful in mood. Picasso's overall intention would seem to have been less resolved as he was painting the Philadelphia picture.[80]

The identification of Pierrot/Apollinaire/Rousseau is secure in what we will now refer to as the second version; whereas in the first, attributes specific to Rousseau are mingled with the Harlequin/Picasso figure in a painter-to-painter identification. Harlequin plays a violin—Rousseau's instrument—which, when the figure is converted wholly to Picasso in the second version, becomes the guitar emblematic of the Spanish artist. In the first version, Harlequin holds the violin bow with a tiny hand that is multiplied in the second version, replacing the large hands of all the figures and, thereby, underscoring the monumentality of the composition by means similar to those we have seen Rousseau employ. The mini-

Pl. 33.
Rousseau. *The Merry Jesters*

79. Cited by Claude Frioux, *Maïakovski* (Paris: Seuil, 1978), p. 183. Maïakovski was staying with Delaunay, so that his primary contact among Parisian artists was with one of the Douanier's greatest partisans.

80. See Reff, "Picasso's Three Musicians," p. 139.

81. Ibid., pp. 135–36.

hand may well derive from the clawlike hand of the back-scratcher with which the monkeys in Rousseau's *Merry Jesters* (pl. 33) play. Picasso would have first seen this picture in his youth at the Salon d'Automne of 1906 (indeed, as we have remarked, it may have played a role in his Rue des Bois landscapes) and he would have subsequently encountered it in the collection of Delaunay. In its central grouping of three revelers and its nuanced blacks, browns, and whites, *Merry Jesters* may well have suggested itself to Picasso as he thought about a picture depicting himself and the companions of his youth as merrymakers.

In the earlier version, where the allusions to Rousseau have not yet been totally shifted to Pierrot, Picasso may have had another painting by the Douanier in mind when he conflated his own Harlequin persona with that of the Douanier. Rousseau's *Myself, Portrait-Landscape* (pl. 5) was a familiar companion to Picasso; it hung in the apartment of his friend Serge Jastrebzoff (called by Picasso and Apollinaire "G. Apostrophe") and his sister the Baroness d'Oettingen (Roch Grey) over the table where they dined, as we know from a sketch by de Chirico showing Picasso seated with the brother and sister under Rousseau's self-portrait (fig. 27). Harlequin's posture, left foot gingerly above the right in the first version of *Three Musicians,* is similar to Rousseau's in *Myself,* and in each the left arm is similarly bent—in the portrait to hold the light palette against the black ground of the figure, and reversed in Harlequin where the light motley of the costume surrounds a deep brown irregular rectangle. Still part Picasso, part Rousseau, Harlequin holds a violin bow that may be an allusion to the long paintbrush held by the Douanier in his self-portrait.

In the earlier version, before the Pierrot figure becomes more positively associated with Rousseau through its relationship with the dark musician in *The Dream,* Picasso may have inserted in characteristic fashion a clue and visual pun to draw attention to Pierrot's identity as Apollinaire. Described in the brown and orange contours that form Pierrot's right hand and the instrument he plays is a rudimentary profile that suggests Apollinaire's aquiline features. Among other changes from the first version to the second is the addition of a fourth figure, the dog under the table, whose presence may be explained on one level as an interpolation from Picasso's domestic life, and on another, more profound, which Reff proposes, as a symbol for death.[81] Placed beneath Pierrot, it is as appropriate to Rousseau as to Apollinaire.

But the dog has uses and associations that may make it more the property of Rousseau. In the more austere second version, the planar black mass of the monk's robe on the right is balanced by the flat dark extension of the dog under the table. Thus he has a formal function analogous, if very different in spirit, to that of the black dog, almost "pasted" onto the bottom of Rousseau's *The Wedding* (1904–05, pl. 28) to anchor the picture. In *Old Junier's Cart* (1908, pl. 39) the black dog, whose largeness was remarked by Weber, has a similar role. The first of these pictures was as familiar to Picasso as was *Myself,* for it, too, was part of the Jastrebzoff collection, and the second was originally owned by Rosenberg and later by the Parisian collector Antoine Villard at whose house Picasso could well have seen it.

Beyond these ways in which Picasso used Rousseauian elements, there are others that function closer to the bone of *Three Musicians.* No artist has been more acute than Picasso in recognizing the possibilities latent in the images and pictorial means of others. Artists were often afraid to show him their work for fear

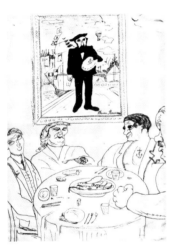

Fig. 27.
de Chirico. *Picasso at Table with the Painter Léopold Survage, Baroness d'Oettingen, and Serge Férat.* 1915
Pen and ink
Collection Mr. and Mrs. Eric E. Estorick

he would cannibalize their ideas before they even knew they had them. If, as Reff says, Picasso may have found a model for *Three Musicians* in Seurat's *La Parade* for "transforming a scene of animated entertainment into one of solemn, hieratical ceremony" and that "the severely formal, symmetrical and planar design" and "nocturnal atmosphere" of Seurat were useful to him,[82] it is hard to believe that he did not also remark some of these qualities in Rousseau. Indeed, it is difficult to imagine that Picasso did not sometimes read *Seurat* across his experience of Rousseau. The often classical direction of Picasso's Synthetic Cubism in the years before *Three Musicians* may indeed owe something to Seurat, but the flat color planes, almost laminated one on top of the other, such as we see in *Three Musicians,* are not anticipated before Picasso's own pictures of 1913–15 in any art except Rousseau's.

Given Picasso's comprehension of pictorial means, his almost absolute command of visual analysis, and his demonstrated prior use of style as metaphor, it is impossible to believe that in a painting partially devoted to Rousseau he was not aware of its stylistic affinities with the Douanier. And, although the subject of *Three Musicians* has to do with Rousseau, it is the culmination of a style that Picasso had initiated some six years before. Certainly Picasso had long been aware of the ways in which his own pictures were like those of Rousseau.

There is, of course, no question that the main impetus in directing Picasso away from the finessed painterlines of high Analytic Cubism was a recrudescence of his primitivizing urge, his need for rawness and directness; this was expressed in his invention of collage in early 1912. Certainly these new forms were the primary movers in stimulating the development of a new style, Synthetic Cubism, in which recessional space was eliminated, color reintroduced, and legibility of subject became greater (though in terms of signs rather than fragments of illusion). While Rousseau has long been recognized in a limited sense as a precursor of collage-inspired art, he is always evoked in relation to the literary (i.e., imagistic) aspect of the technique as in the later Surrealist use of *collage-en-trompe l'oeil,* which denatured objects through "irrational" unexpected juxtapositions (such as Rousseau's nude on a red couch in a jungle, in *The Dream*). But in its flatness and surface treatment of juxtaposed and overlapping planes, Rousseau's art has a collagelike formal quality that also relates it, perhaps fortuitously, to Synthetic Cubism.

Picasso's practice of Synthetic Cubism might well have caused him to see a new relevance in Rousseau, particularly as he was in daily contact with his large *Portrait of a Woman* (c. 1895, pl. 12) by the Douanier, which had gripped him with the force of obsession when he had first seen it in Père Soulier's shop. Comparison of this picture with *Harlequin* (fig. 28), which Picasso painted in late 1915, suggests that the Rousseau painting may indeed have played a role in the alteration of Picasso's Synthetic Cubism that began with the execution of *Harlequin* and culminated in *Three Musicians* six years later.

In its size, scale, and general character *Harlequin* breaks with the tendency of 1913–14 Synthetic Cubism, which carried over in modified form some painterly conventions from Analytic Cubism. Its large, simple, flat planes are Picasso's entirely personal contribution to the language of Synthetic Cubism, beyond anything he had shared with Braque (then away in the army). While Rousseau's portrait is compositionally a nineteenth-century concept—perhaps even based on a photograph—it has nevertheless some clear affinities with Picasso's *Harle-*

Pl. 12.
Rousseau. *Portrait of a Woman*

Fig. 28.
Picasso. *Harlequin.* Late 1915
The Museum of Modern Art,
New York. Acquired through
the Lillie P. Bliss Bequest

82. Ibid., p. 138.

83. Shattuck, p. 240.

84. Vallier believes it was done on commission; see *Tout l'oeuvre peint*, no. 85, pp. 97–98. Certigny believes it to be a portrait of Rousseau's first wife. Salmon, a close friend of Picasso and of Rousseau and a prominent participant at the Rousseau banquet in Picasso's studio, identifies the painting as "Portrait de Femme (Mme Rousseau) qu'on voit chez Picasso"; in *Henri Rousseau dit Le Douanier*, p. 46. Brassaï, in *Conversations avec Picasso* (Paris: Gallimard, 1964), p. 33, refers to the model in no uncertain terms as Yadwigha, and identifies her also as the model for *Eve* (pl. 29) and *The Dream* (pl. 66). Picasso probably told Brassaï that the portrait was of Yadwigha; however, the rest of Brassaï's account is either his own fabrication or the recounting of a tale Picasso may have, in characteristic fashion, invented as a joke. While Brassaï's statement that Yadwigha was the only woman sufficiently devoted to Rousseau to pose for him nude may or may not be true, it certainly cannot be true that this love of his youth (all commentators agree that Yadwigha is associated with Rousseau's youth—in his 1899 play *The Revenge of a Russian Orphan*, Rousseau calls the *aged* Russian aunt "Yadwigha") posed for him in 1909 and 1910 in the still youthful nude. Rather, Rousseau, unhappily in love at the end of his life (see Grey, pp. 14–15), probably thought back to the happier times of his youth and gave these nudes painted in his old age the features of Yadwigha.

85. On the basis of Picasso's demonstrated tendency to adopt the Harlequin persona as his own alter-ego, we may assume that there was some self-identification in this unusually bleak rendition. If this Harlequin was partly inspired by the Douanier's painting of a woman, a spontaneous set of associations may have operated to suggest Rousseau's *Myself, Portrait-Landscape,* as well; it is reflected in the partially painted rectangle (and as such may indeed represent a palette) held by Harlequin as, in much the same posture, the Douanier holds his palette in his self-portrait.

quin. Both pictures have an immediate, direct assertiveness that comes from the bold, iconically frontal disposition of the figure and a stripped-down economy of means devoid of recessional space and shading of the planes. Rousseau's no doubt intuitive comprehension that suppressing the illusion of depth called for a lateral expansion of the picture space, and thus created a need for large scale, was understood by Picasso and is reflected not only in *Harlequin* but in the Synthetic Cubist pictures he painted thereafter.

If in increasing the size of his pictures and simplifying their means Picasso absorbed influences from Rousseau, there are other reasons as well to think that Picasso was paying particular attention to the Douanier's portrait when he painted *Harlequin*. Picasso's use and, even to a degree, his quantification of black, blue, white, and patterned red and green present an image of *Harlequin* that can be considered as a highly sophisticated commentary on its austere nineteenth-century counterpart, and brings to mind a principle of Rousseau's old friend Jarry: "Simplicity does not have to be simple, rather complexity drawn taut and synthesized."[83]

There is no general agreement as to whom the Rousseau portrait represents.[84] There are, however, reasons that propose it as a posthumous portrait of Rousseau's much-cherished first wife Clémence. Although seen in full face, the model's strong features are similar to those depicted in the profiles of Yadwigha (often considered an alter-identity of Clémence) as Rousseau presents her in *Eve* (pl. 29) and *The Dream* (pl. 66). And, given the painting's general severity, especially as compared with the only other similar *Portrait of a Woman* (c. 1895–97, pl. 17) we know, the pervasive blackness of the model's dress, and the branch held upside down—its twigs broken and leaves withering—an allusion to death may well have been intended. Picasso would, however, almost surely have known from Rousseau who his model had been. As a memorial portrait it would have had particular significance for Picasso, whose *Harlequin* reflects his own anguish at the mortal illness of his then mistress, Eva Gouel.[85] Whatever the connection may have been, Rousseau's portrait projects an intensity of feeling that is paralleled in Picasso's *Harlequin*.

After the *Three Musicians,* allusions to Rousseau turn up only sporadically. One of the most interesting and curious of these instances occurs in Picasso's *Studio with Plaster Head* (1925, fig. 29), in which the plaster arm clutching a truncated staff is a negative image both in terms of viewpoint and color of the right arm holding a staff of Rousseau's *The Sleeping Gypsy* (1897, pl. 19). Picasso has

Fig. 29.
Picasso. *Studio with Plaster Head.* Summer 1925
The Museum of Modern Art, New York

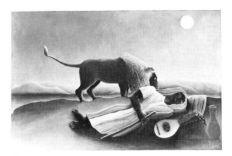

Pl. 19.
Rousseau. *The Sleeping Gypsy*

Fig. 30.
Braque. *Still Life with Musical Instruments.* 1908
Private collection.

Fig. 31.
Matisse. *Variation on a Still Life by de Heem* (detail). Late 1915
The Museum of Modern Art, New York

Pl. 19.
Rousseau. *The Sleeping Gypsy* (detail)

reversed the angle of the elbow of the gypsy's arm, turned it back to front, and converted the dusky velvet flesh to white plaster, and on the right side of the picture he has counterpointed the arm with a carpenter's square in much the way the mandolin bent at a proto-Cubist angle balances the gypsy's arm.

Once again the question arises as to why Picasso might have been thinking of Rousseau at this moment, and why this particular picture. We have not far to look for the answer. In 1923 *The Sleeping Gypsy* had been discovered at a coal dealer's by Louis Vauxcelles and sold by him to Kahnweiler's Galerie Simon the next year. Picasso saw it and was so struck by it that he immediately told Henri Pierre Roché, who had the confidence of the pioneer American collector, John Quinn, that there was something extraordinary at Kahnweiler's which Roché ought to secure for Quinn.[86] Roché shared Picasso's enthusiasm,[87] and the picture was bought by Quinn, but not before, as Kahnweiler reported, "it was seen by everybody."[88]

Picasso's own attitude regarding the picture takes on additional dimension in the light of the events of two years later. After Quinn's death, *The Sleeping Gypsy* was sold at the auction of his work organized by Joseph Brummer at the Hôtel Drouot on October 26, 1926. Picasso's close friend, Jean Cocteau, wrote the preface to the catalogue of the Quinn sale in which he said: "Why, you will ask, did I agree to write this preface? For a precise reason.... The Quinn sale includes something phenomenal, unique, the unmoving hub, the fixed point, the center of centers, where motion spins in place suspended, the rose at the eye of the storm, the sleep of all sleep, silence of all silence: *The Sleeping Gypsy* of Henri Rousseau."

Because of the celebrity and evident importance of the picture, there had been keen competition to acquire it, particularly between the dealers Henri Bing and Paul Guillaume. Bing did in fact buy the picture; but after the auction, rumors, perhaps arising from the ruffled feelings of disappointed contenders, became rife as to its authorship. Years later Kahnweiler wrote to Alfred Barr: "I do not understand how a sane person can doubt the authenticity of *The Sleeping Gypsy*."[89] Nonetheless, just after the sale Paris was abuzz with stories about its possible origins. Bing recounts how Adolphe Basler, who had been a friend of

86. Recounted in an undated letter of Henri-Pierre Roché to Marcel Duchamp, files of The Museum of Modern Art, New York.

87. Excerpts from the text of Roché's letter to Quinn are interesting for the intensity of feeling provoked in Roché by *The Sleeping Gypsy*; his lack of syntax indicates his barely controlled excitement over its discovery :

February 1st 1924.

Dear Mr. Quinn,
 I have seen yesterday a Rousseau which has quite upset me
to me, it beats even the Charmeuse
 Kahnweiler has just received it Picasso saw it there and told me to go at once,
thinking of you
 I went it is still in his cellar
almost nobody has seen it yet
 I have dreamt of it all the night
 It is one of the *absolute* paintings I ever saw....
 I have strongly impressed Kahnweiler that you must have the first photo, that he ought to have your opinion before he exhibits the picture to the public
 If it is exhibited, it is sold. it will make a noise—All Rousseau lovers will be at it. It will go to Tcheko Slovaquia.
 To me it is *the* Rousseau. I would gladly give the two next best Rousseaus I know for it—including the Charmeuse—
 I do not describe it full to you: the photo will do it. There is the desert, a distant range of mountains, the night sky, a mighty strange stately lion against it, he quietly *smells* a big sleeping woman, lying at the foreground, she is dreaming, her face is "momë," [*sic*]—the lion is probably going to eat her, but perhaps he will walk away.
 I have never been more thrilled by a painting in my life....The colours are equal to the composition that is they beat for

me any other Rousseau.
They are a poem strange simple....
 I would even suggest
you buy before having the photo: If
you miss it you would be more incon-
solable than for the Charmeuse. I risk
gladly all my worth and all your
confidence to back this picture

always yours
H P Roché

Transcribed from the letter in the files of The Museum of Modern Art, published by B. L. Reid in *The Man from New York: John Quinn and His Friends* (New York: Oxford, 1968), p. 624.

Alfred Barr, who secured the painting for The Museum of Modern Art in 1939, seems to have admired the painting as much as Roché had before him. In 1955 he responded to Paul Sachs's query as to which acquisition over the years had afforded him the greatest gratification, as follows: "I look back upon with the keenest satisfaction *The Sleeping Gypsy* by Henri Rousseau; indeed, I believe it to be one of the most remarkable canvases of the 19th century" (files of The Museum of Modern Art, New York).

88. Letter of Sept. 6, 1954, to Alfred Barr, files of Museum of Modern Art.

89. Ibid.

90. Letter of July 15, 1952, from Henri Bing to Alfred Barr, files of The Museum of Modern Art.

91. Ibid.

92. Recounted to Rubin. See William Rubin, ed., *De Chirico* (New York: The Museum of Modern Art, 1982), p. 78, n. 29. Rubin also points out that as late as 1949, André Breton, famous for not knowing when Picasso was pulling his leg (he reported the artist deploring "the need to use paint for lack of a satisfactorily durable piece of real, dry excrement" in one still life), was indignant that Picasso, who "says he knew the real author" of *The Sleeping Gypsy*, had done nothing to put a stop to the imposture; cited in *Flagrant délit* (Paris: Thésée, 1949), p. 170.

93. Ibid.

94. For a discussion of the relationship of *Studio with Plaster Head* to de Chirico, see William Rubin, *Picasso in The Collection of The Museum of Modern Art* (New York: The Museum of Modern Art, 1972), pp. 121–22.

95. Jean Cocteau, Preface to the sale catalogue of the John Quinn collection, Hôtel Drouot, Paris, Oct. 26, 1926.

Rousseau's, came to see him, "highly incensed, and informed me that there was talk going around about this picture, talk made up of hints and outrageous fancies, talk that was supposed to have originated in some statement by Picasso. One person was saying that Picasso had said that he had 'painted the picture to amuse himself,' and someone else that 'he had seen him do it,' and a third that 'Derain had seen him,' etc."[90] When Bing, who had known Picasso since the Bateau-Lavoir days, asked Picasso if he could really have claimed to doubt that *The Sleeping Gypsy* was by Rousseau, Picasso reportedly replied: "I never said that. I only said that 'it wasn't a good picture'"—a view he seems to have altered or forgotten years later—and then, responding to Bing's query as to why it was not, Picasso added that especially the jar and the mandolin were "very bad."[91] As there is so much anticipation of the Cubist still life in this particular passage, as later rendered by Picasso and more especially Braque (fig. 30) and even Matisse (fig. 31), we can only speculate on Picasso's motivation in singling these aspects out as "very bad." We do, however, know that, given Picasso's *espirt de contradiction,* questions that annoyed him often elicited deliberately confounding and confusing responses. More importantly, as regards Picasso's true evaluation of the painting, we know that it was he who originally pointed it out to Roché. And much later, concerning rumors that had also circulated proposing Derain as its author, Picasso expressed the opinion that he didn't believe Derain capable of such a painting.[92]

There is no doubt that the powerfully poetic painting would have impressed Picasso whenever he might have encountered it, but in 1924 when his own art was beginning to take on the Surreal overtones it would increasingly assume in the next two decades, its appearance was particularly germane to his own concerns. And it is not at all surprising that *Studio with Plaster Head* painted in the summer of 1925 mixes elements drawn from Rousseau with a strong admixture of Giorgio de Chirico, artists who Picasso spoke of as having a "clear link."[93] Thus the orange in Picasso's still life, quite possibly an allusion to the many oranges in Rousseau's Jungles, and the green sprig of leaves which may have a similar reference, are the unexpected neighbors of studio props extrapolated from de Chirico's metaphysical paintings.[94] The profile within the full face, as in the plaster head, originated earlier in Picasso's work but remained rare before 1925. Its presence here may owe something to the suggestion of the same physiognomy in *The Sleeping Gypsy,* especially as it is joined in that picture to a body which seems to be seen both frontally and in profile. While the plaster head itself would seem to refer to the prevalence of similar imagery in de Chirico, it may have been suggested to Picasso, even if subliminally, by Cocteau's lines about the gypsy: "She could rise up and be cut in half, like the busts that tell fortunes in magic shows."[95] Among the factors that relate *Studio with Plaster Head* to *The Sleeping Gypsy* and to de Chirico's enigmatic paintings of his early period is the shadow next to the plaster head that seems to imply a mysterious presence outside the painting, much as we feel the spell of an outside force in the Rousseau and in the early work of de Chirico.

By the end of the thirties, Picasso had worked through such a variety of manners on which he had so forcefully imposed his own brand that any "influences" thereafter discernible are usually at least once removed from their sources. Such is certainly the case in the paintings where we still see some trace of

Rousseau, as in his late thirties portraits of his daughter Maya (fig. 32), which undoubtedly relate to Rousseau pictures of children, particularly as depicted in *Child with a Doll* (pl. 34), formerly in the Uhde and Quinn collections and then in the Paul Guillaume collection. But the Rousseau influence is more oblique than in earlier pictures, deflected by the whole arsenal of pictorial means from which Picasso was then drawing.

In a similarly elliptical manner we can read echoes of *The Sleeping Gypsy* in the physiognomy, distorted limbs, and eccentric striping of two of the versions of Picasso's *Sailor* of 1938 and 1943.[96] There may also be some ground for thinking that the discovery of Rousseau's *War* in 1944 could even have had an indirect bearing on Picasso's conception of *The Charnel House*, particularly as regards the contorted bound arms, which in the first state of Picasso's picture, in February 1945, suggest the distorted position of the arm on the left in Rousseau's *War*.[97] But, again, whatever relationship exists is filtered through Picasso's previous explorations.

Picasso's influence was extremely strong on the vanguard artists of his generation, and it was largely through him that the Douanier's art had taken on significance for other artists, at least in France, around 1911. But, the Rousseau retrospective organized by the Indépendants in that year and the publication of Uhde's monograph;[98] an exhibition at the Bernheim-Jeune gallery in 1912; the proselytizing of Delaunay, Weber, and Ardengo Soffici; Apollinaire's writings; and the special issue of *Les Soirées de Paris* in 1914 all contributed to the sudden fame of the Douanier after his death. Buried in a pauper's grave, Rousseau's remains were transferred to the cemetery of Bagneux in 1912 financed by a subscription organized by Delaunay and Rousseau's former landlord Armand Queval. Among the contributors were Picasso, Laurencin, Kahnweiler, Raoul Dufy, Apollinaire, Albert Gleizes, Jean Metzinger, Paul Fort, Paul Sérusier, Le Fauconnier, André de Segonzac, and Alexander Archipenko. Constantin Brancusi and Ortiz de Zarate engraved Rousseau's tombstone with a memorial poem written by Apollinaire.[99]

With the exception of Braque, for whom Rousseau's work had operated more or less as it had for Picasso around 1908, most of the artists whose painting careers began in Paris in the first decade of the century absorbed Rousseau through Picasso, and such influences as we see of the Douanier in the work of Derain, Dufy, Diego Rivera, and Weber are of this order.

Although heavily influenced by Cubism, Rivera's early paintings, nonetheless, hold a curious interest with regard to Rousseau. Thanks in large part to Apollinaire's assertions, the legend grew that Rousseau had drawn his inspiration for his Jungle scenes from his experience in the French Army with Maximilian in Mexico. We now know that the marvelous foliage of Rousseau's tropics came entirely from his trips to the Jardin des Plantes and from his imagination. In such paintings by Rivera as *Edge of the Forest* (1918, fig. 33), we have the Rousseauian jungle painted at last with a Mexican accent.

The major exception to the prominence of Picasso's role in expanding the influences of Rousseau lies in the work of Fernand Léger. Léger's painting was, to some degree, formed by the Cubism of Picasso and Braque, but early on it took off

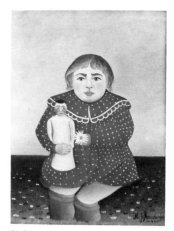

Pl. 34.
Rousseau. *Child with Doll*

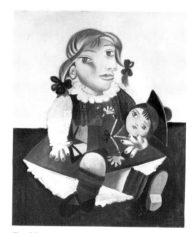

Fig. 32.
Picasso. *Portrait of Maya*. 1938
Musée Picasso, Paris

Fig. 33.
Rivera. *Edge of the Forest*. 1918

in its own direction, and Rousseau's work was fundamental to Léger as it was not to any other major modernist. George L. K. Morris, who was Léger's student in Paris remembers: "His [Léger's] highest admiration was reserved for the Douanier Rousseau," about whom he would exclaim, "Voilà un homme formidable!"[100] Although Léger was fond of saying that he belonged to the tradition of the Romanesque and "the early art that preceded the Italian Renaissance," he would certainly have regarded himself as heir to what he called the "classic" French school, which he distinguished as "starting with the primitives and including Poussin, David, Ingres, Corot, Rousseau...."[101] Pierre Descargues remembers that Léger admired Rousseau because "he painted straightforwardly like David."[102]

Indeed, Léger's robust, monumental art based on strong contrasts of color, line, and form and its use of popular imagery can be seen as the logical twentieth-century extension of Rousseau's peculiar brand of nineteenth-century realism. What Léger saw in 1913 as "the structural basis of modern pictures...pictorial contrasts used in their purest sense (complementary colors, lines, and forms)," and what he called his "realism of conception," were also the informing principles of Rousseau's work.[103] Rousseau's and Léger's paintings share tendencies toward the monumental, exhibit sharply delineated flat forms, high, largely unmodulated colors juxtaposed and isolated from each other, and arrangments of objects parallel to the picture plane, while the subjects of each are drawn from the lives of the working people. The drawing of both has a purged and simplified sense of contour that is also somewhat awkward and naive. Although Léger's depiction of the mechanized world is on a wholly other scale and level of involvement than is Rousseau's, it is anticipated in the Douanier's repeated images of boats, smoking chimneys, and various mechanical contraptions of the urban scene. Indeed, Rousseau's *View of Malakoff* (1908, pl. 47) with its upright telephone poles brings to mind Léger's somewhat atypical *Railroad Crossing* (1912–13, fig. 34), in which, as Léger thought, the bars of the gate "make nature more modern" and "therefore more beautiful."[104]

96. Zervos IX, 191, and Zervos XIII, 167.

97. See p. 70 of this essay regarding the location of the painting from its appearance in the Indépendants of 1894 to its reappearance in 1944, and n. 126 below.

98. Wilhelm Uhde, *Henri Rousseau* (Paris: Eugène Figuière et Cie, 1911), 27 illus. Reprinted in German (Dusseldorf, 1914), 46 illus.

99. Apollinaire's poem reads as follows:
We salute you
Gentle Rousseau you hear us
Delaunay his wife Monsieur Queval and I
Let our baggage through free at heaven's gate
We will bring you brushes, paints, and canvas
So that you can devote your sacred leisure in the
 light of truth
To painting the way you did my portrait
The face of the stars.

100. George L. K. Morris, in Léger, *Functions of Painting*, p. xi.

101. Léger, in ibid., p. 126.

102. Descargues, p. 41.

103. Léger, *Functions of Painting*, pp. 5, 7.

104. Werner Schmalenbach, *Fernand Léger*, trans. Robert Allen, with James Emmons (New York: Abrams, 1976), p. 82.

Pl. 47
Rousseau. *View of Malakoff*

Fig. 34.
Léger. *Railroad Crossing*. 1912–13
Museum moderner Kunst, Vienna. On loan
from the Kunsthistorisches Museum

Influences of the Douanier were found in Léger's work as early as 1911. When Léger showed his *Nudes in the Forest* (1909–10, fig. 35) in the Indépendants of that year, critical opinion discovered in it a "flavor of Rousseau"[105] and later Zervos spoke of the "structural concept of the painting" as being "identical to Rousseau's."[106] Although *Nudes in the Forest* was begun in 1909 when Léger, who had met Rousseau through Delaunay, was very close to the old painter, it is too early a work to manifest those qualities that were later to appear in Léger's art and relate it so nearly to Rousseau. Not until after the First World War, around 1920, when the dynamism and activism of Léger's earlier work gave way to a more austere, architectonic pictorial language, did his painting assume its fundamental Rousseauian attributes.

Léger's *The Mechanic* (1920, fig. 36) seems almost a sophisticated, post-Cubist mutation of Rousseau's portrait-landscape of Pierre Loti (pl. 7).[107] "Actively" mustached, the highly stylized figures hold cigarettes in their beringed right hands, which function not as extensions of the sitters' arms but as separate pictorial elements within their compositional formats. *Loti* is still, of course, an essentially nineteenth-century concept of landscape complete with sky and tree, although interrupted by the smoking chimney stacks at the left that rhyme with the smoker's hands, just as the brown layers of landscape are echoed in the striping of the cat whose miniaturized, divided, and inverted ears are the templates of the model's collar. The painting is replete with such formal analogies, as is also the mechanic, who, like Loti, is rendered in large planes against a flat grid of invented geometric, mechanistic elements that comment upon the forms of the figure and each other in what Léger called "multiplicative contrast." In both paintings, black, red, brown, and white are set down in broad, boldly contrasting zones. The "realism" of each is far from verisimilitude, but is a realism that takes the perceptual data, reinvents them, and produces an image that projects the essence of the exotic nineteenth-century gentleman in one and the burly twentieth-century mechanic in the other—their smoking cigarettes not only attributes, but ironic commentaries on their timelessness.

Rousseau and Seurat were the only Post-Impressionist artists who attempted to maintain a stability of "architectural" structure combined with meticulous

Fig. 35.
Léger. *Nudes in the Forest*. 1909–10
Rijksmuseum Kröller-Müller, Otterlo, the Netherlands

105. Cited in Descargues, p. 41.

106. Christian Zervos, "Fernand Léger, Est-il Cubiste," *Cahiers d'Art* (Paris), vol. 8, nos. 3–4 (1933), n.p.

107. The identity of the sitter as well as the date of the painting are open to question. Vallier, in *Tout l'oeuvre peint*, p. 94, no. 48, believes this is beyond question a portrait of the well-known writer Pierre Loti, and publishes a photo remarkably like the present portrait; whereas Certigny, pp. 255–57, somewhat perversely insists, on the basis of the same photograph, that the model was not Loti. See Elderfield, *European Master Paingings*, p. 38, for a discussion of the painting's dating.

108. Schmalenbach, p. 112.

109. Ibid., p. 118 (owing to a printer's error, Schmalenbach's text reads "the man on the left," whereas it is obvious from the image and Schmalenbach's description that the man on the right is intended).

110. Cited in Katherine Kuh, *Léger* (Urbana: The University of Illinois Press, 1953), p. 21.

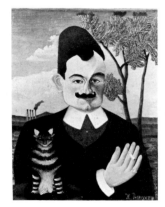

Pl. 7.
Rousseau. *Portrait of Pierre Loti*

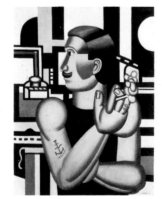

Fig. 36.
Léger. *The Mechanic*. 1920
The National Gallery of Canada, Ottawa

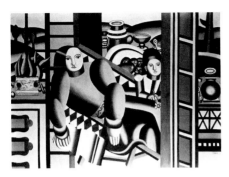

Fig. 37.
Léger. *Mother and Child.* 1922
Oeffentliche Kunstsammlung, Kunstmuseum Basel

execution of detail in large compositions, and Léger can be thought of as their heir in this regard. Although not approaching the dimensions of some of his later works, Léger's *Mother and Child* (1922, fig. 37) is a good example of the artist's ability to hold together a massive composition and yet render each object with solicitous care. Léger's recognition of the Douanier's similar accomplishment can be inferred from the inclusion at the left of some cactus, the forms of which remind us "not by chance," as Werner Schmalenbach has pointed out, "of the tropical plants painted by Henri Rousseau."[108]

Forms that recall Rousseau appear with considerable regularity throughout Léger's work. Such an instance occurs in Léger's *Three Figures* (1924, fig. 38), to which Schmalenbach has again drawn our attention, remarking that the figure on the right "was undoubtedly inspired by the portrait of Apollinaire in Rousseau's *The Muse Inspiring the Poet* (pl. 58) in that the poet has a similar expression and a similar pose and carries a scroll in his left hand."[109] Beyond such similarities, there are, as Schmalenbach recognized, affinities of another order. In its high stylization and feeling of secular gravity, *Three Figures* recalls ancient cultures, the archaic and the Romanesque, much as the Laurencin figure suggests the type of the Apostle from St. Sernin (fig. 24), which itself can be analogized with the figures of Léger. His comment, "the whole question is there, one invents or one does not; the Renaissance copies, the avant-Renaissance invents, Rousseau invents,"[110] seems especially apt.

The Muse Inspiring the Poet would appear to have been a particularly rich source for Léger as echoes of the Laurencin figure repeatedly occur in his work. The flowers at the couple's feet—which had so troubled Rousseau when, after painting the first version of the picture, he realized they were not *oeillets de poète* (sweet Williams) as he had intended but *giroflées* (stock), that he painted a second version—are also metamorphosed in several of Léger's works, sometimes combined as in *The Readers* (1924, fig. 39) with the Laurencin-derived persona.

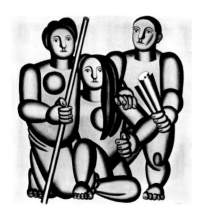

Fig. 38.
Léger. *The Three Figures.* 1924
Collection M. Barbier

Pl. 58.
Rousseau. *The Muse Inspiring the Poet*

Fig. 39.
Léger. *The Readers.* 1924
Musée National d'Art Moderne, Centre Georges Pompidou, Paris

65

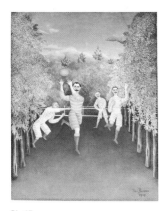

Pl. 45.
Rousseau. *The Football Players*

Fig. 40.
Léger. *Dancers with Keys.* 1929

In the thirties, Léger's paintings were often involved with gymnasts, acrobats, and dancing figures. Many of these are strongly reminiscent of Rousseau's *The Football Players* (1908, pl. 45). The scope of this essay will allow only a cursory glance at this Léger/Rousseau connection as, indeed, it precludes a thorough examination of the subject as a whole. We can, however, point out a relatively early example, *Dancers with Keys* (1929, fig. 40), in which the attitudes of the dancing figures at the right preserve the oddly graceful awkwardness of Rousseau's football players. Richer, but less immediately obvious in Rousseauian associations, is the painting *Composition with Two Parrots* (1935–39, fig. 41), which not only alludes to the Douanier's football players in the postures of the figures but has strong compositional affinities with several of Rousseau's Jungle paintings, acknowledged by Léger with considerable wit in his positioning of the parrots.

We would not be entirely unjustified if we were to regard Léger's late painting *Homage to Louis David (Leisure Time)* (1948–49, fig. 42) as an homage to Rousseau as well. We know that he admired Rousseau for what he called the "frankness" of painting he shared with David, and that he placed both of them squarely within the same French tradition. He said of David's work, "I love the dryness...";[111] and according to George L. K. Morris, "it was Rousseau's dryness that Léger admired."[112] Léger may even have had more personal associations to the two artists, as Descargues claims that it was Rousseau who "dragged Léger to an exhibition of portraits by the nineteenth-century master."[113] In any event, *Homage to Louis David* is arranged like a family photograph in the manner of Rousseau's *Old Junier's Cart* (pl. 39) and *The Wedding* (pl. 28). Schmalenbach's characterization of Léger's people applies equally to Rousseau's; they "seem to have neither troubles nor problems—in a word they seem to be happy....But when we peer into their faces we miss any trace of joy...joy is expressed in the artistic handling, as well as in the subject matter...[their] relaxation is the corollary of work, for obviously [they]...belong to the working class."[114] Léger's figures come from the same social and pictorial stock as Rousseau's. The smoking man in red on the left specifically derives from Rousseau's portraits of Loti (pl. 7) and Brummer (pl. 57), conflated and reinvented by Léger.

Fig. 41.
Léger. *Composition with Two Parrots.* 1935–39
Musée National d'Art Moderne, Centre Georges Pompidou, Paris

Fig. 42.
Léger. *Homage to Louis David (Leisure Time).* 1948–49
Musée National d'Art Moderne, Centre Georges Pompidou. Paris

Fig. 43.
Delaunay. *Cactus.* 1916
Collection Charles Delaunay, Paris

Those differences that separate Rousseau's and Léger's art derive in large part simply from the differences between the nineteenth-century sensibility and that of the twentieth. But Rousseau's singular vision was a model for Léger, and Schmalenbach's appraisal of Léger's late work is germane to the phenomenon of their cross-links—" [Léger] achieves a naiveté of handling and expression that strikes one as the happy reward of his lifelong effort toward simplicity, a naiveté that combines extreme artistic maturity with the spirit of monumental art."[115]

Of all the young painters in Paris none had closer contacts with the Douanier or greater personal regard for him than Robert Delaunay. No one sustained him more in life nor played a comparable role in expanding his reputation outside France after his death. But much as Delaunay deeply admired Rousseau, as is evidenced in his actions and his words, the Douanier's art was never integrated in his style as it was into that of Picasso and Léger. Iconography aside, Delaunay's version of Cubism, based on his theories of simultaneous contrasts of color and the dynamics of light, could not accommodate the stylizations of Rousseau.

The famous quotation from Rousseau's *Myself, Portrait Landscape* (pl. 5) at the left side of Delaunay's *The City of Paris* (fig. 9), which we have already remarked, has no structural relationship to Rousseau, but is rather intended as an homage to the older artist. In this painting Delaunay gives us an allegorical image of Paris, its beauty and tradition represented by the three graces, its modernity and new grace by the Eiffel Tower, and its enduring spirit incarnate in the Seine and anchored boat of Rousseau's *Myself.*

One of the very few paintings by Delaunay that could be considered formally close to any by Rousseau is *Cactus* (1916, fig. 43); but even this is forced, as it owes far more to Matisse and memories of Fauvism than to Rousseau. What links Rousseau's work with the very different art of Delaunay is the appearance in each of the symbols of modernity, the Eiffel Tower, dirigibles, fragile airplanes—as in Delaunay's *Homage to Blériot* (fig. 44), and Rousseau's *The Fishermen and the Biplane* (1908, pl. 43)—and their depictions of sport—the Douanier's *Football Players* (pl. 45) and Delaunay's renderings of the Cardiff team. But it is the subject that relates these images; many of Picasso's bathers of the early thirties are closer to Rousseau's football players than are any of the football players of Delaunay.

111. Cited in Schmalenbach, p. 51.

112. Cited in Léger, *Functions of Painting*, p. xi.

113. Descargues, p. 41. We have Léger's testimony (Léger, *Functions of Painting*, p. 144) that David was the subject of a conversation between himself and Rousseau. It would have been possible for Rousseau and Léger to have seen several portraits at the Cheramy sale, auctioned by Georges Petit, May 5–7, 1908, at the Hôtel Drouot, Paris. From May 15 to July 15, 1909, two David portraits were shown in an exhibition, *Portraits de femmes sous les trois républiques,* at the Palais de Bagatelle, and also that year two portraits were included in the exhibition *Cents portraits de femmes des écoles anglaise et française du XVII siècle* at the Jeu de Paume. The considerable collection of David paintings in the Louvre might also have been seen by Rousseau and Léger. Between 1908 and 1910 the following portraits by David were exhibited in the Louvre: *Portrait de Charles-Pierre, Portrait de Mme Pecoul, Portrait Presume de Kervélégan, Portrait de Madame Trudaine, Portrait de l'Artiste, Portrait de M. Seriziat, Portrait de Mme Récamier, Portrait du Pape Pie VII, Portrait d'Antoine Mongez.*

114. Schmalenbach, p. 40.

115. Ibid.

Fig. 44.
Delaunay. *Homage to Blériot.* 1914
Musée de Peinture de Grenoble

Pl. 43.
Rousseau. *The Fisherman and the Biplane*

At the time of Rousseau's death in 1910, his friends in the artistic vanguard were all painting in a Cubist manner that was in some ways even further from his own style than Neo-Impressionism had been, and Rousseau is reported to have discussed the Cubist phenomenon at length with Delaunay. Certigny recounts that in his last delirium in the Necker hospital, Rousseau asked, "Why has Robert broken up the Eiffel Tower?"[116] In any event, it is symbolic of the special relationship between Delaunay and Rousseau that he alone of all the Douanier's new, celebrated friends was at his deathbed.

Delaunay had met Rousseau in 1906, about the same time that Jarry had introduced the still-condescending Apollinaire to the Douanier. Delaunay almost immediately appreciated the man and his work and frequently received him at the literary-artistic salons held by his mother. It was at one of these that Weber, who was later to arrange the first exhibition of Rousseau's work in America at Alfred Stieglitz's gallery in 1910, met the Douanier. One of Rousseau's greatest paintings, *The Snake Charmer* (pl. 36), was painted on commission for Delaunay's mother, and much later, when Delaunay sold it to Jacques Doucet, it was only on condition that it be bequeathed to the Louvre, where, in fact, it became part of the collection in 1936.

Delaunay owned at least ten other paintings of Rousseau's, two of which he sold after the Douanier's death to help pay for the removal of his remains from a common grave to the cemetery of Bagneux.

In the article Delaunay wrote on Rousseau in *L'Amour de l'art* in 1920, his appreciation of Rousseau as a colorist—particularly as regards the Jungle pictures—is expressed with the sensibility of an artist for whom color was of primary importance. "The blacks are spaces devoid of light that act upon the eye as do prismatic colors with unequal relationships. These blacks glow and live amidst thousands of greens that come together to form trees, hedges, forests. Rousseau does not copy the external effect of a tree; he creates an inner and rhythmic whole that is the true, serene, essential expression of the relationship of a tree and its leaves to the forest. He builds up contrasts by adding whole scales of greens of a richness that testifies to his almost scientific knowledge of the métier."

Finally, Delaunay played a central role in introducing the Douanier's art to Germany. In 1910 Delaunay married Uhde's former wife, Sonia Terk, whose friend Elisabeth Epstein greatly admired Delaunay's paintings and sent photographs of them in October 1911 to Wassily Kandinsky, then feverishly engaged in preparing the book *Der Blaue Reiter* (published in 1912) with Franz Marc and August Macke. Kandinsky's response was immediately favorable, and a brisk correspondence began between the two.

Kandinsky, who had spent the last half of 1906 and the first half of 1907 in Sèvres with his companion Gabrielle Münter, was already familiar with Rousseau's art. In fact, according to Johannes Eichner, Rousseau had made a greater impression on the two than had any other French painter.[117] Rousseau had, however, little immediately discernible influence on Kandinsky, and such as there may have been on Münter can only be adduced from some of her subsequent work in Murnau. Given the intense intellectual excitement produced by the preparations for *Der Blaue Reiter* and the underlying faith of Kandinsky in the spiritual role of art, it is quite possible that he would have thought of Rousseau without any outside stimulus. As it happened, however, the photographs of Delaunay's work arrived almost coincidentally with a copy of Uhde's book[118] on

116. Certigny, p. 444. Cf. Descargues, p. 46.

117. Johannes Eichner, *Kandinsky und Gabrielle Münter von Ursprüngen moderner Kunst* (Munich: Bruckmann, n.d.), p. 52.

118. See n. 98 above.

119. Cited in the catalogue *Robert Delaunay* (Baden-Baden: Staatliche Kunsthalle, 1976), p. 52.

120. Vallier, *Tout l'oeuvre peint*, p. 100, no. 113.

121. L. H. Neitzel, *Neue französische Malerei* (Leipzig: Weissen Bücher, 1913), n.p.

122. Cited in Kenneth C. Lindsay and Peter Vergo, eds., *Kandinsky: Complete Writings on Art*, vol. 1: 1901–1921 (Boston: G.K. Hall & Co., 1982), p. 253.

123. Ibid., p. 252.

Rousseau, which reproduced many of the Douanier's paintings owned by Delaunay. In his first letter to Delaunay of October 28, 1911, Kandinsky thanks the French painter for his photographs, invites him to write an article for *Der Blaue Reiter*, and immediately goes on to say: "Today I got Uhde's book on Henri Rousseau. I was again struck by the expressive power of this great poet. And what beautiful works you own! I have always hoped for the opportunity to acquire a Rousseau,"[119] after which he tells Delaunay that he cannot afford to spend much and then requests him to obtain photographs from Uhde of Rousseau's work that he might reproduce in *Der Blaue Reiter*. In effect, Delaunay was able to arrange for Kandinsky's acquisition of two paintings by Rousseau; and through his intercession with Uhde, the announcement of *Der Blaue Reiter*[120] carried a reproduction of a Rousseau and seven of his paintings were illustrated in the book. Both Delaunay and Rousseau were represented in the first Blaue Reiter exhibition at the Thannhauser gallery, Munich, in December 1911.

Between Kandinsky's first contacts with Delaunay and the outbreak of the First World War, both the art of Rousseau and that of his young champion were increasingly brought to the attention of the German art community. A measure of their growing fame was their inclusion in the *Erster deutscher Herbstsalon* of 1913, in which an entire room was devoted to Rousseau's work.

Outside the Berlin–Munich axis, which was the chief locus of the Kandinsky/Delaunay sphere of influence, the name of Rousseau was also being heard. In 1913 the Weissen Bücher firm of Leipzig published *Neue französische Malerei,* in which the artists included had been selected by Hans Arp. The first two reproductions in the book are of paintings by Rousseau, one of which is his *Myself, Portrait-Landscape*. The accompanying commentary reads: "Is there anyone more worthy than [Rousseau] with whom to begin a portfolio of modern artists?... Everything that Rousseau's spirit perceives he crystallizes in his pictures."[121]

Kandinsky's reawakened interest in Rousseau was furthered, as had been Picasso's in 1908, by developments within his own art. Like Picasso when he was on the brink of Cubism, Kandinsky, then on the edge of abstraction, found the example of Rousseau helpful. In one of his most influential essays, "On the Question of Form," Kandinsky wrote: "Henri Rousseau has opened the way for simplicity and for the new possibilities it offers. This aspect of his many-sided talent now has for us the most significant value."[122] Kandinsky considered Rousseau his counterpart on the two main paths—realism and abstraction—that ultimately would lead to the same truth, the expression of inner vision. If the inner necessity of the artist were expressed, then the form it took, Kandinsky believed, had little importance. Thus, he wrote: "The complete and exclusively simple rendering of the external shell of things constitutes the divorce of the object from any practical purpose, hence permitting the inner element to sound forth. Henri Rousseau, who may be characterized as the father of this [kind of] realism, has with one simple and totally convincing gesture shown us the way."[123] These words were written in the winter of 1911-12 at the height of Kandinsky's excitement over the rediscovery of Rousseau; but later in 1916 when Kandinsky was briefly in Stockholm, he reconfirmed his belief in Rousseau in an essay, "On the Artist," dedicated to Münter, writing: "Henri Rousseau stands formally outside of the major trends, since no labels can be attached to his personal form. But as to content, he is more inseparably tied to the spiritual aspirations of the

time than many an artist whose form is infallibly 'modern.' Through his admirable form Rousseau has made the inner voice of the world resound. This world, which to the present-day artist is merely a pretext for art, in Rousseau's pictures is the only indispensable means of expression for the voice of spirit."[124]

Although there is virtually nothing in the appearance of Kandinsky's post-1913 art to relate it to Rousseau, there are ways in which some of his prior work is not unlike that of the Douanier. From 1910 through 1913, both Kandinsky and Münter were much engaged with *hinterglasmalerei* (glass painting). Inspired by Bavarian folk art and reflective of Kandinsky's fascination with religious symbolism, these small paintings on glass probably owe nothing to Rousseau, but their deliberately naive modes of expression, bright colors, and flat patterns have much in common with many of the Douanier's paintings.

But the most interesting possibility of a Rousseau/Kandinsky connection is elsewhere. Kandinsky's emblematic horse as we see it in *Lyric* (1911, fig. 45) is so close to Rousseau's charging black beast in his 1894 painting *War* (pl. 9), that it is hard to believe that Kandinsky did not extrapolate rather directly from the Douanier's image. Indeed, Peter Vergo and Kenneth C. Lindsay would seem to believe that this was the case as they write, "Kandinsky's magnificent steed…with its outstretched neck that had developed from Boecklin's and Rousseau's War horses of the 1890s had become fully realized in *Lyric* of 1911."[125] We are much inclined to concur, despite the problem posed by the fact that *War* may not have been seen by Kandinsky. This huge picture was painted in 1894; by the time Kandinsky arrived in Paris twelve years later, Rousseau had moved several times, always from one small place to another. We have no record of where the picture then was nor any mention of it in the literature; as far as available documentation goes, it disappeared sometime after its exhibition in the 1894 Indépendants and did not reappear until the end of the Second World War, when it was found at a farmer's house in Louviers. Rousseau had, however, on a commission from Jarry and Rémy de Gourmont, made a lithograph (the only print of his career) of *War* (pl. 10) which was printed in *L'Ymagier* and which Kandinsky could well have seen. But the lithograph, which probably preceded the painting, is a much less strong image and does not provide as compellingly convincing a parallel with *Lyric* as does the painting.[126]

Kandinsky's enthusiasm for Rousseau was shared by Marc, his collaborator on *Der Blaue Reiter*. Klaus Lankheit describes Rousseau as the "great discovery of the pre-Christmas season" of 1911.[127] And, in fact, Marc's Christmas present to Kandinsky was a glass copy (fig. 46) he had made of Rousseau's *Portrait of the Artist* (1900–03, pl. 23) that then belonged to Delaunay and had been reproduced in Uhde's book. Marc essentially shared Kandinsky's feelings about Rousseau's art; but with his almost Franciscan love of animals, Marc was probably also attracted by its jungle imagery replete with monkeys, tigers, lions, and birds. In one of his letters to Delaunay, he wrote: "I beseech you to get from Rousseau another photograph of the Mexico picture with the animals, which is so typical of him."[128]

Marc had much the same quasi-religious theosophic notions about art as Kandinsky, which were rather different from the drier, Cartesian-inflected ideas of someone as French as Delaunay. In correspondence with Delaunay about the possible publication of a book on Rousseau in Germany, Marc seems to have felt the need for a German view of the Douanier when he wrote: "I will gladly write a

Fig. 45.
Kandinsky. *Lyric*. 1911
Museum Boymans-van Beuningen, Rotterdam

Pl. 9
Rousseau. *War*

124. Ibid., p. 411.

125. Ibid., p. 28.

126. If *War* had still been with Rousseau or were its location identified during Kandinsky's stay in Paris and afterwards, it would not only solidify the Kandinsky/Rousseau connection but would allow consideration of the possible influence of *War* on the development of conceptions in Picasso's art that culminated in *Guernica*. Cf. Werner Spies, "L'Histoire dans l'atelier," *Cahiers du Musées National d'Art Moderne*, no. 9 (special number: "Paris-Paris, 1937–1957"), p. 74.

127. Klaus Lankheit, in "Preface to the 1965 German Edition," Wassily Kandinsky and Franz Marc, eds., *The Blaue Reiter Almanac*, New Documentary Edition, The Documents of 20th-Century Art (New York: Viking Press, 1975), p. 22.

128. Dated "13. xii 12"; cited in *Robert Delaunay*, p. 75.

129. Undated; cited in ibid., p. 74.

130. Cited in ibid., p. 75.

131. Max Beckmann, "Gedanken über zeitgemässe und unzeitgemässe Kunst," *Pan* (Berlin), vol. 2 (March 14, 1912), p. 500; cited in Peter Selz, *Max Beckmann* (New York: The Museum of Modern Art, Boston: Museum of Fine Arts, and Chicago: Art Institute of Chicago, 1964), p. 19.

Fig. 46.
Marc. *Portrait of Henri Rousseau.* 1911
Städtische Galerie im Lenbachhaus,
Munich

Pl. 23.
Rousseau. *Portrait of the Artist*

132. Max Beckmann, "Letters to a Woman Painter,"
College Art Journal (New York), vol. 9, no. 2 (Autumn
1949), p. 39 (trans. Mathilde Q. Beckmann and Perry
T. Rathbone); cited in Selz, p. 132.

133. Max Beckmann, "On My Painting," Buchholz
Gallery (New York: Curt Valentin, 1941), p. 13.

134. Mathilde Q. Beckmann, *Mein Leben mit Max
Beckmann* (Munich and Zurich: Piper, 1983), p. 152.

135. For an account of Rousseau's working methods,
see Ardengo Soffici, in Certigny, pp. 410–11 (n. 40
above). Soffici's assertion, "After having drawn all of
the projected work in pencil, he used only one color at
a time when he came to paint it," would seem to be
borne out by the photograph of Rousseau in front of
the unfinished canvas of the second version of *The
Muse Inspiring the Poet* (see p. 230).

short article telling how Rousseau is 'regarded' in Germany and what he means to us: *from the German point of view."*[129] Delaunay, who very much enjoyed and valued his German contacts, apparently found the Teutonic infatuation with mysticism not exactly to his taste as, after a visit to Berlin in January 1913, he wrote in a draft of a letter to Marc:

> I don't believe there is a need for any mysticism in art, in the motive force of art, not Christian, not Jewish, nor any other...what I observed in your country in the most interesting of the young Germans, was an obsession with mysticism, or rather, an addiction that paralyzes life and stupefies...You know how much I love Rousseau...and my love for him can only grow...Rousseau is full of mystery, but he did not fall into mysticism. He is mysterious by his life, by circumstances, by his devotion pushed to the extreme limits of his thought— which for my feeling is a little exaggerated, yet in this regard he is the last of the painters we call classic.[130]

The views of Marc and Kandinsky on art were not, however, universally accepted by their compatriots. About a year before Delaunay drafted the above, Marc had written an article in *Pan* that elicited the following comments from the twenty-six year old Max Beckmann, then working in Berlin: "There is something that repeats itself in all good art, that is artistic sensuousness, combined with artistic objectivity toward the thing represented."[131] Beckmann at the time was reacting to Marc's stress on the mystique of searching for the "inner, spiritual side of nature" that would ultimately lead toward abstraction. Much later, Beckmann's views had so shifted that he could write:

> ...the visible world in combination with our inner selves provides the realm where we may seek infinitely for the individuality of our own souls. In the best art this search has always existed. It has been, strictly speaking, a search for something abstract and today it remains urgently necessary to express even more strongly one's own individuality. Every form of significant art from Bellini to Henri Rousseau has ultimately been abstract.[132]

Still, Beckmann was attached to the object in a visible world in a way that Marc and especially Kandinsky had not been. Beckmann, who intensely admired Rousseau, calling him "that Homer in a concierge's lodge whose prehistoric dreams have sometimes brought me near the Gods,"[133] can indeed be thought of as an inheritor of the "great realism" which Kandinsky regarded as having been fathered by Rousseau.

As with Léger's art, Beckmann's does not significantly begin to reflect his interest in Rousseau until the years immediately following the First World War; thereafter, it abounds with images that clearly reveal their sources in the Douanier's work. Beckmann's wife tells us that, with Cézanne, her husband most treasured Rousseau, especially his "fantasy" and "composition," and he was "simply enchanted...with that kind of painting."[134] Indeed, it is from Rousseau's pictorial fantasy and compositional structures that Beckmann most borrowed. Apart from his dramatic uses of black, there is little to suggest Rousseau in Beckmann's handling of paint, and the fact that both artists drew sketches of their total compositions on their canvases before beginning to paint is no more than coincidence.[135]

One of the earliest of Beckmann's paintings related to Rousseau is *Landscape with Balloon* (1917, fig. 47). Not yet executed in the German artist's mature style, the canvas is chiefly reminiscent of Rousseau in its overall format and its imagery of the street lamp, hot air balloon, and tiny parasoled figure. A later painting frankly inspired by Rousseau, *Iron Footbridge in Frankfurt* (1922, fig. 48), is not only more mature but is also more typical of Beckmann's rearrangements of imagery he picked up from Rousseau. He seems to have upended Rousseau's ubiquitous iron bridge and packed his picture with fragments from several different pictures by the Douanier—likely sources being *View of Grenelle Bridge* (1892, pl. 8) and *Notre Dame: View of the Ile Saint Louis from the Quay Henri IV* (1909, pl. 60), both from Delaunay's collection and in Uhde's 1914 book, and the *Myself, Portrait-Landscape* (pl. 5).

The Rousseau painting that would appear to have held the most importance for Beckmann's work is *Portrait of Pierre Loti* (pl. 7). We first see it directly echoed in *Embitterment,* a print of 1920 (fig. 49), which, like almost all the other works based on the Loti image, is a self-portrait. In all the subsequent works, however, Loti's frontality is preserved; whereas in *Embitterment* we are presented with a sharply etched profile that may have been suggested to Beckmann by the distinctly shaded and unshaded halves of Loti's face. But the Loti connection is unmistakably signaled by the cat and fez. The compressed space of *Embitterment* may derive from the Loti portrait, but in all likelihood comes more directly from another painting, while the man with umbrella glimpsed in the tilted street is a general reference to the ever-present *bonshommes* of Rousseau's street scenes.

That the tight, boxlike space of *Embitterment* is probably more related to Rousseau's *Portrait of the Artist* (pl. 23) than to Loti, we may deduce from Beckmann's 1921 etching *Self-Portrait with Bowler Hat* (fig. 50), which unmistakably merges the Loti and self-portrait images, retaining the cat and hand with smoking cigarette from Loti, adding the oil lamp from the self-portrait, and setting the whole in a format that is a variation on that of the self-portrait. The Beckmann etching so much resembles the Rousseau self-portrait that their relationship seems unquestionable. Should any doubts remain, we have only to compare Beckmann's *Woman with a Candle* (1920, fig. 51) to the Douanier's

Fig. 47.
Beckmann. *Landscape with Balloon.* 1917
Museum Ludwig, Cologne

Fig. 48.
Beckmann. *Iron Footbridge in Frankfurt.* 1922
Kunstsammlung Nordrhein-Westfalen

Fig. 49.
Beckmann. *Embitterment.* 1920
Kunsthalle Bremen

Fig. 50.
Beckmann. *Self-Portrait with Bowler Hat.* 1921
Kunsthalle Bremen

Fig. 51.
Beckmann. *Woman with a Candle.* 1920
Kunsthalle Bremen

Pl. 7.
Rousseau. *Portrait of Pierre Loti*

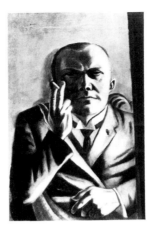

Fig. 52.
Beckmann
Self-Portrait with Cigarette. 1923
The Museum of Modern Art,
New York

Fig. 53.
Beckmann
Self-Portrait with Beret (Gilles). 1934
Museum Ludwig, Cologne

Fig. 54.
Beckmann
Self-Portrait in Black. 1944
Staatsgalerie moderner Kunst,
Munich

Fig. 55.
Beckmann. *Family Lütjens.* 1944
Private collection

Portrait of the Second Wife of Rousseau (1900–03, pl. 24), the former the counterpart to the Beckmann self-portrait, the latter the pendant to the Rousseau self-portrait, and it becomes clear that Beckmann's cross-referencing was intentional.

Beckmann often painted his own portrait, and these pictures are among the most penetrating visions of the interior and exterior self simultaneously presented that any twentieth-century artist has made. While many of them suggest paintings by Rousseau, there are three, executed at approximately ten-year intervals, that were obviously done with the Loti portrait in mind: *Self-Portrait with Cigarette* (1923, fig. 52); *Self-Portrait with Beret (Gilles)* (1934, fig. 53); and *Self-Portrait in Black* (1944, fig. 54). In all of them, as in *Loti,* the face is dramatically shadowed, an arm held close in a flat, almost shieldlike manner against the body, and the figure itself is uncompromisingly frontal, truncated at the waist, pressed into and dominating a confined space. Beckmann's profound feeling of kinship with Rousseau could hardly be more forcefully witnessed than in these intensely felt portraits in which the artist expresses his own personality through images closely related to the Douanier.

When he painted the last of the three self-portraits, Beckmann was in wartime exile in Amsterdam. His life under the German occupation had been difficult, and many of its hardships were relieved by his friend, the Dutch art historian Dr. Helmut Lütjens. When Beckmann, in the last winter of the war, wanted to paint a portrait of his benefactor and his wife and child, the spirit of Rousseau seems to have played a role in his highly empathetic rendering of *Family Lütjens* (fig. 55). Compositionally, the painting most resembles *The Muse Inspiring the Poet* (pl. 58), and there is a like feeling of gentle, secular gravity in each. The expressive play of hands is very much Beckmann's own invention, but not without intermingled variations on the hands of Laurencin, Apollinaire, and Loti, while the little girl at the right holding a puppet is a transfigured version of the baby in *Child with Puppet* (1903, pl. 25).

Although the Loti portrait is the Rousseau painting from which Beckmann most frequently borrowed, his *Lieblingsbilder,* as his widow reports, was *The Sleeping Gypsy.*[136] If his love for this painting is not reflected in his work, it has, at least

136. Mathilde Q. Beckmann, p. 152.

partially, to do with the fact that he probably did not see it until after the war, when he moved to the United States in 1947. That Beckmann, whose art is full of the imagery of dreams, should have been fascinated by *The Sleeping Gypsy* is scarcely surprising.

Beckmann's expressionistic work has very little in common with the parodistically "classical" style of the early Giorgio de Chirico, but in its vivid rendering of the reality of dream it is linked to the Italian artist's paintings of 1911 to 1917. For both artists Rousseau was an important source. Beckmann freely and often admitted his debt to Rousseau; whereas de Chirico in all his voluminous writings never acknowledged the connections between himself and the Douanier, as it would not have accorded with his subsequent will to mold his own legend as *pictor classicus.*

In fact, de Chirico's art of the early period is formally much closer to Rousseau's than is Beckmann's, although it makes use of borrowed imagery much less frequently. In its sense of stasis—the moment arrested in time—in its enigmatic, nonatmospheric "white" light, in its affinities with the work of Seurat, and in its use of broad, simple flat planes, de Chirico's art is anticipated by that of the Douanier. But above all, it is Rousseau's use of poetic, collagelike juxtapositions that prefigures de Chirico, whose work in turn is prophetic of Surrealism. Apollinaire would later remark of de Chirico: "In order to depict the fatal character of modern things, ... [he] utilizes the most modern motive force of all— surprise."[137]

As to this element of astonishment, consider Rousseau's last great work, *The Dream* (1910, pl. 66), painted the year before de Chirico's arrival in Paris. There we see a huge, fantastic jungle of exotic foliage, its myriad greens illumined not by the pale moon above but by glowing irradiations of its enormous blue, pink, and violet flowers and by some internal iridescence of its inhabitants—an orange-feathered bird, a sinuous snake, a dark musician in a brilliantly striped sarong playing a yellow wind instrument, a nude woman lying on a red sofa, and two yellow-eyed lions. The illogic is stunning, and partially for that reason the vividness and reality of dream has scarcely ever found a more forceful visual expression. Rousseau explained the presence of the sofa as wholly natural, belonging as it did to a dream. The woman is Yadwigha, a youthful love of Rousseau's as well as the possible alter-identity of his first wife Clémence; she is asleep on the couch of Rousseau's studio. The scene, as explicated in a poem such as Rousseau frequently wrote to accompany his important paintings, is Yadwigha's dream.[138] While de Chirico and the Surrealists after him would posit a kind of metaphysical and poetic logic in order to justify their irrational juxtapositions and dream imagery, Rousseau felt his imaginative life to be as real or even more so than the quotidian world around him. If we are to credit Apollinaire, Rousseau was sometimes so seized by terror and awe when painting a fantastic subject that he would have to rush to the window for air.[139] That being said, Rousseau was pictorially aware even as he transcribed his dream, and to André Salmon he gave another reason for the presence of the couch, telling him that the sofa is only there "for the richness of the red."[140] In his review of the 1910 Indépendants in which *The Dream* was Rousseau's only entry, Apollinaire wrote: "In this painting we find beauty that is indisputable.... Ask the painters.... They are unanimous: they

137. Guillaume Apollinaire in Rousseau issue, *Les Soirées de Paris*; cited in Leroy C. Breunig, ed., *Apollinaire on Art: Essays and Reviews 1902–1918,* trans. Susan Suleiman, The Documents of 20th-Century Art (New York: Viking Press, 1972), p. 366 (pub. in French by Gallimard, 1962).

138. Rousseau's verse reads as follows:
Having fallen into a gentle sleep
Yadwigha, in a dream,
Heard the sounds of a musette
Played by a benevolent magician.
While the moon shone down
Upon the flowers, the green trees,
The wild serpents listened to
The instrument's merry tunes.

Vallier, in *Tout l'oeuvre peint*, p. 116, no. 256, speculates that the above was actually written by Apollinaire; the somewhat questionable merits of the argument aside, this does not accord with the fact (to which Vallier draws attention) that the verse was falsely transcribed by Wilhelm Uhde, who wrote *fleuves* for *fleurs* in line 6; Uhde's error was frequently picked up by subsequent authors, including Apollinaire in the Rousseau issue of *Les Soirées de Paris*, p. 65. Rousseau also explained the sofa to the critic André Dupont (n. 2) as follows: "This woman asleep on the couch dreams that she has been transported into the forest, listening to the sounds from the instrument of the enchanter. This is the reason the couch is in the picture.

139. Apollinaire, *Les Soirées de Paris*, p. 24.

140. Salmon, *Henri Rousseau dit Le Douanier*, p. 37; cited in Barr, *Masters*, p. 14.

141. Guillaume Apollinaire, *L'Intransigéant*, Mar. 18, 1910; cited in Certigny, p. 407.

142. In his classes at the Ecole du Louvre, Michel Hoog has suggested that the pictures of elegantly clad women promenading in an exotic forest were suggested by "the memory of Mme Delaunay [mère]."

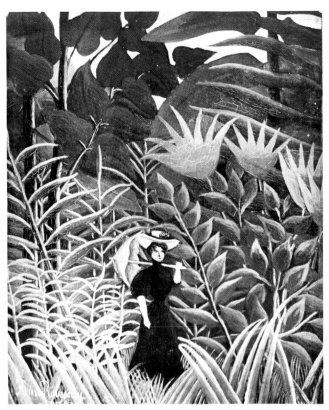

Fig. 56.
Rousseau. *Woman in Red in the Forest.* 1905–10

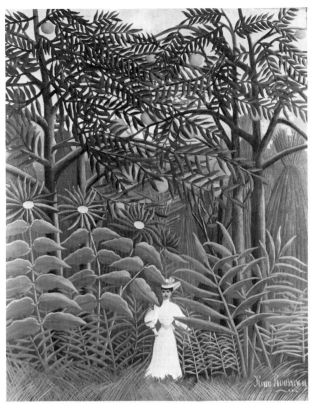

Fig. 57.
Rousseau. *Woman Walking in an Exotic Forest.* c. 1905
The Barnes Foundation, Merion, Pa.

admire. They admire it all, believe me, even that Louis-Philippe sofa lost in the virgin forest; and they're right."[141]

Because *The Dream* is one of the masterpieces of Rousseau's career and so manifestly anticipates Surrealist collage and its antecedents in de Chirico, we will briefly digress to speculate on its possible sources. In only three known prior works did Rousseau image a nude in the jungle. The earliest, *The Unwelcome Surprise,* presenting a nude woman, who having been surprised by a bear, is about to be rescued by a hunter, is an anecdotal rendering of fairy tale—beauty surprised by a beast. In the second, *The Snake Charmer* (pl. 36), we are in an enchanted realm where the naked flute player seems not unlikely, although her presence, arresting or transforming the expected malefic intent of the serpents, does have the same eerie magic as the gypsy untouched by the lion or Yadwigha tranquil on her beast-surrounded couch. In the third, the naked woman as *Eve* (pl. 29) in a forest setting seems only appropriate. More surprising images are Rousseau's paintings of elegantly clothed women somewhat inexplicably strolling about in dense tropical foliage, parasol in hand, as though on a fashionable Parisian street.[142] In a very early picture *Walking in the Forest* (c. 1886, pl. 3) the *flaneuse* is not yet in the tropics and appears manifestly surprised that she is adrift in the woods. In later paintings (figs. 56, 57) the modishly dressed women have the calm aplomb of Yadwigha—sedately at their ease amidst thick, engulfing

foliage. Woman and forest, each long understood as symbols of both mystery and paradise, thus converge in an enigmatic way in Rousseau's art before their epiphanous combination in *The Dream*.[143]

Given Rousseau's concern with the theme and his acknowledged predilection for visiting Paris museums, he must certainly have reacted to the almost simultaneous acquisition by the French State Museums in 1907 of two still notorious paintings by Edouard Manet. *Déjeuner sur l'herbe* (fig. 58) was installed in that year as part of the Moreau-Nelaton gift in the Musée des Arts Décoratifs, and *Olympia* (fig. 59), after much public controversy, was moved from the Luxembourg to the Louvre where it was hung next to Ingres's *Grande Odalisque*. If elements of Rousseau's art were later picked up by other artists, Rousseau may well have found this the occasion to take inspiration from a genius of French painting whose art, which had been as maligned as his own, was at last enshrined in the artistic pantheon of the French state.

Manet's young woman in the *Déjeuner* is not alone in the outdoors as were Rousseau's, but sits in the woods with her companions, bourgeois, and quite surprisingly naked, her fashionable walking dress and hat in a heap beside her. It is entirely likely that Rousseau saw parallels in Manet's imagery and his own, and in contemplating the execution of *The Dream*, the image of Manet's naked woman outdoors became merged with a conception partially drawn from *Olympia* reclining on her couch attended by a dark servant and glowing-eyed cat. There is nothing of Manet in the formal construction of *The Dream*, but its motifs can quite reasonably be attributed to a typically personal reading of the Manets by Rousseau. The process could be described as a selective "collaging" of elements Rousseau found in the two Manets and his own prior work plus an admixture of the exoticism and sensuousness of Ingres's *Grande Odalisque* then hanging next to *Olympia* in the Salle des Etats of the Louvre. With the partial exception of *The Sleeping Gypsy* there is no other painting by Rousseau in which elements that are essentially disparate, rather than eccentric by virtue of their renderings, are so boldly brought together. Certainly this may have to do with Rousseau's cumulative mastery of his idiom, but concomitantly it may reflect a relatively uncharacteristic use of advanced pictorial sources.[144]

That *The Dream* and other paintings by Rousseau were well known to de Chirico cannot be doubted. De Chirico was a close friend of Ardengo Soffici, who had not only known the Douanier, but had written an article on him just before Rousseau's death that appeared in *La Voce* at the end of 1910. Soffici may have provided de Chirico's introduction into the circle around Apollinaire who, as editor of *Les Soirées de Paris,* was closely associated with its financial backers, the Baroness d'Oettingen (Soffici was also her lover) and her brother Serge Jastrebzoff. Not only would he have heard a great deal about the Douanier from these people, but he would have seen his work in the apartments of Apollinaire and the poet's friend, Picasso, and, of course, at Jastrebzoff's, as is confirmed by his sketch of Picasso seated at table below *Myself* (fig. 27). While *The Dream* was not in the 1912 Bernheim-Jeune Rousseau retrospective, it was owned by Vollard whom de Chirico would surely have encountered, most likely through Picasso; it was, as well, reproduced in Uhde's 1911 book and its 1914 German reprint. De Chirico's stay in Paris coincided with the period when the Douanier, overlooked in life, was suddenly widely celebrated, and the celebrators were exactly the vanguard painters and writers with whom de Chirico was most intimate.

Fig. 58.
Manet. *Déjeuner sur l'herbe.* 1863
Musée du Louvre, Paris

Fig. 59.
Manet. *Olympia.* 1862–63
Musée du Louvre, Paris

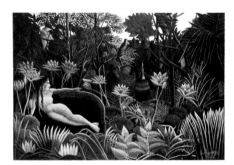

Pl. 66.
Rousseau. *The Dream*

Manet and Rousseau

Fig. 60.
de Chirico. *The Child's Brain*. 1914
Moderna Museet, Stockholm

143. See Descargues, pp. 129–32, for a discussion of the woman-and-forest theme in Rousseau.

144. See Le Pichon, p. 210, for other possible sources.

145. Robert Melville, "Rousseau and Chirico," *Scottish Arts and Letters*, no. 1 (1944), p. 35.

146. Reproduced in Rubin, *De Chirico*, pl. 29.

147. Cited in *12 Opere di Giorgio de Chirico precedute da giudizî critici* (Rome: Edizione di Valori Plastici, 1919), n.p., and in Willard Bohn, "Metaphysics and Meaning: Apollinaire's Criticism of Giorgio di Chirico," *Arts*, vol. 55, no. 7 (Mar. 1981), p. 110.

148. Melville, p. 33.

149. Ibid., p. 35.

Although there are isolated elements in de Chirico's work that remind us specifically of Rousseau, such as the prevalence of smoking chimneys and flags carefully fluttering in the same direction in a windless, airless space, the Douanier was chiefly important to de Chirico as an example in formulating his poetic technique of the irrational or incongruous juxtaposition of familiar objects. Robert Melville declared that de Chirico in placing "untransformed objects in a transforming relationship...was heir to part of Rousseau's poetic genius," whereas the greater "gift for creating shapes was bequeathed to Picasso."[145] As we have seen, Picasso did indeed find ideas in Rousseau, but even in the late period of his Synthetic Cubism, the affinities between his work and the Douanier's are not as great as those linking the latter's with the art of the early de Chirico.

De Chirico's metaphoric spaces, sometimes tight and confining as in *The Child's Brain* (fig. 60) and sometimes vast as the other world of dream as in *The Enigma of a Day*,[146] are similar to those of Rousseau—compressed as in the portrait of Loti or beyond measure as in *The Sleeping Gypsy*. And the paintings of each are permeated by an enigmatic, seemingly timeless, "white" light of dreamlike fixity. Apollinaire, searching to clarify his impressions remarked, "I really don't know to whom to compare Giorgio de Chirico. The first time I saw his paintings I instinctively thought of the Douanier."[147] While the tightly packed imagery of Rousseau's Jungle pictures is unlike anything in de Chirico, their dense foliage is symbolic of some limitless immensity; as metaphors for the infinite space of dream, even these paintings are related to the oneiric expanses of de Chirico's.

Both de Chirico and Rousseau were compared by Apollinaire and others to Paolo Uccello. And, indeed, both treat the background plane in the distance as a foil or backdrop with no mediation between it and the foreground as did Uccello, the net effect of which is to produce a quality of enigma that would cause the Surrealists to be interested in all three artists. Rousseau's use of this technique evolved from his pragmatic approach and "stubborn labor," Uccello's from his obsession with linear perspective, and de Chirico's from his willful perversion of the canons of fifteenth-century perspective. To some degree de Chirico must have found Rousseau's work a useful example as he began the program of subversion of the principles of Renaissance painting that persisted in his art until 1917.

Nonspecific as the affinities of Rousseau and de Chirico tend to be, there are two paintings by de Chirico which have been suggested as deriving from canvases by Rousseau. *The Child's Brain* was first proposed by Melville as having been inspired by *Loti*.[148] Indeed, Melville's arguments are well taken; both compositionally and in their affective impact the two paintings are very similar. If Melville sometimes strains our credulity in his analysis of *The Child's Brain,* he is certainly right when he describes the paintings as having a common, "curious, not unduly stressed, goetic atmosphere: sly power informs the gaze of Loti and his 'familiar.'..."[149] Widely accepted as a fantasy portrait of the painter's father, *The Child's Brain* largely sustains a sinister, semierotic reading such as Melville propounds, and which accords with seeing Loti as a kind of necromancer or magician. However, given de Chirico's intimate familiarity with the Jastrebzoff pictures, the family-connected motif of *The Child's Brain,* and the greater superficial resemblance of the figure to a type of mustached man whose features are more typical of Rousseau than of Loti, we would suggest that *The Child's Brain* takes

the Loti persona and merges it with such avowed father images as those portrayed in *The Family, The Present and the Past,*[150] and *The Wedding* (pl. 28)—all from the Jastrebzoff collection. Indeed, in *Man with a Pipe* (fig. 61), his 1915 transformation of the de Chirico painting, Picasso, who would certainly have recognized its origins in Rousseau (he could well have been prompted to execute his painting by the "clear link" he recognized between the two artists), relieves the heavy atmosphere of the de Chirico and brings his image closer to the spirit of the Rousseaus in the Jastrebzoff collection.[151] Although Picasso's addition of the hat does not reflect any similarly adorned figure in the pictures of the Jastrebzoffs—indeed, it may relate to Picasso's own associations with Cézanne—it may also be an additional reference to Rousseau, whose landscapes are never complete without a small gentleman in what appears to be a kind of bowler hat who is often identified with Rousseau himself.

Fig. 61.
Picasso. *Man with a Pipe* (detail). 1915
The Art Institute of Chicago. Gift of Mary
L. Block in memory of Albert D. Lasker

The other de Chirico that has been advanced as being directly related to a Rousseau is *Gladiators and Lion* (1927, fig. 62).[152] If, indeed, this painting were partially inspired by the discovery of *The Sleeping Gypsy* and the ensuing publicity, it would still be of considerably less interest to us, as de Chirico was then far beyond the period of his early modernism and painting in a rhetorical, illusionist style of debased academicism that has nothing in common with Rousseau. In any event, there is little doubt that *The Sleeping Gypsy* was partly inspired by Gérôme,[153] and it is perhaps more his spirit than Rousseau's which informs the de Chirico.

Although de Chirico never acknowledged any debt to Rousseau, his brother Alberto Savinio did it for him, albeit after the fact and putting him in unexpected company. In May 1919, in *Valori Plastici,* Savinio, writing on what he considered the only new, significant painting, the Italian Scuola Metafisica (Metaphysical School)—a reaction against Futurism heavily based on the prior art of de Chirico—declared that the origins of the new art were in a kind of primitivism that had evolved through the Fauves, especially Matisse and Derain, and had touched "first on the work of Rousseau," whence he predicted it widening into a new classicism that was appearing in the work of de Chirico and Carrà.[154]

The Scuola Metafisica was short-lived, but one of its founders and chief theoreticians, Carrà, was vociferous in his praise of Rousseau. He devoted a chapter to the Douanier in his *Pittura Metafisica* of 1919, and much later wrote of the painter he called the "gentle and terrible Rousseau" as follows: "I shall try to make clear the Douanier meant as much to us in post-Futurist Italy as his great predecessors of the fourteenth and fifteenth centuries.... The need to return to universality in painting led us back to the art of Giotto, Paolo Uccello, and Piero della Francesca."[155]

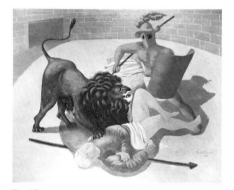

Fig. 62.
de Chirico. *Gladiators and Lion.* 1927
The Detroit Institute of Arts

A parallel return to a more realistic, object-oriented kind of painting was happening in Germany in the movement called Neue Sachlichkeit (New Objectivity), but whatever role Rousseau may have had in this manifestation or its Italian counterpart, it is less significant than his importance to the more influential developments of Surrealism.

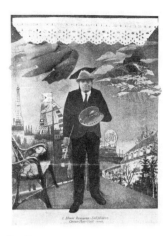

Fig. 63.
Grosz and Heartfield. *Henri Rousseau Self-Portrait Montage,* from catalogue annoucement of the *Erste internationale Dada-Messe*

150. Vallier, *Tout l'oeuvre peint,* nos. 41 and 87. Both paintings are now in the Barnes Foundation, Merion, Pa.

151. For the relevance of the Picasso painting to the de Chirico, see Rubin, *De Chirico,* pp. 69–70.

152. See Christian Derouet, "Un problème du baroque italien tardif à Paris," in William Rubin, Wieland Schmied, and Jean Clair, *Giorgio de Chirico* (Paris: Centre Georges Pompidou, Musée National d'Art Moderne, 1983), pp. 126–27; German ed. (Munich: Prestel Verlag, 1982, pp. 125–26).

153. For a discussion of *The Sleeping Gypsy* and the art of Gérôme see Albert Boime, "Jean-Léon Gérôme, Henri Rousseau's *Sleeping Gypsy* and the Academic Legacy," *Art Quarterly,* vol. 34 (Spring 1971), pp. 3–29.

154. Alberto Savinio, "Anadyomenon: Principles in the Evaluation of Contemporary Art," *Valori Plastici* (Rome) nos. 4–5; cited in Massimo Carrà, with Patrick Waldberg and Ewald Rathke, *Metaphysical Art,* trans. Caroline Tisdall (New York and Washington: Praeger, 1971), p. 160.

155. Carlo Carrà, *Pittura Metafisica* (1919), pp. 261, 263.

156. André Breton, *L'Art magique* (Paris, 1959), p. 37.

157. Cited in Descargues, pp. 123–24.

Dada, which was Surrealism's nihilistic, less programmatic forerunner, provided Rousseau with a tiny, walk-on part when George Grosz and John Heartfield made a "corrected masterpiece" of the Douanier's *Myself,* collaging a reproduction of it with extraneous photographic elements. Thus, Rousseau, as Heartfield (fig. 63), makes an appearance in the broadside catalogue announcement of the climactic event of Berlin Dada, the *Erste internationale Dada-Messe* in June of 1920.

Although Rousseau's ties with Surrealism run deep, his direct contributions to the movement were largely made through de Chirico, while other affinities between his art and that of Surrealism are probably not related causally. A chief goal of Surrealism was to reveal the landscape of the mind, to image dreamlike experience, whether by automatic techniques or through illusionist realism, and Rousseau had so evidently accomplished this that it remains surprising that André Breton did not list him among the precursors of the movement in its first manifesto of 1924. At the time, however, no concept of Surrealism in painting yet existed; indeed, as Breton defined Surrealism as being "beyond any aesthetic...preoccupation," painting could only be "a lamentable expedient." In declaring his belief "in the future resolution of the states of dream and reality," Breton relegates the plastic arts to a footnote in the 1924 manifesto, listing, however, Uccello, Seurat, and de Chirico, among others, as being of importance to the new movement. Thus, we could claim for Rousseau a kind of association by proxy with the official beginnings of Surrealism. Breton's famous epiphanous experience of some years prior to the manifesto, when he first saw de Chirico's *The Child's Brain,* and his subsequent acquisition of the painting, reinforces Rousseau's second-remove relevance to Breton's early conception of Surrealism, although it would not be until after the Second World War that he unequivocally acknowledged him in print, observing: "It is with Rousseau that we can speak for the first time of Magic Realism...of the intervention of magic causality."[156]

Surrealism's origins were poetic and literary; only secondarily were they translated into the plastic arts. In a pantheon of its generally recognized progenitors, Lautréamont, Jarry, Mallarmé, and Apollinaire, only one of them, Lautréamont, had not known and admired Rousseau. But Lautréamont had died in 1870 when Rousseau had not yet produced important paintings. Nevertheless, of all the literary forebears of Surrealism, it is Lautréamont who is closest to the one specific contribution of Rousseau to Surrealism. Lautréamont's image of "the chance encounter of a sewing machine and an umbrella on a dissection table" was taken as the prototype of collage and virtually licensed Dada and Surrealist use of that technique in the irrational juxtaposition of unexpected objects; in terms of the plastic arts, as we have seen, this was anticipated by de Chirico and first practiced by Rousseau. Indeed, it was this aspect of Rousseau's art that Breton had in mind when he wrote: "Of meager interest from a realistic point of view, his works are totally Surrealist in inspiration, before their time (as are the early Chiricos)."[157] Waxing enthusiastic, Breton goes on from this to predict that Rousseau's *The Dream* would one day be promenaded through the streets as was Duccio's *Maestà* in Siena.

Prior to the official advent of Surrealism, Max Ernst in 1919 in Cologne began to use collage in a way that was the visual articulation of Lautréamont's Symbolist type of verbal hybrid. Ernst was most probably familiar with Rousseau's work through August Macke as far back as 1912, and certainly had known it since 1913 when he contributed to the *Erster deutscher Herbstsalon* at which work by

Rousseau was featured. To judge by *Hat in the Hand, Hat on the Head* (c. 1913, fig. 64), the young Ernst may even have been slightly influenced by the Douanier. It is, however, highly unlikely that his Dada collages in postwar Cologne owe anything to the Douanier, despite parallels we can find between them and works by Rousseau.

Ernst's conception of collage was unlike that of the Cubists in that he was not primarily interested in formal, plastic values but in "image" values. Using catalogue and magazine illustrations, Ernst employed a variety of methods to disguise the collage technique itself, producing images that puzzle and surprise by their illogics of scale and figuration. Although the frequency of mechanical imagery in these collages sets them apart from Rousseau and relates them to prior work by Duchamp and Picabia, what Ernst called his "culture of systematic displacement and its effects" associates them also with de Chirico and thereby with Rousseau. Indeed, Melville's perception that "a recipe for the enigma in painting" is to be found in Rousseau's *The Sleeping Gypsy*, namely "the situating of utterly still, impenetrably self-contained figures in a purely formal relationship which contrives nevertheless to simulate the appearance of an encounter,"[158] articulates Rousseau's proximity to the Ernst whose strategy was defined as the exploiting of "a meeting of two distant realities on a plane foreign to them both."

As noted, in the Cologne collages as well as those executed toward the end of the next decade, Ernst's material sources were often nineteenth-century catalogue and magazine illustrations; one of the richest of these, *Magasin pittoresque*, is generally recognized to have served Rousseau as well. When Rousseau transposed a figure found in a book or magazine to the theater of his painting, his conscious aim was not, as was that of Ernst, to subvert the art-making process; consequently the resulting images are less immediately shocking although sometimes almost as disorienting. Rousseau's picture of the elegant Parisian apparently at ease in a monstrous jungle (fig. 56), which probably had some such pictorial source as a contemporary postcard (fig. 65),[159] provokes responses not unlike Ernst's *Two Young Girls Promenade across the Sky* (fig. 66).

Fig. 64.
Ernst. *Hat in the Hand, Hat on the Head.* c. 1913
Estate of Roland Penrose, London

Fig. 65.
In the Zoological Garden: The Camellia Hothouse
Supplement to *Le Petit Journal*, no. 331
(March 21, 1897)

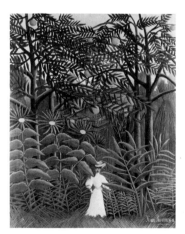

Fig. 57.
Rousseau. *Woman Walking in an Exotic Forest*

Fig. 66.
Ernst. *Two Young Girls Promenade across the Sky.*
1920
Collage

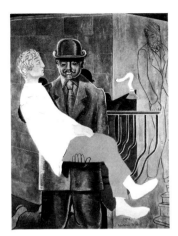

Fig. 67.
Ernst. *Pietà or the Revolution by Night.* 1923
The Tate Gallery. London

Fig. 68.
Ernst. *The Joy of Living.* 1936
Estate of Roland Penrose, London

158. Melville, p. 33.

159. The possible relationship of this postcard to Rousseau's imagery was pointed out by Le Pichon, pp. 130–31.

160. Max Ernst, "An Informal Life of M. E. (as told by himself to a young friend)," in William S. Lieberman, ed., *Max Ernst* (New York: The Museum of Modern Art, 1961), pp. 11–12.

161. Tristan Tzara, "Le Rôle du temps et de l'espace dans l'oeuvre du Douanier Rousseau," *Art de France* (Paris), no. 2 (1962), p. 324. For more on Rousseau and the durational experience in his plays and paintings, see Tzara, "Henri Rousseau," trans. Bernard Frechtman, in *Transition Forty-eight* (Paris), no. 3 (1948), pp. 29–40.

162. Tzara, "Le Rôle du temps," p. 324.

Ernst's description of his creation of collage may reasonably be imagined to apply to Rousseau—with emendations allowed for differences of temperament and historical period as well as of actual method.

The advertisements...provoke...a hallucinatory succession of contradictory images, double, triple, multiple superimposed upon each other with the persistence and rapidity characteristic of amorous memories and visions of somnolescence. These images in turn, provoke new planes of understanding. They encounter an unknown—new and non-conformist. By...painting or drawing, it suffices to add to the illustrations a color, a line, a landscape foreign to the objects represented....These changes, no more than docile reproductions of *What is visible within me,* record a faithful and fixed image of my hallucination. They transform the banal pages of advertisement into dramas which reveal my most secret desires."[160]

While Rousseau's paintings are still and "timeless," as are most of Ernst's proto-Surreal and Surreal illusionist pictures, they emanate, as do Ernst's, a sense of time telescoped and demand of us a durational reading. Tzara, observing this quality in Rousseau, remarks that movement has been "captured at an especially representative moment—in a story that is happening in his mind and for which the picture is somehow the symbol," and compares Rousseau's pictorial evocations of temporal juxtapositions with the devices he used in his play *The Revenge of a Russian Orphan.*[161] Tzara also suggests that particularly as we see these qualities in *The Sleeping Gypsy,* Rousseau "anticipates what Ernst meant by the collage."

Titles are important elements in Ernst's collages, as they often were for Rousseau. Indeed, the introduction of language to the image was fundamental to the tradition of *peinture-poésie* from the time of Redon and before through its use by Surrealism. But Rousseau's titles, like most of Redon's, are directly related to the image and thus descriptive in a way that Ernst's or de Chirico's before him often are not. Tzara explains that the verses that accompany Rousseau's paintings are meant to "fill out their intelligence," to aid us in reconstituting "the fiction upon which they repose,"[162] as a sort of key to unscramble the inconclusive narrative sliced into the static theater of his canvas. With Ernst, however, as with other Surrealists, titles are often used to compound the enigma, heighten absurdity, or enhance ambivalences of meaning.

There was always some effort in Ernst's Cologne collages to camouflage the collage technique itself; logically, therefore, just before going to Paris in 1922, he began to paint large "collages." The paintings of this type done between 1921 and 1924, of which his variation on *The Child's Brain* is one (fig. 67), constitute the link between de Chirico's style and Surrealist illusionism, which—certain works by Joan Miró apart—is the side of Surrealism closest to Rousseau.

If in Ernst's early post–First World War work we find no direct links with Rousseau, there are generally recognized connections between Ernst's depictions of lush tropical vegetation of the late thirties and early forties (fig. 68) and Rousseau's Jungle paintings. But Rousseau's Jungles are a dream of some primordial Arcadia; they are all part of an enchanted realm that encompasses the desert of *The Sleeping Gypsy* and the oasis of *The Flamingos* (pl. 37) by the sides of which at nightfall the dark flute player charms the serpents emerging from the sur-

rounding forests where animals battle and Yadwigha dreams. If it is not the proverbial Peaceable Kingdom, it is nonetheless a world of natural order, harmonious within itself, where animal carnage obeys the wild but innocent impulses of nature. And even these are stayed by the necromancy of music and the female presence. Rousseau's tropics depict a secular Eden, sensuous, joyful, and awesome which in paintings such as *The Dream* recalls lines from Andrew Marvell's *Bermudas:* "He hangs in shades the Orange bright/Like golden lamps in a green Night,"[163] and others such as *The Hungry Lion* (pl. 31) suggest Shakespeare's vision from *The Tempest:* "How lush and lusty the grass looks! How green!."[164]

By contrast—and this is characteristic of differences between French and German art—Ernst's forests are menacing, sinister. Far from natural or innocent, they are sometimes metaphors for the corruption of civilization. Green and lush as they also are, they often seem on the verge of putrescence and thus certainly refer to the oncoming war and the troubled conditions of the world at the time. Close as some of Ernst's fantastic forests may superficially appear to certain of Rousseau's images, they are more nearly related to the language of alienated and melancholic Symbolism; whereas those of Rousseau descend through his childhood memories of the tapestries of the Apocalypse at Angers by way of a kind of robust nineteenth-century sensibility, such as we see in the romanticism of Delacroix and even the realism of Courbet in his paintings of stags battling in the woods.[165] Rousseau's Arcadia is finally much closer in spirit to the urban Utopia of Léger as in *Homage to Louis David (Leisure Time)* than it is to the nightmare forests of Ernst.

In a lighter vein, Ernst quotes indirectly from Rousseau in one of his collages of the Loplop Presents series (fig. 69) where he combines a botanical illustration with drawn elements in such a way as to suggest Rousseau's *The Snake Charmer*.[166] A year earlier Ernst had used the same painting by the Douanier to create, in conjunction with his wife at that time, Marie-Berthe Aurenche, a double portrait of themselves (fig. 70) in a Loplop paradise, which is a paraphrase of the snake charmer's jungle.[167]

One of Rousseau's strongest appeals to Surrealism was as a poet-painter. As Tzara observed, he considered the imaginative subject as the very center of his

Fig. 69.
Ernst. *Loplop Presents.* 1932
Collage and pencil

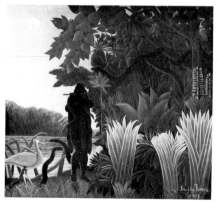

Pl. 36.
Rousseau. *The Snake Charmer.*

Fig. 70.
Ernst and M.-B. Aurenche. *Loplop Paradise.* 1931

preoccupations. Additionally, the legend that enveloped him by the time of the advent of Surrealism placed him outside the "professional" tradition of art, which, if not entirely true, did carry an accurate corollary; he had, indeed, been the embodiment of the Surrealist ideal of the integration of art and life.[168] Although Zervos was not especially associated with Surrealism, he has written about Rousseau in a way that makes clear his appeal to that group: "He has looked into the invisible, as much as our condition permits." His soul, Zervos goes on to say, is still connected to the soul of the world and such a "soul assembles within itself all the sensations of creation. It is the soul of the bird, of water, of the forest. It is the stroller in a garden, the monkey in his palm tree, the present and the past, it is fable itself."[169]

For all these reasons, we might assume that the finest painter associated with Surrealism and unquestionably its poet-painter par excellence, Miró, would have been drawn to Rousseau. And, indeed, we have Miró's most emphatic testimony that he was. He wrote to James Thrall Soby in 1958: "As I told you from 1916 to 1920 I was impressed by van Gogh, Rousseau, and Picasso—admirations which I feel to this day to the highest degree."[170] Miró's enthusiasm for Rousseau's work was, however, probably totally spontaneous, appealing to the young painter by its freshness, inventiveness, color, and evident poetic spirit. At the time Surrealism had not been invented, and Miró himself had not yet found his mature style. Soby conjectured that Miró may first have "become aware of the miraculous gifts" of Rousseau at Picasso's apartment."[171] This, however, would seem unlikely as, even if Miró's memory had not been wholly accurate in placing the beginning of his admiration for the Douanier in 1916, it would probably have been off by no more than a year. Certainly he would have remembered if he had first become aware of the Douanier in Paris, which, were it the case, would have been no earlier than 1919, when he first visited the French capital. Indeed, Dupin believes paintings of 1918 such as *Vegetable Garden with Donkey* (fig. 71) evidence the influence of Rousseau.[172] It may well be that Miró learned of the Douanier through Picabia, who was often in Barcelona from 1917 to 1919 and who had known the Douanier well enough to be a guest at his *soirées familiales et artistiques*.

Fig. 71.
Miró. *Vegetable Garden with Donkey.* 1918
Moderna Museet, Stockholm

163. Andrew Marvell, *Miscellaneous Poems*, 1681; cited in *The Oxford Book of Seventeenth-Century Verse* (Oxford: Clarendon, 1934; reprinted 1938, 1942, 1947), p. 739.

164. Alfred Harbage, ed., *William Shakespeare: The Complete Works*, rev. ed. (Baltimore: Penguin Books, 1969), p. 1380.

165. Other than his often repeated remarks about the academicians of his day, Rousseau seems to have rarely spoken about other painters he admired. That he was drawn to Courbet seems borne out by Brummer's recollection that "he mentioned only Courbet with admiration"; cited in Rich, p. 49. And, Tzara has pointed out, in "Le Rôle du temps," p. 324, that, although, as is well known, Rousseau meticulously kept press clippings, often adding his comments, they almost without exception had to do with himself; a rare exception was a piece deploring current painting and evoking, by contrast, Courbet. In the margins of the clipping in Rousseau's hand appears "Courbet regretté." As Tzara remarks, "[what a] laconic formulation, but how charged with significance," and adds, "Courbet, it seems to me, constitutes one of the sources for Rousseau's painting...."

166. This was pointed out by Werner Spies in *Max Ernst Loplop: The Artist in the Third Person* (New York: Braziller, 1983), p. 92.

167. Ibid.

168. In this connection Tzara, in *Transition Forty-eight*, p. 36, observed that Rousseau's disengagement from "a world which was not strictly his" brought about "the formation of a personality distinctive enough to give birth to a style which is not only of a pictorial or theatrical order, but which is a style of life."

169. Christian Zervos, "Henri Rousseau et le sentiment poétique," *Cahiers d'art* (Paris), vol. 1, no. 9 (Nov. 1926), p. 229.

170. Cited in James Thrall Soby, *Joan Miró* (New York: The Museum of Modern Art, 1959), p. 24.

171. Ibid.

172. Jacques Dupin, *Joan Miró: Life and Work* (New York: Abrams, 1962), p. 84.

Fig. 72.
Miró. *Table with Glove*. 1921
The Museum of Modern Art, New York
Gift of Armand G. Erpf

Fig. 73.
Miró. *Self-Portrait*. 1919
Musée du Louvre, Paris
Picasso Bequest

Pl. 12.
Rousseau. *Portrait of a Woman*

Soby sees in Miró's *Table with Glove* (fig. 72) an "attempt to simplify...forms through a deliberate primitivism which reflects [Miró's] regard for the Douanier Rousseau," which may well be the case.[173] Indeed, the iconic disposition of the table, the overall flatness, and the monumentality of the image on its small canvas may all owe something to Miró's observation of Rousseau. For the same reasons, we may speculate that Miró's 1919 self-portrait (fig. 73), which Picasso acquired shortly after Miró's first visit, has associations with Rousseau. Even if Miró's first contacts with Rousseau's painting did not occur in Picasso's apartment, he would surely, when visiting him in Paris in 1919, have seen the *Portrait of a Woman* (pl. 12) owned by Picasso. We can only imagine that the presence of Rousseau in the living presence of his countryman, a painter whom he equally admired, would have been a particularly moving experience for the young Catalan. Certainly it would have reinforced Miró's desire to give his self-portrait to Picasso.[174]

Four years later, at the time of the 1923 discovery of *The Sleeping Gypsy*, Miró was a fully mature artist and beginning to paint in a spontaneous, almost totally abstract manner that made him, with André Masson, the chief practitioner of Surrealist automatism, the side of Surrealist art that has very little to do with de Chirico and would seem to share nothing with Rousseau other than a common concern to convey pictorially the experience of dream. To be sure, Miró's loosely brushed, atmospheric, automatist paintings are at an almost absolute formal remove from Rousseau's art. Miró, however, alternated this manner with works executed in a painstaking, precise style, the tight painting, flat patterning, sharp contouring, and even surfaces of which relate them formally to pictures by Rousseau. The latter way of painting was an option Miró retained throughout his life, and although his work in this style is inflected by Cubism, and often so schematic as to be almost abstract, it is frequently inhabited by a gaiety, childlike whimsy, and concern with detail and anecdote that relate it spiritually to Rousseau. It may not be wholly farfetched to wonder if the series of anecdotal-type landscapes with sharply defined divisions of horizons that Miró painted between 1926 and 1927 do not owe something to all the stir then surrounding *The Sleeping Gypsy*.

173. Soby, p. 31.

174. Dupin, p. 91, asserts that "the very first time he saw Miró Picasso insisted that he wanted the self-portrait," and Claudie Ressort reports in the catalogue *Donation Picasso: La Collection personnelle de Picasso* (Paris: Editions de la Réunion des Musées Nationaux, 1978), p. 60: "This painting was offered to Picasso by Dalman, acting as intermediary, on the occasion of the first Miró exhibition in Paris, Galerie de la Licorne, 1921."

175. Cocteau, Preface.

176. Marcel Jean, *The History of Surrealist Painting*, trans. Simon Watson Taylor (New York: Grove Press, 1967), p. 40 (Paris: Editions de Seuil, 1959).

177. Cocteau, Preface.

178. For the most recent account of this encounter, see Roland Penrose in *Yves Tanguy: A Retrospective* (New York: The Solomon R. Guggenheim Museum, 1983), p. 5.

Cocteau had written of *The Sleeping Gypsy* that it was the contrary of "poetic painting," that in this painting, "we brush up against painted poetry, a poetic object, the abstract made concrete."[175] Cocteau's words could well apply to work by Miró, and are capable of triggering many associations to his art. But one in particular comes to mind, Miró's *Poetic Object* (1936, fig. 74), which, in turn, can cause us to think of Rousseau, especially *The Dream*. Certainly Miró's object and Rousseau's painting represent parallel voyages of the mind to a similar poetic terrain. What is spelled out in the Rousseau is alluded to in the Miró; we sense Rousseau's exotic setting to be far off, as Miró's map tells us his must be too, and it is as strange as Rousseau's—its denizens a tropical bird and the erotic presence of woman. What we conceptualize about the Rousseau—that it is a landscape of the mind—is made concrete by the Miró in which the hat supports the elements that represent its metaphoric wearer's dream. Marcel Jean's observation about Rousseau would probably have been appreciated by Miró: "The rosy pink flamingos of the Botanical Garden contain the voyage, the memory, and the dream and reveal poetic reality connected directly with concrete reality."[176]

Surrealism in the twenties was very involved with the role of chance, and Mallarmé's famous last poem, "Un Coup de dés jamais n'abolira le hasard" ("A Throw of the Dice Will Never Abolish Chance") could have been carried as its standard. The relevance of *The Sleeping Gypsy* to the concerns of Surrealism is certainly underscored if not deliberately alluded to, in lines by Cocteau, which must certainly have been written with Mallarmé, consciously or unconsciously, in mind—"From where does such a thing fall? From the moon. Like the round-eyed beast, past and future are striving to sample at its source a river of innocent colors. This desert scene seems to have been captured by trickery; it might even be the result of some celestial absentmindedness. Its actuality is the result of a fantastic stroke of chance, as if a pack of cards were to reassemble itself in its original order after having been shuffled and tossed up into the air."[177]

By the end of the twenties and throughout the thirties, the illusionist dream image came to dominate Surrealist painting. What relates Rousseau most to its leading practitioners, Yves Tanguy, René Magritte, and Salvador Dali, is a common opposition to the exploitation of the aesthetic possibilities of the paint substance. Rousseau's suppression of brushwork and texture in favor of a smooth finish originated, as we have seen, in his early admiration for the academic painters of his day. Tanguy, Magritte, and Dali, who have been called the "academic Surrealists," opted for the even surface because it is most conducive to the immediate focusing of attention on the image. Of these artists, only Magritte and his fellow Belgian, Paul Delvaux, painted in a manner anything like that of Rousseau. The styles of Tanguy and Dali are closer to those of the academicians Rousseau admired than they are to his own work.

Like Rousseau, Tanguy was an autodidact, whose determination to become a painter came about in a most marvelous way through an encounter, which in an exemplary demonstration of Surrealist *hasard objectif,* threw together Rousseau, de Chirico, and Breton. Some years after Breton's stunning experience when he saw de Chirico's *The Child's Brain* in dealer Paul Guillaume's window, Tanguy experienced his own epiphany at the sight of the same picture, in the same place—this time, however, the painting was at Guillaume's on loan from Breton.[178] After this encounter, Tanguy began painting in a primitivistic style that occasionally suggests an awkward de Chirico and sometimes uses imagery that

Fig. 74.
Miró. *Poetic Object.* 1936
Assemblage
The Museum of Modern Art, New York
Gift of Mr. and Mrs. Pierre Matisse

Fig. 75.
Tanguy. Title unknown. 1926
Private collection

displays Rousseauian overtones as in the figure of the little girl crushed by a cart in a painting of 1926 (fig. 75). By 1927, however, Tanguy had found his mature style to which he adhered, as faithfully as had Rousseau to his, for the rest of his career. The deeply illusionist space and tight modeling of the typical Tanguy imaginary landscape or "mindscape," recalls, for all the abstractness of its forms, the techniques of Rousseau's early idols. With Rousseau in mind, we might see Tanguy as the "Bouguereau of the biomorphic," the autodidact who proves that academic techniques can, indeed, be self-learned, and makes evident the limits of Rousseau's *real* aspirations in this regard, despite his admiration of Bouguereau.

If we agree with the statement quoted earlier that de Chirico in placing "untransformed objects in a transforming relationship...was heir to Rousseau's poetic genius,"[179] then Magritte becomes the third generation to benefit from this legacy. But unlike his much less original compatriot, Delvaux, his pictures demonstrate virtually no direct relationship with those of Rousseau.

Some of Delvaux's paintings, such as *The Forest* (1948, fig. 76), which is a paraphrase of *The Dream,* contain imagery immediately inspired by that of the Douanier. John Elderfield has pointed out that, "Delvaux uses realism to escape into fantasy, whereas realism as such seeks to escape from it."[180] Although Rousseau's "realism" is hardly of the same order as Delvaux's, nor was he using it to escape but to body forth an inner vision that was already acutely real, the above angle of perceiving Delvaux provides a tenuous measure of comparison between the two artists. Perhaps Delvaux's escape into fantasy via realism provides, as he intended, a "real world that is even more precarious in its reality than ever we feared";[181] but Delvaux's world can provoke nothing comparable to the suspenseful, disquieting sensations that arise in us before certain paintings by Rousseau. Even while not yet taking Rousseau seriously, Arsène Alexandre recognized this quality when he wrote of his paintings, "If they weren't so expensive one would want to possess his works, [but] not to hang them on the wall, for they would exercise a dangerous fascination on our minds."[182]

Of the new recruits to Surrealism during the thirties the Rumanian Victor Brauner was the most interesting artist. He worked in a heterogenous variety of

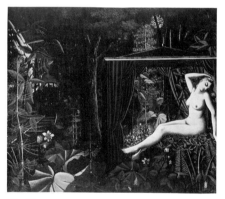

Fig. 76.
Delvaux. *The Forest.* 1948
Collection Carol and Robert Straus

179. See Melville, "Rousseau and de Chirico," p. 35.

180. John Elderfield, *The Modern Drawing: 100 Works on Paper from The Museum of Modern Art* (New York: The Museum of Modern Art, 1983), p. 176.

181. Ibid.

182. *Comoedia,* Apr. 3, 1909; cited in Certigny, p. 376.

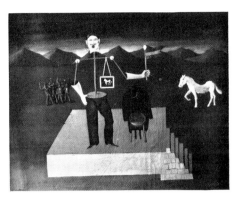

Fig. 77.
Brauner. *The Orator.* 1932

Pl. 25.
Rousseau. *Child with Puppet*

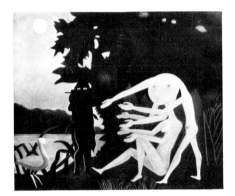

Fig. 78.
Brauner. *The Meeting at 2 bis rue Perrel.* 1946

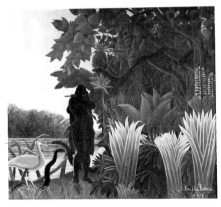

Pl. 36.
Rousseau. *The Snake Charmer*

manners all of which were very much in the tradition of the "occultation" of Surrealism promised by Breton in the second Surrealist manifesto of 1929. Owing in large part to the slightly suspect testimony of Apollinaire and Vollard, Rousseau had gained a reputation for "having a decided taste for phantoms." This alleged interest in ghosts was one of the facets of Rousseau that was most appealing to Breton and would also have interested Brauner, whose art was extremely involved with the apparitional. Some of Brauner's early work in Paris recalls that of another believer in specters, de Chirico, and suggests as well associations to Rousseau. *The Orator* of 1932 (fig. 77) is reminiscent not only of de Chirico, but also Rousseau, particularly his *The Football Players* (pl. 45) and *Child with Puppet* (pl. 25).

In the miraculous tradition of Surrealist *hasard objectif,* Brauner was to have a true encounter with the ghost of Henri Rousseau when, quite accidentally, in 1945 he moved to 2 bis rue Perrel, the building in which Rousseau had lived the last years of his life. Brauner commemorated this uncanny event in the painting *The Meeting at 2 bis rue Perrel* of 1946 (fig. 78). The correspondence between Brauner and Breton, who was then at the end of his wartime exile in New York, regarding the genesis and execution of this canvas is interesting as concerns late Surrealism and its regard for Rousseau. On learning of Brauner's installation in Rousseau's old building, Breton wrote to Brauner: "Rue Perrel . . . how odd it must be, the trace of Rousseau you sense there. I wouldn't be surprised if it inspired you with a painting; such a painting should exist." And in a subsequent letter he returns to the subject, "I always have the feeling that you should paint a large canvas, a 'tale of my studio,' in which your creatures and Rousseau's would appear side by side in the very unexpected poses that would ensue from their sharing a common space and occupying different times. At least it would pose a great problem to be solved and you are just the man for such gatherings." Upon completion of this painting Brauner replied as follows: "So here is the picture of the encounter at 2 bis rue Perrel, one that does not look as if it is fated to be sold. Nor is it a painter's picture like the ones dealers or magazine editors want. Had I been able to encounter one of my characters in the company of one of Rousseau's, I would have been the first to admit that painting such a meeting was a must; as a matter of fact you suggested it to me in several letters. Now here is a coincidence that lends such a meeting an even more essential validity than we had imagined,

an astonishing (or moving) numerical coincidence, which I have included at the bottom of the picture.

```
L A R E N C O N T R E D U
2 B I S R U E P E R R E L
1 2 3 4 5 6 7 8 9 10 11 12 13

L A C H A R M E U S E
C O N G L O M E R O S
1 2 3 4 5 6 7 8 9 10 11

H E N R I R O U S S E A U
V I C T O R B R A U N E R
1 2 3 4 5 6 7 8 9 10 11 12 13
```

1910 = 2

1946 = 2"[183]

As to the notations at the bottom of the painting one must have the Surrealist faith of Brauner and Breton to find the "coincidences" they record magically portentous.

While there are surely instances of Rousseau's influence on the work of artists working outside Surrealism,[184] as there are on that of others who came after the movement,[185] it was his action on early twentieth-century art up to and through Surrealism that is most direct. Thereafter, his contributions are largely filtered through the art of those painters whose affinities with Rousseau have herein been explored.

This essay has attempted to indicate the major areas of Rousseau's influence on twentieth-century art, but its catalogue format has necessarily precluded a full examination of the extent of the utility of Rousseau's art to the pioneering masters of modernism. Nonetheless, the evidence so far assembled suffices to demonstrate that Rousseau's role in opening up the possibilities of new ways of painting to early twentieth-century artists was indeed significant, and can be compared to the parts played by his contemporaries of the Post-Impressionist generation.

The extreme individualism of Rousseau's style was underscored by his status as an outsider. What André Malraux was later to perceive as his escape "from the wheel of art history,"[186] though not wholly true, nonetheless conferred on Rousseau a position that reinforced the potency of his work as an example to artists seeking to throw off the spent conventions of Western art. The freshness of the Douanier's vision, the naiveté that he cherished, arose, as Salmon points out, from the fact that, "he didn't have to waste his time, to squander his freshness in that urge to react so keenly felt by the impressionists."[187] To these words Delaunay's appraisal of Rousseau reads as a coda: "He did not establish his style by comparison, nor out of obedience to style. His manner arose out of the desire

183. Cited in *Victor Brauner* (Paris: Musée National d'Art Moderne, 1972), p. 99.

184. A case in point would be Balthus, whose pictorial sources in Seurat and *Images d'Epinal* relate him to Rousseau, as do the enigmatic light and the static, timeless qualities of his paintings. Certain of his figures, particularly of children, also recall Rousseau (particularly the child at the left in *The Street*, 1933, The Museum of Modern Art, New York). Discreet quotations from other artists are not uncommon in Balthus, and Grace Glueck's perception (*The New York Times*, Sept. 18, 1983, sec. 2, p. 27) that the "young girl recumbent on the grass" in Balthus's *The Mountain* is "like Rousseau's *Sleeping Gypsy*" may reflect a real relationship between the two.

185. Fernando Botero has painted many pictures the imagery of which would seem to derive quite directly from Rousseau; for a discussion of his work as it relates to Rousseau, see Jasia Reichardt, "Botero's Blow-ups," *Art International*, vol. 26, no. 3 (July–Aug., 1983), p. 24.

186. André Malraux, *The Voices of Silence*, trans. Stuart Gilbert, Bollingen Series XXIV (Princeton: Princeton University Press, 1978), p. 512 (orig. pub. New York: Doubleday, 1953).

187. André Salmon, "L'Art Nègre," *Propos d'atelier* (Paris: G. Crès, 1922), p. 120.

188. Delaunay, "Henri Rousseau le Douanier," p. 230.

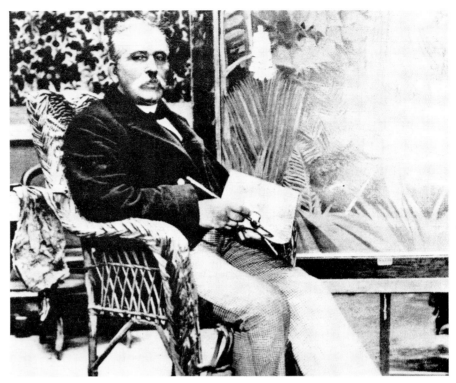

Fig. 79.
Rousseau in his studio

of his whole spirit and was the incarnation of his artistic aspirations. Rousseau's art is old. It is also very modern. He must be studied in relationship to the other painters of our era: the destroyers and the rebuilders. He soared above them, he gave the appearance of being so whole that he seemed phenomenal, an isolated case, whereas he was truly a popular synthesis."[188]

Carolyn Lanchner
William Rubin

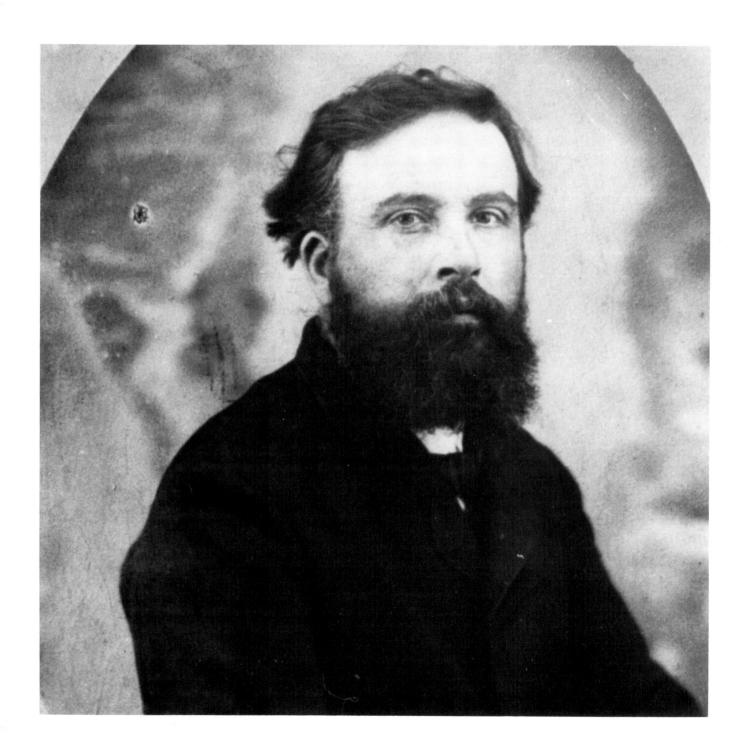

Chronology

1844	Birth of Henri Julien Félix Rousseau, son of a Laval tinsmith, on May 21.
1849	Enters school. A mediocre student, both in primary school and later at the *lycée* in Laval, he is nevertheless runner-up for prizes in music and drawing; his childhood is spent in the atmosphere of a modest provincial bourgeois family.
1851	His father declares legal bankruptcy. The family moves several times and settles in Angers in 1861.
1863	Exempted from military service, Rousseau begins work in the office of an attorney-at-law; appropriates a very small sum of money and therefore enlists for seven years in the Fifty-first Infantry Regiment. His military dossier contains the following data: "Height, 1.65 m. [5'4"], oval face, high forehead, black eyes, average nose, average mouth, rounded chin, dark auburn hair and eyebrows, cut on left ear."
1867	At barracks in Angers, hears the reminiscences of some soldiers who had taken part in the ill-fated Mexican expedition installing Austrian Archduke Maximilian I as Emperor of Mexico. He later uses this information to give the impression that he had himself participated in it.
1868	Upon his father's demise applies for and is granted a discharge from the military. Moves to Paris. He meets Clémence Boitard, whom he marries the following year and with whom he has seven children. Only two of them survive, a son, who dies at eighteen years of age, and Julia Clémence, whose daughter is Rousseau's only descendant. He finds a job as a bailiff's clerk.
1869	After beginning of Franco-Prussian War, Rousseau is recalled by the army, but is again discharged as the sole support of his widowed mother.
1871	He is employed by the Octroi, the toll-collecting service of Paris. Date of début as painter is unclear. At his trial in 1907, he will state: "My superiors in the Octroi gave me an easier shift so that I could work more easily."
1884	Rousseau applies for and obtains copyist's permit for the Louvre, Luxembourg, and Versailles museums. He moves frequently: for a time, at 135, rue de Sévres, he is a neighbor of painter F. A. Clément, whose talent he admires.

1885	In Rousseau's book of press clippings a handwritten note mentions his being represented in 1885 Salon with two paintings: *Italian Dance* and *Sunset*: "one was slashed with a penknife, and then they cheated me out of a payment, which made me have to show it again at the Réfusé [Rejected] group show that was held in June"; there is no other evidence that he actually showed at the Salon. The first unfavorable criticisms appeared in *L'Evénement*.
1886	At the time of the last Impressionist group show, Rousseau submits four works (among them *A Carnival Evening,* pl. 1) to second Salon des Artistes Indépendants. Seurat's *Sunday Afternoon on the Island of La Grande Jatte* hangs in the same Salon. In 1923, G. Kahn will say that Pissarro had noticed Rousseau's works, "in which emotion takes the place of training." With the exception of the years 1899 and 1900, Rousseau shows at the Salon des Indépendants every year, considering it "the finest society and the most legal, since everyone in it has the same rights."

At the time of the last Impressionist group show, Rousseau submits four works (among them *A Carnival Evening,* pl. 1) to second Salon des Artistes Indépendants. Seurat's *Sunday Afternoon on the Island of La Grande Jatte* hangs in the same Salon. In 1923, G. Kahn will say that Pissarro had noticed Rousseau's works, "in which emotion takes the place of training." With the exception of the years 1899 and 1900, Rousseau shows at the Salon des Indépendants every year, considering it "the finest society and the most legal, since everyone in it has the same rights."

Although the butt of laughter and mockery on the part of public and critics, Rousseau nevertheless in this period begins to benefit from a few favorable reviews; in *Le Mot d'ordre:* "A word of encouragement for Monsieur Rousseau, non-impressionist. He is sincere, and he reminds us a bit of the primitives"; and Fouquier, a well-known journalist, comments that his painting "is somewhat dry and harsh but very odd, since by its very naiveté it evokes the memory of the Italian primitives." Paul Alexis, the critic for *Le Cri du peuple,* with ties to the Impressionists, expresses his "extreme admiration" and "total sympathy with Monsieur Rousseau's painstaking works."

Death of his wife, Clémence.

1889 Opening (May) of the World's Fair: Rousseau writes three-act vaudeville play, *A Visit to the 1889 Fair (Une visite à l'Exposition de 1889),* which is rejected by the Châtelet Theater. Many canvases testify to his fascination with the Fair.

1891 At the seventh Salon des Indépendants, which includes a Van Gogh retrospective, Rousseau shows his first exotic landscapes. The canvases he submits, including *Surprise!* (pl. 6), inspire a review by the young painter Félix Vallotton in *Le Journal suisse* (March 25): "In spite of those doubled up with stifled laughter...Rousseau becomes more and more astonishing each year, but he commands attention and, in any event, is earning a nice little reputation...he is a terrible neighbor, since he crushes everything else. His tiger surprising its prey ought not be missed; it's the alpha and omega of painting." Rousseau is informed he has been awarded a Silver Medal by the City of Paris, a decoration that was in fact intended for someone else with the same name.

1893 Rousseau moves to 44, avenue du Maine, a mews of artists' studios. He enters a competition for the decoration of the Mairie (Town Hall) of Bagnolet, but his proposal does not win. On December 1 he resigns from his position as an employee of the Octroi with the modest pension of 1,019 francs. About this time Rousseau meets Alfred Jarry, like himself a native of Laval, who introduces him in literary circles. The young writer and the forty-nine-year-old painter become friends.

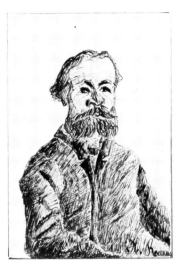

Rousseau
Self-Portrait. Pen and ink
Formerly collection Santamarina,
Buenos Aires

1894	The first issue of *L'Ymagier* (October), a review founded by Jarry and Rémy de Gourmont, makes mention of an exhibition "at Le Barc de Boutteville" in which Rousseau's work is being shown. Among the works hung at the Salon des Indépendants is *War* (pl. 9), which is later praised by *Mercure de France*.
1895	The second issue of *L'Ymagier* (January) publishes lithograph of *War* (pl. 10). Rousseau shows his canvases to dealer Ambroise Vollard, who will not, however, purchase any until several years later. The portrait of Jarry, which in 1906 Apollinaire will see in a partially burned state, is one of ten works hung at the Salon des Indépendants that arouse the indignation of the critic of *Le Gaulois*. For proposed second volume of "Portraits du prochain siècle" (never issued) Rousseau submits self-portrait in pen and ink and biographical note (see p. 256).
1896	Rousseau runs up debt with art-supply dealer P. Foinet. Nevertheless, in 1897 provides shelter for Alfred Jarry and several of his friends, among them painter Maxime Dethomas, a friend of Henri de Toulouse-Lautrec, and musician Claude Terrasse, Pierre Bonnard's brother-in-law, who has a passion for marionettes.
1898	Rousseau enters, unsuccessfully, a competition for the decoration of the Mairie of Vincennes and offers to sell the Mayor of Laval (who rejects the offer) his painting, *The Sleeping Gypsy* (pl. 19), which had been shown at the Salon des Indépendants the previous year. The painter moves to the rue Vercingétorix.
1899	Rousseau writes another play, *The Revenge of a Russian Orphan,* which he also submits to the Châtelet Theater and is turned down again. It is not published until 1947. He is married a second time, to Joséphine Noury, a widow.
1900	Unsuccessful entry in competition for decoration of the Mairie of Asnières. Joins a neighborhood orchestra and gives music and painting lessons at home. For a while he becomes the local neighborhood sales representative for *Le Petit Parisien*.
1901	Listed as teacher of drawing and painting on china and porcelain in the Bulletin of the Philotechnic Association until 1904.
1903	Death of Joséphine, his second wife.
1904	Appointed Professor of Drawing at the Philotechnic Association, continues to give classes at home "at moderate prices." He is charged with nonpayment of debts by art-supply dealer Foinet, is found guilty by the justice of the peace for the Fifteenth Arrondissement, and ordered to reimburse his supplier of canvases and paints with monthly payments. Publication of his waltz, "Clémence". Once again, in error, he is awarded a decoration, the *Palmes académiques,* mention of which he is to have printed on his visiting cards for several years.
1905	Rousseau moves to 44, rue Daguerre. His works are noticed at the third Salon d'Automne, at which the great revelation is the emergence of the Fauves. Louis Vauxcelles, who is responsible for naming them, compares *The Hungry Lion* (pl.

31) to a Byzantine mosaic and the Bayeux tapestry, but expresses regret that Rousseau's technique "is not equal to his candor." In *Le Temps,* Thiébaut-Sisson writes: "It is an enlarged Persian miniature transformed into a vast stage setting, not, indeed, without merit."

1906 Rousseau shows for second time at the Salon d'Automne (*The Merry Jesters,* pl. 33). Moves to 2 bis, rue Perrel. Either this year or the next meets Guillaume Apollinaire through Jarry.

1907 Last appearance at the Salon d'Automne. Meets the German critic and collector Wilhelm Uhde, who is living in Paris; Uhde will write the first monograph on Rousseau (1911). Also meets Robert and Sonia Delaunay, who will eventually own some twenty of his works. A story told by Delaunay's mother about her trip to the Indies becomes the basis of *The Snake Charmer* (pl. 36). The majority of Rousseau's exotic canvases are inspired by visits to the Jardin des Plantes in Paris and by illustrations in books and magazines. His friend Louis Sauvaget, member of an amateur orchestra and employed in a bank, organizes a swindle against the Banque de France, into which Rousseau allows himself to be drawn. Spends several weeks in prison and writes a number of letters to prosecutor in an attempt to prove his innocence. His friends, among them a municipal councillor and fellow Freemason and the painter Maximilien Luce, testify in his favor. In January 1909 Rousseau is given a suspended sentence of two years' imprisonment. Vollard and a few buyers begin to show an interest in his work; among the latter are Serge Férat, a painter of Russian extraction (whose real name is Jastrebzoff), and his sister Baroness d'Oettingen, who is known by several pseudonyms (Roch Grey, Leonard Pieux).

1908 The Salon d'Automne rejects *Old Junier's Cart* (pl. 39). Uhde then organizes the first Rousseau exhibition in the premises of a furniture seller in Paris; unfortunately, since the address is inadvertently left off the invitations, no one shows up.

At first meeting, Apollinaire had not appreciated Rousseau's work, findng "his ingenuity too chancy. . . . Rousseau was intended to be no more than a craftsman." Later mentions Rousseau in his reviews of the Salons and this year introduces him to Picasso (or perhaps in 1907). Relaxing, Rousseau gives *soirées familiales et artistiques* in his home for his Plaisance neighbors, the parents of his pupils, painters and writers drawn to his work and amused by the Douanier's personality, and foreign dealers and collectors. Picasso purchases large *Portrait of a Woman* (pl. 12), which will remain in his possession until his death, and organizes Banquet at the Bateau-Lavoir attended by Apollinaire, Marie Laurencin, Fernande Olivier, Georges Braque, André Salmon, Jacques Vaillant, Leo and Gertrude Stein, Maurice Raynal, and others. Many will later recount the way in which, overjoyed, Rousseau presided beneath the Chinese lanterns. Drink flows plentifully, and the evening is very animated. Rousseau plays his waltz, "Clémence," on the violin and declares to Picasso: "We are the greatest painters of our time, you in the Egyptian style, I in the modern"; Apollinaire dedicates to him the famous lines:

You recall, Rousseau, the Aztec landscape
The forests where the mango and pineapple grew,
The monkeys sucking out the juice of watermelons,

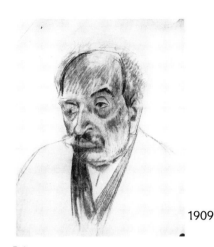

Delaunay
Portrait of the Douanier Rousseau. 1908
Charcoal
Musée National d'Art Moderne, Centre
Georges Pompidou, Paris

And the blond emperor they shot out there.
The pictures you paint you saw in Mexico...

Tu te souviens, Rousseau, du paysage astèque,
Des forêts où poussaient la mangue et l'ananas,
Des singes répandant tout le sang des pastèques,
Et du blond empereur qu'on fusilla là-bas.
Les tableaux que tu peins, tu les vis au Méxique...

Although the organizers of the Banquet may not have been completely reverent, they are nonetheless serious in their homage to the guest of honor.

1909 Rousseau has more and more purchasers, among them Vollard, Uhde, Joseph Brummer, the Baroness d'Oettingen and her brother Serge Férat, and Ardengo Soffici. Rousseau falls in love with a fifty-four-year-old widow who turns down his offers of marriage—he is profoundly upset.

1910 Rousseau shows The Dream (pl. 66) at the Salon des Indépendants. The critic A. Mercereau asks him for three works for an exhibition in Russia. Rousseau is becoming famous, and some reviews are full of praise. As a result of an infection in his leg, however, he dies almost alone in a hospital on September 2. Only seven persons attend his funeral, among them Paul Signac, representing the Salon des Indépendants, and Robert Delaunay. Delaunay and Rousseau's landlord Quéval provide for his burial in a grave for which they pay for a thirty-year lease; Apollinaire writes an epitaph that is engraved on a stone by Brancusi and Ortiz de Zarate in 1913:

We salute you
Gentle Rousseau you hear us
Delaunay his wife Monsieur Quéval and I
Let our baggage through free at heaven's gate
We shall bring you brushes, paints, and canvas
So that you can devote your sacred leisure in the light of truth
To painting the way you did my portrait
The face of the stars

Nous te saluons
Gentil Rousseau tu nous entends
Delaunay sa femme Monsieur Quéval et moi
Laisse passer nos bagages en franchise à la porte du ciel.
Nous t'apporterons des pinceaux des couleurs et des toiles
Afin que tes loisirs sacrés dans la lumière réelle
Tu les consacres à peindre comme tu tiras mon portrait
Face aux étoiles.

In late 1910, Max Weber organized at 291 in New York an exhibition of the works of Rousseau in his possession, and in 1911, the Salon des Indépendants held a retrospective showing of his works (45 paintings, 5 drawings). In 1947 Rousseau's remains were transferred to Laval.

Plates

Notes to the plates have been prepared by
Michel Hoog (all but those listed below) and
Carolyn Lanchner (13, 14, 16, 38, 48, 50, and 53)

In the dimensions that follow, height precedes width

1 A Carnival Evening

1886
Oil on canvas
46 x 35⅛″ (106.9 x 89.3 cm)
Signed lower right: *H. Rousseau*
JB 2; DV 6
Philadelphia Museum of Art, the Louis E. Stern Collection
New York exhibition only

...On the lawn after the ball
The moonlight as the clock struck twelve.

...*Après le bal sur la pelouse*
Le clair de lune quand le clocher sonnait douze.

—Verlaine, *Parallèlement*

This is one of the rare pictures that can be fixed with total certainty at the beginning of Rousseau's output. Dora Vallier has analyzed Rousseau's progress in achieving mastery in his métier over the course of several years by tracing the recurrence of the motif of figures in a forest clearing (see note, pl. 3). However, Rousseau's themes and intense poetry are in all essentials present in his earliest works. These two figures in white carnival costume (whether drawn from Watteau or from some advertisement) need no justification other than the painter's whim, intended as they are to introduce a touch of fantasy into his wintry forest landscape (did Rousseau take pains to find out whether the trees are in leaf at the Carnival season?).

The delicacy of the faded tints (the chromatic scale is similar to that of *War,* pl. 9), the branches, whose sinuous structures, varied at will, stand out sharply against the sky, and the moon itself all create an unreal atmosphere, a kind of effect like that of Friedrich. Is this a stage set, a scene from some pantomime, or is the moonlight only the expected accompaniment to such a sentimental scene?

When the painting was shown at the Salon des Indépendants, Camille Pissarro admired "the justness of its values, the richness of tints" (quoted by Gustave Kahn, *Mercure de France,* August 1, 1923), one of the few appreciations of the Douanier by an Impressionist painter. With less generosity, the critic of a daily newspaper described this work as follows: "A Negro and Negress, in costume, are lost in a zinc forest on an evening in Carnival season beneath a circular moon that shines but does not illuminate anything, while under the black sky a highly bizarre constellation, made up of a blue cone and a pink cone, is affixed" (*Le Soleil*).

Provenance
L. E. Stern, New York

Bibliography
Compte rendu du Qème Salon des Indépendants, *Le Siècle,* 1885; *Bulletin of the Art Institute of Chicago,* vol. 35, no. 2, 1942; D. Catton Rich, 1942 and 1946, pp. 14–15, frontispiece in col.; D. Vallier, 1961, p. 114, repr. 35–180; D. Vallier, *Revue de l'art,* 1970, p. 93, fig. 9; P. Descargues, 1972, pp. 72, 74, 113, repr. col. p. 73, 136, and back cover; C. Keay, 1976, no. 1, repr. col.; G. Bernier, *L'Art et l'argent,* 1977, pp. 136–37; D. Vallier, 1979, repr. p. 14; Y. Le Pichon, 1981, p. 35, repr. col.

Exhibitions
Paris, 1886, no. 336; Chicago and New York, 1942, unnumbered

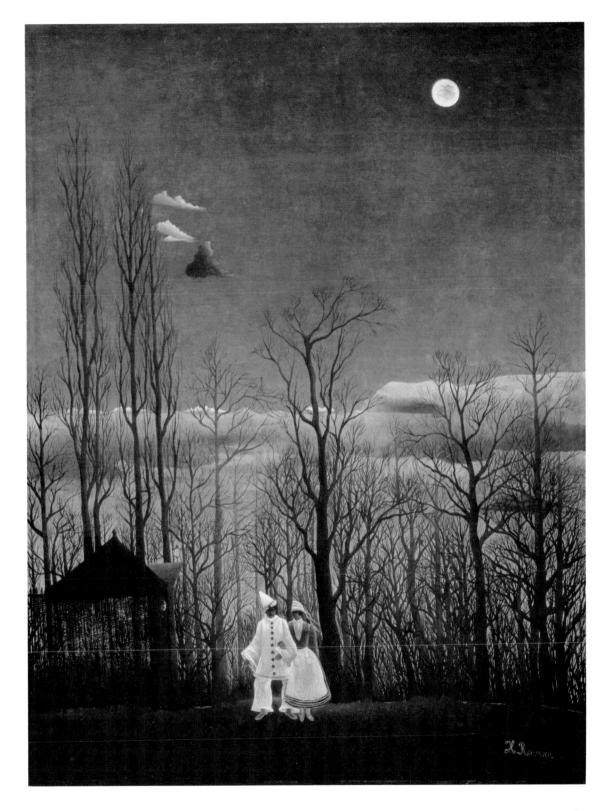

2 Rendezvous in the Forest

1889
Oil on canvas
36¼ x 28¾" (92 x 73 cm)
Signed lower right: *Henri Rousseau*
JB 62; DV 21
National Gallery of Art, Washington D.C., gift of the W. Averell Harriman
Foundation in memory of Marie N. Harriman, 1972

The relationship of this painting to *A Carnival Evening* (pl. 1) and *Walking in the Forest* (pl. 3) is clear: the theme is a forest stroll, treated in a vertical format, which recurs often in Rousseau's oeuvre. However, the Douanier evidences sufficient invention or imagination—or, indeed, eclecticism—through his choice of models for these pictures so that when brought together, they are more striking in their diversity than in their similarities. In the end they are more dissimilar from each other than are Claude Monet's Haystacks and Poplars, with which they are exactly contemporary.

The couple on horseback in eighteenth-century dress—the source for which has not been identified—lend scale and color to the wooded valley stretching behind them. Here, perhaps more than in other paintings in the series, Rousseau suggests the shapes of the landscape and nuances of light by placing a clear area in the background behind and at the level of the characters. The sky is treated with a delicate scaling down of color, in contrast to the painted-canvas aspect he often gives it. "Rousseau is expressing the arrival of the seasons, the fine outline of the branches against the sky, the piles of russet leaves on the ground" (A. Malraux, *Les Voix du silence,* Paris, 1951, p. 508).

The foot of the trees is buried in the grass in the same manner as, later, he would conceal the feet of his characters. D. Vallier attributes this process to his clumsy technique. Perhaps it was a recipe he gleaned from some handbook for beginning painters, one that then became a habit.

Although it is impossible to give the precise meaning of the scene, it can be set within the tradition—somewhat outmoded, to be sure—of the *scène galante* in period costume as we see it in Diaz or Adolphe Monticelli. The forest setting is a reassuring décor quite different from the danger-fraught and impenetrable Jungle scenes Rousseau was to produce a few years later.

Provenance: Bala Hein, Paris; The Honorable W. Averell and Mrs. Marie Harriman, New York

Bibliography
D. Catton Rich, 1942, pp. 17–18, repr. p. 16; D. Catton Rich, 1946, p. 14; D. Vallier, 1961, no. 40; L. and O. Bihalji-Merin, 1971, no. 2; C. Keay, 1976, no. 5; R. Alley, *Portrait of a Primitive: The Art of Henri Rousseau*, Oxford, 1978, pp. 12–13, repr. no. 4; S. Monneret, 1979, vol. 2, p. 211; Y. Le Pichon, 1981, p. 37, repr. col.

Exhibitions
New York, 1931; Chicago, New York, Boston, and Pittsburgh, 1942, unnumbered; Rotterdam and Paris, 1964, no. 3

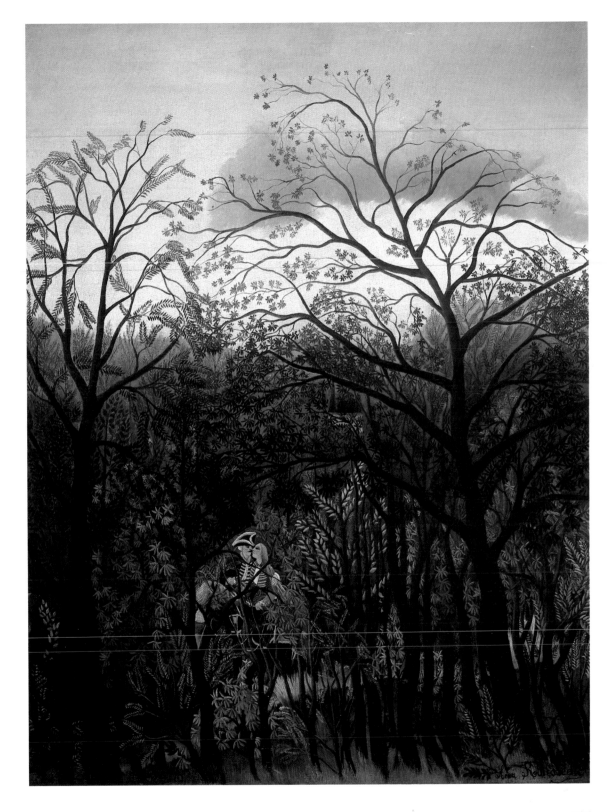

101

3 Walking in the Forest

c. 1886
Oil on canvas
27⁹⁄₁₆ x 23¹³⁄₁₆" (70 x 60.5 cm)
Signed lower left: *H. Rousseau*
JB 1; DV 23
Kunsthaus Zurich

Akin to the Philadelphia *Carnival Evening* (pl. 1), which can be dated with certainty, this picture is a characteristic work of Rousseau's first period. The tapering forms of the tree trunks and the increasingly light hues of the foliage suggest depth; in this regard, Dora Vallier has noted Rousseau's clever manipulation of airy perspective in the early paintings, contrasting them with *Woman in Red in the Forest* and *Woman Walking in an Exotic Forest* (p. 75, figs. 56, 57) later pictures with analogous but thickly wrought woodland settings. Here, the painter evidences a real ease in drawing, in the placing of the trees, and, in the delicate play of colors. The pink and pale-green nuances in the underbrush, the gradation in the sky, and the gray outlining the tree trunk on the right are very different from the sharp outlines and metallic flat colors of the foliage in the Jungles. This is one of the rare works in which Rousseau nods to the Impressionists, in particular to Camille Pissarro.

The depiction of human beings lost in a forest is one of the prevalent themes in Rousseau's oeuvre, whether they are strollers in city clothes, as here, or hunters or "savages." Here the character, who has been identified without any clear evidence with the painter's first wife, is carrying an umbrella, like the woman in the large portrait (pl. 17). Turning, she is caught in what appears to be a gesture of surprise. The dead branch on the ground at the right and the signs of another branch apparently recently sawn off above the woman remind us of elements in a rebus. In an imprecise way, we can already sense the strangeness, the suggestion of danger we will encounter in the Jungle paintings. It is difficult to say what youthful adventure or reading underlies this uneasy or hazardous confrontation of human and forest; in contrast, the Impressionists—like the Barbizon painters and their innumerable followers who filled the Salons in Rousseau's day—most often represented nature as peaceful and reassuring.

Provenance
W. Uhde, Paris; A. Villard, Paris

Bibliography
H. Kolle, 1922, pl. 11; R. Huyghe, 1939, repr. pl. 93; Roch Grey, 1943, repr. no. 45; P. Courthion, 1944, p. XXII; W. Uhde, 1949, repr. no. 47; J. Cassou, 1960, p. 609; D. Vallier, 1961, p. 115, nos. 41 and 180; W. Haftmann, 1965; L. and O. Bihalji-Merin, 1971, repr. col. no. 3; P. Descargues, 1972, repr. p. 77; C. Keay, 1976, repr. p. 117, no. 4; S. Monneret, 1979, p. 211; D. Vallier, 1979, repr. p. 14; Y. Le Pichon, 1981, p. 83, repr. col.

Exhibitions
Paris, 1912, no. 6; New York, 1931, no. 30; Basel, 1933, no. 19; Paris, 1961, no. 2

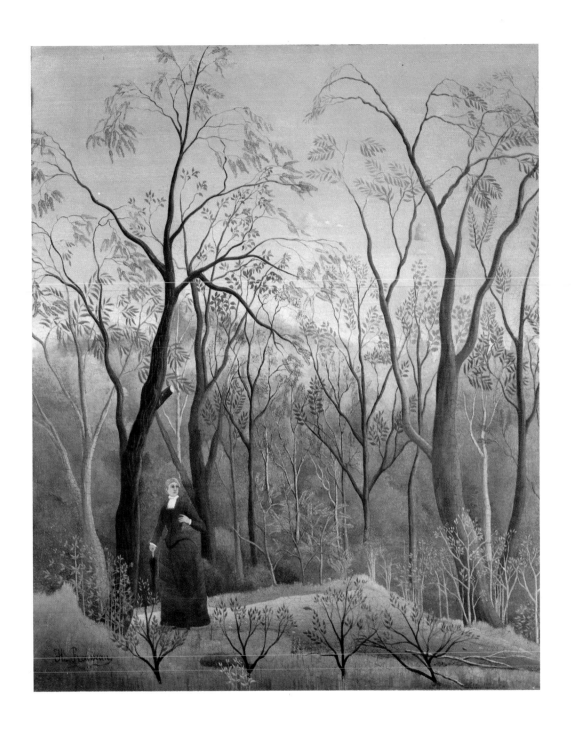

103

4 River Bank

c. 1890
Oil on canvas
8¼ x 15⁵⁄₁₆″ (21 x 39 cm)
Signed lower right: *H. Rousseau*
JB 9; DV 14
Private collection, Paris

River Bank is one of the most agreeable of Rousseau's frieze landscapes. He provides no vanishing point other than in the shape of the house on the right—the viewer seems to follow the course of the river and always to be opposite any particular section of the view. This unusual layout is intensified in an analogous composition with an even broader format, *Landscape with Tree Trunks* (Barnes Foundation, Merion, Pa., DV 20), as well as in *View of Grenelle Bridge* (pl. 8). Although Rousseau often followed the precepts of traditional drawing methods, here he flouts them with varying degrees of success. Georges Seurat had similarly dispensed with traditional perspective in *Sunday Afternoon on the Island of La Grande Jatte* (1884–86, p. 42, fig. 5), a friezelike composition shown at the Salon des Indépendants in 1886, in which Rousseau was also represented.

Depth is suggested by a succession of planes cleverly laid out from foreground to background parallel to the width of the canvas. The effect of backlighting in the foreground, an antique painting technique, is rare in Rousseau's work. The red-roofed buildings, the factory chimneys, the trees, the fisherman and his boat—all are peaceful, calm motifs that occur many times elsewhere. "A tree above the house shelters the roof with its branches" ("Un arbre par dessus le toit, berce sa palme"), a line from Verlaine, very nearly describes this scene. The affinities of the poet with the Douanier have been noted by Malraux.

D. Vallier dates this picture 1886, J. Bouret 1896–98. *View of Grenelle Bridge,* whose layout is similar, albeit less systematic, would appear to date from the winter of 1891–92.

Provenance
M. Bontemps; G. Varèse; E. Tappenbeck

Bibliography
D. Vallier, 1961, no. 37

Exhibitions
Paris, 1961, no. 5

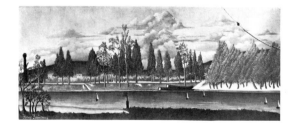

Fig. 1.
Rousseau
Landscape with Tree Trunks. 1887
The Barnes Foundation, Merion, Pa.

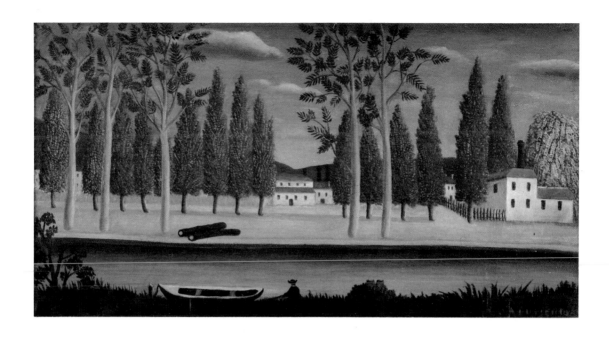

Myself, Portrait-Landscape

1890
Oil on canvas
56¼ x 43¼" (143 x 110 cm)
Signed and dated bottom left: *Henri Rousseau 1890*
JB 67; DV 32
National Gallery, Prague

Overtly or tacitly, all Rousseau's ambitions are present here. First, there is the fine figure of the man himself—well built, with beard and sideburns typical of politicians of the day—who has deemed himself worthy of a full-length portrait, a format that, according to the hierarchy which still held sway in the Salons, was generally reserved for public officials and eminent members of society. Rousseau has commissioned his official portrait from himself, and has every intention of immortalizing himself as an artist, with beret, palette, and brush. "Dignified behind his mustaches, his pose flattering, and bearing his palette like a ewer! Is this the simpleton, the dupe, the eternal butt of others' jokes?" (X. Tilliette, pp. 175–76). Painters most often depict themselves in half length, seated, and at work. The exceptions are rare and Rousseau, outstanding among them, has chosen to equip himself with the attributes of the artist within a framework that also tends to raise his social scale. E. Hareux's well-known handbook, *Cours complet de peinture à l'huile* (*A Complete Course in Oil Painting*), contains a figure that meets Rousseau's needs (fig. 1), and it is accompanied by a caption explaining the ways to lend a portrait more or less importance. In stance, although not in expression, the figure bears a striking resemblance to painter Emile Schuffenecker in Gauguin's *The Schuffenecker Family* (1889, fig. 2).

Provenance
I. Jastrebzoff (Serge Férat), Paris

Bibliography
Letter from Jastrebzoff to Delaunay, undated, published by B. Dorival, 1977, p. 79; *Les Soirées de Paris*, no. 20, January, 15, 1914, repr. p. 19; L. Gillet, *Revue des deux mondes*, April 1, 1922; C. Bell, 1923, pp. 53–55; A. Basler, 1927, pl. 1; A. Salmon, 1927, repr. no. 40; C. Zervos, 1927, pl. 62; P. Soupault, 1927, pl. 2; D. Catton Rich, 1946, repr. p. 10; T. Tzara, preface to *Une visite à l'exposition de 1889*, 1947, p. 21; W. Uhde, 1949, p. 57, repr. p. 31; R. Delaunay, "Mon ami Henri Rousseau," *Les Lettres françaises*, August 8, 1952, repr. p. 1; H. Perruchot, 1957, repr. frontispiece; H. Certigny, 1961, pp. 87, 107, 108, 111, repr. p. 87; X. Tilliette, "Inspection du Douanier Rousseau," *Etudes* (Paris), 1961, pp. 175–76; M. Hoog, "La Ville de Paris de Delaunay: Sources et développement," *La Revue du Louvre*, 1965, no. 1, pp. 31–32; R. Passeron, 1968, repr. p. 43; L. and O. Bihalji-Merin, 1971, repr. col. no. 21, detail no. 20; A. Jakovsky, 1971, repr.; H. Certigny, 1971, pl. 9; P. Descargues, 1972, repr. col. p. 44, pp. 26, 47, 135; C. Keay, 1976, p. 119, repr. no. 6; W. S. Rubin, undated (1977), p. 211; Y. Le Pichon, 1981, pp. 72–73, repr. col.

Exhibitions
Paris, 1890, no. 660; Zurich, 1937, no. 1; Venice, 1950, no. 1; Paris 1964, no. 1

Fig. 1.
Hareux. *Complete Course in Oil Painting: Figure*. Paris, n.d.

Fig. 2.
Gauguin. *The Schuffenecker Family* (detail). 1889
Musée d'Orsay, Paris

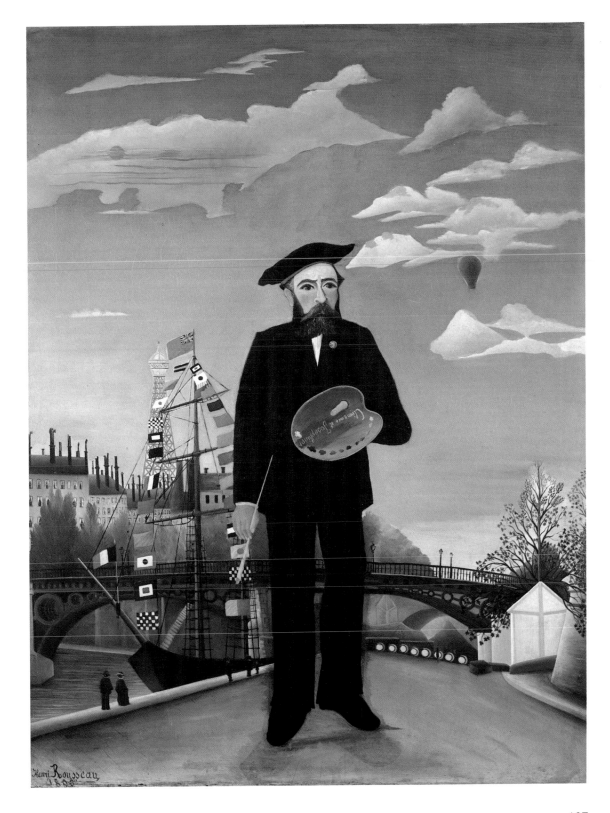

Rousseau has also managed to fit onto his palette a discreet—without being at all cryptic—reference to his private life. He has inscribed the name of Clémence, his first wife, as well as another name he effaced and for which he substituted Joséphine, the name of his second wife.

According to the title, which is Rousseau's own, the picture is a "portrait-landscape, " a formula, he would maintain at his trial in 1908-09, that he had invented. And indeed, he has made an attempt to insert the character into the framework of nature and town. On the right is a row of buildings and trees; on the left, a complex, highly organized network of outlines: along the quay of the Seine is moored a boat whose bow and bowsprit mast interact with the edge of the quay to create a scheme Rousseau repeated in numerous paintings. The boat itself sports the British colors atop its mast and is flying maritime signal flags, some faithfully copied from an encyclopedia, others imaginary.

In the background are buildings bristling with chimneys and the Eiffel Tower. Built for the 1889 World's Fair, this edifice was still quite a novelty. It is hard for us today to imagine the scandal it created in literary and artistic circles at the time. With the exception of a Seurat sketch (p. 32, fig. 7), which shows the tower in an unfinished state, Rousseau was the first—and, for a long time, the only—painter foolhardy enough to depict the detested monument. This is an indication of his independent mind and of his penchant for glorifying the achievements of technological progress. Such persistence contradicts the notion frequently advanced, even by the Douanier's earliest defenders, that he attempted to gain respect by hewing to academic norms. In the sky on the right he introduces another subject unusual for painters, a balloon. One wonders whether Rousseau knew the small picture by Puvis de Chavannes (Musée Carnavalet, Paris) in which a balloon is linked to a particular event, the 1870 Siege of Paris. A few years later Rousseau was to begin to paint many representations of flying machines (see pl. 41).

This portrait exerted a real fascination for Rousseau's early admirers. Wilhelm Uhde, Philippe Soupault, and Serge Férat all make mention of it. As for Robert Delaunay, he copied the left-hand portion of the picture in his important work, *The City of Paris* (fig. 3), shown at the Salon des Indépendants in 1912.

Fig. 3.
Delaunay. *The City of Paris* (detail). 1910–12
Musée National d'Art Moderne, Centre Georges Pompidou, Paris

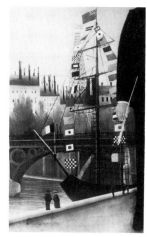

Fig. 4.
Rousseau. *Myself, Portrait-Landscape* (detail, pl. 5)

6 Surprise!

1891
Oil on canvas
51⅛ x 63¾" (130 x 162 cm)
Signed and dated lower left: *Henri Rousseau 1891*
JB 73; DV 47
The Trustees of the National Gallery, London

This picture, considerably earlier than the other extant Jungle paintings, differs from them in its feeling of movement: the lightning in the sky, the bending grass, leaves, and branches, all suggest a violent storm. The impression of marquetry, the careful outlining of objects, the exaggeratedly enlarged scale of the foliage, do not occur in later Jungle scenes. We perhaps discern in this picture the earliest traces of contact with the Synthesism and *Cloisonnisme* of Gauguin and the Nabis.

Rousseau's submission of this painting to the 1891 Salon des Indépendants gave rise to the first really serious, detailed article about him. Written by Félix Vallotton, a future member of the Nabi group, it was the first that did not also poke fun at him. Newly arrived in Paris, Vallotton was having a difficult time making ends meet (he was to evoke the period in his book, *La Vie meurtrière*) and was turning his hand to art criticism:

> Monsieur Rousseau becomes more and more astonishing each year, but he commands attention and, in any event, is earning a nice little reputation and having his share of success: people flock around his submissions and one can hear the sound of laughter. In addition he is a terrible neighbor, as he crushes everything else. His tiger surprising its prey ought not be missed; it's the alpha and omega of painting and so disconcerting that the most firmly held convictions must be shaken and brought up short by such self-sufficiency and childlike naïveté. As a matter of fact, not everyone laughs, and some who begin to do so are quickly brought up short. There is always something beautiful about seeing a faith, any faith, so pitilessly expressed. For my part, I have a sincere esteem for such efforts, and I would a hundred times rather them than the deplorable mistakes nearby (*Le Journal suisse,* March 25, 1891).

The very personal and innovative style of this picture, as well as the ambiguity of the title (is the tiger surprised or is he surprising missing characters on the right?), led Vallier to make the following very precise analysis of Rousseau's working methods:

> Rousseau employed a pantograph. With the help of that mechanical enlarger he was able to draw the outlines of some object taken from an illustration, one found in a children's book, for example, like the ones we know he later used for the same purpose. Once the outlines were drawn, he had simply to fill in the colors, which he did with enormous gusto. The

Provenance
G. Bernheim, Paris, 1933; H. Clifford, Radnor, Pa. (?)

Bibliography
F. Vallotton, *Le Journal suisse*, March 25, 1891; A. Basler, 1927, pl. 15; C. Zervos, 1927, pl. 47; D. Catton Rich, 1942, repr. and text, p. 19; P. Courthion, 1944, p. XV; D. Catton Rich, 1946, p. 17; R. Huyghe, *L'Art et l'homme*, Paris, 1957, vol. 1, p. 9, repr. no. 12; H. Certigny, 1961, pp. 114–15; D. Vallier, 1961, p. 41, repr. col. (*L'Orage dans la jungle*); D. Vallier, 1970, no. 7. pp. 93–94, repr. fig. 8; C. Keay, 1976, repr. col. no. IV; S. Monneret, vol. 2, 1979, p. 211; D. Vallier, 1979, pp. 42–43, repr. col.; Y. Le Pichon, 1981, pp. 114–45, repr. col.

Exhibitions
Paris, 1891, no. 1029; Basel, 1933, no. 10; New York, 1963, no. 5.

small, insignificant image that forms the basis for the picture is crushed beneath such chromatic exuberance. The clumsy draftsman whose task was taken over by the pantograph gave way to the born colorist, who worked marvels.... If the eccentric character of the title testifies to his desire to conceal his source, a slip in the process of transcription reveals the origin of the image, the illustration he copied with his pantograph, in which the tiger was certainly tracking explorers that had to be left out of the picture when it was enlarged (1979, p. 42).

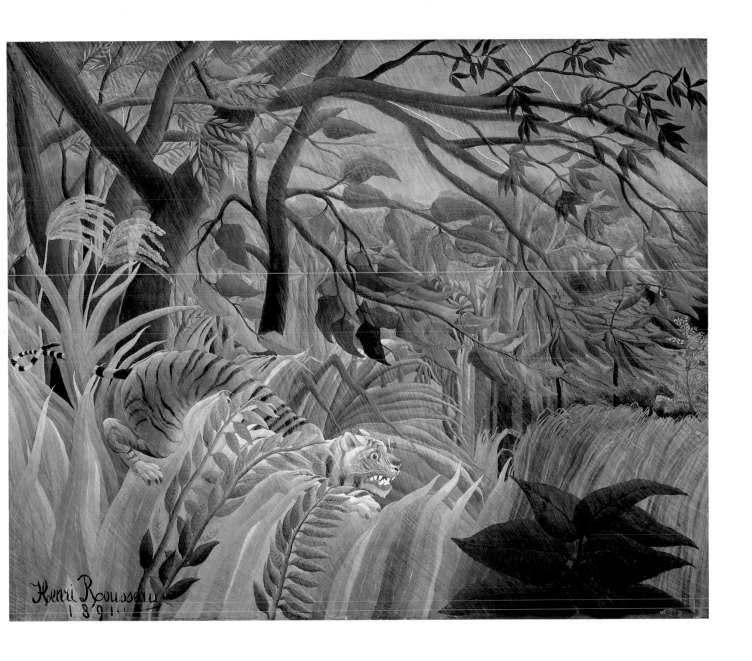

7 Portrait of Pierre Loti

c. 1891
Oil on canvas
24⅜ x 19⅝″ (62 x 50 cm)
Signed lower right: *H. Rousseau*
JB 30; DV 48
Kunsthaus Zurich

The portrait of Pierre Loti demonstrates Rousseau's ability to vary the settings and poses of his models. Here he has probably drawn his inspiration from works of the northern painters of the late fifteenth century, in which the subject is treated in half length, obliquely, one hand gesturing. Pierre Loti is posed against an outdoor background; on either side, like symbols of countryside and city, Rousseau has placed trees and smokestacks, edifices rarely featured by painters of the period with the exception of Seurat and Cézanne. The portrait of Alfred Jarry, destroyed by its subject, probably followed a similar formula, depicting an owl and a chameleon as attributes of its model.

The catalogues of the Salons des Indépendants mention several portraits that are now lost. Of Rousseau's known production, this is perhaps the only portrait (unless we count the figures of Heads of State in the painting *Representatives of Foreign Powers Arriving to Hail the Republic as a Sign of Peace* [pl. 35]) of a well-known person who undoubtedly had not posed for the Douanier. Rousseau was directly inspired by a photograph that was familiar at the time and that contained similar items of clothing, among them the tarboosh and the Eton collar. The resemblance is striking, casting doubt on Henry Certigny's contention that this is a portrait of the industrialist Edmond Franck. Rousseau painted the latter's portrait in 1909–10, and Franck claimed to recognize himself when shown a photograph of the Loti portrait in 1952. However, Franck himself stated that he had destroyed his own portrait and surmised that Rousseau must have made a copy of it, although that would have been unusual for him. It is conceivable that Rousseau painted Edmond Franck in the style and pose of some earlier portrait of Pierre Loti. The present picture is also difficult to date (see "Henry Rousseau and Modernism," n. 107). It is heavily painted and has been greatly reworked. The tarboosh was painted in *over* the hair.

As much as his physiognomy, the character and work of Pierre Loti (1850–1923) might have been designed to attract Rousseau's attention. Loti's reputation as a novelist was at its height at the time; he had concurrently pursued the careers of naval officer and novelist. In 1891 he was elected to the Académie Française. Like his life, his many novels reveal his yearnings for the exotic and for escape, yearnings shared by Rousseau, the untraveled city dweller, and many of his peers, even though Loti effected his escape within the confines of bourgeois conventions and not, like Gauguin or Rimbaud, in revolt against them.

Philippe Soupault has this to say about the painting's first owner:

Provenance
G. Courteline, Paris; P. Rosenberg, Paris; Mendelssohn-Bartholdy, Berlin; C. Vogel

Bibliography
H. Kolle, 1922, pl. 6; P. Soupault, "La Légende du Douanier Rosseau," *L'Amour de l'art*, 1926, p. 337; C. Zervos, 1927, p. 49; A. Basler, 1927, pl. 7; P. Soupault, 1927, pl. 4; Roch Grey, 1943, repr. no. 24; P. Courthion, 1944, pl. IV; M. Gauthier, 1949, pl. III; D. Cooper, 1951; M. Georges-Michel, *De Renoir à Picasso: Les Peintres que j'ai connus*, Paris, 1954, pp. 84–86; H. Perruchot, 1957, repr. pl. 1; O. Bihalji-Merin, 1959, p. 45, repr. p. 161; H. Certigny, 1961, pp. 255, 257, 261, 262, 477–78, repr. between 246 and 247; D. Vallier, 1961, pp. 44–46, 123, 126, 307, repr. no. 48; L. and O. Bihalji-Merin, 1971, repr. col. no. 25 and fig. 70; P. Descargues, 1972, repr. col. p. 81, cover detail and frontispiece; C. Keay, 1976, repr. no. 49, p. 149; J. Elderfield, *European Master Painting from Swiss Collections: From Post-Impressionism to World War II*, New York: The Museum of Modern Art, 1976; W. S. Rubin, undated (1977), p. 128, repr. D. 24, p. 422; Y. Le Pichon, 1981, p. 78, repr. col.

Exhibitions
Berlin, 1926, no. 4; Paris, 1961, no. 80; Rotterdam and Paris, 1964, no. 14

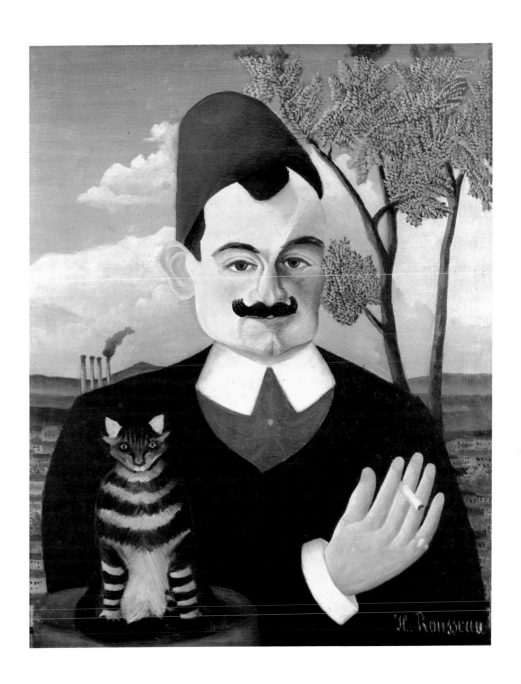

113

Jules Chéret was to tell the story of the triumph of Courteline, who had once had in his museum of horrors a canvas by Rousseau, the portrait of Pierre Loti, which, after some haggling, he had purchased for a few francs one day when Rousseau had been flat broke and had not known how he was going to get food. Then one day one of the Douanier's admirers turned up at Courteline's and went into ecstasies. Courteline remained impassive. The admirer ended up offering ten thousand francs for the picture. "Done," Courteline said curtly. And, Chéret added, Boubouroche's creator rubbed his hands with pleasure in anticipation of the nice little trip to Italy the visit had earned him (Philippe Soupault, *Henri Rousseau, dit le Douanier,* Paris, 1927).

8 View of Grenelle Bridge

c. 1892
Oil on canvas
7⅞ x 29½″ (20 x 75 cm)
Signed bottom left: *H. Rousseau*
JB 77; DV 49
Private collection, Paris
Paris exhibition only

If this picture, in which snow is much in evidence, was inspired by the harsh winter of 1891–92, it is then one of Rousseau's earliest cityscapes. The relatively exact representation of an easily recognized Parisian locale can perhaps be explained by the painter's participation in a competition, and the unusual format, by the area to be decorated. *La Carmagnole* (1893, DV 64), which has an identical format, was in all probability also a sketch for a competition, the decoration of the Mairie of Bagnolet, which Rousseau entered in 1893.

The painter is not striving for rigorous exactitude. The oblique lines of the pathway on the left, the river bank and the line of trees on the right, suggest a nonconstant perspective. The composition unrolls like a frieze, and Rousseau, with beguiling charm, introduces almost the full repertory of motifs of his future cityscapes: trees, a river with a boat flying the tricolor, a port and cargoes, a cart that forecasts *Old Junier's Cart* (pl. 39). In so doing he succeeds in filling and animating the entire width of the canvas.

At right, the French flag flies alongside the Statue of Liberty. The statue by Frédéric-Auguste Bartholdi (1834–1904) had been erected in New York harbor in 1886 through public contributions. Its quarter-size reduction was given by the Americans to the City of Paris in 1886 and erected at the tip of the Ile des Cygnes in 1889, the centenary of the French Revolution. In the political climate of the young Third Republic, the values symbolized by the Statue of Liberty and the national tricolor (whose rejection by the Duc de Bordeaux had destroyed the attempt to bring about a restoration of the monarchy) were closely associated. Whether aware of this or not, Rousseau brought them together spatially. (In Rousseau's day the statue faced upstream; it was turned

Provenance
Robert Delaunay, Paris; P. Rosenberg, Paris; Goldschmidt-Rothschild, Paris

Bibliography
W. Uhde, 1911, fig. 27; W. Uhde, 1914, pl. 30; Letters from Fénéon to Delaunay, March 3, 1914, and March 27, 1914; Letter from Delaunay to Walden, September 1919, published by B. Dorival, 1977, pp. 2, 23, 25; A. Basler, 1927, Appendix 7; A. Salmon, 1927, repr. no. 11; C. Zervos, 1927, pl. 83, D. Catton Rich, 1942, p. 20, repr.; Roch Grey, 1943, repr. 83; D. Catton Rich, 1946, p. 48; "Memoir of Max Weber," 1958, in S. Leonard, 1970, p. 225; D. Vallier, 1961, no. 57; Elie Faure, *Histoire de l'Art: L'Art moderne,* vol. 2, Meaux, 1948, p. 219; V. Nezval, 1972, p. 79; Y. Le Pichon, 1981, p. 103 repr. col.

Exhibitions
Paris, 1892, no. 1024 [*Vue du Pont de Grenelle (Trocadéro)*]; Paris, 1911, no. 33; Paris, 1912, no. 21; Berlin, 1912, *Berliner Secession,* no. 225; Berlin, 1913, *Erster deutscher Herbstsalon,* no. 7; Chicago and New York, 1942, unnumbered

Fig. 1.
Signac. *The Grenelle Bridge in 1927*
Musée Carnavalet, Paris

the other direction in 1927, an event captured by Signac in his sketch, fig. 1.)

Robert Delaunay, who discovered this picture at a secondhand dealer's, mentions it in a letter to H. Walden, founder and director of the gallery Der Sturm, Berlin, who was, along with Wassily Kandinsky, one of the first persons in Germany to show an interest in Rousseau. In his letter Delaunay sketched a charming drawing based on the picture.

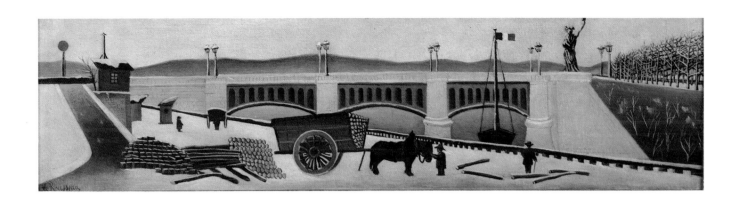

9 War

1894
Oil on canvas
44⅞ x 76¾" (114 x 195 cm)
Signed bottom right: *Henri Rousseau*
JB 7; DV 69
Musée d'Orsay, Galerie du Jeu de Paume, Paris

Lord, when the fields are cold
…
Let the beloved adorable crows
Swoop down from the vast skies.
…
Above the fields of France
Where yesterday's dead lie sleeping
Turn in your thousands, winter
…
O our funereal black bird!

Seigneur, quand froide est la prairie,
…
Faites s'abattre des grand cieux
Les chers corbeaux délicieux.
…
Par milliers, sur les champs de France,
Où dorment des morts d'avant-hier,
Tournoyez, n'est-ce pas, l'hiver
…
O notre funèbre oiseau noir!

—Rimbaud, *Les Corbeaux*

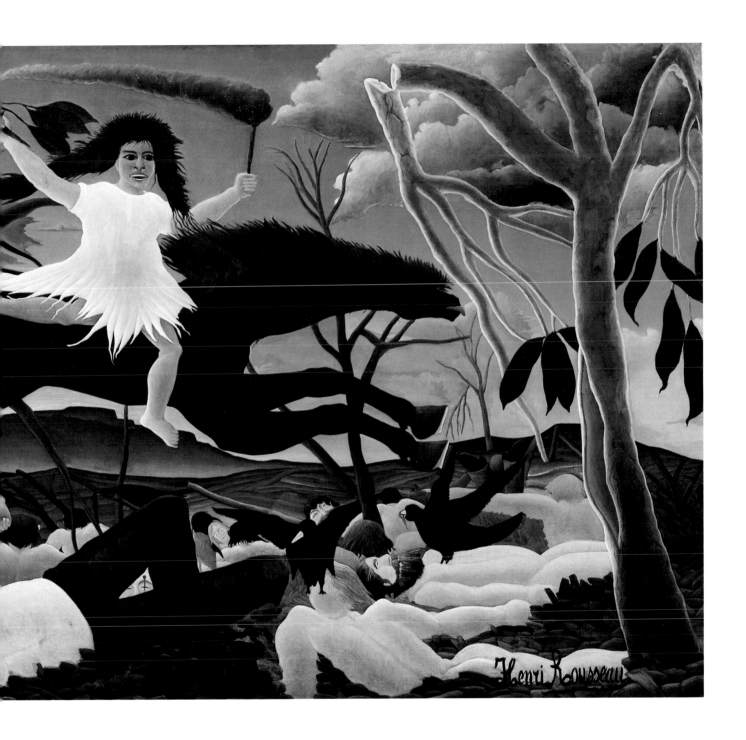

"War (terrifying, she passes by, leaving behind on all sides despair, tears, and ruin)." —Rousseau

Painted during the winter of 1893–94 and shown at the Salon des Indépendants before being lost for fifty years, *War,* wrote Dora Vallier (1970), is "the most ambitious work he had painted up until then, the work in which he attacked a large surface for the first time."

The ugly, grimacing figure holding a sword and smoking torch rides sidesaddle at full gallop on an animal that seems to be part horse, part anteater. Its posture, like that of the horse in Géricault's *The Epsom Derby* (Musée du Louvre), was, thanks to photography, already known in Rousseau's day to be impossible. As for the woman's pose, it derives from a stereotype of classical statuary. Rousseau was to return to it some ten years later for the figure of Liberty in *Liberty Inviting Artists to Take Part in the Twenty-second Exhibition of the Société des Artistes Indépendants* (pl. 32).

We know that Rousseau had been inspired by the 1870 Franco-Prussian war, in which he had taken little part. Here, the personification of War hovers above the bodies of dead or wounded men, none of whom wears a uniform or any military accoutrements. Crows pick at the corpses. The earth is brown, black, gray; the trees are dead, their branches broken, their leaves black. The clouds are red. Notwithstanding his lack of firsthand experience, Rousseau has managed to transform the images in his tragedy, his *Massacres de Scio* and his *Guernica,* without having recourse to anecdotal or narrative elements. The plethora of broken forms and above all the choice of colors all play a role: the green of hope is completely absent; black and red dominate. The colors of mourning and blood, which, along with the white garment of the grotesque *Bellone,* are also the colors of the flag of the German Empire, the hereditary enemy. As shall be seen, *The Snake Charmer* (pl. 36) constitutes a sort of pendant to *War.*

Rousseau made his only print on the same motif. Jean Bouret and Dora Vallier consider it to be an early sketch; Charles Pérussaux, Henry Certigny, and M.-T. de Forges believe it to be a later reduction (see note, pl. 10). Vallier cites as one of the possible sources for *War* an Epinal chromolithograph by F. Georgin, *The Battle of the Pyramids* (p. 25, fig. 2), which was reproduced in the same issue of *L'Ymagier* as Rousseau's lithograph. Even closer to the Rousseau is *The*

Provenance
L. Angué, Louviers; E. Bignou, Paris

Bibliography
A. Jarry, "Minutes d'art," *L'Art littéraire,* May–June 1894, and *Essais d'art libre,* June–July 1894; L. Roy, "Un Isolé: Henri Rousseau," *Mercure de France,* March 1895, pp. 350–51; J. Christophe, *La Plume,* June 1914; W. Uhde, 1932, p. 84; D. Catton Rich, 1942, p. 25, repr.; G. Bazin, "La Guerre du Douanier Rousseau," *Bulletin des Musées de France,* April 1946, pp. 18–19; W. Uhde, 1948, p. 18, repr. col.; A. Breton, *Flagrant délit: Rimbaud devant la conjuration de l'imposture et du trucage,* Paris, 1949, p. 170; H. Perruchot, 1957, pl. III; R. Shattuck, 1974, pp. 109–10, 384; O. Bihalji-Merin, 1959, pp. 55, 56, repr. p. 158; W. Haftmann, 1960, vol. 2, pp. 212–14, repr. p. 212; J. Bouret, 1961, pp. 19, 25; H. Certigny, 1961, pp. 131, 137, 142, 147–52, 157, 159, repr. col. p. 102; D. Vallier, 1961, pp. 50–57, 60, 134–39, repr. col. p. 55; M.-T. de Forges, "Une Source du Douanier Rousseau," *Art de France,* vol. 4, 1964, pp. 360–61; L. and O. Bihalji-Merin, 1971, repr. col. no. 46; A. Jakovsky, 1971, repr.; P. Descargues, 1972, pp. 52–53, 114, 117; C. Keay, 1976, repr. col. no. VII; D. Vallier, 1979, repr. col. pp. 58–59, detail p. 57; S. Monneret, 1979, p. 211, repr. col. p. 210; Y. Le Pichon, 1981, pp. 214–17, 222, 223, repr. col.

Exhibitions
Paris, 1894, no. 327; Paris, 1944, no. 2; Paris, 1964, no. 5

Fig. 1.
The Tsar. Caricature published in *L'Egalité*
(October 6, 1889)

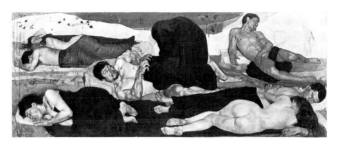

Fig. 2.
Hodler. *The Night.* 1889–90
Kunstmuseum, Bern

Tsar (fig. 1), which, as M.-T. de Forges has noted, appeared in *L'Egalité* on October 6, 1889, and in *Le Courrier français* on October 27. To those sources may be added Ferdinand Hodler's *Night* (fig. 2), which was exhibited with great effect at the 1891 Salon des Artistes Français and about which Hodler himself wrote: "I regard *The Night* as the great symbol of death" (quoted by A. Dückers, catalogue of the exhibition *Hodler,* Petit Palais, Paris, 1984, p. 135). The parallel grouping of bodies at the bottom of the picture, the macabre atmosphere, the gamut of colors with the emphasis on blacks, and the presence of Death at the center of the composition, are all elements that Hodler could have suggested to Rousseau. The identification of certain of the bodies with Rousseau himself or with the husband of a woman of whom he was fond seems highly improbable.

As can be imagined, the picture did not go unnoticed. Although it elicited sarcasm, it also received a sympathetic and understanding reaction from Louis Roy, a young painter close to Emile Bernard:

> At the Exposition des Artistes Indépendants in 1894, Monsieur Rousseau's *War* was certainly the most remarkable canvas. Without being either a complete achievement or a perfect work, this picture nevertheless, whatever some may say, represents a courageous attempt to create symbol. The artist who has made this attempt has once again expressed his personality; this manifestation seemed odd because it harked back to nothing seen before. Is that not in itself a masterful quality? Why should oddity give rise to mockery?... Monsieur Rousseau has encountered the fate of all innovators. He continues along his own path; he has the merit, a rare one today, of being completely himself. He is tending toward a new art.... One would be dishonest to be so bold as to maintain that the man capable of suggesting such ideas to us is not an artist (*Mercure de France,* March 1895).

As for the young Alfred Jarry, who had just met his countryman from Laval, he mentioned *War* twice in terms that were perhaps more descriptive than admiring (see "Jarry, Rousseau, and Popular Tradition").

10 *War*

Published 1895
Lithograph
8¾ x 13″ (22.2 x 33.1 cm)
The Museum of Modern Art, New York, given anonymously
New York exhibition only

Rousseau's only known print is a highly simplified version of his painting, *War* (see pl. 9). It first appeared in *L'Ymagier,* the review edited by Rémy de Gourmont and Alfred Jarry, who was one of the Douanier's discoverers (see "Jarry, Rousseau, and Popular Tradition"). Later, Rémy de Gourmont was to write:

> I knew Rousseau in the days when I was amusing myself with an illustrated review that introduced several other unknown or little-known artists, the least ignored of whom was Paul Gauguin, who was still a diamond in the rough. He [Rousseau] gave me a pen lithograph and sent me the sketch for another plate *(Le Puits de la vérité,* Paris, 1922, p. 110).

Charles Pérussaux compared the lithograph with the painting:

> In the lithograph, the sky is larger; the trees, on the other hand, are far less important and less decorative than in the canvas. Whereas in the latter Rousseau has the bodies of the victims lying directly on the ground, in the lithograph he has them lying on what appear to be stones. In addition, some of the dead appear to be writhing in a last dying convulsion, which is not the case in the canvas. Finally, the face of the destroying child is quite dissimilar in each case.

There has been much discussion about whether the lithograph precedes or follows the picture. Although the contrary is expressed in "Henri Rousseau and Modernism," it would appear, as Charles Pérussaux suggests, that the lithograph is a simplified reduction rather than a preparatory study.

Bibliography
L'Ymagier, January 1895; D. Catton Rich, 1942, p. 25, repr.; A. Breton, 1949, reproduction on cover; Ch. Pérussaux, "Commandée par Rémy de Gourmont: L'Unique lithographie du Douanier Rousseau," *Les Lettres françaises,* August 30, 1956, repr.; J. Bouret, 1961, p. 19; H. Certigny, 1961, pp. 145–47; D. Vallier, 1961, repr. no. 21; D. Vallier, 1979, repr. p. 56; M.-T. de Forges, "Une source du Douanier Rousseau," *Art de France,* vol. 4, 1964, pp. 360–61.

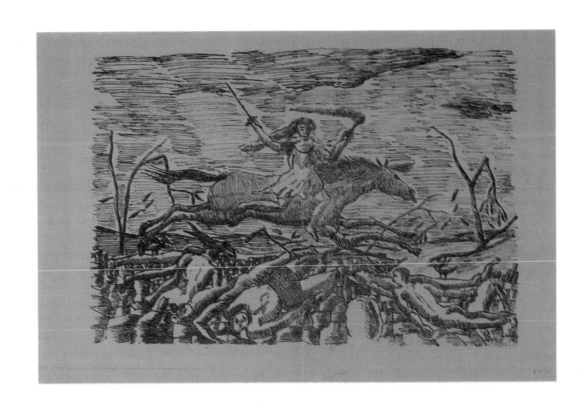

11 Artillery Men

c. 1893–95
Oil on canvas
31⅛ x 39" (79.1 x 98.9 cm)
Signed lower right: *H. Rousseau*
JB 86; DV 65
The Solomon R. Guggenheim Museum, New York, gift of Solomon R. Guggenheim, 1938
New York exhibition only

An artillery battery in fatigue dress is posed around a 90 Bange system model 1877 gun, against a landscape background. This is one of Rousseau's most carefully constructed compositions. There is a strong probability that he drew inspiration from a photograph, perhaps taken in the barracks yard, since the men are in fatigue dress and armed. It is difficult to tell whether the harmoniously worked-out placement of the subjects is Rousseau's own or whether it derives from the conventions of group photography. In any event, the group is carefully balanced and the curved positioning of the men is echoed by the grove of trees behind them. The composition closest to this in spirit is *The Family* (fig. 1), although the latter reflects less care in the placement of the subjects. Here, they are stiff and holding a pose (a further example of the photograph's effect upon Rousseau's art): their silhouettes make a pleasant rhythm within the composition, and Rousseau carefully varies their positions and details the slight differences in dress and weapons by employing accents of color; thus he punctuates the black tunics with touches of red and gold: in the center, in pride of place, stands the squadron sergeant-major with his red facings, gold stripes, and two unidentifiable decorations; there are two farriers wearing the insignia of their posts, a red horseshoe, on the left arm. The horsemen wear straps and buckles of fawn-colored leather from the left shoulder to the right hip. Some of the men are carrying the regulation knapsack or canteen slung in the opposite direction. The subject on the right behind the stacked muskets does not appear to be a soldier.

Such care and fidelity to detail, such precision in the description of uniforms and weapons (for their identification we must express thanks to Colonel Neuville, the curator of the Musée de l'Armée), reveals both Rousseau's mistrust of his imagination and also, perhaps, his nostalgic fascination with things military. His periods of service in the army, which according to Henry Certigny were fairly brief, included neither participation in the French expeditionary force to Mexico nor in the daring battle for the defense of Dreux during the 1870 war, two fables made famous by Apollinaire, who had probably been indoctrinated by Rousseau himself. Angelica Rudenstine has advanced the hypothesis that this picture shows the artillery battery of Frumence Biche, whose portrait we know Rousseau painted in 1893 (DV 66).

Although Rousseau demonstrates considerable ease in the composition of the painting, he shows less flair in its execution: the faces, all looking directly forward, are stereotypes that recall the artist's own features; the trees in the

Provenance
Maurice Renou, Paris; Galerie Van Leer, Paris, v. 1926; Knoedler, New York, 129; Roland Balaÿ, Paris, 1937; Galerie Louis Carré, Paris, 1938; Solomon R. Guggenheim, 1938

Bibliography
P. Soupault, *L'Amour de l'art,* 1926, repr. p. 332; A. Basler, 1927, pl. 10; D. Catton Rich, 1942 and 1946, p. 29, repr.; P. Courthion, 1944, pl. XXX; *A Handbook to the Solomon R. Guggenheim Museum,* 1959, fig. 132; J. Bouret, 1961, pp. 49–50; H. Certigny, 1961, p. 51; D. Vallier, 1961, repr. col. p. 52; L. and O. Bihalji-Merin, 1971, repr. no. 32; R. Shattuck, 1974; C. Keay, 1976, repr. p. 120; D. Vallier, 1979, repr. col. p. 52; Y. Le Pichon, 1981, p. 225, repr. col.

Exhibitions
Chicago and New York, 1942, unnumbered; New York, 1963, no. 9; Rotterdam and Paris, 1964, no. 4

Fig. 1.
Rousseau. *The Family.* c. 1890
The Barnes Foundation, Merion, Pa.

central group are fleecy and remind us of a stage or photographer's backcloth, while the two separate trees on the right are treated with greater freedom. As was his frequent practice, Rousseau painted the feet of his characters and then covered them with grass. The foregound is filled with interwoven grasses, as in several of the Jungle paintings (pls. 62, 66).

12 Portrait of a Woman

c. 1895
Oil on canvas
63 x 41⁵⁄₁₆″ (160 x 105 cm)
Unsigned
JB 94; DV 85
Musée du Louvre, Paris, Picasso Bequest

It is possible that this is a real portrait, and perhaps even a commission. The attempt to give individuality to the face and hands of the model (note the lobster-claw deformation of the little finger) is obvious, but all attempts to identify the subject have been conjectural. The most likely candidate, first put forward by Maurice Raynal (1914, p. 69), is Yadwigha, the Polish woman with whom Rousseau was in love, who served as inspiration for *The Dream* (1910, pl. 66) and whose name he gave to a character in his play *The Revenge of a Russian Orphan* (1899). The style of the dress enables us to date the picture post 1895, as Yvonne Deslandres has kindly pointed out, and the collar is characteristic of the detachable accessories worn with ready-to-wear clothing.

Rousseau probably worked from a photograph or, in any event, based his picture on the conventionalized pose employed by photographers. The fall of the curtain is a bit clumsy; the background of mountain and balcony could have been inspired by a photographer's backdrop. Intentionally or not, Rousseau has given no depth to either the sitter or the setting. As for the latter, Fernande Olivier reported that Rousseau had told her it was supposed to represent the fortifications of Paris (1933, p. 83).

Certain details do reveal Rousseau's attempt to break away from the stereotyped formal portrait to which he was to turn with greater ease on a later occasion (pl. 17): there is the odd touch of the branch held pointing down, which replaces the usual table on which the model would rest her left hand. The meticulously painted flowers, pansies among them, one of the few species Rousseau painted with any verisimilitude, may also have had symbolic meaning. Finally there is a note of fantasy in this rather sober composition—a bird in the sky is flying toward the model.

This picture, which Picasso purchased for 5 francs from a secondhand dealer, was hung in a place of honor in his studio on the occasion of the famous 1908 banquet. It was probably the earliest purchase in his collection, but opinions vary as to the exact date (see p. 46, n. 49). According to Roland Penrose, Picasso kept the painting "beside him" for years afterward and declared that it was "one the pictures he [loved] above all" (*Picasso: His Life and Work,* London, 1958; 1973, p. 145).

Provenance
Pablo Picasso, c. 1908; bequeathed to the State in 1978

Bibliography
W. Uhde, 1911; W. Kandinsky, 1912, repr. p. 76 (French edition, 1981, p. 198); C. Zervos, *Cahier d'Art,* 1926, repr. p. 231; P. Fierens, *Le Journal des débats,* June 24, 1927; C. Zervos, 1927, pl. 91; P. Soupault, 1927, pl. 9; P. Picasso, "Lettres sur l'art," *Formes,* no. 2, February 1930; Fernande Olivier, 1933, pp. 82–83; Roch Grey, 1943, p. 47, repr. no. 14; P. Courthion, "Henri Rousseau," *L'Oeil,* October 1958, no. 46, pp. 18–27; H. Certigny, 1961, pp. 170–71; A. Breton, 1965, p. 115; A. Malraux, *La Tête d'obsidienne,* Paris, 1974, p. 13; A. Salmon, 1969, pp. 49–50; C. Keay, 1976, p. 127, repr. no. 18; M.-T. de Forges, *Catalogue donation Picasso,* 1978, no. 33, p. 78; S. Monneret, 1979, p. 214; D. Vallier, 1979, repr. col. p. 82; Y. Le Pichon, 1981, p. 80, repr. col.

Exhibitions
Paris 1895 (?) or 1896 (?)

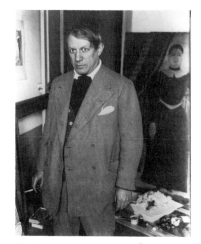

Fig. 1.
Picasso, 1932, in front of *Portrait of a Woman* by Rousseau
Photograph by Brassaï

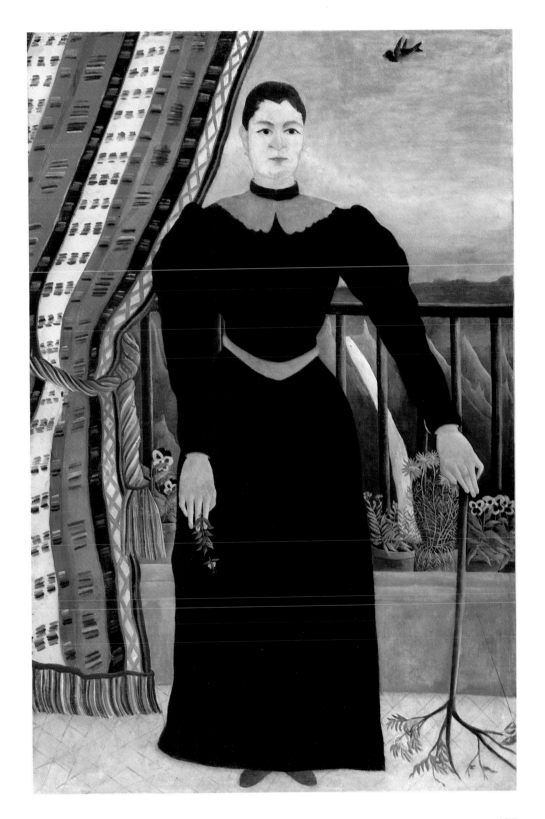

13 Study for Family Fishing

c. 1895
Oil on canvas
7½ x 11⅞" (19 x 29 cm)
JB 149; DV 84B
Collection Sam Spiegel, New York
New York exhibition only

14 Family Fishing

c. 1895
Oil on canvas
14¾ x 18" (37.5 x 45.7 cm)
JB 148; DV 84A
Private collection
New York exhibition only

Although Rousseau was deeply dependent on observation of the model, his finished paintings do not reflect his optical experiences before his motifs but his conceptions of them. For his portraits, which were either made from the model or a photograph, and for his fanciful compositions, which were based on imaginatively composed mental collages derived from diverse sources, he appears to have made no studies. The oil sketches that have survived are all for landscapes. Comparison of these studies with their finished versions reveals a great deal about Rousseau and his mode of picture-making.

In spite of the penetrating analysis of the relationship between the sketches and their finished states made by Ingeborg Eichmann as long ago as 1938[1] and subsequent observations made by Daniel Catton Rich[2] and James Johnson Sweeney in 1942,[3] the popular conception of Rousseau as an artist who painted the way he did because he could do no other persists. A comparison of the sketch for *Family Fishing* with the finished picture convincingly supports Eichmann's observation that "it becomes clear from the sketches that Rousseau knew the technique of impressionism but for him it was only a preparatory stage. Beyond the impression he wanted to fix the solid object in all its completeness." It also substantiates Rich's remark that "seeing the sketch and completed picture side by side reveals how the artist *chose* [italics added] his method and his own stylization." Sweeney adds: "From the outset of his career to Rousseau 'the realist' true pictorial realism always meant something beyond an attempt to transcribe literally visual experiences of the world in nature. This is clear from the departures he was accustomed to make in his final versions of landscapes from the initial impressionistic sketches painted on the ground."

Pl. 13
Study for Family Fishing

Provenance
W. Rees Jeffreys, Esq.

Bibliography
I. Eichmann, 1938, pp. 302–07

Pl. 14
Family Fishing

Bibliography
P. Courthion, 1944, pl. 10

Exhibitions
Paris, 1961, no. 38; New York, 1963, no. 36; Tokyo, 1966, no. 25

1. "Five Sketches by Henri Rousseau," *Burlington Magazine*, no. 72 (June 1938), pp. 302–07.
2. *Henri Rousseau*, 2d rev. ed. (New York: The Museum of Modern Art, in collaboration with the Art Institute of Chicago, 1946), p. 58.
3. *College Art Journal*, vol. 1 (May 1942), pp. 108–110.
4. "Five Sketches by Henri Rousseau"

As is evident from the study and the completed painting of *Family Fishing,* the "sketch is only a signpost to guide [Rousseau] towards reality."[4] In the studio the schematically rendered forms and the massed differentiations of light and dark are converted in the interest of fixing the permanent character of the motif to the meticulously organized, highly detailed, sharply outlined image rendered in local color typified in the completed version of *Family Fishing.*

The sketch we see here was characterized by Eichmann as "perhaps the most masterly example of Rousseau's painting known. The subtlety with which the light ground is used and at some places left uncovered is unparallelled." While this praise may seem extravagant, it was made in one of the earliest and still rarely attempted efforts to find the real Rousseau behind his legend as "primitive." Eichmann concludes with the observation that "the paintings made after the sketches...show nature in a final, as it were, petrified form which has been called stiff by those who have failed to realize that it is penetrated by the passionless order of eternal things."

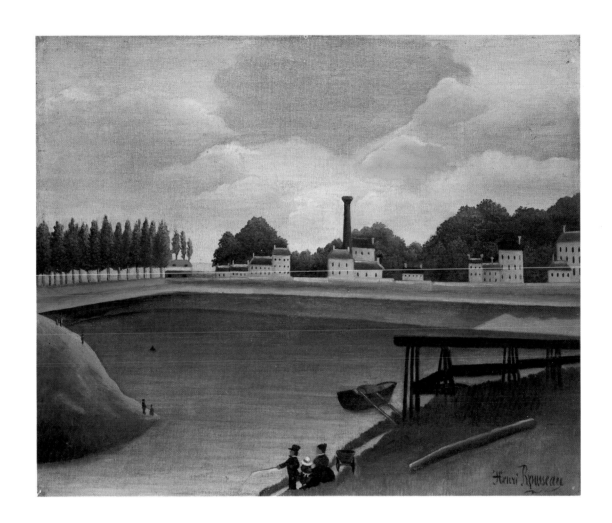

15 The Boat in the Storm

post 1896
Oil on canvas
21½ x 25½" (54 x 65 cm)
Signed lower left: *Henri Rousseau*
JB 110; DV 57
Musée de l'Orangerie, Paris
Collection Jean Water–Paul Guillaume

This picture is of a type that is rare in Rousseau's known output. The painter maintained (and Apollinaire was to be taken in by and propagate) the fable that he had taken part in the French army's expedition to Mexico in 1862–67, whereas in fact he had traveled hardly at all and had probably never been on board a ship.

A sideshow display of a model ship pitching in a storm or a diorama at the 1889 World's Fair in Paris most likely furnished the elements for this odd composition. That would explain the metallic cutout appearance of the sea, its waves with shapes reminiscent of Hokusai's famous woodcut. As for the boat, its source is more probably a picture in an illustrated newspaper. Yann Le Pichon (p. 123) has discerned the profile of the cruiser *D'Entrecasteaux*, launched in 1896.

Whatever models he used, Rousseau has again interpreted them freely. In addition, the painting attests to his interest in the events of his day. By painting a recently launched warship at sea with its flag flying and braving the storm, Rousseau is enriching his range of subject matter by exalting an achievement of France's national industry and Army.

Provenance
A. Vollard, Paris; P. Guillaume; Mme J. Walter

Bibliography
A. Basler, 1927, pl. 35; C. Zervos, 1927, pl. 29; W. George, 1931, repr.: Roch Grey, 1943, pl. 61; J. Bouret, 1961, pp. 10, 256; D. Vallier, 1961, pp. 42–43, 132, repr. no. 54; L. and O. Bihalji-Merin, 1971, repr. col. no. 9; A. Jakovsky, 1971, repr.; V. Nezval, 1972, p. 80; C. Keay, 1976, repr. no. 21; F. Elgar, 1980, pl. 22; Y. Le Pichon, 1981, p. 123, repr.

Exhibitions
Basel, 1933, no. 34; New York, 1951, no. 1; Paris, 1961, no. 20; Rotterdam and Paris, 1964, no. 9

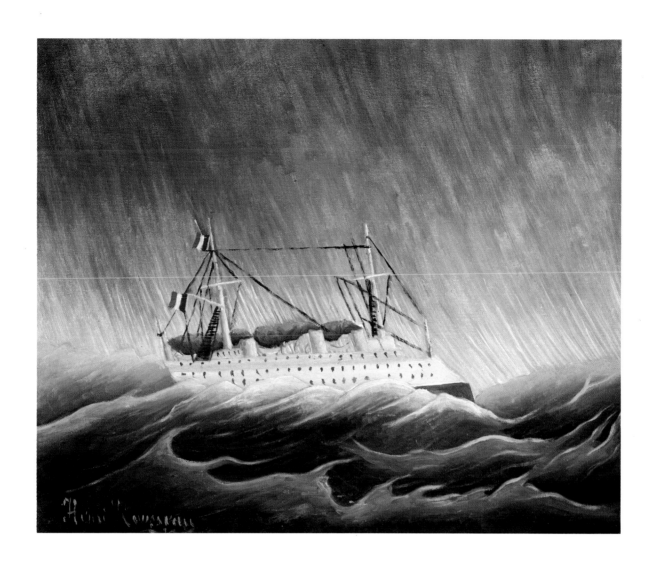

16 The Quarry

1896–97
Oil on canvas
18½ x 21¾″ (47 x 55.3 cm)
JB 41; DV 102
Private collection
New York exhibition only

The small *bonhomme* in black, umbrella in hand and large-brimmed Sunday hat on his head, is a ubiquitous figure in Rousseau's landscapes, but in no other of his known paintings has he quite the prominence he is given in *The Quarry*. Small as he is compared to the other objects in the painting, he is relatively larger than in any other of his appearances in Rousseau's work; his blackness and central positioning against the light-colored road running up the middle of the picture focus him immediately in the viewer's eye. Rousseau identifiably puts himself in many of his pictures, and while we can rarely discern the features of the small black-clad personage, he is generally recognized to be Rousseau's version of himself as observer of nature and the urban scene. Here, he has turned from his observations to face the viewer; in a kind of "Bonjour, M. Rousseau" posture he invites us to observe him on a Sunday stroll in his own fanciful landscape. As *Myself, Portrait-Landscape* (pl. 5) was an emphatic announcement of Rousseau the painter, this is a modest statement describing Rousseau the *flâneur*.

As is typical of Rousseau, the countryside in which he strolls is a landscape of symbols expressing the artist's sense of the prevailing harmony between man and nature and man's use of nature. The fantastic, oddly scaled rocks, the tiers of variously colored grasses and shrubs that climb up the surface of the picture, and the formalized trees all bespeak a poignant and highly concentrated sincerity that is kin to what Kenneth Clark has described as the "surprised delight" of the illustrators of the late Middle Ages.

Unusual here is Rousseau's free rendering of the scattered red and white flowers. While we never sense any wind in Rousseau's landscapes, they often convey a feeling of air; and in this rather bold composition in which half the canvas is devoted to sky, the free dosage of red and white dots may be intended to evoke a sensation of wind much as their similar sprinkling in Monet's *Red Poppies* does. Rousseau's stylization of the landscape into tonally differentiated bands that lie flat across the picture surface anticipates Paul Klee's far more radical striped Egyptian landscapes. What makes this one of the Douanier's most engaging landscapes is the experience it allows us of Rousseau in his world.

Provenance
H. Purrman, Paris, 1912; O. Mietschaninoff, Paris; Galerie Bing, Paris

Bibliography
W. Uhde, 1914, pl. 23; Roch Grey, 1922 (*Vue des fortifications*); A. Basler, 1927, pl. 21 (*Paysage de banlieue*); A. Basler, 1929, p. 33; C. Zervos, 1927, p. 85; D. Cooper, 1951; D. Vallier, 1961, p. 61; P. Descargues, 1972, p. 88; R. Alley, *Portrait of a Primitive: The Art of Henri Rousseau*, 1978, p. 36; M. Morariu, 1979, no. 33; Y. Le Pichon, 1981, p. 113.

Exhibitions
Paris, 1912, no. 3 (*Carrière de pierre près du fort de Vanves*); Paris, Salle Royale, 1937, no. 3; Paris, 1961, no. 57; Tokyo, "Rousseau et le monde des naïfs," 1961, no. 37; New York, 1963, no. 48

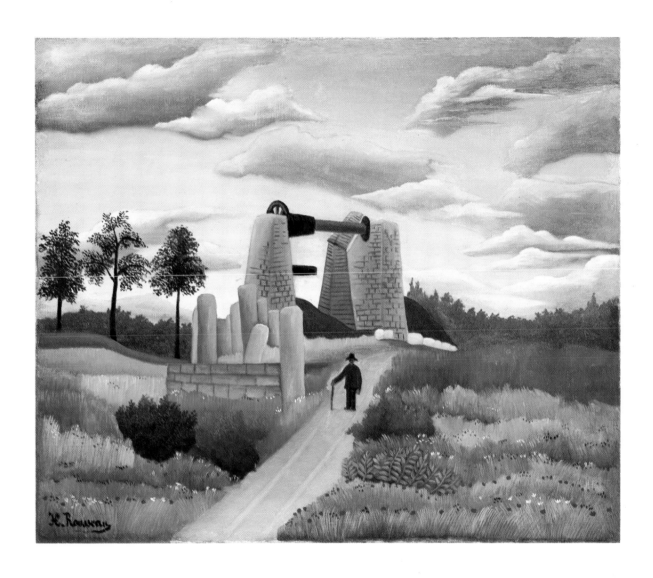

135

17 Portrait of a Woman

c. 1895–97
Oil on canvas
78 x 54¼″ (198 x 115 cm)
Signed lower left: *Henri Rousseau*
JB 66; DV 101
Musée d'Orsay, Galerie du Jeu de Paume, Paris

Compared to Rousseau's other large full-length portrait of a woman (pl. 12), this 1895–97 painting shows greater assurance in its conception and placement on the canvas, as well as a greater degree of care in its execution. This does not, however, prove that it is later in date. The picture is probably a commission, for according to a remark by W. Uhde (1911, p. 20), the better the pay, the more care Rousseau put into his work. However that may be, he would appear to be trying to rival, albeit unconsciously, the worldly portraits of the Salon painters Bonnat and Bouguereau, who depicted society women standing face forward, dressed in their most sumptuous clothes. Or perhaps he was mimicking the great seventeenth-century Flemish portraits. The so-called Medici sleeves support the latter notion. The dress, as Yvonne Deslandres has noted, was in fashion around 1895, although no proof exists that Rousseau's model was wearing a dress of an up-to-date style.

The face is less frozen than in other portraits; Rousseau has reduced the volume of the head by decreasing the fullness of the hair (one senses the overpainting). The dissymmetry of the arms and the advanced left foot create a slight feeling of movement. The frame of greenery in which a cat is playing with a ball of string also serves to soften the stiffness of this portrait. Rousseau has surrounded his model with flowers and shrubs of different varieties as was his habit (there are ten here), but whose appearance is too stylized to allow them to be identified. There is one exception, however: the pansies in the foreground of the composition. The woman also holds one in her hand. This species is in evidence in several pictures. The delicate coloring of the flowers and the variety of hues in the greenery contrast with the striking, slightly watered black of the dress and umbrella.

Provenance
E. Suermondt, Drove; Gourgaud, Paris

Bibliography
W. Uhde, 1911, fig. 19; W. Uhde, 1914, p. 3; W. Uhde, 1921, p. 26, repr.; A. Basler, 1927, pl. 4; C. Zervos, 1927, pl. 38; P. Courthion, 1944, pl. XXI; H. Certigny, 1961, p. 102; D. Vallier, 1961, no. 79; L. and O. Bihalji-Merin, 1971, repr. no. 23; Monneret, 1979, pl. 213; Y. Le Pichon, 1981, p. 81, repr. col.

Exhibitions
Paris, 1911, no. 19; Paris, 1912, no. 8 (*Portrait of Rousseau's First Wife*); Basel, 1933, no. 8

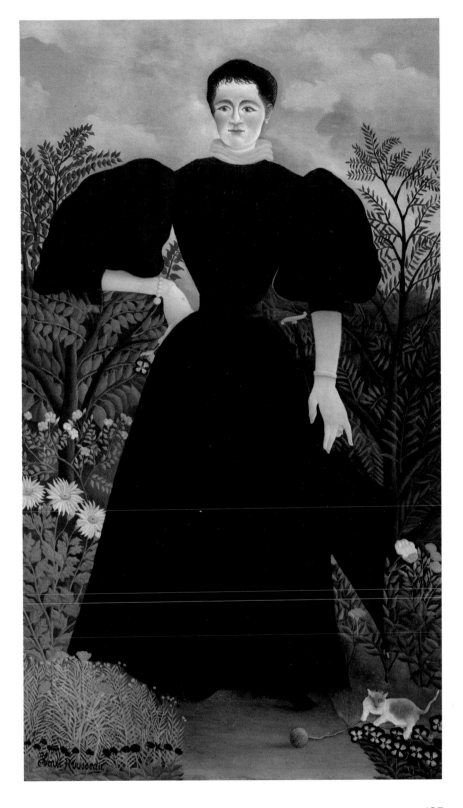

18 The Chair Factory

c. 1897
Oil on canvas
28¾ x 36³/₁₆" (73 x 92 cm)
Signed lower right: *Henri Rousseau*
JB 106; DV 103A
Musée de l'Orangerie, Paris
Collection Jean Walter–Paul Guillaume

Rousseau's urban landscapes are based, generally, on direct and careful observation of apparently insignificant locales in the vicinity of Paris. Here a chair factory at Alfortville is endowed by the painter with the severe poetry of a stage set for some naturalistic play, in contrast to the exotic charm of his tropical landscapes. This is one of the rare urban pictures that is fairly large in size. Its execution is especially painstaking, particularly the sky, where Rousseau shows a good grasp of traditional technique. The drawing of the clouds and the color relationship between them and the blue sky bear resemblance to Poussin's skies.

The stiff-shaped buildings are depicted with an exactitude that borders on the academic, although the principles of linear perspective are not adhered to. Nevertheless, the main axes are laid out following the Golden Section. The curvilinear edge of the sidewalk and the bank of the Seine are elements that lend suppleness and animation to the composition: the few figures present are strollers and a fisherman.

It is tempting to regard a small version (fig. 1) in the Musée de l'Orangerie, Paris, as a preliminary sketch for this painting, whose careful execution and large size enable us to identify it with near certainty as the work submitted to the 1897 Salon des Indépendants. However, the small version is considerably larger than most of the other known sketches, and so it would seem more likely that it is a repetition of the theme done several years later at a time when the painter's success had led him to return to some of his older compositions.

Provenance
P. Guillaume; Mme J. Walter

Bibliography
H. Kolle, 1922, p. 17; F. Fels, *Formes*, no. 11, 1931; W. George, 1931, repr. p. 5; P. Courthion, 1944, pl. XXXVII; D. Vallier, 1961, no. 146; H. Certigny, 1961, p. 17; J. Cassou, E. Langui, N. Pevsner, 1961, fig. 115; A. Jakovsky, 1971, repr.; L. and O. Bihalji-Merin, 1971, repr. no. 8; P. Descargues, 1972, repr. p. 86, detail, p. 37; D. Larkin, 1975, pl. 14; C. Keay, 1976, repr. no. 20; F. Elgar, 1980, fig. 18; Y. Le Pichon, 1981, p. 120, repr col.

Exhibitions
Paris, 1897, no. 1025; Basel, 1933, no. 16; Paris, Galerie Rosenberg, 1937, no. 3 (*La Banlieue*); Paris, Salle Royale, and Zurich, 1937, no. 16; New York, 1951, no. 6; Paris, 1961, no. 77; Rotterdam and Paris, 1964, no. 8

Fig. 1.
Rousseau. *The Chair Factory at Alfortville.* After 1897? Musée de l'Orangerie, Paris

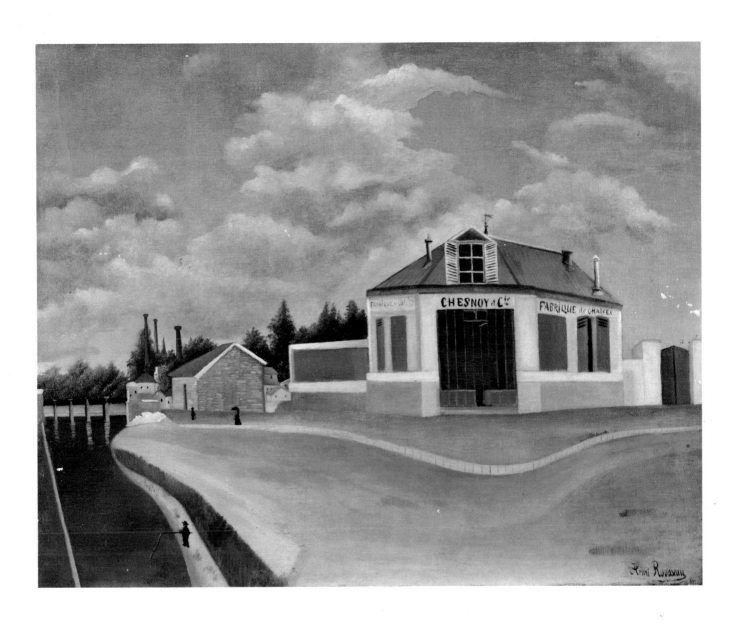

19 The Sleeping Gypsy

1897
Oil on canvas
51″ x 6′7″ (129.5 x 500.7 cm)
Signed and dated lower right: *Henri Rousseau 1897*
JB 13; DV 112
The Museum of Modern Art, New York, gift of Mrs. Simon Guggenheim, 1939

"The feline, though ferocious, is loathe to leap upon its prey, who, overcome by fatigue, lies in a deep sleep." —Rousseau (inscription on the frame)

"A wandering Negress, a mandolin player, lies with her jars beside her (a vase with drinking water) overcome by fatigue in a deep sleep. A lion chances to pass by, picks up her scent yet does not devour her. There is a moonlight effect, very poetic. The scene is set in a completely arid desert. The gypsy is dressed in oriental costume" (Rousseau's letter to the Mayor of Laval, July 10, 1898, offering to sell him the picture).

The Sleeping Gypsy is undoubtedly the most *invented* and also the most fascinating of Rousseau's large pictures. Particularly striking is its formal perfection, the rigor in the disposition of masses, the precision of its contours, the almost miraculous placement, in which every line, every surface, and every accent finds its rhyme within the composition itself. The workmanship is careful, almost overpolished, in the manner of the academic painters. Rousseau plays delicately with light on the lion's body and on the lute, which is quite faithfully depicted, probably after an illustrative engraving in an encyclopedia. Rousseau has vaguely sketched in the features of a face in the moon.

It has long been suggested that Rousseau drew his inspiration from the paintings of J.-L. Gérôme (1824–1904), whom he greatly admired. In *The Two Majesties* (1885, p. 13, fig. 2), for example, Gérôme uses empty spaces for their expressive value. We could also refer to the *Egyptian Orange Sellers* (1872, fig. 1) of F.-A. Clément (1826–1890), a painter Rousseau admired and with whom he was acquainted. The veils and multicolored gems, the jars, even the facial type, could all have inspired Rousseau, but no specific painting can explain the total irrationality of this composition. Since the advent of Surrealism, the painting's unique and astonishing atmosphere have been widely appreciated. Jean Cocteau described it in this way:

> We are in the desert. The gypsy lying in the middle ground is lost in dream, or has been carried away by a dream, so far away—like the river in the background—that a lion behind her sniffs at her without being able to reach her. Indeed, the lion, the river, may even be the sleeping woman's dreams. Such peace! The mystery believes in itself and stands naked, revealed.... The gypsy sleeps, her eyes closed.... How to describe this motionless flowing figure, this river of forgetfulness? I think of Egypt, who knew how to sleep in death with her eyes open as do divers under water....From where does such a thing fall? From the moon...And perhaps it is not without motive that the painter, who never overlooks

Provenance
L. Vauxcelles, Paris, 1923; D. H. Kahnweiler, Galerie Simon, Paris, 1924; J. Quinn, New York, 1924; John Quinn Sale, Hôtel Drouot, Paris, October 26, 1926; H. Bing, Paris, 1926; Mme E. Rucksfuhl-Siegwart, Switzerland

Bibliography
Faverolles, *Le Gaulois*, April 6, 1897; T. Natanson, *La Revue blanche*, June 15, 1897; Y. Rambosson, *La Plume*, May 15, 1897; W. Uhde, 1914, p. 62; W. Uhde, 1921, p. 85; F. Roh, "Ein neuer Henri Rousseau," *Der Cicerone*, no. 16, July 1924, pp. 713–16, repr. p. 710, reprinted in *Jahrbuch der jungen Kunst*, 1924, pp. 57–60, repr. p. 54; *Das Querschnitt Buch*, 1924, Berlin, repr. p. 101; *L'Esprit nouveau*, no. 22, 1924 (?), repr., n.p.; A. Ozenfant and C.-E. Jeanneret, *La Peinture moderne*, Paris, 1925, repr. p. 54; *Art News*, January 2, 1926, repr.; P. Soupault, *L'Amour de l'art*, 1926, repr. p. 336; C. Zervos, *Cahiers d'art*, 1926, repr. p. 219; A. Basler, *L'Art vivant*, October 15, 1926, p. 778, repr. facing p. 783; *The John Quinn Collection of Paintings, Watercolors, Drawings and Sculptures*, New York, 1926, p. 14, repr. p. 108; C. Zervos, 1927, pl. 70; A. Basler, 1927, p. 27, col. frontispiece; P. Fierens, "Henri Rousseau," *Journal des débats*, June 24, 1927; P. Soupault, 1927, pl. 10; A. Salmon, 1927, repr. pl. 1; A. Basler, *Henri Rousseau le Douanier*, Les Albums Druet, no. 24, 1930; *Gazette des Beaux-Arts*, February 1931, repr. p. 22; W. Uhde, "Henri Rousseau et les primitifs modernes," in R. Huyghe and G. Bazin, *Histoire de l'art contemporaine: La Peinture*, Paris, 1935, p. 190; V. Nezval, *Henri Rousseau*, 1937, repr. pl. 12; J. Laver, *French Painting and the 19th Century*, London, 1937, p. 97, fig. 139; *Apollo*, January 1938, repr. p. 54; A. H. Barr, Jr., *Art in our Time*, New York, 1939, no. 84, repr.; R. H. Wilenski, 1940, pp. XIX, 134–35, 155, 200, 207, 273, 301, 309–10, repr. pl. 42; *Royal Society of Arts Journal*, January 26, 1940, repr. p. 255; *Modern Masters*, New York, 1940, col. frontispiece; R. Melville, *The White Horseman*, London, 1941, p. 140; R. Schoolman and C. E. Slatkin, *The Enjoyment of Art in America*, Philadelphia, 1941, p. 565, repr. pl. 562; R. Frost and A. Crane, *Contemporary Art*, New York, 1942, p. 19; D. Catton Rich, 1942, pp. 28–29, detail repr. p. 32, repr. col. p. 33; *Art in Australia*, March–May 1942, repr. p. 45; *Bulletin of the Art Institute of Chicago*, January 1942, repr. p. 16; Roch Grey, 1943, repr. p. 103; A. H. Barr, Jr., *What Is Modern Painting?*, New York, 1943, p. 31, repr.; J. Rothenstein, "European Painting 1893–1943," *The Studio*, April 1943, p. 102, repr. col. p. 100; P. Courthion, 1944, p. 43; R. Melville "Rousseau and Chirico," *Scottish Arts and Letters*, no. 1, 1944, pp. 31–33, repr. between pp. 32–33; J. Fernandez, *Prometeo*, Mexico, 1945; p. 19, pl. 13; R. Alberti, *A la*

pintura, Buenos Aires, 1945, repr. col.; M. Georges-Michel, *Chefs d'oeuvre de peintres contemporains*, New York, 1945, repr.; D. Catton Rich, 1946, pp. 28–32, repr. col. p. 33; *Transatlantic*, June 1946, repr. p. 14; J. Gomez Sicré, "Douanier Rousseau," *Norte*, August 1948, pp. 17–21, repr. facing p. 20; A. Breton, *Flagrant délit: Rimbaud devant la conjuration de l'imposture et du trucage*, Paris, 1949, p. 17; W. Uhde, 1949, repr. p. 59; B. S. Myers, *Modern Art in the Making*, New York, 1950, pl. 135, note, p. 268; A. H. Barr, Jr., *Masters of Modern Art*, 1954, pp. 12–14, repr. col. p. 13; H. Perruchot, 1957, pl. IV; J. Cassou, 1960, p. 609; H. Certigny, 1961, pp. 167–69, 183–84, repr. facing p. 167; J. Bouret, 1961, repr. p. 14; D. Vallier, 1961, pp. 63, 67, 138–39, col. repr. p. 65; X. Tilliette, 1961, pp. 174, 184; A. Boime, "Jean-Louis Gérôme, Henri Rousseau's Sleeping Gypsy and the Academic Legacy," *Art Quarterly*, Spring 1971, pp. 2–39; L. and O. Bihalji-Merin, 1971, repr. col. no. 40, detail no. 59; V. Nezval, 1972, p. 84; P. Descargues, 1972, pp. 49, 58, 117, 119, repr. col. p. 51; H. Franc, 1973, repr. col. p. 13; C. Keay, 1976, repr. col. no. XI; G. Bernier, *L'Art et l'argent*, 1977, p. 121; W. S. Rubin, undated [1969], pp. 127–28; D. Vallier, 1979, repr. col. pp. 62–63; S. Monneret, 1979, p. 213; Y. Le Pichon, 1981, pp. 178, 204–07, repr. col.; Craven, *Treasury*, undated, p. 154, repr. col. pl. 154

Exhibitions
Paris, 1897, no. 1020; Basel, 1933, no. 15; Zurich, 1937, no. 4; Chicago, New York, Pittsburgh, 1942, unnumbered

any detail, has been careful to omit any prints on the sand around the sleeping feet. The gypsy did not come there where she sleeps. She is there. She is not there. She occupies no human site. She lives in mirrors which, in advance, are reflecting cubist still lifes (Preface to the catalogue for the John Quinn Sale, Hôtel Drouot, October 26, 1926).

Should we regard this picture as one of Rousseau's dreams and the gypsy as a projection of Rousseau himself, the ignored artist-musician? As for the lion, we must bear in mind that in his Jungle paintings Rousseau very seldom attributed cruelty to the lion and often endowed it with the stereotyped appearance of protective King of the Beasts, as he was to do in the foreground of *Liberty Inviting Artists to Take Part in the Twenty-second Exhibition of the Société des Artistes Indépendants* (1905–06, pl. 32). After the Mayor of Laval's refusal to purchase *The Sleeping Gypsy* at Rousseau's urging, the picture disappeared until 1923. It was then found by Louis Vauxcelles—according to some, in the possession of a charcoal seller; according to others in a plumber's shop—and entrusted to the dealer D. H. Kahnweiler. There it was seen by Serge Férat, Robert Delaunay, Wilhelm Uhde, Jacques Doucet, Brancusi, and Picasso. The latter brought it to the attention of Henri Pierre Roché (see "Henri Rousseau and Modernism," n. 87), who alerted the American collector John Quinn, for whom he was purchasing works of art in France. The picture was sent to America. Oddly enough, it was later said that Picasso had expressed doubts as to the authenticity of *The Sleeping Gypsy* and that he had even claimed to have painted it himself (see the letter from Roché to Marcel Duchamp, undated, and a letter from Alfred H. Barr, Jr., to Paul Sachs dated May 3, 1955, Archives of The Museum of Modern Art, New York; also, "Henri Rousseau and Modernism," ns. 86, 87). Since the affair had caused talk in Parisian art circles, it is possible that Picasso, harassed with questions, took this course in order to rid himself of pests. Picasso's statements were later repeated by André Breton, who occupied the same position vis-à-vis Doucet as Roché had vis-à-vis Quinn.

Fig. 1.
Clément. *Egyptian Orange Sellers*. 1872
Musée Jules Chéret, Nice

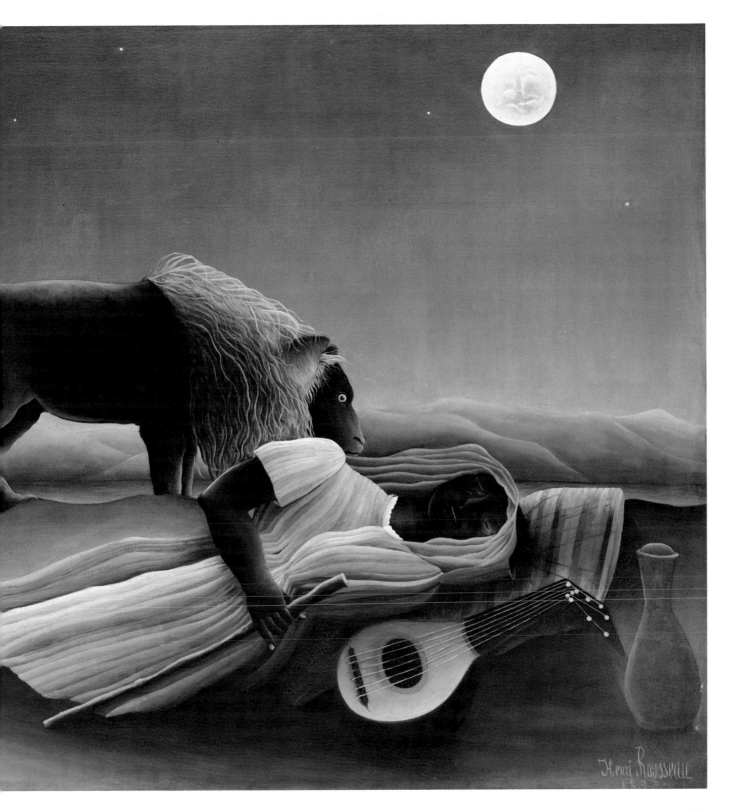

20 Footbridge at Passy

c. 1895
Oil on canvas
15¼ x 18¼" (38.7 x 46.2 cm)
Signed lower left: *H. Rousseau*
JB 87; DV 160
Private collection

Rousseau was often attracted to the most prosaic and least picturesque aspects of the Parisian landscape. Sand banks along a quay, an avenue of trees, a charmless metal bridge (since dismantled)—these were all he needed to create a muted poetry from the banks of the Seine, with the traditional fisherman to add a touch of fantasy. Two unexpected elements, however, catch our attention and lend a patriotic feeling to this everyday panorama: the figure of the Statue of Liberty on the Grenelle Bridge (as in pl. 8) and the tricolor flying atop a mast. The scene recalls Verlaine's poem:

> In this Paris, so ugly, so modern, there are still—
> Or rather, there were, for everything is tarnished—
> There were a few courtyards, far from picturesque,
> But odd in a horrid way, and vacant lots without any name
> None of them...
> ...Masons somewhat the worse
> For wine would sing the Marseillaise
> And plant the tricolor atop it.

Un Peu de bâtiment

The selection and arrangement of these various motifs also occur for formal reasons. The extremely precise rectilinear lines give this simple scene on the banks of the Seine a rigorous, monumental character. René Huyghe, writing in 1939, observed that "the Douanier's *Footbridge at Passy* ingeniously links up with the daring schematizations of the moderns." Indeed, Rousseau must certainly have distorted the real aspect of the site deliberately. He has moved the Statue of Liberty a full half-circle—in his day it faced upstream.

The Passy footbridge was built in 1878 and later replaced by a bridge-viaduct of the same name (now the Bir-Hakeim), on which construction began in 1903. Unless we suppose Rousseau to have worked from a postcard, we must therefore abandon Vallier's date, 1905. Rousseau twice showed a painting under this title at the Salon des Indépendants, in 1891 and in 1895. When it was sold at public auction in 1914, Apollinaire noted that R. Delaunay owned a sketch for it (*Paris Journal,* May 14, 1914).

Provenance
H. Kullmann, Manchester; Kullmann Sale, Hôtel Drouot, Paris, May 16, 1914, no. 11 (first of Rousseau's paintings to be sold at public auction, with *Eclaireurs attaqués par un tigre* [DV 152] and *Vue des fortifications* [DV 89]); A. Villard, Paris; P. Guillaume, Paris, Valentine Gallery, New York

Bibliography
G. Apollinaire, *Paris Journal,* May 14, 1914, reprinted in *Chroniques d'Art 1902–1918,* Paris, 1960, p. 375; C. Zervos, *Cahiers d'Art,* 1926, repr. p. 232; A. Basler, 1927, pl. 16; A. Salmon, 1927, repr. no. 10; C. Zervos, 1927, pl. 7; P. Soupault, 1927, pl. 5; *Les Arts à Paris,* May 1928, no. 15, repr.; R. Huyghe, 1933, p. 187; R. Huyghe, 1939, p. 41; D. Catton Rich, 1942, p. 28, repr.; Roch Grey, 1943, no. 64; P. Courthion, 1944, pl. XXIV; D. Catton Rich, 1946, p. 7; D. Vallier, 1961, no. 88; Y. Le Pichon, 1981, p. 103, repr. col.

Exhibitions
Paris, 1895, no. 1310 (?); London, 1926; New York, 1931, no. 22; Basel, 1933, no. 13; Pittsburgh, 1942, unnumbered; New York, 1951, no. 4

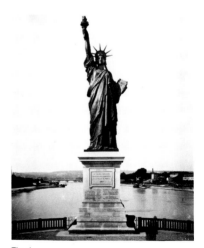

Fig. 1.
Bartholdi. *Liberty Illuminating the World*
Ile des Cygnes, Paris (in the original position, facing upstream)

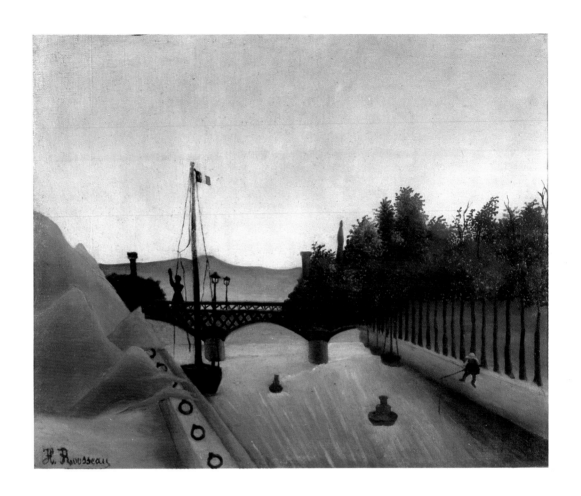

21 Bouquet of Flowers

1895–1900
Oil on canvas
24 x 19½" (61 x 50.2 cm)
Signed lower right: *Henri Rousseau*
JB 21; DV 115
The Trustees of the Tate Gallery, London

Although Rousseau sometimes isolated and gave special importance to certain objects in his large compositions (for example, to the lute in *The Sleeping Gypsy,* pl. 19), he painted few still lifes. At the Salon des Indépendants he was to show only three—in 1902, 1903, and 1904—and we know of only ten, none of which can be dated with certainty. Most of them depict flowers in a vase or basket.

Rousseau never attempted, as he did with landscape, to follow the traditional pattern of the structured, organized still life, nor does he seem to have profited from the complex experiments of Cézanne or Gauguin. Yet there is a similar isolation of the motif, the same simplicity of presentation, as in Van Gogh and Redon.

> The nucleus of the composition consists of dark pansies, whose burnished density is crowned by a light, transparent network of flowers and leaves radiating round it. The leaves of the pansies are arranged with flawless symmetry; to the yellow flowers on the left corresponds the complementary blue of the flowers on the right; the delicate graphic precision of the plants is set off by the calm uniform tones of white vase, pink background and red rug.

> The result is a sustained, thoughtful style; but nothing mars the unbelievable purity of the painter's initial impression. Rousseau fulfills the dream of everyone who has dabbled in paints in his childhood: he keeps the gaze of a child, yet invents the language of an accomplished painter. Which, however, is not at all the language of an adult painter, for it remains foreign to every optical or pictorial convention. His imagination alone stands between him and nature....No one sees a bouquet of ordinary flowers as Rousseau sees it: for him it is a dense forest full of heady aromas, out of which pansies gaze at us like soft, furry animals (Charles Sterling, p. 119).

Pansies are among the few flowers Rousseau painted with precison; in other paintings, they have been symbolically linked to special personages, such as the subject of the large *Portrait of a Woman* (pl. 17) and to Marie Laurencin, whose head is encircled by them in *The Muse Inspiring the Poet* (pl. 58).

Provenance
A. Flechtheim, Dusseldorf; Bernheim-Jeune, Paris, 1921; K. Vollmoeller, Basel; C. Franck Stoop, London, 1931

Bibliography
Roch Grey, 1922; H. Kolle, 1922, pl. 55; P. Soupault, 1927, pl. 12; J. H. Johnstone, "La Collection Stoop," *L'Amour de l'art*, 1932; P. Courthion, 1944, pl. XLVIII; C. Sterling, *Still Life Painting: From Antiquity to the Present Time*, New York, Paris, 1959, repr. col. no. 106; R. Alley, *Tate Gallery Catalogues: The Foreign Paintings, Drawings and Sculptures*, London, 1959, p. 122, fig. 8; D. Vallier, 1961, p. 307, no. 51; A. Jakovsky, 1971, repr.; R. Shattuck, 1974, p. 110; D. Vallier, 1979, p. 77 repr. col.; Y. Le Pichon, 1981, p. 237, repr. col.

Exhibitions
Basel, 1933, no. 25; Rotterdam and Paris, 1964, no. 26

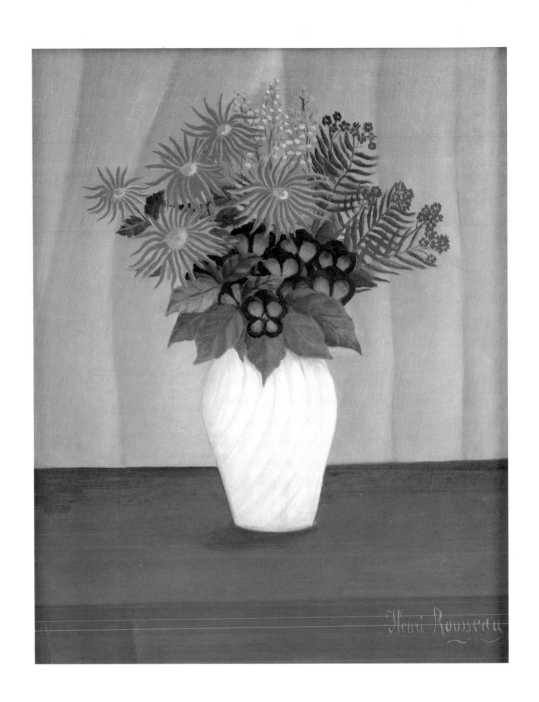

22 Happy Quartet

1901–02
Oil on canvas
37 x 22½" (94 x 57 cm)
Signed lower right: *H. Rousseau*
JB 19; DV 129
Collection Mrs. John Hay Whitney, New York

One of Rousseau's most elaborate works, this painting is also unusual in being one of his rare landscapes with abundant but nontropical vegetation and, with *Eve* (pl. 29) and *The Dream* (pl. 66), one of his few nudes. For this complex composition, he chose an unusual vertical format that evidences a striving toward elegance, almost to the point of affectation, in the graceful arabesque of the woman's pose, far different from the severity of *Eve*. The man is loosely based on the Marsyas of antiquity, and, despite the difference in pose, the picture as a whole is probably derived from a famous painting in the Louvre, *Apollo and Marsyas* (fig. 1), the "Morris Moore Raphael," which is now attributed to Perugino.[1] The child, stuck in like a collage, is derived from the *Choir* by Donatello (fig. 2); its contrapposto attitude is a cliché to be found, for example, in *Mars and Venus,* which hung in the Louvre in Rousseau's day and was attributed to Poussin (recently reattributed to C. A. Du Fresnoy).[2] As for the animal, a kind of wolfhound, it too is treated in the same spirit of elegant stylization.

Provenance
A. Flechtheim, Dusseldorf, 1914; P. Mendelssohn-Bartholdy, Berlin, 1922; various galleries

Bibliography
Les Soirées de Paris, no. 20, January 15, 1914, repr. p. 54; W. Uhde, 1914, pl. 11; *Dodici opere di Rousseau,* 1914, repr.; W. Uhde, 1920, repr. p. 27; H. Kolle, 1922, pl. 10; Roch Grey, 1922, pl. 18; Roch Grey, 1924, repr.; A. Basler, 1927, pl. XLIX; C. Zervos, 1927, pl. 39; Roch Grey, 1943, repr. no. 27; D. Vallier, 1961, no. 76; D. Vallier, *Revue de l'art,* 1970, fig. 6; V. Nezval, 1972, p. 83; S. Monneret, 1979, p. 213, D. Vallier, 1979, repr. col. p. 33; Y. Le Pichon, 1981, p. 36, repr.

Exhibitions
Paris, 1902, no. 1538; Berlin, 1912, *XXIV Berliner Secession,* no. 227; Dusseldorf, 1913; Berlin, 1926, no. 7; New York, 1951, no. 9

1. See S. Bequin, *Raphael dans les collections françaises,* Grand Palais, Paris, 1983, no. 34. It is probable that this Perugino also furnished Picasso with the motif for his *Pipes of Pan* (1924).

2. J. Thuillier, *Revue de l'art,* 1983, no. 61, p. 52.

Fig. 1.
Vannucci, called Perugino
Apollo and Marsyas
Musée du Louvre, Paris

Fig. 2.
Donatello. *Choir* (detail)
Museo del Duomo, Florence

Fig. 3.
Gérôme. *Innocence.* 1852
Musée Massey, Tarbes, France

Another source has been suggested by Dora Vallier, the *Innocence* (fig. 3) of Gérôme, whom Rousseau so admired. Vallier notes with regard to Gérôme's painting:

> Rousseau does not "copy," he extracts elements: the man, the woman, the cupid, the animal; at the same time, however, he brings about a shift in meaning: the cupid takes part in the scene and the hind is turned into a dog, a symbol of fidelity necessary for this allegory of love with its eternal heroes Rousseau has brought together on the framework of *Innocence*. He was vainly to concentrate his efforts on the structure of the borrowed elements, the nudes, the cupid; his total inability to articulate the academic language correctly accentuated his clumsiness even further and rendered his figures grotesque. The iconography he so carefully prepared, drawn from another context, ended up as parody, whereas the surrounding greenery, which is freely worked, and the huge mass of trees, all in chromatic variation, produce the true meaning of the picture: an image of happiness (1979, pp. 31–32).

Here Rousseau has given his picture precise content. Like any true creator, he brings together iconographic elements and formal procedures to make the meaning explicit. Unspoiled nature like that of the Garden of Eden, delicate nuances, such as the flower garlands, the poses of the figures, and the choice of accessories all refer back, through Gérôme (who furnished only a schema and an idea), to earlier representations of the Earthly Paradise or the Golden Age, particularly the evocations of Poussin, which Rousseau would have seen.

Unconsciously, at least, the picture embodies the principle of the hierarchy of genres. Such allegorical scenes, which Rousseau described with the word "creation" in his account book, were valued by him much more highly than landscapes or portraits. We know from an annotated catalogue of the Salon des Indépendants that for *Happy Quartet* Rousseau was asking the particularly elevated sum of 2,000 francs.

Should we go even further in our interpretation and regard this picture as the visualization of one of Rousseau's fantasies? Does the picture represent the painter-musician, who had lost all but one of his children, practicing the flute? As for the title itself—Rousseau's own—it is a designation more usually employed for a musical group than for a couple with child and dog. The quartets that played at Rousseau's evening musicales were probably less harmonious than the one in his picture.

23 Portrait of the Artist

c. 1900–03
Oil on canvas
9⁷⁄₁₆ x 7½″ (24 x 19 cm)
Unsigned
JB 118; DV 140A
Musée du Louvre, Paris, Picasso Bequest

24 Portrait of the Second Wife of Rousseau

c. 1900–03
Oil on canvas
8⁵⁄₈ x 6¹¹⁄₁₆″ (22 x 17 cm)
Unsigned
JB 119; DV 140B
Musée du Louvre, Paris, Picasso Bequest

These two small portraits (pls. 23, 24) have always been regarded as a pair, representing the painter and his wife. This identification was made as early as 1912, when they were published in the *Blaue Reiter* almanac. The resemblance between the man's portrait and Rousseau's known self-portraits erases any doubt as to its identity and leads us to suggest a date between 1900 and 1903.

On the other hand opinions differ with regard to the identity of the woman. Certigny (1961, p. 96) believes her to be the painter's first wife. However, if the two pictures were painted at the same time, which appears likely, it is improbable that Rousseau would have made a portrait of his first wife, who died in 1888, for he had been remarried since 1899. When the two small portraits, formerly owned by Picasso, entered the Musée du Louvre collection in 1978, M.-T. de Forges wrote:

> In a painting with an allegorical subject, *The Present and the Past* (Barnes Foundation, Merion, Pa., p. 26, fig. 4), the Douanier painted himself with his second wife at his side. The resemblance between those subjects and the two small portraits in the Picasso collection is striking. However, although the painter's features differ very little from one portrait to the other, those of his companion are quite different. In full healthy bloom in the canvas in the Barnes Foundation, her expression here is one of suffering. Thus we can presume that his portrait, obviously the result of careful observation, dates from the early part of 1903, since the subject died on 14 March of that year (M.-T. de Forges, 1978).

Rousseau may well have relied on photographs. If so, however, he obviously interpreted them, altering them to suit his purpose and adding the

Pl. 23
Provenance
R. Delaunay, Paris; Galerie Bing, Paris; L. Neumann, Zurich; P. Rosenberg, Paris; P. Picasso, Paris

Bibliography
Letter from G. Apollinaire to R. Delaunay, undated (1911), published by B. Dorival, 1977, repr.; W. Uhde, 1911, fig. 4; W. Kandinsky, 1912, repr.; W. Uhde, 1914, pl. 1; A. J. Eddy, *Cubism and Post-Impressionism*, Chicago, 1914, repr. between pp. 12–13; H. Kolle, 1922, pl. 1; letter from Delaunay to an American dealer (Bourgeois Galleries?), May 30, 1923 (B. Dorival, *op. cit.*); Roch Grey, 1924, repr.; C. Zervos, 1927, pl. 66; P. Soupault, 1927, repr. frontispiece; Roch Grey, 1943, pl. 18; P. Courthion, 1944, pl. 1; M. Gauthier, 1949, pl. IV; H. Certigny, 1961, p. 96; D. Vallier, 1961, no. 83; P. Descargues, 1972, repr. col. p. 64; C. Keay, 1976, repr. no. 23; M.-T. de Forges, *Donation Picasso*, Paris, 1978, no. 34, repr.; D. Vallier, 1979, repr. col., frontispiece; Y. Le Pichon, 1981, p. 42 repr. col.

Exhibitions
Paris, 1911, no. 36; Berlin, 1912, no. 106; Berlin, 1913, no. 13; Berlin, 1926, no. 1; Basel, 1933, no. 8a

151

detail of the oil lamp, which is slightly different in each picture. In 1911 W. Uhde wrote: "There are two small portraits representing Rousseau and his wife. Neither of them is young. Devoid of any decoration or symbol the heads stand out against the background, but a lamp, unobtrusively set next to them, suggests calm domesticity and happiness far more evocatively than a home painted in all its details could have done."

Rousseau's predilection for self-portraits, whether as a solitary figure (see *Myself, Portrait-Landscape,* pl. 5) or as part of a scene (as in the Barnes canvas), reveals an evident narcissism. Rousseau is a man with a high opinion of himself and one desirous of leaving behind a flattering and respectable self-image. This is also shown in photographs taken in his studio, in which he always strikes a complacent pose.

The technique employed in these two pictures is somewhat unusual: the paint itself is thick and brilliant, with delicate light-colored nuances. The woman's portrait is thicker and more worked. This manipulation of the surface, unusual in Rousseau's oeuvre, brings him close to the Impressionists.

After having belonged for some time to Robert Delaunay and having been selected by Kandinsky for inclusion in the *Blaue Reiter* almanac, both portraits were purchased by Picasso who, according to Roland Penrose, kept them "beside him permanently" (Penrose, 1958; 1973, p. 148).

"Visible in a photograph by Edward Quinn taken at La Galloise (Vallauris), [the self-portrait] is hanging on the wall next to its partner. Near the Rousseau family Picasso had hung one of his own works—*Mother and Child*—and the reproduction of a female portrait by Cranach. A real relationship, due, it seems to me, to a certain shared rigidity, was thus oddly established between all those portraits" (Lemoyne de Forges, 1978).

Pl. 24
Provenance
R. Delaunay, Paris; Galerie Bing, Paris; L. Neumann, Zurich; P. Rosenberg, Paris; P. Picasso, Paris

Bibliography
Letter from G. Apollinaire to R. Delaunay, undated [1911], published by B. Dorival, 1977, repr.; W. Kandinsky, 1912, repr. (French ed. 1981, p. 243, repr.); letter from R. Delaunay to an American dealer (Bourgeois Galleries?), May 30, 1923 (B. Dorival, *op. cit.*); Roch Grey, 1924, repr.; A. Salmon, 1927, repr. no. 66; C. Zervos, 1927, pl. 67; P. Soupault, 1927, pl. 3; Roch Grey, 1943, pl. 19; M. Gauthier, 1949, pl. V; H. Certigny, 1961, pp. 96–97; D. Vallier, 1961, no. 84; C. Keay, 1976, repr. no. 24; M.-T. de Forges, *Donation Picasso,* Paris, 1978, no. 35, repr.; D. Vallier, 1979, p. 34, repr. col.; Y. Le Pichon, 1981, p. 43, repr. col.

Exhibitions
Paris, 1911, no. 37; Berlin, 1912, no. 107; Berlin, 1913, no. 4; Berlin, 1926, no. 2; Basel, 1933, no. 8b

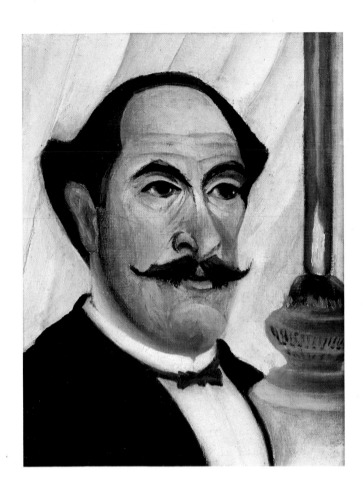

25 Child with Puppet

1903
Oil on canvas
39⅜ x 31⅞" (100 x 81 cm)
Signed lower right: *Henri Rousseau*
JB 25; DV 145
Kunstmuseum, Winterthur
Paris exhibition only

Compared to Rousseau's three other known portraits of children (see pl. 34), this picture is noteworthy because of the variety and vivacity of its colors and the evident effort made to lend animation to the subject. The child is holding a figure of Punch, with which it makes a complete contrast. Blond, plump, impassive, the subject is wearing only a white gown.

> As usual in Rousseau's work, there are formal analogies between typologically disparate elements. Here they seem to take on special symbolic importance. The sturdy child in white lifting up the dress to hold flowers displays legs like tree trunks, rooted to the ground, and the hair is like the open leaves that hang above and around it. The colors of the flowers the child carries are repeated in the costume of the puppet, but there become harsher as well as assuming flattened angular forms. Behind the figures stand two trees, one spare, one full and flourishing. The child and the puppet are easily seen as images of the natural and the mechanical, of innocence and experience, youth and age—the child the father of the man. We are also reminded of fairy-tale encounters between children and toys brought to life—emblems of the adult world in the control of children (John Elderfield, 1976, p. 36).

Here, Rousseau has managed to create one of his most fascinating images. In his hands a commonplace and banal theme—the child may have been derived from an advertisement, the Punch from a playing card—has taken on an element of mystery.

Provenance
K. F. von Freyhold, Freiburg; Dr. W. Reinhart, Winterthur, 1944; G. Reinhart, Winterthur, 1951; Mme O. Reinhart, Winterthur, 1955

Bibliography
W. Uhde, 1921, pp. 32, 56, 86, repr. p. 30; Roch Grey, 1924, unnumbered; A. Basler, 1927, pl. 8; A. Salmon, 1927, repr. no. 35; P. Soupault, 1927, pl. 13; Roch Grey, 1943, repr. no. 13; P. Courthion, 1944, pl. VII; D. Cooper, 1951, pp. 17–41, repr. col. p. 33; *Du*, Zurich, 1952, no. 2, repr. col. on cover; D. Vallier, 1961, p. 91, 141, repr. col. p. 73; H. Certigny, 1961, pp. 226–27; R. Huyghe, *Sens et destin de l'art*, Paris, 1967, repr. p. 236; L. and O. Bihalji-Merin, 1971, repr. col. no. 28; F. Johansen, *Henri Rousseau: Morfars rejse til Vetskoven*, Copenhagen, 1972, pl. 1; P. Descargues, 1972, repr. col. p. 103; C. Keay, 1976, repr. no. 34, p. 136; J. Elderfield, *European Master Paintings from Swiss Collections: From Post-Impressionism to World War II*, New York, 1976; S. Monneret, 1979, pl. 212; D. Vallier, 1979, repr. col. p. 44; Y. Le Pichon, 1981, repr. col. p. 63; "Der Vater der naiven Malerei," *Pan*, Offenburg, 1982, repr. col. p. 11

Exhibitions
Paris, 1903, no. 2140; Basel, 1933, no. 26

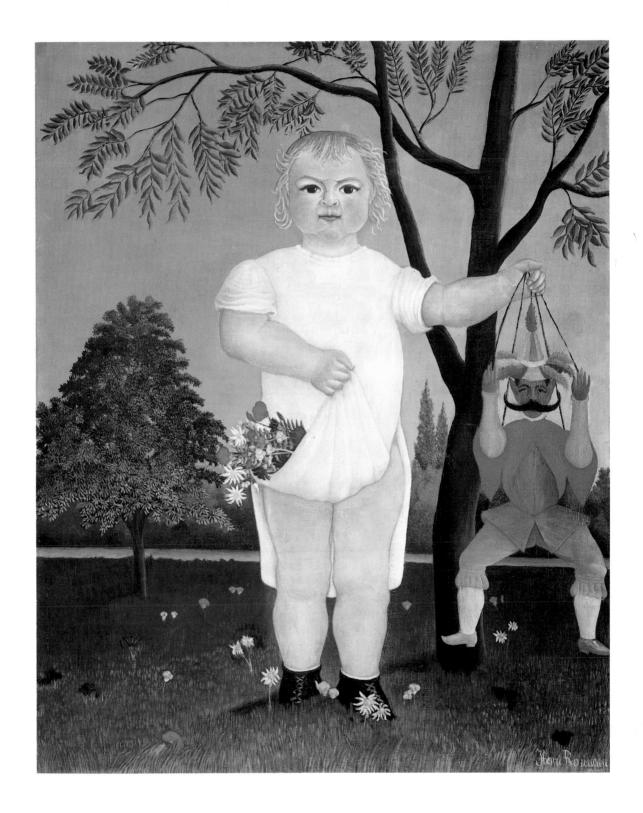

26 House on the Outskirts of Paris

c. 1902
Oil on canvas
13 x 18¼" (33 x 46.4 cm)
Signed lower right: *H. Rousseau*
JB 153; DV 137A
Museum of Art, Carnegie Institute, Pittsburgh, acquired through the generosity
of the Sarah Mellon Scaife family, 1969

In his suburban landscapes Rousseau varied formulas and his disposition of elements to a much greater degree than did his contemporaries or immediate predecessors. A sketch for this picture (DV 137B, private collection) was made on the site and was for many years in the possession of the German sculptor Renée Sintenis (1888–1965), while the painting was Max Weber's first purchase from Rousseau in 1908.

Here Rousseau has difficulty in solving the problem in perspective posed by a street receding toward the horizon when seen on the axis. If we compare the completed picture with the sketch, we can see that Rousseau transformed the usual greenery of the Parisian suburbs into a kind of tropical foliage. S. Leonard notes that the technique employed here is similar to that found in the Jungle paintings. She compares Rousseau to Van Gogh in his ability to endow houses and elements of the landscape with an almost human life: "It is actually a portrait of a house." The site and placement of the scenic elements remind us of Cézanne's canvases during his time in Pontoise and Auvers (1872–80), when a white house, a village street, and a few trees were all he needed to construct a painting. Rousseau, however, may have had Corot in mind, as in *Ville d'Avray, The Cabassud Houses* (fig. 1).

Provenance
Max Weber, Great Neck, N.Y.; Mrs. Max Weber, Great Neck, N.Y.

Bibliography
M. Weber, preface to catalogue of the exhibition, Little Galleries of the Photo-Secession. New York, November–December 1910, reprinted in *Camera Work,* 1911, p. 49; W. Uhde, 1911, fig. 3; letter from A. B. Davies to Max Weber, January 1, 1913, published by S. Leonard, 1970, p. 52; W. Uhde, 1914, pl. 22; H. Kolle, 1922, pl. 16; D. Catton Rich, 1942 and 1946, p. 44; J. O'Connor, Jr., "Henri Rousseau," *Carnegie Magazine,* December 1942, p. 221; R. H. Wilenski, 1953, p. 2; D. Vallier, 1961, no. 88; S. Leonard, 1970, p. 66, repro. p. 67; D. Vallier, 1979, repr. col. p. 70

Exhibitions
New York, 1910; New York, 1913; no. 982; Chicago and New York, 1942, unnumbered; Boston, 1942; Pittsburgh, 1942; New York, 1951, no. 11

Fig. 1.
Corot. *Ville d'Avray: The Cabassud Houses.* 1865–70
Musée du Louvre, Paris

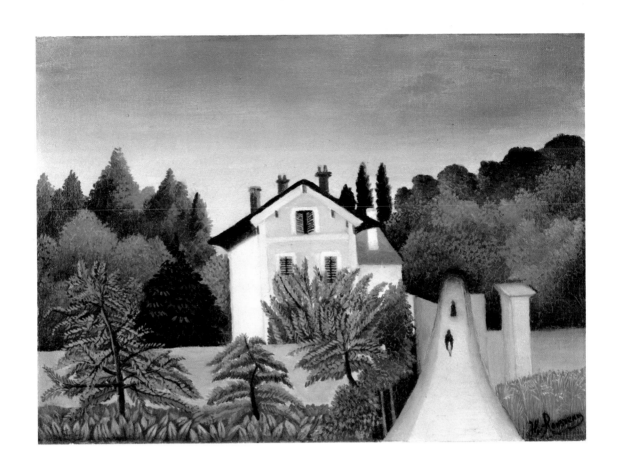

27 The Mill at Alfort

Before 1905
14½ x 17½" (36.8 x 44.5 cm)
Signed lower left: *Henri Rousseau*
JB 20; DV 165A
Private collection

The Mill at Alfort is another landscape of the Paris suburbs showing a stretch of water, varied foliage, and several charmless buildings. The conventional but craftsmanlike layout probably derived from a postcard, which has also been used in a hasty sketch of the same subject (DV 165B, private collection; see Le Pichon, p. 121).

As in *The Chair Factory* (pl. 18), which depicts a crossroads in the Paris suburbs (Alfortville), Rousseau here deploys the regular slope of the various roofs in such a way as to suggest depth. The forms and colors stand out against the mass of greenery in which he has set them, lending animation to his composition. The lines of perspective converge toward a single point, following handbook principles that Rousseau was rarely to apply so faithfully. The device of painting a clearly legible sign on a building is used in several other suburban views, including *The Chair Factory*.

Works such as this, in which Rousseau conquers or circumvents technical difficulties created by his lack of training, shares something of the spirit of the Barbizon painters and their followers, whose works filled the Salons in his day.

Provenance
J. Walter, Paris, 1961; W. Josten, New York

Bibliography
M. Georges-Michel, *De Renoir à Picasso: Les peintres que j'ai connus*, Paris, 1954, pp. 84–85; C. Keay, 1976, repr. no. 30; Y. Le Pichon, 1981, p. 121, repr. col.

Exhibitions
New York, 1963, no. 32

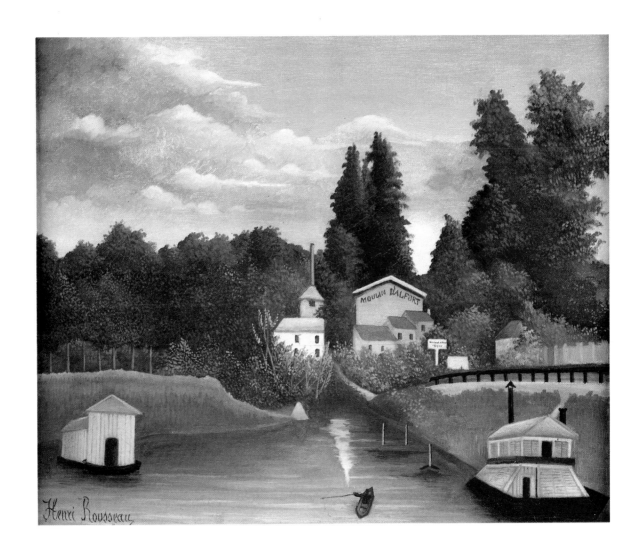

28 The Wedding

1904–05
Oil on canvas
64¼ x 44⅞" (163 x 114 cm)
Signed lower right: *Henri Julien Rousseau*
JB 27; DV 167
Musée de l'Orangerie, Paris, Collection Jean Walter–Paul Guillaume

This picture, although one of the most famous of Rousseau's works, is almost never mentioned in the abundant literature on his sources and working methods. Neither the identity of the subjects, obviously portraits, nor the photograph from which, from all the evidence, Rousseau derived his inspiration has been uncovered.

The composition is one of Rousseau's most ambitious: a large-scale group portrait in which the faces are all fully individualized, the species of trees clearly differentiated. As in *Old Junier's Cart* (pl. 39), a dog resembling a cutout figure is placed in the foreground. The force lines in the composition form the shape of a Saint Andrew's cross, the center of which falls precisely at the tie in the bride's sash. The schema is approximately the same as, although more static than, that of *The Football Players* (pl. 45). Through their placement and the decreasing width of their trunks and leaves, the trees suggest a kind of perspective, as though Rousseau were attempting to dissociate himself from the painted backcloths traditionally employed by photographers in group portraits. By contrast, the motionless subjects are all on the same plane, their outlines flat and without depth, in an arrangement that brings to mind Manet's *The Balcony*, which, thanks to the Caillebotte bequest, had been hanging in the Musée du Luxembourg since 1896 and was then known to Rousseau. The dog in the foreground also figures in Manet's picture. X-rays have revealed several important repaintings: some faces are turned toward the bride; the dress of the grandmother, at right, once extended down to the dog; and the bride's veil was painted over the other figures once they had been finished. Such a procedure—neglecting to provide for elements that are later to be added to a picture—is typical of the working methods of an artist with little academic experience. Some have identified the man on the right in the second row as Rousseau himself.

Provenance
S. Jastrebzoff (Serge Férat), Paris; Galerie Percier, Paris; P. Guillaume; J. Walter

Bibliography
F. Lepeseur, *La Renovation esthétique*, June 1905; A. Soffici, 1910; letter from S. Jastrebzoff to R. Delaunay published by B. Dorival, 1977, p. 19; G. Apollinaire, "Les Indépendants," *L'Intransigéant*, April 20, 1911, reprinted in *Chroniques d'Art 1902–1918*, 1960, p. 209; W. Uhde, 1911, pl. 8; W. Kandinsky, 1912 (French ed. 1981, rep. p. 231); W. Uhde, 1914, pl. 8; H. Kolle, 1922, pl. 5; Roch Grey, 1924, repr.; A. Basler, 1927, pl. 3; A. Salmon, 1927, no. 34; P. Soupault, 1927, fig. 17; C. Zervos, 1927, p. 93; A. Basler, 1929, pl. 41; *Les Arts à Paris*, no. 16, January 1929, repr.; R. Huyghe, 1933, p. 188, fig. 236; Roch Grey, 1943, pp. 48–49, pl. 3; P. Courthion, 1944, pl. XX; W. Uhde, 1949, repr. p. 32; M. Gauthier, 1949, pl. XV; H. Perruchot, 1957, repro. pl. VII; J. Bouret, 1961, p. 50; H. Certigny, 1961, repr. facing p. 246; D. Vallier, 1961, pl. 98; L. and O. Bihalji-Merin, 1971, nos. 35, 37, 65; A. Jakovsky, 1971, repr.; P. Descargues, 1972, repr. col. p. 96; R. Nacenta, 1973, pl. 2; D. Larkin, 1975, repr. col. no. 19; I. Niggli, 1976, p. 47, fig. 74; C. Keay, 1976, p. 36, repr. col. no. XVII; F. Elgar, 1980, repr. col. no. 36; Y. Le Pichon, 1981, pp. 38–39, repr. col.

Exhibitions
Paris, 1905, no. 3589; Paris, 1911, no. 1; Paris, 1923, no. 5; New York, 1931, no. 00; Basel, 1933, no. 31; Paris, 1937, no. 6; Paris, 1944, no. 3; Venice, 1950, no. 9; New York, 1951, no. 13; Paris, 1961, no. 75

Fig. 1.
Dagnon-Bouveret.
The Wedding Party at the Photographer's
(detail)
Musée des Beaux-Arts, Lyons

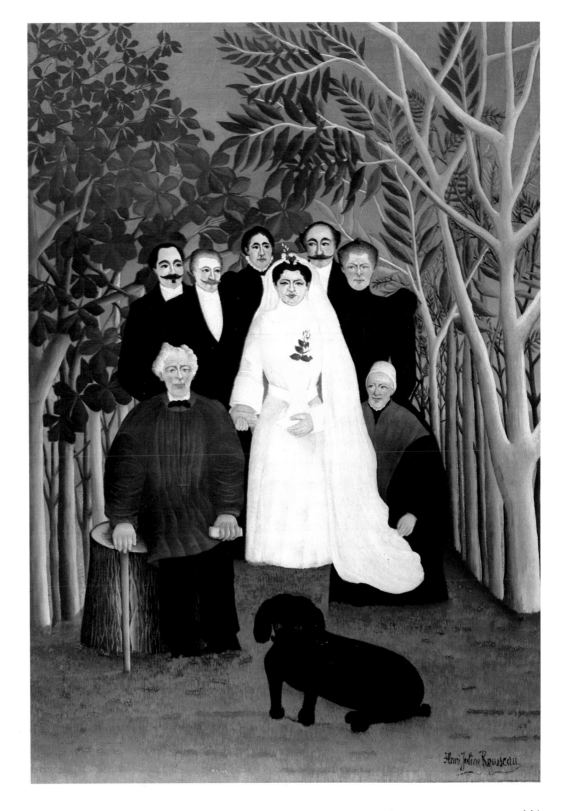

29 Eve

c. 1905–07
Oil on canvas
24 x 18″ (61 x 46 cm)
Signed lower right: *Henri Rousseau*
JB 180; DV 164
Kunsthalle, Hamburg

The first impression is one of clumsiness or, at the least, a certain awkwardness in the treatment of the nude. It is a theme Rousseau rarely dared undertake, even though the Salons to which he was an assiduous visitor were filled with nudes, the pretext for which was in those days provided by mythology, allegory, or the Bible. Eve's body with its heavy contours is roughly drawn. Rousseau placed her in the very center of the canvas, probably with the help of a plumbline, and attempted to suggest contours and depth through the use of shading and halftones.

Once again Rousseau demonstrates more invention than métier, and he is more at ease in his treatment of the foliage, where, unlike his anatomical renderings, the deformation is more easily viewed as intentional, a stylization. The extremely varied vegetation is akin to that in other Jungle paintings, and, at the top of the picture, there is a reddening sky. The same red had been used for the fruits that grow on a tree that has leaves totally unlike those of any apple tree. A pink and blue serpent twined around the trunk holds in its mouth the fruit of temptation.

The picture has countless forerunners, and there is no lack of analogies. Le Pichon compares it to *The Charmer* (fig. 1), a painting by Alexandre-Jacques Chantron (1842–1918), a pupil of Bouguereau; the *Charmer* was shown at the 1898 Salon and reproduced in *Panorama–Salon,* 1899. The female figure in that picture is holding a palm branch in her left hand and the serpent is entwined around her right wrist. Although there are many direct iconographic analogies between Chantron's painting and this work of Rousseau's, their significance is clearly different, and a comparison of the Chantron with the Douanier's *Snake Charmer* (pl. 39) would seem more apt. The present picture would seem to be another of those works in which the same set of partners can be brought together for antithetical iconographic purposes. Rousseau, familiar with the usual depictions of events in the Bible, here shows us sacred history's first woman on the verge of succumbing to sin, faced with the evil, tempting serpent—the antithesis of Chantron's *Charmer,* who is a pagan, sensual savage taming serpents devoid of hostility or guilty meaning. We might also compare *Eve* to *Happy Quartet* (pl. 22), which represents a family in the Golden Age surrounded by beneficent nature.

Provenance
P. Mendelssohn-Bartholdy, Berlin

Bibliography
W. Uhde, 1914, pl. 10; H. Kolle, 1922, pl. 9; A. Basler, 1927, pl. 48; P. Soupault, 1927, pl. 33; C. Zervos, 1927, pl. 63; Roch Grey, 1943, no. 103; P. Courthion, 1944, pl. XIX; D. Vallier, 1961, no. 132; L. and O. Bihalji-Merin, 1971, no. 48, detail no. 77; P. Descargues, 1972, repr. col. p. 121; Y. Le Pichon, 1981, p. 201, repr. col.

Exhibitions
Paris, 1912, no. 7 (*Eve au Paradis*); Berlin, 1926, no. 6

Fig. 1.
A. J. Chantron. *The Charmer*
Reproduced *Panorama Salon* (1899)

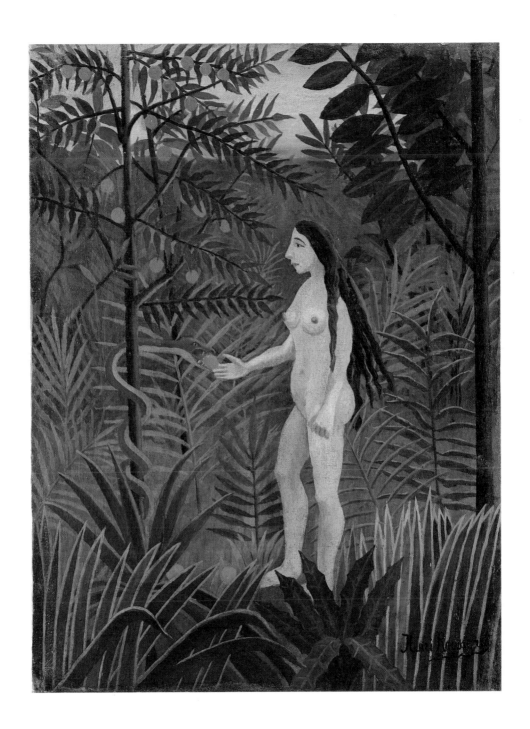

30 Jungle with Lion

1904–10 (?)
Oil on canvas
15¼ x 18½″ (38.7 x 46.8 cm)
Signed lower left: *H. Rousseau*
JB 145; DV 163
Private collection, New York

This painting is one of the rare Jungles in a small format. It contains only one animal, which resembles a panther as well as a lion, and is probably derived from a photograph or book illustration. The vegetation is laid out in horizontal planes with a certain dryness, whereas the long grasses in the foreground are given some animation.

D. Vallier considers this picture a study that should be dated earlier than the large Jungles of 1905–10. S. Leonard suggests it may be the *Forest Scene* (no. 88) of the Second Post-Impressionist Exhibition held at the Grafton Gallery London in 1912—the first occasion on which Rousseau was exhibited in England—and that Arthur B. Davies and Walt Kuhn had tried to borrow it for the Armory Show, New York, in 1913.

Provenance
W. Uhde; L. Rosenberg, 1910; A. Vollard, Paris, c. 1920; P. Guillaume, Paris; Valentine Gallery, New York; L. P. Bliss, New York, 1928; The Museum of Modern Art, New York, 1931–68

Bibliography
C. Zervos, *Cahiers d'art,* 1926, p. 230; A. Salmon, 1927, pl. 29; A. Basler, *Henri Rousseau,* 1927, pl. 36; C. Zervos, 1927, pl. 6; *Art News,* May 23, 1931, p. 20; *Die Kunst für Alle,* September 1931, p. 383; D. Catton Rich, 1942 and 1946, p. 40; W. Uhde, 1948, repr. no. 32; D. Vallier, 1961, no. 150

Exhibitions
Chicago and New York, 1942, unnumbered; Pittsburgh, 1942, no. 9; Paris, 1961, no. 72

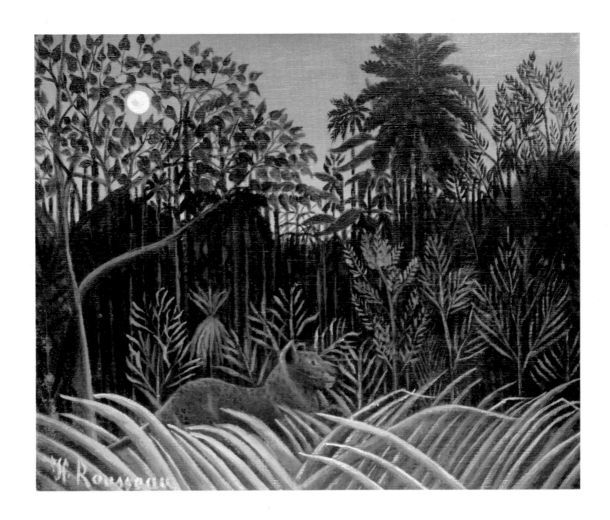

31 The Hungry Lion

1905
Oil on canvas
79⅜ x 118¾″ (201.5 x 301.5 cm)
Signed lower right: *Henri Rousseau*
JB 26; DV 172
Private collection

"The hungry lion, throwing himself upon the antelope, devours him; the panther stands by awaiting the moment when he, too, can claim his share. Birds of prey have ripped out pieces of flesh from the poor animal that sheds a tear!" —Rousseau (pamphlet for the Salon d'Automne, 1905)

This picture, therefore, tells a story, with characters like those in an illustration in a picture book, whereas the story in the other Jungle paintings is merely combat, usually without any hint of the outcome. This was Rousseau's largest picture to date; its size would only be equaled by that of *The Dream* (pl. 66). Perhaps he felt that this outsized format also called for the presence of many actors; indeed, it is unlikely that an explosion of plants alone would have enlivened such a large surface.

Here Rousseau has used his whole repertory of effects in a cleverly laid-out composition for which no preliminary sketches exist. The principal group is inspired by stuffed and mounted animals he could have seen in the Paris Museum of Natural History (see Y. Le Pichon, *Les Peintres du bonheur*, Paris, 1983, p. 130). He has placed the lion at the focal point of the composition, while the other animals—the panther, two birds, and a kind of misshapen bear (which can be made out vaguely in the foliage at the left)—are placed on the arc of a circle at whose highest point a lurid sun emerges mysteriously from a background of clouds or mountains.

As in the other Jungle paintings, the vegetation is extremely varied and set on a single plane, like a tapestry background, a similarity that contemporary critics did not fail to note. What is unusual here is the presence of grasses in the foreground, the glimpse of sky showing through the trees, and the insertion of brownish autumn leaves amidst the dense foliage (perhaps to suggest the name of the Salon for which the picture was undoubtedly painted).

Rousseau rarely—as he does here—imputed cruelty to the lion, most often depicting it in its stereotypical role as the serene "King of Beasts." Lions even appear in his urban scenes (*Liberty Inviting Artists to Take Part in the Twenty-second Exhibition of the Société des Artistes Indépendants*, pl. 32, and *Representatives of Foreign Powers Arriving to Hail the Republic as a Sign of Peace*, pl. 35). Here he carefully absolves it, however, by stating that it is hungry and that the birds had been the first to attack the antelope. "Above the lion that Rousseau never saw in Mexico, where there are none, is the owl from the Jardin des Plantes, ancient symbol of the demonic" (A. Malraux, *Les Voix du silence*, p. 507).

Provenance
A. Vollard, Paris, 1906

Bibliography
L. de Fourcault, *Le Gaulois*, October 17, 1905; *L'Evénement*, October 18, 1905; Furetières, *Le Soleil*, October 18, 1905; "Le Salon d'Automne," *Illustration*, November 4, 1905, repr. p. 294; C. Morice, *Le Mercure de France*, December 1, 1905; D. Catton Rich, 1942, pp. 38–39; Roch Grey, 1943, repr. no. 126; P. Courthion, 1944, pl. XIII; A. Malraux, *Les Voix du silence*, Paris, 1951, detail p. 507; D. Vallier, 1961, p. 74, repr. col. p. 75; M. Hoog, "La Direction des Beaux-Arts et les Fauves, 1903–1905," *Art de France*, 1963, III, pp. 364–66, n. 3; D. Vallier, *Revue de l'art*, 1970, fig. 13, detail; H. Certigny, 1971, no. 2, p. 31, inset; L. and O. Bihalji-Merin, 1971, no. 47; P. Descargues, 1972, pp. 112, 127–28, repr. p. 119; P. Descargues, *Le Journal de l'Art moderne (1884–1914)*, Geneva, 1974, repr.; C. Keay, 1976, no. 42, p. 119, repr. col. p. 112, 127, 128; R. Alley, Oxford, 1978, repr.; D. Vallier, 1979, repr. col. p. 91; S. Monneret, 1979, p. 213; Y. Le Pichon, 1981, pp. 151–153; Y. Le Pichon, *Les Peintres du bonheur*, Paris, 1983, p. 130

Exhibitions
Paris, 1905, Salon d'Automne, no. 1365; Basel, 1933, no. 32; Paris, Salle Royale, and Zurich, 1937, no. 6

Because of its size—and perhaps because of its subject—this picture did not go unnoticed. For several years the critics had been paying attention to Rousseau. Some were gradually becoming sympathetic, while others, even though they did not like his work, were aware of his originality. Furetières wrote, for example: "Monsieur Rousseau, the respectable retired customs man, occupies his leisure time by painting. And here he is, with all his naiveté, his outlook derived from the Japanese masters, on his way to becoming a decorator" (*Le Soleil*). The same idea was expressed by Thiébault-Sisson, the critic and close friend of the elderly Claude Monet: "It is an enlarged Persian miniature transformed into a vast stage setting, not, indeed, without merit" (*Le Temps*). However, Gustave Geffroy, another great friend of Monet's, does not appear to have understood Rousseau's work when he wrote: "I cannot bring myself to comment on the pitiful foliage and the poor story of the Lion and the Antelope of Monsieur Rousseau, hung, with questionable humor, in the place of honor close to Ingres" ("Le Salon d'Automne," *Le Journal,* October 17, 1905). As for Louis Vauxcelles, he noted: "Monsieur Rousseau has the rigid mentality of the Byzantine mosaicists, the tapestry-makers of Bayeux; it's a pity that his technique is not equal to his candor. His frieze is far from negligible; I will agree that the antelope in the foreground of his picture should not have been given a cod's snout, but the red sun and the bird set amongst the leaves bear witness to a rare decorative ingenuity" (*Gil Blas,* October 1905).

Was it the presence of this huge picture in the 1905 Salon d'Automne that led Louis Vauxcelles to coin his famous *mot,* "Donatello among the wild beasts" (*"Donatello parmi les fauves"*), that gave Fauvism its name? We know that it was inspired in part by the proximity of the paintings of Matisse and his friends to the Quattrocento-style bust of Albert Marque; there is virtually nothing, however, to indicate that Rousseau's canvas was in the same room. Vauxcelles's text preceded the appearance of the double-page spread reproducing Rousseau's picture in *L'Illustration* (fig. 1), where it was accompanied by "non-Fauvists" such as Cézanne, Vuillard, Alcide Le Beau, and Guérin; whereas *The Hungry Lion* could have played a small part in suggesting the term "Fauve" to Vauxcelles, the sobriquet could have been justified only by the high color present in the art of Matisse and his friends.

Fig. 1.
"Le Salon d'Automne,"
L'Illustration, no. 3271
(November 4, 1905), p. 294

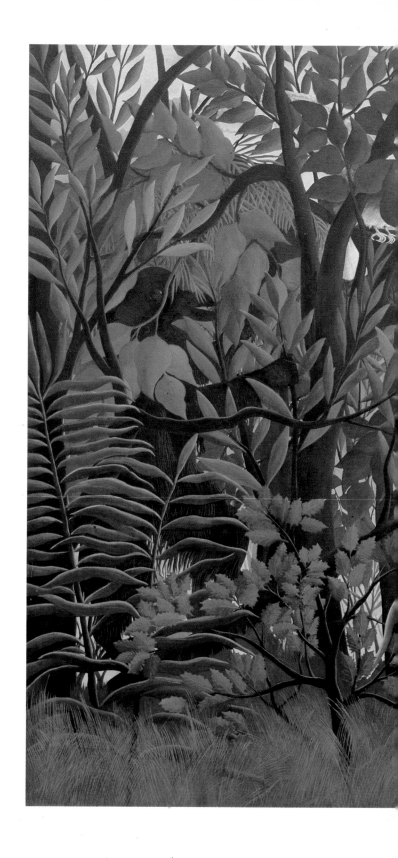

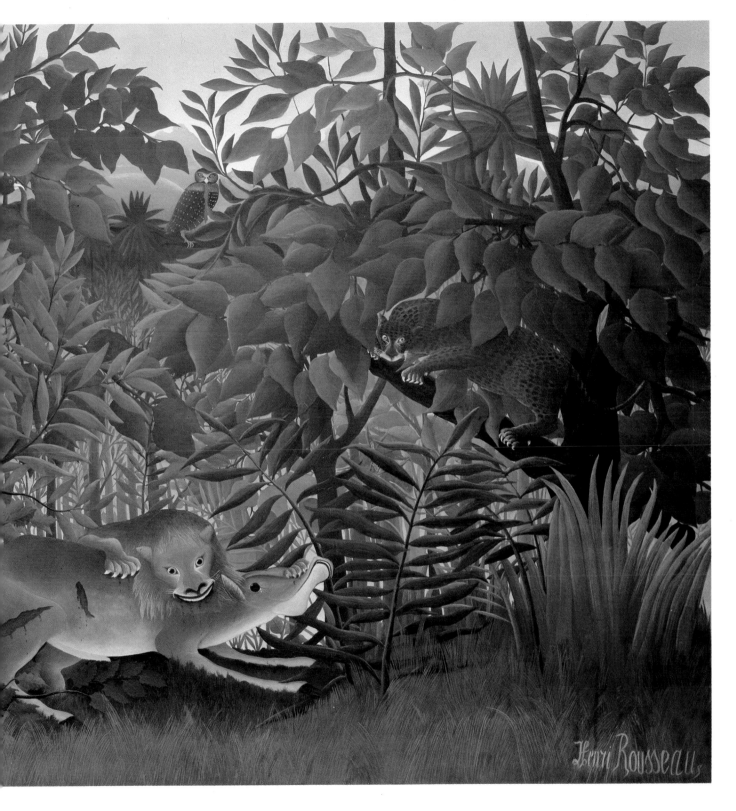

32 Liberty Inviting Artists to Take Part in the Twenty-second Exhibition of the Société des Artistes Indépendants

1906
Oil on canvas
68¾ x 46½" (175 x 118 cm)
Signed lower left: *Henri Rousseau*
JB 29; DV 185
National Museum of Modern Art, Tokyo

O glorious painter of the Republican soul
Thy name is the banner of proud Independents
—Apollinaire

This picture is one of the most accomplished demonstrations of the free association of the real with the imaginary in Rousseau's art: starting with observed or borrowed elements, he manipulates them to realize his private vision.

Without the Salon des Indépendants—which had been created in 1884 to enable those artists who were turned away from the official Salons freely to show their works—Rousseau would never have been seen by the public, nor is it likely that his work would ever have developed. We can therefore understand his desire to pay tribute to an institution to which he felt indebted. Rousseau depicts the contributors to the Salon (we note several women) and suggests their numbers. Some are holding their works under their arms; others, as did Rousseau himself on many occasions, carry them in a handcart or wagonette; they are converging on the wide-open entrance to the Salon, whose bright color

Provenance
G. Courteline, Paris, 1906; P. Mendelssohn-Bartholdy, Berlin

Bibliography
Furetières, *Le Soleil*, April 12, 1906; F. Lepeseur, *La Rénovation esthétique*, April 1906, reprinted in C. Chassé, "Les Fausses gloires; D'Ubu Roi au Douanier Rousseau," *La Grande Revue*, April 1923, pp. 177–212; H. Kolle, 1922, pl. 8; C. Zervos, 1927, pl. 41; P. Soupault, 1927, pl. 20; Roch Grey, 1943, no. 29; H. Perruchot, 1957, pl. VIII; R. Shattuck, 1958, pp. 74, 76; O. Bihalji-Merin, 1959, p. 55; repr. p. 163; J. Bouret, 1961, pp. 20–21; H. Certigny, 1961, p. 160, repr. p. 231; D. Vallier, 1961, pp. 76, 89, 136, repr. col.; M. Hoog, 1963, III, p. 366; J. Golding, *Le Cubisme*, Paris, 1965, pp. 267–68; D. Vallier, *Revue de l'art*, 1970, p. 96, detail fig. 125; L. and O. Bihalji-Merin, 1971, no. 39; A. Jakovsky, 1971, repr.; P. Descargues, 1972, pp. 107–08 repr. col. pp. 54, 60, 107; C. Keay, 1976, repr. col. no. XVIII; S. Monneret, 1979, p. 213; D. Vallier, 1979, col. repr. p. 67; Y. Le Pichon, 1981, p. 197, col. repr.

Fig. 1.
Coysevox. *Fame*. 1701–02
Tuileries Garden, Paris

Fig. 2.
Bartholdi. *The Lion of Belfort*
Place Denfert-Rochereau, Paris

171

acts as a kind of magnet. In the foreground two characters, one bearded and the other very tall (Signac?), are chatting. The only significant exceptions to this regularity are a soldier and a man with a child who seem to be turning away toward the left. The trees and glassed-in building suggest the City of Paris hothouses on the Champs-Elysées where the Salon des Indépendants was then held. The scene is enlivened by flags with the colors of France and the City of Paris, whose pennant was also to be found on the cover of the Salon catalogue. To these Rousseau has added other flags, both real (the United States, Great Britain) and imaginary.

The canvas is clearly laid out according to the Golden Section, and in the sky that fills the majority of the space, there soars the allegorical figure of Liberty who, with her trumpet, looks more like the traditional figure of Fame. Rousseau has drawn inspiration from a stereotype in classical sculpture (fig. 1) and for that matter has given a similar attitude to the figure of *War* (pl. 9).

At the bottom center is a lion, obviously drawn from Bartholdi's Lion of Belfort, or, more precisely, from the reproduction located at the Place Denfert-Rochereau in Paris (fig. 2). Both the statue and the name of the Place, which commemorate respectively the Siege of Belfort in 1870–71 during the Franco-Prussian War and the colonel who defended that town, have a national significance to which Rousseau would hardly have been indifferent. The lion, here a symbol of courage and the spirit of independence, not of cruelty, is holding between his paws a rather eclectic list of Salon contributors: "Men such as Les Valton, Signac, Carrière, Willette, Luce, Seurat, Ortiz, Pissarro, Jaudin, Henri Rousseau, etc., etc., are thy emulators."

Exhibitions
Paris, 1906, no. 4367; Berlin, 1926, no. 10; New York, 1931, no. 14; New York, 1951, no. 14; Paris, 1961, no. 44; New York, 1963, no. 43; Paris, 1964, no. 16

33 The Merry Jesters

c. 1906
Oil on canvas
57⅜ x 44⅝″ (145.8 x 113.4 cm)
Signed lower left: *Henri Julien Rousseau*
JB 179; DV 180
Philadelphia Museum of Art, the Louise and Walter Arensberg Collection
New York exhibition only

This picture instantly poses conundrums. What is the explanation for the overturned milk or baby's-feeding bottle, the gardening tool or back-scratcher, and the animals placed with such meticulous care, staring out at the viewer as if posing for their photographs? All of these clues, along with the title chosen by Rousseau, suggest the dénouement of some tragi-comic episode, the tale of a kidnapped child or errant animal trainer. Turning from the depiction of wild beasts in combat, Rousseau is probably introducing a bit of humor here, moving toward the unexpected and perhaps the absurd. The manner in which the plants open out, the stage lighting, and the anthropomorphism of the faces all suggest that Rousseau represents the end of a pantomime.

Once again, however, the fantastic inventiveness is locked into a rigid format that extends out from a central axis to cover every surface; thus the bird perched in the tree is exactly balanced by the branch of white foxglove on the left, the only flower depicted. The greenery in this picture is especially opaque, and the sky can be glimpsed only at the very top of the canvas. The viewer is stopped by the animals, grimacing or laughing, but also by the wall of vegetation that forms such an impenetrable curtain. In its precise placement and density, the greenery is not unlike Cézanne's most intense undergrowths, several of which had been shown in Salons in previous years. Although Cézanne's concern for the expression of volume and space was foreign to Rousseau, he shared Cézanne's sense of harmony between adjacent tonalities; this picture is still almost monochromatic, as was *The Hungry Lion,* but the greens are more nuanced and the areas of color somewhat more numerous.

The ambiguous and even unsettling character of this picture was clearly described by Philippe Soupault. Unlike André Breton, his associate in the Surrealist movement, Soupault took note of the Douanier's work at a very early stage, recognizing its affinities with his own interests:

> In spite of the oddness of the situation *The Merry Jesters* is not amusing, even less astonishing; it leaves, however, a unique impression of freshness....

> The deep forest all around the merry and agile quadrumanes is full of sounds and harbors within its vines the lives of innumerable insects and huge wild beasts; we can hear the twittering of birds, the hissing of serpents, the cry of some wounded animal; and some even more disturb-

Provenance
R. Delaunay, Paris; L. and W. Arensberg, New York, c. 1918

Bibliography
Letter from R. Delaunay to J. C. Bernard-Rousseau, March 18, 1911; letter from S. Jastrebzoff to R. Delaunay, undated; letter from F. Fénéon to R. Delaunay, March 27, 1914, all published by B. Dorival, 1977, pp. 18, 20, 23, repr. p. 19; R. Delaunay, "Henri Rousseau le Douanier," *L'Amour de l'art,* November 1920, repr. p. 229; P. Soupault, *L'Amour de l'art,* 1926, repr. p. 334; A. Basler, 1927, pl. 24; D. Catton Rich, 1942, p. 587, repr. p. 48; Roch Grey, 1943, no. 94; P. Courthion, 1944, pl. XVIII; J. Cassou, 1960, repr. p. 80; D. Vallier, 1961, repr. col. p. 103; A. Breton, 1965, p. 52; L. and O. Bihalji-Merin, 1971, fig. 49; P. Descargues, 1972, repr. p. 118, detail p. 120; C. Keay, 1976, repr. col. no. XIX; S. Monneret, 1979, p. 213; D. Vallier, 1979, repr. col. p. 72; Y. Le Pichon, 1981, p. 166, repr. col.

Exhibitions
Paris, 1906, Salon d'Automne, no. 1499; Odessa, 1909, no. 605; Kiev, 1910, no. 605; St. Petersburg and Riga, 1910, no. 462; Paris, 1911, no. 20; Berlin, 1913, *Erster deutscher Herbstsalon,* no. 1; New York and Chicago, 1942, unnumbered; New York, 1963, no. 44

ing sounds raise through the mass of the flora a drawn-out echo like the sound of a bell on the sea.

Terror, perched among the entwined branches, crouched in the tall grass, hides among the tree trunks and spreads across a sky heavy with the dark glow that announces the arrival of twilight and night (Soupault, *Les Feuilles libres,* August-September 1922).

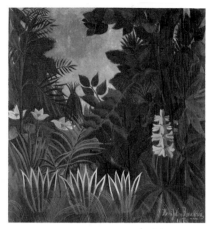

Fig. 1.
Rousseau. *Exotic Landscape.* 1909
National Gallery of Art, Washington, D.C.

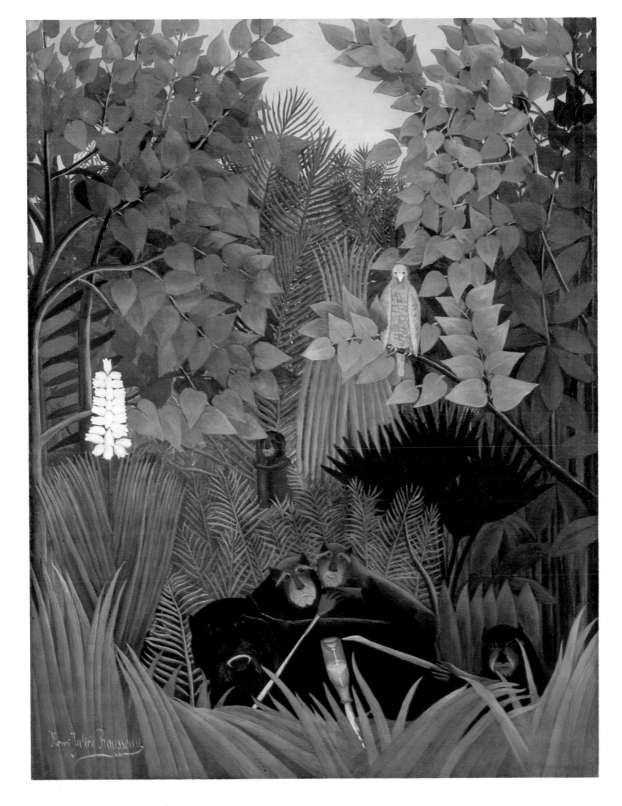

34 Child with Doll

c. 1904—05
Oil on canvas
26½ x 10½" (67 x 52 cm)
Signed lower right: *H. J. Rousseau*
JB 169; DV 207
Musée de l'Orangerie, Paris
Collection Jean Walter—Paul Guillaume

This child, like so many of Rousseau's subjects, is posed facing straight ahead. The same frontalism, the same planar reductions (Rousseau had studied Gauguin) can be found in the face, collar, and the doll and daisy the child holds. The regularity of the white polka dots on the dress destroys any attempt at modeling, as it also did in the case of Bonnard's subjects at the height of the Nabi period (*Le corsage à carreaux,* 1892, Musée d'Orsay, Paris, Palais de Tokyo).

Rousseau always had great difficulty in placing his subjects on the ground. Dora Vallier, however, notes some progress here compared to the *Enfant aux rochers* (DV 86) in the National Gallery of Art, Washington, D.C. The child's legs appear to be stuck into a carpet of grass strewn with tiny flowers that are reminiscent of the late medieval tapestries with which Rousseau was familiar. The decreasing size of these white, red, and black flowers, along with the gradual shading of the increasingly darker green, suggests distance and perspective. The important use of the color red is rare in Rousseau's work, and is even totally absent from some of his canvases.

The features are treated with a clumsy care. They are the same, albeit a bit older, as those of the model in *Child with Puppet* (pl. 25), which Dora Vallier has suggested can be identified with a picture shown at the 1903 Salon des Indépendants. If such is the case, the present picture can be dated c. 1904—05. We know only four portraits of children by Rousseau. In addition to the three already mentioned, he painted a seated baby (fig. 1).

Provenance
W. Uhde, Paris; Uhde Sale, Paris, May 30, 1921, no. 58; J. Quinn, New York; P. Guillaume; Mme J. Walter

Bibliography
W. Uhde, 1911, p. 47; W. Uhde, 1914, pl. 6; H. Kolle, 1922, pl. 4; C. Zervos, 1927, pl. XIX; A. Basler, 1927, pl. 11; W. George, undated (c. 1929), p. 55, repr. p. 58; Roch Grey, 1943, repr. no. 11; C. Ferratton, "Laurier et topinambours: Une Fort Simple Explication de l'art exotique du Douanier Rousseau," *Arts,* September 9, 1949, p. 1, repr. p. 5; D. Vallier, 1961, no. 105; C. Roger-Marx, "Les Enchantements du Douanier Henri Rousseau à la Galerie Charpentier: Un Ensemble jamais réuni," *Le Figaro littéraire,* November 11, 1961, repr.; S. Leonard, 1970, n. p. 20; L. and O. Bihalji-Merin, 1971, p. 22, repr. col. no. 29; D. Larkin, 1975, pl. 26; C. Keay, 1976, no. 48; F. Elgar, 1980, fig. 42; Y. Le Pichon, 1981, p. 62; repr. col.

Exhibitions
New York, 1931, no. 11; Basel, 1933, no. 35; Paris, 1937, no. 5; Paris, 1944, no. 13; Venice, 1950, no. 7; New York, 1951, no. 12; Paris, 1961, no. 13; Rotterdam and Paris, 1964, no. 13

Fig. 1.
Rousseau. *Portrait of a Baby.* c. 1905
Private collection
This photograph belonged to Rousseau; the inscription is in his hand

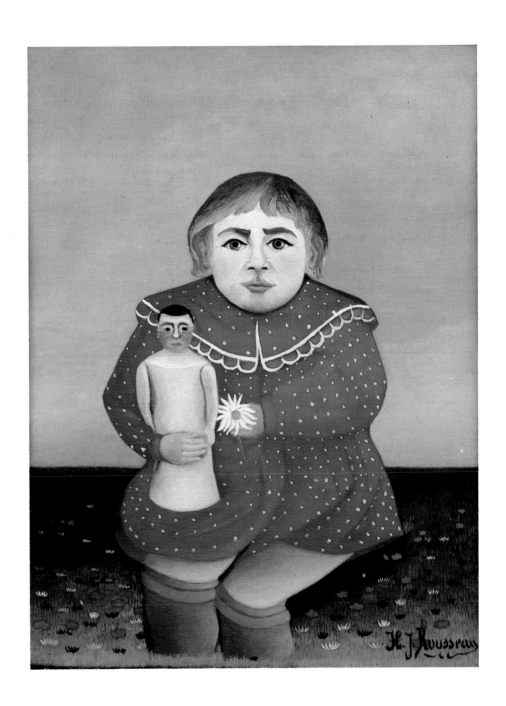

35 Representatives of Foreign Powers Arriving to Hail the Republic as a Sign of Peace

1907
Oil on canvas
51⅝ x 63⅜" (130 x 161 cm)
Signed and dated lower right: *Henri J. Rousseau 1907*
JB 171; DV 194
Musée du Louvre, Paris, Picasso Bequest

Even if Rousseau was inspired by photographs of official ceremonies, this scene is imaginary and the Heads of State assembled here (identified below) never found themselves together in Paris at the same time.

Rousseau was already an adult when the Second Empire came to an end; he lived through the Commune and the difficult birth of the Third Republic; according to Certigny, he had become interested in politics; here, he pays tribute not so much to country or nation as to the Republic, as is clearly indicated by the mottoes around the border (*Paix, Travail, Liberté, Fraternité*) and by the figure wearing the Phrygian cap of the Revolution. The "foreign powers" (most of which were monarchies at the time) had snubbed the young Republic for some time, and its reacceptance in the "concert of nations" was a gradual process. The allegorical character of the scene, suggesting lengthy political and diplomatic maneuvers, is clearly indicated by the simultaneous presence of six Presidents of the Republic.

Rousseau did not confine himself solely to friends and allies of France; he included, among others, both Kaiser Wilhelm II of Germany and Emperor Franz-

Provenance
A. Vollard, Paris; P. Picasso, Paris, c. 1910

Bibliography
Furetières, *Le Soleil,* April 2, 1907; A. Alexandre, *Le Figaro,* September 30, 1907; A. Soffici, 1910; P. Soupault, *Feuilles libres,* August-September 1922; C. Zervos, *Cahiers d'art,* 1926, repr. p. 229; C. Zervos, 1927, pl. 89; P. Soupault, 1927, pl. 23; Roch Grey, 1943, no. 28; A. Soffici, 1950; M. Weber, transcription of interview with G. S. Gruber, 1958, p. 225, published by S. E. Leonard, 1970; H. Certigny, 1961, pp. 268–69; D. Vallier, 1961, p. 308; J. Golding, *Le Cubisme,* Paris, 1965, pp. 267–68; P. Cabanne, 1975, p. 286; C. Keay, 1976, no. 50, p. 149; M.-T. de Forges, *Catalogue Donation Picasso,* 1978, no. 36, p. 84; D. Vallier, 1979, repr. col. p. 40; Y. Le Pichon, 1981, pp. 198–200, repr. col.

Exhibitions
Paris, Salon des Indépendants, 1907, no. 4284; Paris, 1911, no. 117 (*Les Souverains*)

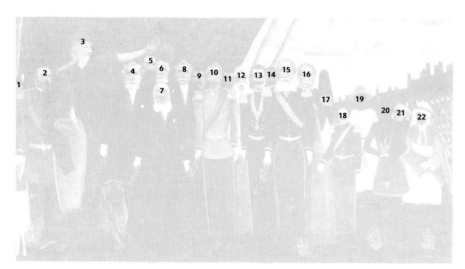

The following figures can be identified:
1. A Scotsman
2. Edward VII, King of England (1901–10)
3. The Republic
4. President Armand Fallières (1906–13)
5. President Sadi Carnot (1887–94)
6. President Emile Loubet (1899–1906)
7. President Jules Grévy (1879–87)
8. President Félix Faure (1895-99)
9. President Casimir-Périer (1894–95)
10. Nicholas II, Czar of Russia (1894–1917)
11. Peter I, King of Serbia (1903–18)
12. Franz-Joseph, Emperor of Austria (1848–1916)
13. Kaiser Wilhelm II of Germany (1888–1918)
14. George I, King of Greece (1863–1913)
15. Leopold II, King of Belgium (1865–1909)
16. Menelik II, Emperor of Ethiopia (1889–1910)
17. Muzaffar-ed-Din, Shah of Persia (1896–1907)
18. Victor Emmanuel III, King of Italy (1900–46)
19. Madagascar
20. Equatorial Africa personifications of the
21. Indochina French colonies
22. North Africa

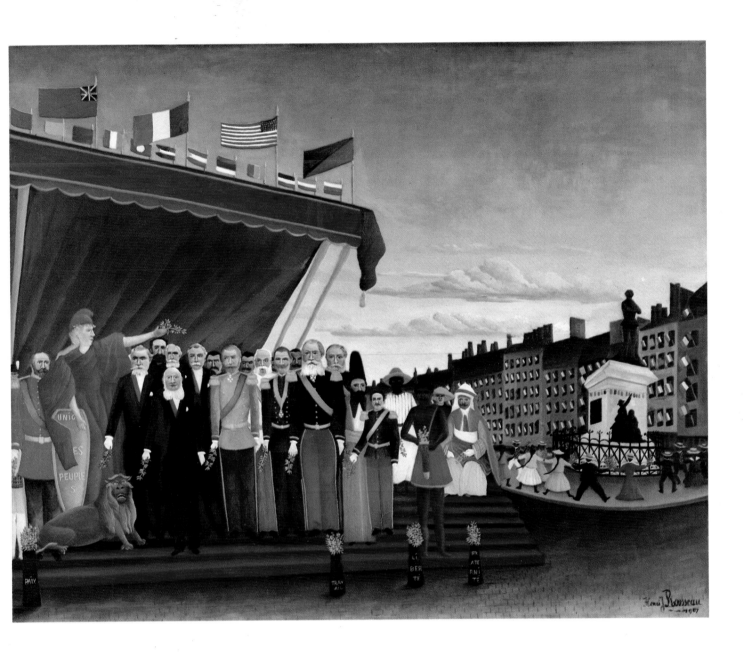

Joseph of Austria. Rousseau also wanted to celebrate France's peaceful intentions: each personage bears an olive branch in his hand. The flags too give the celebration an international flavor and significance: above the reviewing stand the French flag is flanked by those of the United States, Great Britain, and the colors of the City of Paris; elsewhere—intermingled with imaginary concoctions—can be seen the flags of Belgium, Italy, Japan, and others. As for the smaller dancing figures, the blacks and the Annamites, they recall France's colonial role.

Are the houses hung with bunting and the monument on the right there only to suggest the public nature of the ceremony? Y. Le Pichon has identified the statue as that of French freethinker Etienne Dolet (1509–1546). Guilbert's statue had been erected in 1889 on the boulevard Saint-Germain, Paris, near the place Maubert where Dolet had been burned at the stake. We can make out the haut-relief representing *The City of Paris Protecting Freedom of Thought*. The statue was torn down during the Occupation. Did Rousseau, a devoted Left Bank *flâneur*, choose it solely because he liked its appearance, because he owned a postcard of it, or because, two years after the passage of the law on the separation of Church and State, he wanted to refer to the religious controversies of the Third Republic?

The vivacity and diversity of the colors used to depict the uniforms, medals, and sashes and the contrast between the stiff official personalities and the dancing figures all give this canvas a lively character that is for the most part absent from the *Hundred Years of Independence* (1892, DV 54) and *La Carmagnole* (1898, DV 64), two other canvases in which he expressed his republican and patriotic feelings.

Laboratory tests reveal that Rousseau laid out his composition beforehand with ruled lines, and later overpainted it many times. He had sketched in other heads that he eventually wiped out, but he painted in the black wearing a loincloth *over* other figures he had already put in. Similarly, the reviewing stand was painted on top of the sky.

The picture was a great success at the 1907 Salon des Indépendants, as Rousseau himself recounts: "I could not get out of the hall there were so many people who came up to shake my hand, who crowded around me to congratulate me. And do you know why? It is because it was just at the time of the Hague Conference, and yet that hadn't even entered my mind" (interview with A. Alexandre, *Comoedia,* March 19, 1910). Rousseau was obviously sincere, since the Salon des Indépendants had opened March 20 and submissions would have been accepted several weeks before that; the second International Conference on the Settlement of International Disputes at The Hague, convened at the urging of the United States President Theodore Roosevelt, was held from June 15 to October 18, 1907.

36 The Snake Charmer

1907
Oil on canvas
66½ x 74⅜" (169 x 189 cm)
Signed and dated lower right: *Henri Julien Rousseau 1907*
JB 34; DV 200
Musée d'Orsay, on loan to the Musée National d'Art Moderne, Paris

Although it is easy to recognize elements of this picture in other compositions, their special presence and combination here contribute to this canvas's exceptional quality. This is one of the few jungle paintings in which the figure is not reduced to the proportion of a figurine. It is also, aside from *The Flamingos* (pl. 37), the only one that depicts fresh water, whether river or spring. Exceptionally, man and animals live peacefully together. Equally unusual are the plausible dimensions and proportions of the plant life. Everything, including the very large format, points to Rousseau's desire to realize an ambitious, well thought-out work.

According to Sonia Delaunay, the inspiration for the painting was provided by the elder Madame Delaunay, to whose home her son Robert had brought Rousseau. From a trip to the Indies, she had brought back exotic tales she recounted to visitors to her Paris apartment on the avenue de l'Alma (today the avenue George V). The apartment was filled with plants: Rousseau's recollection of the varieties to be found there was perhaps superimposed on the tropical flora at which he was already an expert. Robert, in his desire to assist the elderly painter he so admired, suggested that his mother commission a painting from him.

Whatever its actual historical inspiration, the painting has gone beyond mere anecdote to become part of the rich Occidental tradition of myth, that of the Earthly Paradise, Orpheus, and the noble savage. Although even older sources can be found, the second half of the nineteenth century furnishes a superabundance of illustrations for such themes in literature of every type including travel narratives found in popular illustrated books and periodicals. The specific borrowings for this or that detail in the end have less significance than *The Snake Charmer's* kinship with representations of an exotic and marvelous world suggesting vast distances in space as well as time. In those days of explorations, colonial expeditions, and intensive spread of religious missionary activity, the image of the savage, the creature to be "civilized" but in whom one could still nostalgically discover a kind of "innocence," is an ambiguous one, both in *Snake Charmer* and in the work of Rousseau's exact contemporary, Gauguin, who was entranced by the South Sea's mystery. True, his fauna (horses, dogs, pigs, peacocks) are domesticated; yet in Gauguin's works and in *The Snake Charmer,* the character submerged in tropical flora has a significance that is more incantatory than anecdotal. Rousseau could not help but have been aware of Gauguin's paintings, which were to be seen in the Parisian Salons, and here, as elsewhere, he reveals that he was more sensitive to them than is generally supposed.

Provenance
Madame Delaunay; R. Delaunay; J. Doucet; J. Doucet bequest to the Louvre, 1936

Bibliography
W. Uhde, 1911; G. Apollinaire, "Les Indépendants," *L'Intransigéant,* April 20, 1911, reprinted in *Chroniques d'art (1902-1908),* 1960, p. 163; Letter from F. Fénéon to R. Delaunay, March 3, 1914, published by B. Dorival, 1977, p. 23, detail repr. p. 21; H. Kolle, 1922, pl. 30; Roch Grey, 1924, repr.; P. Fierens, *Journal des débats,* June 24, 1927; A. Basler, 1927, pl. 19; C. Zervos, 1927, pl. 82; A. Salmon, 1927, no. 27; P. Soupault, 1927, pl. 27; R. Cogniat, "Figures de Collectioneurs: Jacques Doucet," *Formes,* February 1930, pp. 10–11, repr. p. 11; W. George, "Le Miracle Rousseau," *Les Arts à Paris,* July 1931; W. George, 1931, repr. p. 6; W. Uhde, 1933, fig. 238; A. Lhote, 1936, p. 148; Roch Grey, 1943, repr. no. 29; P. Courthion, 1944, pl. XVI; W. Uhde, 1949, repr. p. 60; M. Gauthier, 1949, pl. XVIII; A. Malraux, *Les Voix du silence,* Paris, 1951, detail repr. p. 511; H. Perruchot, 1957, repr. pl. X; X. de Langlais, *La Technique de la peinture à l'huile,* Paris, 1959, pp. 274, 279, repr. facing p. 326; J. Bouret, 1961, pp. 49–50; J. Cassou, E. Langui, N. Pevsner, 1961, p. 115, repr. col. pl. X; M. Hoog, "La Ville de Paris de Delaunay: Sources et développement," *La Revue du Louvre,* 1965, no. 1; p. 32; A. Dasnoy, 1970, repr. p. 22; L. and O. Bihalji-Merin, 1971, repr. col. no. 52; P. Descargues, 1972, p. 117; detail repr. col., pp. 130–31; V. Nezval, 1972, p. 83; R. Nacenta, 1973, repr. p. 361; C. Keay, 1976, repr. col. no. XX; D. Vallier, 1979, repr. col. p. 69; Y. Le Pichon, 1981, pp. 183–84, 202–03, repr. col; F. Chapon, *Mystères et Splendeurs de Jacques Doucet,* Paris, 1984, pp. 283, 293; repr. facing p. 225.

Exhibitions
Paris, 1907, Salon d'Automne, no. 1491; Paris, 1911, no. 31; Berlin, 1913, no. 2; Zurich, 1937, no. 7a

As we have noted, many of Rousseau's canvases can be grouped in contrasting or complementary pairs. As it happens *The Snake Charmer* and *War* (pl. 9), two pictures whose features are in sharp contrast, hang today in the same museum: the peaceful black woman surrounded by the animals she has tamed is the antithesis of the white-robed woman, the bearer of death, surrounded by malevolent beasts. In *Snake Charmer* the static composition of large masses and strong verticals contrasts with that of *War*, with its dynamic play of floating forms. Here, pale blue and the green of hope are almost the only colors, with the exception of the whitish star—sun or moon—which is completely lacking in red. There is no red at all in the canvas, either in the sky or in any of the flowers; in *War*, red and black, the colors of blood and death, predominate. Is it merely happenstance that these colors—along with white—are also the colors of the flag of the hereditary enemy, the German Empire?

Upon the death of the elder Madame Delaunay, the picture came into the possession of Robert and Sonia Delaunay and remained part of their collection until 1922, when they were forced to sell it. Robert Delaunay, well aware of the exceptional importance of the work, whose provenance gave it sentimental value, offered it to Jacques Doucet on the condition that he leave it to the Musée du Louvre at his death (M. Hoog, 1965, p. 32). The arrangement was made by André Breton, who was serving at the time as Doucet's adviser; it was embodied in a written agreement the text of which was recently published by François Chapon:

> I acknowledge having purchased from Monsieur Robert Delaunay his picture by Rousseau entitled *The Snake Charmer* for the sum of 50,000 francs, which I shall pay to him in five monthly installments of 10,000 francs each, beginning on June 15, 1922, and month by month thereafter, the last payment falling on October 15, 1922.
>
> The picture will remain in the possession of Monsieur Delaunay until payment is completed.
>
> I shall assume the expense of having the picture insured.
>
> I also undertake to bequeath this picture to the Musée du Louvre and, during my lifetime, I further undertake to obtain an assurance that such a bequest will be accepted.
>
> Paris, May 9, 1922
> Jacques Doucet

(François Chapon, *Mystères et splendeurs de Jacques Doucet,* Paris, 1984, p. 283.)

In a highly unusual procedure, Doucet began in 1925 to petition the national museums to agree to accept this bequest in advance; the request was acceded to in June-July 1925. However, the national museums did not take possession of the work until 1935, several years after Jacques Doucet's death in 1929, since Madame Doucet had wanted to keep the picture in her possession along with Seurat's sketch for *Circus* (1890–91), which Doucet had also bequeathed to the Louvre.

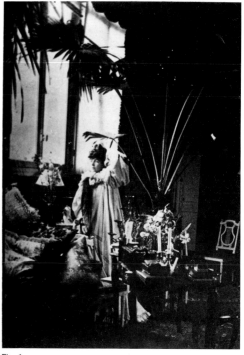

Fig. 1.
Mme Delaunay (the mother of Robert) in her salon

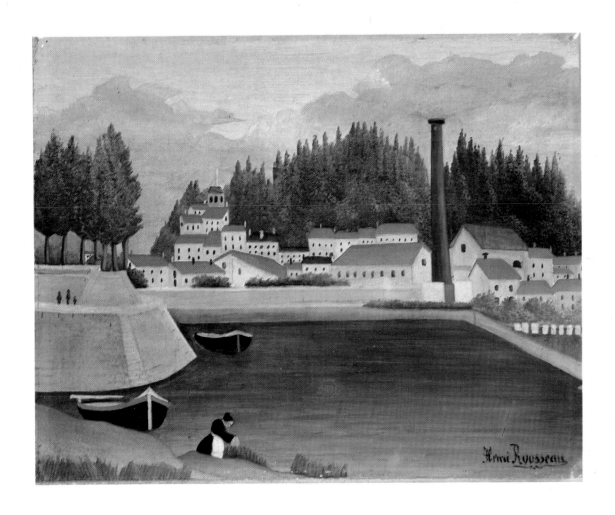

of the house at the right and is echoed variously in the red roofs of the other buildings, culminating in the gray roof atop the stack of Gothically piled-up dwellings at the left. The jetty or quay at the left repeats in larger format the variants in negative image of the water's form at play in the shapes of the houses themselves. The colors and curves of the woman's figure are emphasized by the colors and rounded forms of the two boats, while the assertive chimney at the right balances the weight of clustered figuration at the left. There is a disarming playfulness in the way the chimney is fancifully echoed in the tiny figures standing on the jetty at left, as there is in the staccato notes of the laundry on the line at right, which reverberates the squares of white on either side of the chimney.

Village near a Factory has the exquisiteness of enamel painting, and its spirit recalls Andre Salmon's verdict on Rousseau: "He is immortally clad in that fresh innocence that characterizes medieval poetry."

39 Old Junier's Cart

1908
Oil on canvas
38¼ x 50⅞" (97 x 129 cm)
Signed and dated lower left: *Henri J. Rousseau 1908*
JB 42; DV 212
Musée de l'Orangerie, Paris, Collection Jean Walter–Paul Guillaume

Here we have evidence of one of those neighborly friendships we know played such a large role in Rousseau's life. Claude Junier (once thought to be Juniet) owned and operated, with his wife Anna, a grocer's shop on rue Vercingétorix (no. 74), where it intersected with rue Perrel, on which Rousseau lived. The neighbors became friends and, in 1908, Rousseau painted a family portrait, probably at their request. We see, in the front seat of the cart, Claude Junier and Rousseau himself and, behind them, Madame Junier with her niece on the right and her nephew's child on her lap.

Claude Junier, who was also a horse trainer, was especially proud of his white mare, Rosa. We note also the three dogs. Such a wealth of domestic animals is a rarity in Rousseau's work.

This picture is one of those for which Rousseau's photographic sources are known. Two photographs have often been reproduced (most recently by Yann Le Pichon, 1981, p. 58). One of them, bearing traces of paint, belonged to Robert Delaunay (fig. 1); the other is in the J. J. Sweeney collection; a third (fig. 2) was previously printed in a private publication (A. Labrosse, 1961) and in the Catalogue of the Musée de l'Orangerie Paris (1984, no. 110). All three photographs were taken without moving either the cart or the camera. Similarly the mare retains the same position in all three; on the other hand, the people and the dogs have changed position in each one.

These photographs provided Rousseau with a schema that he could fill in as he wished (Dora Vallier believes that he also used a pantograph). Thus, he suppressed the tree that appears in the photograph behind the horse's head and rearranged most of the greenery. As for the humans, they are portrayed in poses that do not correspond to any of the three known photographs. It is possible that there were others, or that Rousseau just arranged the scene to suit his taste. Although the people are stiffly grouped, the overall composition is unusually open. The most important lines lie on the vertical and horizontal axes.

According to the valuable testimony of Max Weber (quoted by Daniel Catton Rich, 1946, p. 52), who saw the picture when it was in progress, the last portion Rousseau painted was the area underneath the cart, where he planned to put the black dog. "When Weber asked him if he didn't think that, in view of the space available, the dog might not be too large, Rousseau looked at his canvas thoughtfully and replied that that was the way it had to be."

D. Vallier goes on to observe that Rousseau commits his greatest "error" in perspective, "the misplaced spokes and hub of the wheel," in the area hidden by the dog in Delaunay's photograph. There are several other areas where

Provenance
Mr. Junier; P. Rosenberg, Paris; A. Villard, Paris; P. Guillaume; Mme J. Walter

Bibliography
A. Soffici, 1910; W. Uhde, 1914, pl. 14; *Les Soirées de Paris*, no. 20, January 15, 1914, repr. p. 63; H. Kolle, 1922, pl. 17; Roch Grey, 1924, repr.; F. Lehel, *Notre Art dément*, Paris, 1926, pl. 25; A. Salmon, 1927, repr. p. 34; A. Basler, 1927, pl. 9; C. Zervos, 1927, pl. 3; *Les Arts à Paris*, no. 13, June 1927, repr. p. 7; P. Soupault, 1927, p. 37, fig. 32; A. Basler, 1929, pl. 37; W. George, undated (c. 1929), p. 55, repr. p. 590; J. Combe, "Un Douanier Rousseau au XVIIe siècle," *L'Amour de l'art*, no. 12, December 1931, p. 487, fig. 38; W. Uhde, *L'Amour de l'art*, 1933, p. 189, fig. 237; R. Huyghe, 1939, pl. 94; D. Catton Rich, 1942, pp. 50–52, repr. p. 53; Roch Grey, 1943, pl. 6; P. Courthion, 1944, pl. XIII; D. Catton Rich, 1946, p. 52; W. Uhde, 1949, repr. p. 38; M. Gauthier, 1949, pl. XXI; S. Delaunay, "Images Inédites du Douanier," *Les Lettres françaises*, August 1, 1952; W. Kees, "On a Painting by Rousseau," *Receuil de poèmes*, San Francisco, 1956; H. Perruchot, 1957, pl. XI; J. Bouret, 1961, p. 43; D. Vallier, 1961, pl. 136; H. Certigny, 1961, pp. 330–31, repr. facing p. 327; T. Tzara, "Le Rôle du temps et de l'espace dans l'oeuvre du Douanier Rousseau," *Art de France*, no. 2; 1962, p. 236; L. Cheronnet, "La Légende dorée du Douanier Rousseau," *Médecine, Peintures*, no. 74, October 1964, pl. X; M.-T. de Forges and G. Allemand, "La Collection Jean Walter–Paul Guillaume," *Revue du Louvre*, no. 1, 1966, p. 57, fig. 6; "Des révélations sur le Douanier Rousseau," *Montmartre*, no. 1, undated, pp. 4–5, repr. p. 1; D. Vallier, *La Revue de l'art*, 1970, pp. 96–97, fig. 21; L. and O. Bihalji-Merin, 1971, pp. 25, 66, repr. col. fig. 34; detail no. 36; P. Descargues, 1972, repr. col. p. 97; V. Nezval, 1972, p. 81; R. Nacenta, 1973, no. 3; repr. col.; D. larkin, 1975, repr. col. no. 25; C. Keay, 1976, p. 34, repr. col. no. XXVII; I. Niggli, 1976, fig. 78, p. 48; D. Vallier, 1979, repr. p. 81; F. Elgar, 1980, fig. 50; Y. Le Pichon, 1981, pp. 67, 58, repr. col. pp. 56–57

Exhibitions
Paris, 1911, no. 46; London, 1926, no. 8; New York, 1931, no. 12; Basel, 1933, no. 51; Paris, 1937, no. 1; Paris, 1944, no. 4; Venice, 1950, no. 16; New York, 1951, no. 12; Paris, 1961, no. 76; Paris, 1964, no. 51

traditional perspective goes awry, for example, in his positioning of the human subjects in the body of the cart, where they are carefully posed facing front, as in *The Wedding* (pl. 28). On the other hand, Rousseau alluded to depth perspective by means of the edge of the sidewalk and the paved gutter cutting diagonally across the lower part of the composition.

Fig. 1.
The Junier Family. Photograph taken by Anna Junier, 1908.
Used by Rousseau, it still bears traces of paint

Fig. 2.
Photograph (retouched) by Anna Junier

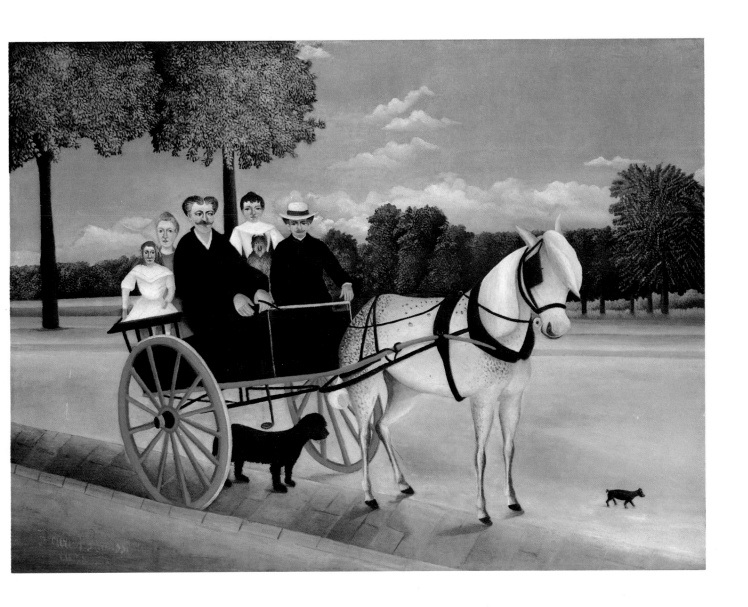

40 The Banks of the Oise

c. 1908
Oil on canvas
18¼ x 22" (46.2 x 56 cm)
Signed lower left: *H. Rousseau*
JB 159; DV 173
Smith College Museum of Art, Northampton, Massachusetts, Purchase, 1939

Far from the birds, the flocks, the village life,

. . .

Amidst the tender hazel copses

. . .

What could I not quaff from the young Oise?

Loin des oiseaux, des troupeaux, des villageoises,

. . .

Entourée de tendre bois de noisetiers,

. . .

Que pouvais-je boire dans cette jeune Oise?

Rimbaud

Provenance
Blank, Hofheim, Germany; Suermondt, Drove;
Voemel, Dusseldorf

Bibliography
Letter from Rousseau to Max Weber, August 21, 1908,
reproduced in S. Leonard, 1970, pp. 82–83; W. Uhde,
1911, fig. 14; W. Uhde, 1914, pl. 35; W. Uhde, 1921,
p. 48, repr.; Roch Grey, 1924, repr; C. Zervos, 1927,
pl. 92; P. Soupault, 1927, pl. 18; A. Basler, 1927, pl. 26;
A. Salmon, 1927, repr. no. 23; "Northamption:
A Rousseau Acquisition," *Art News*, October 21, 1939,
p. 14, repr.; R. H. Wilenski, 1940, p. 2; Sheldon Cheney,
The Story of Modern Art, New York, 1941, p. 367,
repr.; J. O'Connor, Jr., "Henri Rousseau," *The
Carnegie Magazine*, December 1942, p. 209;
D. Catton Rich, 1942 and 1946, pp. 39, 44, repr. p. 42;
Roch Grey, 1943, no. 48; *Smith College Museum of
Art Bulletin*, June 1947, p. 1; George Heard Hamilton,
*Forty French Pictures in the Smith College Museum of
Art*, 1953, no. 34, pp. VII and XIV, repr.; D. Vallier,
1961, p. 85, repr. col.; C. Keay, 1976, no. 45, repr.;
R. Alley, *Portrait of a Primitive: The Art of Henri
Rousseau*, Oxford, 1978, pl. 28; Deborah C. Phillips,
"Optimistic Folk," *Art News*, March 1982, repr.
col. p. 209.

Exhibitions
Berlin, 1926, no. 25; Chicago and New York, 1942,
unnumbered; New York, 1963, no. 41.

Among Rousseau's landscapes of the Ile de France, there are few in which the décor consists solely of vegetation. Rousseau has a repertory of stereotyped objects (including trees, buildings, clouds) which he arranges and juxtaposes according to whim, but always differently. Often he adds one or two unusual elements, in this instance the haystacks (perhaps an unconscious homage to Claude Monet) and the two sailboats whose hulls and curved sails remind us of the boats Rousseau could have seen in Signac's paintings (for example, *Sloops under Sail Entering the Harbor at Concarneau*, fig. 1, exhibited at the 1892 Salon des Indépendants). The hull, sail, and pennon make up the French flag, whose three colors seem to have flowed naturally from his brush. The curves of the river's banks, echoed in the supple outline of the trees and the mountainlike clouds, introduce life and dynamism into this somewhat somber nature scene.

We have retained the traditional title of this picture, which goes back as far as Wilhelm Uhde (1921). It is likely that this is the picture mentioned in a 1908 letter from Rousseau to Max Weber (see S. Leonard, pp. 82-83). Whether sketched from nature or not, this graceful landscape is one of the rare instances of an escape by Rousseau to the more countrified suburbs and river that had so inspired the Impressionists thirty years earlier.

Fig. 1.
Signac. *Sloops under Sail Entering the Harbor at Concarneau* (detail). 1891

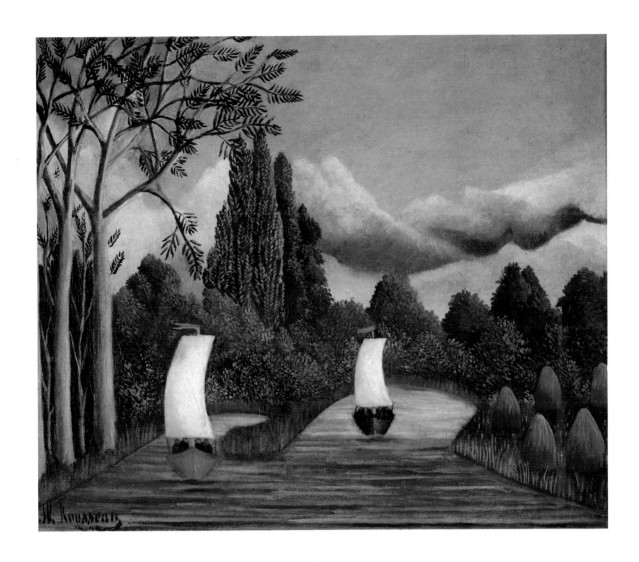

41 View of the Bridge of Sèvres

1908
Oil on canvas
31⅞ x 39½″ (81 x 100 cm)
Signed and dated lower left: *Henri Rousseau 1908*
JB 197; DV 215A
Pushkin State Museum of Fine Arts, Moscow

Rousseau has somewhat "rearranged" the landscape of Sèvres and the hill of Saint Cloud near Paris to suit his own taste and has come up with a composition in which the elements are particularly well balanced. Rousseau often used a bridge to hold his composition together. Here, the trees, houses, boats, and various buildings are placed with considerable ease and felicity. The picture, with *The Chair Factory* (pl. 18), is the largest suburban landscape extant. Here Rousseau manipulates the red hues of the autumn foliage and also—which is even more rare—the nuances and reflections in the water.

Present in the sky are representations of three vehicles for "violating the virgin azure": a balloon, a dirigible, and an airplane. Rousseau is paying tribute to progress, whose achievements he was one of the first bold enough to include in his pictures (Eiffel Tower, factory smokestacks, metal bridges, and, here, airships). Newspapers of the period were full of enthusiastic accounts of the "pioneers of aviation" and their "conquest of the air." Robert Delaunay, in his *Homage to Blériot* (Kunstmuseum, Basel) and *Astra* (Musée d'Art Moderne de la Ville de Paris), and Roger de La Fresnaye, in *The Conquest of the Air* (The Museum of Modern Art, New York), working shortly after Rousseau and probably following his example, also glorified the first aviators.

Rousseau's aircraft are taken directly from detailed pictures and have none of the premonitory and malevolent character of the products of the imagination of Jules Verne and his illustrators (*Robur le Conquérant*, 1886; *Le Maître du Monde*, 1904). Representations of balloons, whether real or imagined, were far from rare prior to Rousseau. The same does not hold true, however, with regard to dirigibles, and especially to airplanes (see catalogue of the exhibition *L'air et les peintres,* Musée de Poitiers, 1975).

There was a sketch (DV 215B, present location unknown) for this painting with the date 1908 on the back. Vallier has published a photograph of the picture *prior* to the addition of the airships. The dirigible is the *Patrie,* which also appears in *The Quay of Ivry* (pl. 42) and in a work in a Japanese collection (DV 203); there, as in plate 43, it is accompanied by the airplane we see here, the 1907 Wilbur Wright plane, which is clearly recognizable owing to its lack of landing gear (C. Dollfus and H. Bouché, *Histoire de l'aéronautique,* Paris, 1942, p. 197).

Provenance
A. Vollard, Paris; Shchukin, Moscow

Bibliography
Catalogue of the Shchukin Collection, 1913; C. Zervos, 1927, p. 92 (photograph of the picture *prior to the addition of airplane and dirigible*); D. Vallier, 1961, p. 113; L. and O. Bihalji-Merin, 1971, repr. col. no. 13; C. Keay, 1976, repr. col. no. XXIV; Y. Le Pichon, 1981, repr. col. p. 99

Fig. 1.
Le Petit Journal illustré de la jeunesse, no. 220 (December 27, 1908). Wilbur Wright's plane is followed by the biplane *Voisin* piloted by Henri Farman

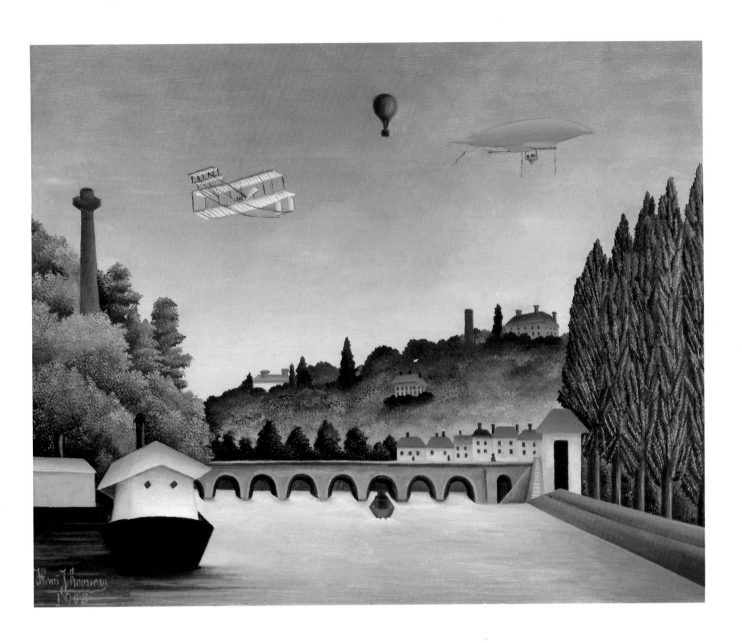

42 The Quay of Ivry

1908
18¼ x 21⅝″ (46 x 55 cm)
Signed lower left: *Henri Rousseau*
JB 186; DV 205A
Bridgestone Museum of Art, Tokyo, Ishibashi Foundation
New York exhibition only

In his late years, Rousseau increased his production of suburban landscapes, which he seems to have painted for sale with some success. We know that Robert Delaunay once owned a sketch for this landscape (DV 205B, present location unknown) and that a second, considerably different version exists (pl. 43).

Rousseau lays out his broad planes with ease and animates them by his placement of the strolling figures on the quay; he has taken little trouble to link them in some activity or to make the size of the people proportionate to that of the houses. Once again the Parisian suburban landscape, although it can hardly be called picturesque (containing, as it does, ordinary houses, a metal bridge, and a factory chimney; see pl. 41), is presented with an articulated, open, peaceful, and soothing space that contrasts line by line with the hermetic horizon and dramatic confrontations depicted in the majority of the Jungle pictures.

The title *Quay of Ivry* was first used for this picture by Wilhelm Uhde in 1914; Rousseau often represented particular sites in the southeastern Parisian suburbs. It is difficult, however, and even vain, to attempt to single out an exact locale or to establish whether or not Rousseau could actually have observed the passage of a dirigible. The one shown here has been identified by D. Vallier as the *Patrie,* which provides a basis for dating this picture and others like it: "The installation of ailerons, with which this dirigible was the first to be equipped, had not been completed during its first tests; it was not until 1907 that it made an ascension equipped with the ailerons that can distinctly be seen in this picture" (D. Vallier, 1970, p. 108). With regard to Rousseau's interest in aviation, see pl. 41.

Once again we note the presence of the tricolor, this time in the form of a pennant flying from the dirigible. The *Patrie* was the first dirigible to be ordered by the French Army.

Provenance
S. Jastrebzoff (S. Férat), Paris; private collection, Osaka

Bibliography
Letter from Jastrebzoff to R. Delaunay, published by B. Dorival, 1977, p. 19; *Dodici opere di Rousseau.* 1914, pl. 12; Roch Grey, 1943, repr. no. 68; B. Dorival, "Un Musée japonais d'art français," *Connaissance des arts,* November 1958, repr. p. 62; D. Vallier, 1961, no. 122; R. Huyghe and J. Rudel, 1970, p. 347; F. Johansen, *Henri Rousseau: Morfars rejse til Vestkoven,* Copenhagen, 1972, pl. 5; C. Keay, 1976, repr. no. 52; Y. Le Pichon, 1981, p. 98; repr. col.

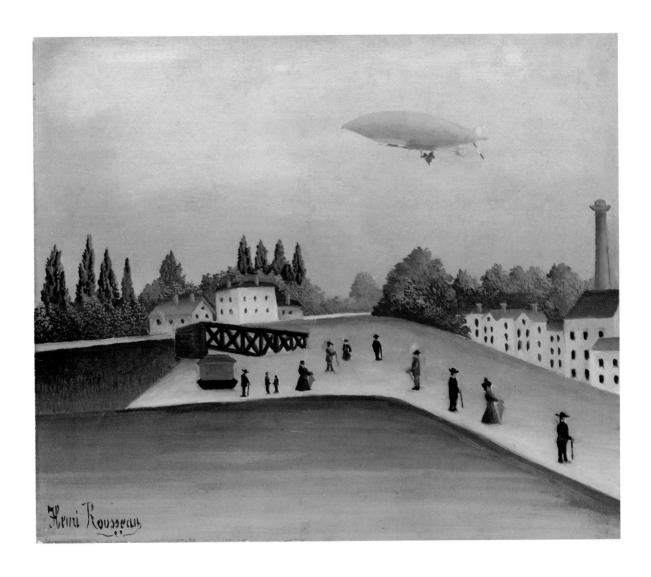

43 The Fishermen and the Biplane

1908
18⅛ x 21⅝" (46 x 55 cm)
Signed lower left: *H. Rousseau*
JB 33: DV 208
Musée de l'Orangerie, Paris, Collection Jean Walter–Paul Guillaume

Often, probably in reply to requests, Rousseau made another version of a work that had met with success (see pl. 42). However, he did not copy himself, and the later picture is always markedly different from the first.

The subject of the present work is approximately the same as that of preceding, but it has been simplified and slightly altered. The Douanier obviously tended to avoid overly literal repetitions. The strollers with their umbrellas have become fishermen, and the metal bridge has disappeared—perhaps because it would have been too much like the airplane that has here replaced the dirigible. The landscape itself is a kind of assemblage composed of the various elements upon which Rousseau drew, rather like the pieces of a puzzle, and whose selection and positioning vary from one picture to another: houses with meticulously aligned windows, a chimney, trees, and fishermen whose dark outlines stand out against the backlighting. The middle ground is taken up by an oddly curved beach, whose characteristic shape can be found in several canvases. Like the houses arranged in tiers on the right, it allowed Rousseau to suggest depth.

Here Rousseau clearly set aside space to insert Wilbur Wright's airplane in the sky. It also appears in the *View of the Bridge of Sèvres* now in the Pushkin State Museum of Fine Arts (see note, pl. 41).

Provenance
P. Guillaume; Mme J. Walter

Bibliography
Letter from Jastrebzoff to R. Delaunay, published by B. Dorival, 1977, pp. 19–20; A. Basler, 1927, pl. 22; C. Zervos, 1927, pl. XXVIII; W. George, 1931, repr. p. 9; Roch Grey, 1943, pl. 80; D. Vallier, 1961, no. 120; V. Nezval, 1972, p. 79; P. Descargues, 1972, repr. p. 45; C. Keay, 1976, repr. col. no. XXI; F. Elgar, 1980, fig. 44; H. Certigny, 1981, p. 64, fig. 4

Exhibitions
New York, 1931; no. 25; Basel, 1933, no. 48; Paris, 1937, no. 14; Venice, 1950, no. 22; New York, 1951, no. 15; Paris, 1961, no. 49

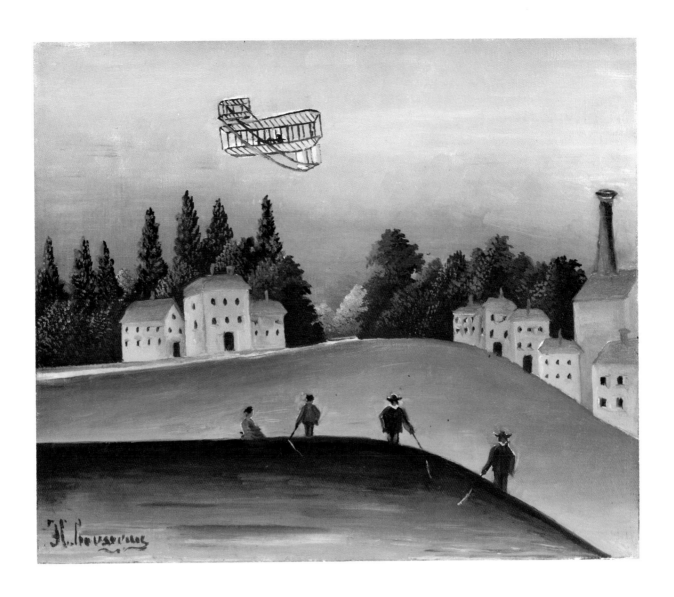

44 The Avenue, Park of Saint Cloud

c. 1907—08
Oil on canvas
18³⁄₁₆ x 14¹³⁄₁₆" (46.2 x 37.6 cm)
Signed lower right: *H. Rousseau*
JB 22; DV 219A
Städtische Galerie im Städelschen Kunstinstitut, Frankfurt-am-Main

This painting is something of an exception among Rousseau's landscapes for its selection of motifs; that is, he has adapted the lushness of his tropical forests to the spirit of his suburban landscapes. In turning to the theme of strollers in a park, traditional since Watteau, Rousseau gives new freshness to the subject. The composition, which is based on the Saint Andrew's cross, with strong lines of perspective and highly symmetrical layout, recalls that of *The Football Players* (pl. 45) and *The Wedding* (pl. 28). The trees with their vivid green trunks are without depth, like greenery painted on stage flats. The diminishing size of the small strolling figures contributes to the impression of distance. Rousseau has provided them with shadows, something his figures do not usually have. The portion of sky that can be glimpsed beneath the avenue of trees is of a pale pink Rousseau often used for distant vistas. A sketch (DV 219B) shows even more rigidity in the positioning of the trees, whose alignment must have been traced with a ruler, but greater freedom in the treatment of their foliage.

The picture's title is of long standing; however, the structure that can be glimpsed in the distance resembles no clearly identifiable monument. If Rousseau indeed painted this subject in the Park of Saint Cloud in the spring of 1907, it is contemporary with the period when Kandinsky, who would become a great admirer of Rousseau, was also going there to paint from Sèvres, where he was living in 1906—07 (fig. 1).

Provenance
P. Kowarzik, Frankfurt-am-Main

Bibliography
H. Kolle, 1922, pl. 15; P. Courthion, 1944, pl. XLIII; M. Gauthier, 1956, pl. 18; D. Vallier, 1961, col. frontispiece; L. and O. Bihalji-Merin, 1971, repr. no. 10; A. Jakovsky, 1971, repr.; P. Descarques, 1972, p. 114, repr. col. p. 115; C. Keay, 1976, no. 33, p. 135; Y. Le Pichon, 1981, p. 109; repr. col.

Exhibitions
Basel, 1933, no. 28; Venice, 1950, no. 6; Paris, 1961, no. 36; Paris, 1964, no. 10

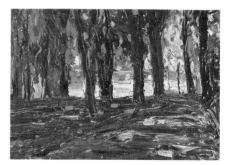

Fig. 1.
Kandinsky. *In the Park of St. Cloud.* 1906
Städtische Galerie im Lenbachhaus, Munich

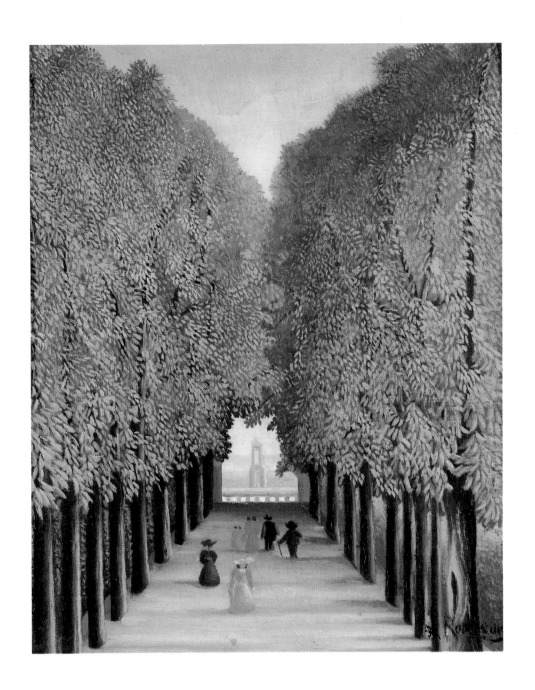

45 The Football Players

1908
Oil on canvas
39½ x 31⅝" (100.5 x 80.3 cm)
Signed and dated lower right: *Henri Rousseau 1908*
JB 37; DV 214
The Solomon R. Guggenheim Museum, New York

The Football Players is unique in Rousseau's work. Of all his modern scenes, it is the only one in which the figures are given any animation. Although then approaching the end of his career (the painting is dated just two years prior to his death), Rousseau here manifests a great freedom of spirit in his choice of subject as well as in his manner of treating it.

The composition is again laid out in the form of a Saint Andrew's cross, as were *The Wedding* (pl. 28) and *The Avenue, Park of Saint Cloud* (pl. 44). Notwithstanding Rousseau's title, the sport being played is rugby, which was just beginning to be popular in France, and the first France-England match in Paris was held in the same year, 1908. But, even though the Douanier was here inspired by a current event, he nevertheless treated it with fantasy. Neither the attire (Rousseau has transposed the colors of the jerseys and socks), the movements, nor, above all, the field and the small number of players, corresponded to any plausible match. Even if Rousseau relied upon drawings (see A. Rudenstine) or a newspaper photograph (as did his admirer, Robert Delaunay, in his *Equipe de Cardiff*), he has given his imagination free rein in the layout and framework of this quasi-ballet in which four players with stereotyped features are struggling for possession of an oval ball within a setting of remarkably small trees. Once again, Rousseau has turned to a new subject, one as startling as any that could be imagined.

It is very likely that we owe the existence of Albert Gleize's *The Football Players* (1912-13, private collection), the various versions of Robert Delaunay's *Equipe de Cardiff* (1913), and André Lhote's *Football* (1920, Musée National d'Art Moderne, Paris) to the Douanier's example. Although the theme is different, there are close affinities between this picture and Picasso's dancing bather in a striped suit (fig. 1).

The passion for rugby in France, even in so-called intellectual circles, receives unexpected corroboration in the correspondence between Charles Péguy and Alain Fournier (letter of April 4, 1914). The newspaper *Excelsior* had printed a photograph of Charles Péguy with a reference to a "very literary rugby team among whose members are Jean Giraudoux, Alain Fournier, Pierre Mac Orlan, and Louis Sue, and whose honorary president is none other than Charles Péguy. The 'fifteen' are growing." It seems likely that the reference to "fifteen" is a bad pun on the name of the revue Péguy edited, *Cahier de la Quinzaine*.

This picture was used by Jiri Kolar to make a 134 x 49 quadrichrome photo-montage for *Art Zanders '80*.

Provenance
Thannhauser, Munich, 1914; Suermondt, Drove; P. Rosenberg; Mrs. Henry D. Sharpe, Providence, Rhode Island

Bibliography
L. Vauxcelles, "Le Douanier persécuté," *Gil Blas*, March 22, 1908; W. Uhde, 1914, pl. 15; W. Uhde, 1921, repr. p. 42; Roch Grey, 1922; C. Zervos, 1927, pl. 76; D. Catton Rich, 1942, p. 50, repr. p. 51; Roch Grey, 1943, repr. no. 81; P. Courthion, 1944, pl. XI; D. Catton Rich, 1946, p. 51; T. Tzara, 1947, pp. 16–17; M. Gauthier, 1949, pl. XXI; A. Werner, 1957, pl. 25; H. Certigny, 1961, p. 315; D. Vallier, 1961, repr. col. p. 111; L. and O. Bihalji-Merin, 1971, repr. no. 38–68; A. Jakovsky, 1971, repr.; R. Shattuck, 1974; C. Keay, 1976, repr. col.; A. Rudenstine, *The Guggenheim Museum Collection, Paintings*, vol. 2, 1976; Y. Le Pichon, 1981, p. 111, repr. col.

Exhibitions
Paris, 1908, no. 5261; Berlin, 1926, no. 11; Paris, Galerie Rosenberg, 1937, no. 12; Paris, Salle Royale, and Zurich, 1937, nos. 15 and 8; Chicago, New York, Boston, 1942, unnumbered; Venice, 1950, no. 15; New York, 1951, no. 17; New York, 1963, no. 49; Rotterdam and Paris, 1964, no. 22

Fig. 1.
Picasso. *Bathers*. Summer 1918
Musée Picasso, Paris

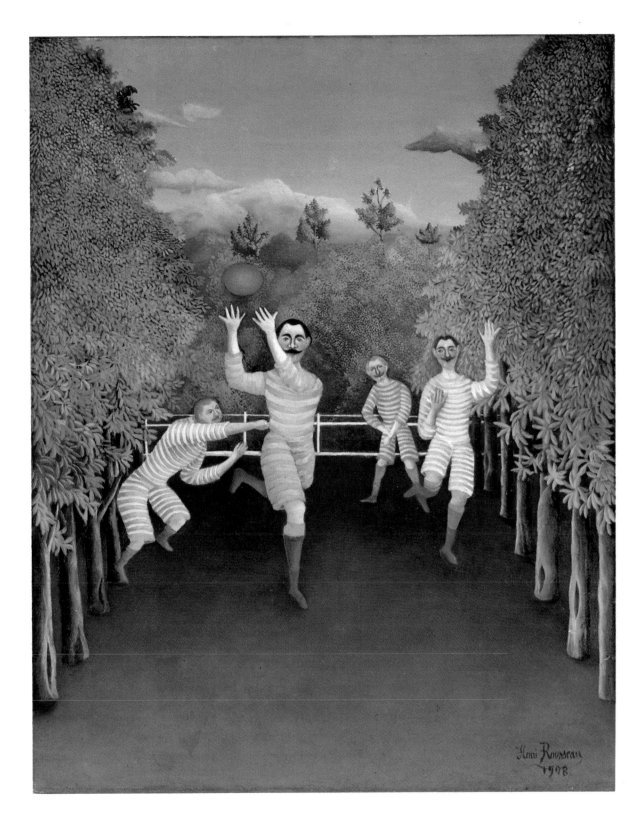

46 Study for View of Malakoff

1908
Oil on canvas
7½ x 11″ (19 x 28 cm)
Signed lower right: *H. Rousseau.* Dedicated on back: "Presented to my friend / Weber 2 December 1908 / Paris, 2 Xbre / his friend / H. Rousseau / view of Malakoff / outside Paris" (*offert à mon ami / Weber le 2 décembre 1908 / Paris, 2 Xbre / son ami / H. Rousseau / vue de Malakoff / environs de Paris*)
JB 200; DV 213B
Private collection

47 View of Malakoff

1908
Oil on canvas
18⅛ x 21⅝″ (46 x 55 cm)
Signed and dated lower right: *Henri Rousseau 1908*
JB 199; DV 213A
Private collection, Switzerland

We know that at least ten of Rousseau's studio-painted landscapes were preceded by a sketch from nature. The *View of Malakoff* (pl. 47) and its study were, during Rousseau's own lifetime, owned by two of his first admirers, Wilhelm Uhde and Max Weber. As Sandra Leonard has pointed out, Weber preferred his sketch to the finished picture. It has "freedom and rapidity of execution" and "reveals Rousseau's working methods; they are studies to be used later as memoranda for more formal and detailed paintings to be done in the studio. . . . There is a stylistic difference between Rousseau's studies and his finished landscapes" (p. 39). From an almost impressionist sketch with vaguely defined outlines, the artist would arrive at a very different final version. The line is dominant, enclosing the forms and immobilizing them. Comparison with the sketch gives us a different perception of the finished landscape: what we may have regarded as a maladroit stiffness is the result of the artist's deliberate intention.

The locale depicted has been identified by Wilhelm Uhde. One of Rousseau's daughters had been put out to nurse in Malakoff, and in 1891 he had shown an earlier *View of Malakoff* (DV 42, present location unknown) at the Salon des Indépendants. This composition, with its trees, houses, and receding street, is not in essence very different from that of several other suburban views. Perhaps Rousseau shows greater ease here in the handling of perspective than in other works. What made this landscape so startlingly original at the time it was painted was Rousseau's painstaking emphasis on the telephone wires and streetlamp. He was fond of depicting technological achievements; from the Eiffel Tower to airplanes and factory chimneys, his canvases are full of objects that seemed shocking in his day. Here, again, he was preceded by Seurat, who

Pl. 46
Provenance
Max Weber, 1908

Bibliography
M. Weber, preface to catalogue of the exhibition *Henri Rousseau,* Little Galleries of the Photo-Secession, New York, December 1910, reprinted in *Camera Work,* 1911, p. 50; J. J. O'Connor, "Henri Rousseau," *Carnegie Magazine,* December 1942, p. 212; D. Catton Rich, 1942 and 1946, p. 36, repr.; D. Vallier, 1961, no. 23; M. Brown, 1963, p. 286; S. Leonard, 1970, pp. 38–39; R. Shattuck, 1974; Y. Le Pichon, 1961, p. 59, repr. col.

Exhibitions
New York, 1910; New York, 1913, no. 979; New York, Chicago, Boston, Pittsburgh, 1942, unnumbered; New York, 1951, no. 11; New York, 1963, no. 42

Pl. 47
Provenance
W. Uhde, Paris; A. Villard, Paris, 1927–33; G. Renand, Paris; Galerie Bing, Paris

Bibliography
W. Uhde, 1911, repr. 25; W. Kandinsky, Munich, 1912, repr. (published in Paris, 1981, p. 216); W. Uhde, 1921, p. 74; P. F. Schmidt, *Die Kunst der Gegenwart,* Berlin, undated (c. 1922), no. 172, p. 109; A. Basler, 1927, pl. 30; C. Zervos, 1927, p. 50, repr. 40; Roch Grey, 1943, pl. 542; P. Courthion, 1944, repr. pl. XL; D. Catton Rich, 1946, repr. p. 37; W. Uhde, 1948, repr. 13; W. Uhde, 1949, p. 63; H. Certigny, 1961, p. 336; D. Vallier, 1961, p. 107; S. Leonard, 1970, pp. 38–39, repr. no. 123; L. and O. Bihalji-Merin, 1971, p. 38; P. Descargues, 1972, repr. col. p. 87; Y. Le Pichon, 1981, repr. col. p. 59

had twenty years earlier incorporated streetlamps into particularly delicate compositions. However, Seurat had had few immediate followers, and the wheels of progress had elicited this reaction from a famous colleague: "Unfortunately, what we call progress is only an invasion by two-legged creatures who will not quit until they have transformed everything into odious quays with gas jets and—which is even worse—electric lighting. What times we live in!" (Cézanne, letter dated September 1, 1902.)

Kandinsky, on the other hand, who was a great admirer of Rousseau, made telegraph poles the focal point of his painting *Railroad near Murnau* (fig. 1). Perhaps he had seen Rousseau's 1908 picture (pl. 47) or a photograph of it. In any event, both painters, and at almost the same moment, were giving proof of their sensitivity to the plastic values in modern, unpicturesque objects, and it was surely with his own picture in mind that Kandinsky selected Rousseau's to illustrate the *Blaue Reiter* almanac in 1912.

Exhibitions
Paris, 1908; Paris, 1911, no. 24; New York, 1931, no. 20; Basel, 1933, no. 17; Paris, Salle Royale, and Zurich, 1937, no. 5 (*The Telegraph Poles*); Paris, 1944, no. 5

Fig. 1.
Kandinsky. *Railroad near Murnau.* 1909
Städtische Galerie im Lenbachhaus, Munich

48 Exotic Landscape

1908
Oil on canvas
45¹¹⁄₁₆ x 35¹⁄₁₆″ (116 x 89 cm)
Signed and dated: *Henri J. Rousseau, 1908*
JB 39; DV 217
Private collection
New York exhibition only

One of the few known Jungle pictures in a vertical format, *Exotic Landscape,* like the artist's other tropical forests, witnesses Rousseau's joy in the perception of natural fact imaginatively transformed and submitted to a highly organized formal structure. As in most of Rousseau's exotic landscapes, thick foliage and the verticals of trees frame the composition at its lateral edges while the mass of clustered, subtly nuanced greenery curves down toward the center. Rousseau, who was a sometime playwright, has set this jungle vignette theatrically; the radiant white, green-bordered cacti at the bottom serve as stage lights to illumine the positions of the actors whose gestures are frozen as if in the moment before action begins.

Carefully arranged, the composition is divided along a central axis rising from the left edge of the white cactus leaf in the middle to the oranges that form a gravityless, vertical "zip," the right edges of which track the middle of the canvas, which is further delineated in the narrow space of sky between the brilliant disk of the orange sun and the dark-green fronds of palm trees at the right. Within this geometrically organized format, a dynamic dialogue of forms and color contrasts is at play. Not only is there a multiplicity of rhyming shapes, but there is as well a calculated "quantification" of figuration. The four dark monkeys on the second level of the picture are balanced by and contrasted with the four white cacti on the first; the two brown monkeys at the left in the third tier are set off by two stark white flowers and in a variation on the theme the gray monkey at the right is weighted against a blue flower of related hue. Typical of Rousseau's wit and whimsicality is the rather eccentric bird at the upper center, whose shape and grave demeanor mimic the form and owl-like expression of the monkey to its right. The bird's contours and its blue-and-white plumage resume the outlines and colors of the flowers while its brilliant red breast reverberates against the green ground to animate the entire composition.

In its range of fantastic imagery and imaginative freedom, *Exotic Landscape* recalls the *drôleries* found in manuscript painting of the late Middle Ages, and in its painstaking concentration on detail, its scrupulous attention to the rendering of foliage and flowers, it harks back to the "realism of particulars" that characterizes the International Style.

Provenance
Bernheim-Jeune, Paris

Bibliography
D. Vallier, 1961, no. 155

Exhibitions
Paris, Salle Royale, 1937, no. 7; Paris, 1961, no. 59; New York, 1963, no. 47; Tokyo, *Rousseau et le monde des naïfs,* no. 39

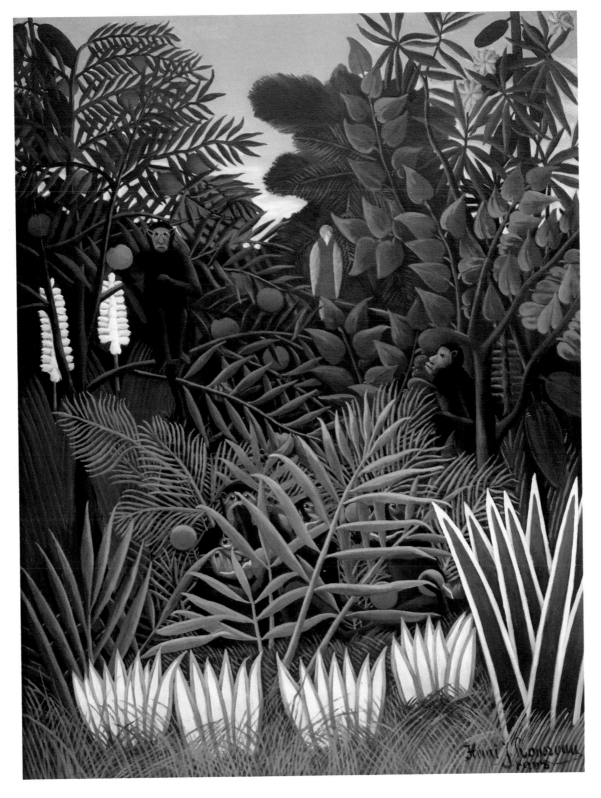

49 The Repast of the Lion

c. 1907
Oil on canvas
44¾ x 63" (113.7 x 160 cm)
Signed lower right: *Henri Rousseau*
JB 160; DV 193
The Metropolitan Museum of Art, New York
Bequest of Sam A. Lewisohn, 1951

The Repast of the Lion is one of the most grandiose of the Jungles and also one that gives the strongest impression that the flowers and plants have been imagined and combined solely for the pleasure of the eye, without any concern whatsoever for botanical accuracy. Rousseau was, of course, inspired by graphic sources such as newspaper illustrations and technical works, but he in no way felt constrained to respect either the actual appearance of plant species or their proportions. The flowers are monstrous in size and their species unclear; the areas of color they create are larger here than in most of the other Jungles.

The disjunction between the plant life and the two wild animals is also more clearly in evidence here than it is, for example, in *The Hungry Lion* (pl. 31). "The dreamlike unreality is accentuated by the disproportion between the size of the beasts and that of the enormous flowers. With extreme refinement the sharply drawn stems and immobile leaves form a monumental tapestry" (Charles Sterling and Margaretta Salinger, p. 167). The fighting beasts, however, are not merely a pretext, a theme to give the picture a title: their color area, their position at the bottom of the picture, and the contrasted lighting of the lion recalls that of the beasts in *The Merry Jesters* (pl. 33) and makes their presence indispensable from the viewpoint of plasticity.

In a departure from his usual practice, Rousseau painted the sun white; or is it the moon? Aside from the faded pink flower on the right and the animal's wounds, there is no use of red. It would appear that Rousseau first painted the tree trunks dark green and then filled in the spaces between them with a gray-green; he then added the flowers and leaves on top. Several reworkings can be discerned on the right.

Provenance
J. Keller, Aachen, c. 1914; S. Bourgeois, New York, 1933; A. Lewisohn, New York, c. 1923; Sam A. Lewisohn, New York, 1938

Bibliography
W. Uhde, 1911, fig. 13; W. Uhde, 1914, pl. 40; C. Einstein, *Die Kunst des 20. Jahrhunderts,* 1926, p. 241, repr.; P. Soupault, 1927, pl. 19; A. Basler, 1927, pl. 42; A. Salmon, 1927, repr. no. 31; S. Bourgeois, *The Adolf Lewisohn Collection of Modern French Paintings,* 1928, p. 196 et seq., repr.; S. Bourgeois and W. George, *Formes,* 1932, XXVIII–XXIX, pp. 301, 306, repr.; A. Vollard, 1936, pp. 216 et seq., R. H. Wilenski, 1940, pp. 206, 363; Roch Grey, 1943, pl. 23; D. Vallier, 1961, p. 101, repr. col.; C. Sterling and M. Salinger, *French Paintings: A Catalogue of the Collection of the* Metropolitan Museum of Art, 1967, pp. 166–67, repr.; C. Keay, 1976, p. 140, repr.; D. Vallier, 1979, repr. col. no. 70; Y. Le Pichon, 1981, pp. 154–55; repr. col.

Exhibitions
Paris, 1911, no. 21

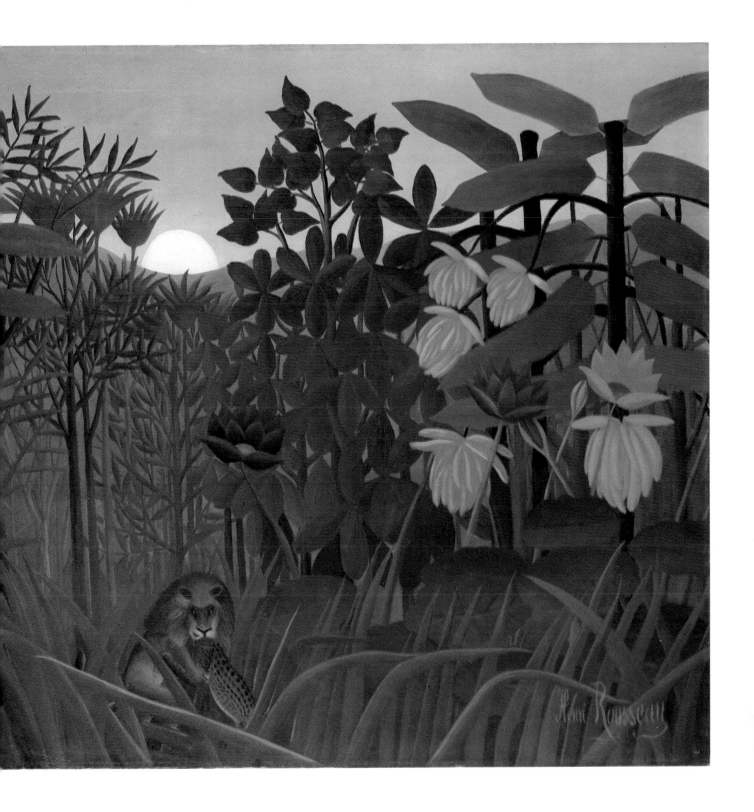

50 The Jungle: Tiger Attacking a Buffalo

1908
67¾ x 75⅜" (172 x 191.5 cm)
Signed and dated lower right: *Henri Rousseau 1908*
JB 195; DV 211A
The Cleveland Museum of Art, gift of Hanna Fund
New York exhibition only

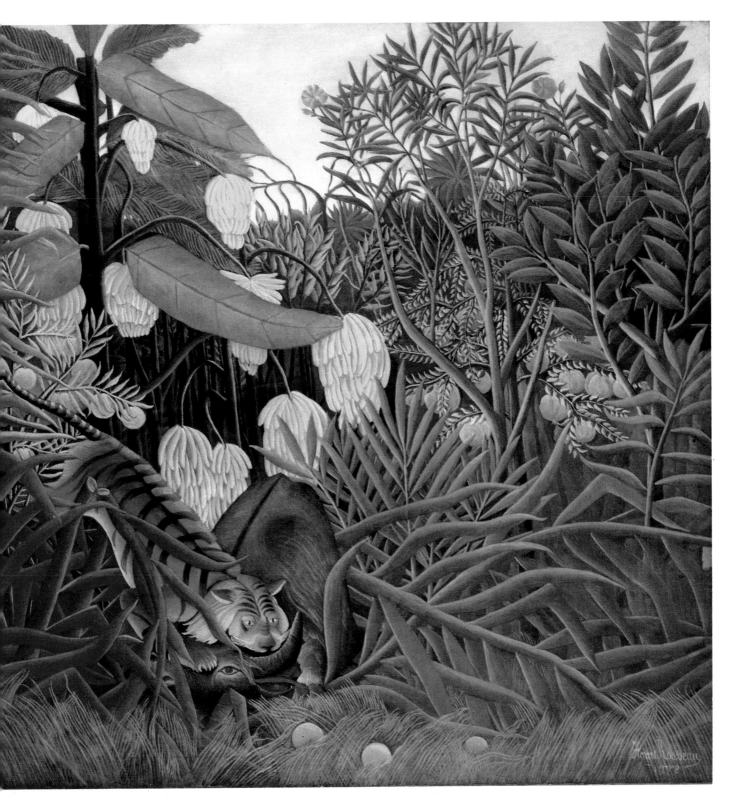

This large painting was begun by Rousseau before his imprisonment for fraud (see Chronology) in December 1907, and probably finished during the months of January and February 1908 after his release. During the period of his incarceration, Rousseau sent many pleading and anxious letters to the judge assigned to his case; in one dated December 28, he expresses his distress over the possibility that he might not be able to finish this painting in time for the spring exhibition of the Indépendants. With modest, but nonetheless insistent, urgency he implored the judge:

> I am once again seeking your indulgence on my behalf and requesting, as I have earlier had occasion to do, that you extend to me your protection. I hope, your Honor, that you will do me this favor in order that the year now stretching before us may be a benevolent one for me, and that you will grant me, as I have earlier requested, my release in order that I may work on the painting I had begun for the Salon two square meters in size, for which I need at least two months because of its composition (cited in H. Certigny, *La Vérité sur le Douanier Rousseau,* Paris, p. 311).

Thanks to the goodwill of the judge and a skillful defense based on the childlike naïveté of the accused, the Douanier was able to finish the painting in time for the March opening of the Salon, where it was shown along with *The Football Players* (pl. 45) and two other paintings. Given the generally mocking tone of the contemporary press when mentioning Rousseau, we can legitimately assume that the critic responsible for the remarks in *Le Matin* of March 20 had little notion of his own clairvoyance when he wrote:

> And, to crown our happiness, we have the divine Douanier Rousseau, who has on this occasion brought together a buffalo and a panther [sic] as striped as his football players hung not far away! Come, come, vain and ironical spectators, and cease blaspheming. Henri Rousseau is a present-day Giotto, and all the rest, all the painters that give rise to your laughter here, will one day—who knows?—provide salutary lessons. You lack foresight. Behind such painterly debauchery are the coming men. Be patient. They will come forward. Today they themselves are not sure who they are. But before passing sentence, remember that mediocrity is the only thing that encounters immediate success and that the spittle of those whose policy is to wait and see has always been the first prize tendered to genius.... (cited in H. Certigny, "Une source inconnue du Douanier Rousseau," *L'Oeil,* October 1979, p. 74).

In the judgment of a later and very percipient critic of the Douanier, Daniel Catton Rich, this painting is an example of those "final canvases [that] show the self-taught artist wholly in command of his style." He goes on:

> The minute elaboration of a passage which he loved and which in certain early pictures breaks up the larger rhythms and forms is replaced by an all-over spatial design. If we study the right-hand section of *The Jungle: Tiger Attacking a Buffalo,* we find it amazingly complex. One cut-out plane is laid over another and yet another, but Rousseau's control is now so sure that all is directed and unified. Soffici, who watched him paint,

Provenance
A. Vollard, Paris; J. Quinn, New York; Mrs. J. A. Carpenter, Chicago (?); Valentine Gallery, New York; Mrs. P. C. Hill, Washington, D.C.; Pierre Matisse, Gallery, New York

Bibliography
The John Quinn Collection of Paintings, Watercolors, Drawings, and Sculpture, Huntington, New York, 1926, p. 108; A. Basler, 1927, pl. 5; A. Basler, 1929, pl. 29; D. Catton Rich, New York, 1942, p. 49; Roch Grey, 1943, pl. 110; H. Gardner, *Art through the Ages,* New York, 1948, p. 730; *L'Oeuvre du XXe siècle,* Paris, 1952, no. 98; *Fifty Paintings 1905–1913,* Buffalo, 1955, p. 64; W. M. Milliken, *The Cleveland Museum of Art,* New York, 1958, p. 57; D. Vallier, 1961, no. 152; L. and O. Bihalji-Merin, 1971, no. 54; F. Johansen, *Morfars rejse til Vestkoven,* Copenhagen, 1972, p. 14; C. Keay, 1976, p. 155, repr. p. 61; R. Alley, *Portrait of a Primitive: The Art of Henri Rousseau,* 1978, p. 74; J. Zilczer, "The Noble Buyer"; John Quinn, Patron of the Avant-Garde,* Washington, D.C., 1978, p. 182; H. Certigny, "Une Source Inconnue du Douanier Rousseau," *L'Oeil,* October 1979, p. 75; D. Vallier, 1979, p. 90; *Twenty-five Great Masters of Modern Art: Rousseau,* Tokyo, 1981, no. 39; K. Bazarov, *Landscape Painting,* London, 1981, p. 170; Y. Le Pichon, 1981, p. 147.

Exhibitions
Paris, 1908, no. 5260; New York and Chicago, 1942, no. 49; Venice, 1950, no. 143; New York, 1963, no. 46

tells us that he filled in all the greens, then all the reds, then all the blues, etc. He had conceived the picture in such precise relationship that he could estimate how many days it would take him to finish a canvas.

At last he was able to interlock figures and landscape and unite their diverse movements. The tiger in *The Jungle* has stripes which not only repeat the surface design of the leaves, but his diagonal movement is linked with the three-dimensional broken stalks in the foreground just as the solid weight of the buffalo is bound up with the heavy bunches of bananas that hang downward. All of this takes place in a setting of tremendous magnification. A branch becomes a towering tree and flowers are as prodigiously large as lions. This distortion of natural scale lends a peculiar emotional overtone to the whole composition (D. Catton Rich, *Henri Rousseau,* New York, 1942, p. 64).

As Henry Certigny pointed out, Rousseau's picture is probably based on Eugène Pirodon's engraving after a painting by Charles Verlat (1824–1890), reproduced in *L'Art,* March 1906 (see *L'Oeil,* op. cit., pp. 74–75). A later and smaller version of the painting is in the collection of the Hermitage State Museum, Leningrad (pl. 51).

51 Combat of a Tiger and a Buffalo

1908
Oil on canvas
18⅛ x 21⅝" (46 x 55 cm)
Signed lower left: *Henri Rousseau*
JB 196; DV 211B
Hermitage State Museum, Leningrad

"Every flower is a dream, a wholly new shape suggested by its name. The gradations in his usually cloudless skies prevent them from being real skies....His pictures are copies of his dreams," noted Roch Grey (1922), who knew Rousseau well. It is useless to catalogue the intertwined foliage, which defies identification by any botanist. The flowers and the fruits exist only to animate the green surface with their touches of color and to add a note of chromatic fantasy to a canvas of rectilinear lines. In a manner unusual for him, Rousseau has carefully placed a few leaves in front of the grouping of animals, but here—more, perhaps, than in the other Jungle paintings—the grasses form a kind of impassable barrier, recalling in a way the railings of *Art Nouveau* balconies. The Jungle paintings, which have their basis in an exotic daydream inspired by the Jardin des Plantes in Paris, are transformations of that site into an arena for a bloody struggle that takes place behind a veritable fence.

As in the first version (pl. 50), the tiger and buffalo are taken from a rendering (fig. 1) after a work by the Belgian painter of portraits and animals Charles Verlat, whom Van Gogh had also admired (see catalogue of the exhibition *Van Gogh et la Belgique,* Mons, 1980). Whether Rousseau saw the original or only the reproduction it is impossible to say—perhaps he made a tracing of the print and reversed the image. In any event his animals face in the same directions as in the picture. For that matter, the position of the tiger here is very like that in other paintings, particularly *Surprise!* (pl. 6).

The first, considerably larger, version (67¾ x 75⅜") of this picture was exhibited at the 1908 Salon des Indépendants and sold, along with the present example, to Ambroise Vollard. Rousseau, however, did not repeat himself. In reducing his composition to a smaller format, he simplified and considerably altered it. Although the pair of animals and the fencelike vegetation are almost identical, there are numerous variations in the flowers and fruits.

Provenance
A. Vollard, Paris; S. Shchukin, Moscow

Bibliography
Catalogue of the Shchukin Collection, Moscow, 1913, no. 198; Catalogue of the Museum of Modern Western Art, Moscow, 1928; G. Viatte, *Art de France,* 1962, II, p. 332; Catalogue of Western European Painting in the Hermitage Museum, Leningrad, rev. ed., 1976, p. 290; C. Keay, 1976, repr. no. 62, p. 152; H. Certigny, "Une source inconnue du Douanier Rousseau," *L'Oeil,* October 1979, pp. 74–75, repr; Y. Le Pichon, 1981, pp. 146–47, repr. col.; A. Barskaïa and A. Izerghina, *French Painting in the Hermitage Museum, Leningrad,* 1982, no. 72

Fig. 1.
Etching by Eugène Pirodon after a painting by Charles Verlat

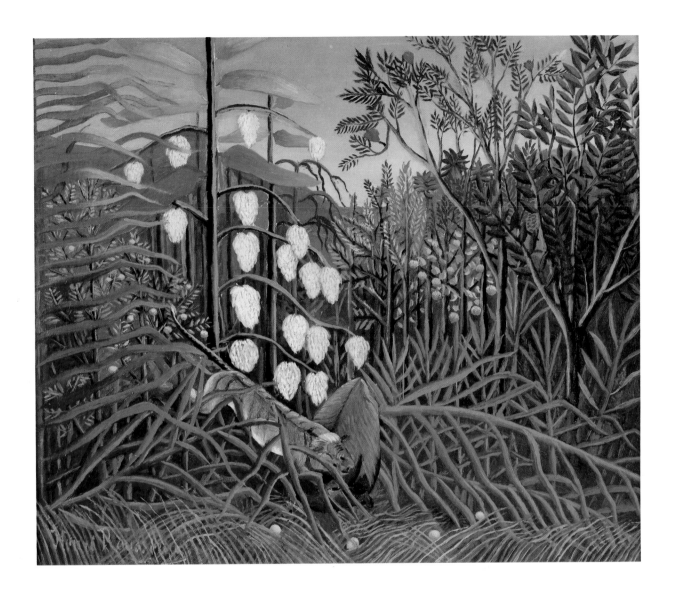

52 Flowers in a Vase

1909
Oil on canvas
$17\frac{7}{8} \times 12\frac{7}{8}''$ (45.4 x 32.7 cm)
Signed and dated lower left: *Henri Rousseau 1909*
JB 214; DV 232A
Albright-Knox Art Gallery, Buffalo, New York
Room of Contemporary Art Fund

Rousseau apparently did not become interested in still life until late in his career. The subject is almost always a bouquet of flowers, but the species and disposition vary from picture to picture. It is likely that he worked from printed sources. Rather than consulting encyclopedia color plates, he probably sought out such descriptive works as Pierre Zaccone's *Nouveau langage des fleurs*, Kate Greenaway's *The Language of Flowers*, or Anais de Neuville's *La Véritable langage des fleurs*, all of which had charming color illustrations showing bouquets of cut flowers, and were reprinted many times during the second half of the nineteenth century. Use of these sources would explain the ease of presentation and pictorial quality of the bouquet itself, in contrast to the awkward stiffness of the vase and the hanging behind it.

The flowers in Rousseau's bouquets have none of the exuberance of the colorful examples that punctuate his Jungle paintings. Here we have the garden flowers of which Verlaine was so fond. However, Rousseau prefers ornamental richness to the traditional descriptive precision to be found in, for example, Fantin-Latour. Flowers have always been thought to be the loveliest and also the most ephemeral works of Creation. They are the favorite choice for a gift to a friend or loved one, for a votive or religious offering. H. Focillon detected in "this sentimental customs inspector a kind of romantic poetry—more than the spontaneity of a primitive, he had the praiseworthy desire to paint a picture" (*La Peinture aux XIXe et XXe siècles*, Paris, 1928, p. 303). For the painter it was also the most tractable motif, as well as that which permitted the most varied and unusual combinations of forms and colors. From Cézanne to Redon, Rousseau's contemporaries also turned to the floral still life as the basis for both their plastic experiments and their emotional expression.

The same vase, as well as the strand of ivy, also appear in another still life (Collection William S. Paley, DV 232B). Perhaps the ivy motif should be regarded as an indication of the work's destination (gift? commission? we do not know). Was it a symbol of friendship, fidelity—or of servile attachment, dependency ("a bit of ivy twined about a tree," as Edmond Rostand wrote). The symbolism of flowers and plants was a very popular subject at the time, occurring even in popular songs, and Rousseau could not have been totally unaware of it.

Provenance
Count Sandor, Hungary, 1911; Countess Sandor, Hungary; A. Tooth, London, 1939; Knoedler & Co., London and New York, 1939

Bibliography
A. Basler, 1927, pl. 53; C. Zervos, 1927, pl. 8; Gordon B. Washburn, *Art News*, June 8, 1940, p. 8, repr.; J. O'Connor, Jr., "Henri Rousseau, Exhibition at Carnegie Institute," *Carnegie Magazine*, December 1942, p. 212; D. Catton Rich, 1942 and 1946, p. 63, repr; D. Cooper, "Henri Rousseau artiste peintre," *Burlington Magazine*, London, July 1944, p. 164, pl. 2; P. Courthion, 1958, p. 17, repr.; D. Vallier, 1961, p. 21, repr. col.; A. Werner, *Henri Rousseau*, New York, 1961, pl. 28; W. Haftmann, 1965, vol. 2, p. 222, repr.; A. Jakovsky, 1971, repr.

Exhibitions
Chicago and New York, 1942, unnumbered; Venice, 1950, no. 18; New York, 1951, no. 20; New York, 1963, no. 55; Rotterdam and Paris, 1964, no. 25

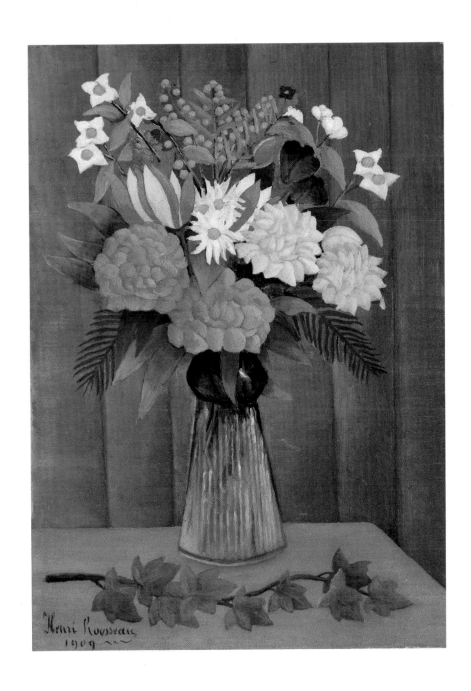

Henri Rousseau
1909

53 View of Saint Cloud

1909
Oil on canvas
14¾ x 11⅝″ (37.4 x 29.6 cm)
Signed lower left: *H. Rousseau*
JB 41; DV 161
Collection Sam Spiegel, New York

Rousseau was one of the most moving portraitists of the city of Paris and its environs, and Saint Cloud appears to have been one of his favorite spots. Here, as in virtually all his urban and country views, the landscape is validated by the human presence—in this example by the minuscule woman in plump profile who seems suspended above, rather than sitting on, the gentle curve of the foreground hill. Typically, the figure is not used to animate the scene but to express Rousseau's sense of the prevailing harmony between man and nature. The tiny black-clad lady has not happened upon this place above Saint Cloud; rather, she is simply there—as integral to this vignette of domesticated nature as the little pink house she faces. In Rousseau's world, there is no nostalgia for a prelapsarian paradise; the Paris Sunday of petit bourgeois leisure is both the dream and the reality of a modernized Golden Age.

The careful structuring of this painting is characteristic of Rousseau. Divided along a central axis, the composition is balanced by the division of the canvas into quadrants of light and dark, which set off and echo each other. The stability of the whole is in no way endangered by the unequal grouping of trees—five at the left and one at the right. The branches of the trees meet to form an arch framing the view of the village, its apex almost directly over the church steeple.

As well as being useful structural elements, trees were one of Rousseau's favorite motifs, whether rendered as they are here in slender silhouette, their branches and leaves carefully articulated against a contrasting ground, or, as is elsewhere frequent, as clustered masses of green with virtually no indication of branches. It was trees of the type we see in this painting that caused Kenneth Clark to say of the trees in the Hugo van der Goes Portinari Altarpiece: "As decorative in design as if they were by the Douanier Rousseau" (*Landscape into Art,* London, 1952, p. 18).

Provenance
A. F. Ball, New York, W. Rees Jeffrey

Bibliography
W. Uhde, 1911, fig. 10; W. Uhde, 1914, pl. 33; A. Basler, 1927, pl. 20; A. Salmon, 1927; P. Courthion, 1956, pl. 1; D. Vallier, 1961, no. 91

Exhibitions
Paris, 1961, no. 10; New York, 1963, no. 12

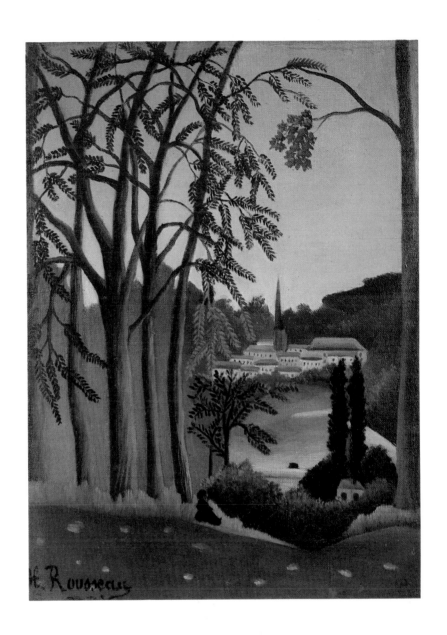

221

54 Banks of the Bièvre near Bicêtre, Spring

1909
Oil on canvas
21½ x 18″ (54.6 x 45.7 cm)
Signed lower right: *H. Rousseau.* Label on stretcher: "View of the banks/of the Bièvre near/Bicêtre Spring/23
February 1909/H. Rousseau" (*Une vue des bords/de la Bièvre près/Bicêtre Printemps/23 février 1909/H. Rousseau*)
JB 38; DV 162
The Metropolitan Museum of Art, New York, gift of Marshall Field, 1939

A river in the background, wooded slopes on both banks,
And above, crowning those green hills,
The vast and deep blue sky.

*Une rivière au fond, des bois sur les deux pentes
Et pour couronnement à ces collines vertes
Les profondeurs du ciel toutes grandes ouvertes.*

Victor Hugo

Perhaps Rousseau had in mind these lines from Victor Hugo describing the valley of the Bièvre when he painted this landscape, one of his most graceful, of the Paris countryside. An attempt at elegance is evidenced in the sinuous drawing of the branches and the nuances of color in the foliage, whose shadings and fluffiness contrast with the sharp, flat outlines of the flora in the tropical paintings. In the background at the right, a red-tiled roof and a mass of reddish foliage enliven the color harmonies using a technique that had been common since the days of Corot. Once again we note how different Rousseau's Ile-de-France landscapes are from his Jungle pictures, not only on the representational level but also with regard to formal disposition. The strollers (wearing peasant dress) are walking not in the midst of impenetrable nature but along a road.

The picture has usually been dated very early, mainly because of the clumsy attempt at perspective (although the suggestion of depth is greater here than usual). Nevertheless, it is impossible to disregard Rousseau's own note on the stretcher on the back of the picture. The hypothesis that he affixed the inscription and date several years after finishing the picture because the foliage could not have been so plentiful on February 23, 1909—spring having been fairly late that year—fails to convince. We have too many indications that Rousseau painted from memory rather than from what he saw before him; witness the trees in the foreground, which are almost like ideograms. For that matter, it is probable that Rousseau worked from a postcard, since the site was well known. In the background on the right we can see the Arcades de Buc, the aqueduct built under Louis XIV to supply the fountains in the park at Versailles.

Provenance
A. Vollard, Paris; P. Guillaume, Paris; Galerie E. Bignou, Paris; Marshall Field, New York

Bibliography
A. Basler, 1927, pl. 13; C. Zervos, 1927, pl. 31; H. B. Wehle, *Metropolitan Museum Bulletin*, New York, vol. 34, 1939, pp. 64 et seq., repr.; D. Catton Rich, 1942, p. 52; D. Cooper, *Burlington Magazine*, LXXXIV–LXXXV, 1944, p. 164, repr. facing p. 159; D. Catton Rich, 1946, p. 57; W. Uhde, 1948, pl. 40; D. Cooper, 1951, p. 12, repr.; D. Vallier, 1961, no. 92; C. Sterling and M. M. Salinger, *French Paintings: A Catalogue of the Collection of the Metropolitan Museum of Art*, vol. 3, 1967, pp. 167–68, repr.; L. and O. Bihalji-Merin, no. 24, repr.; C. Keay, 1976, repr. p. XXV

Exhibitions
Chicago and New York, 1942, unnumbered; Venice, 1950, no. 19; Rotterdam and Paris, 1964, no. 21

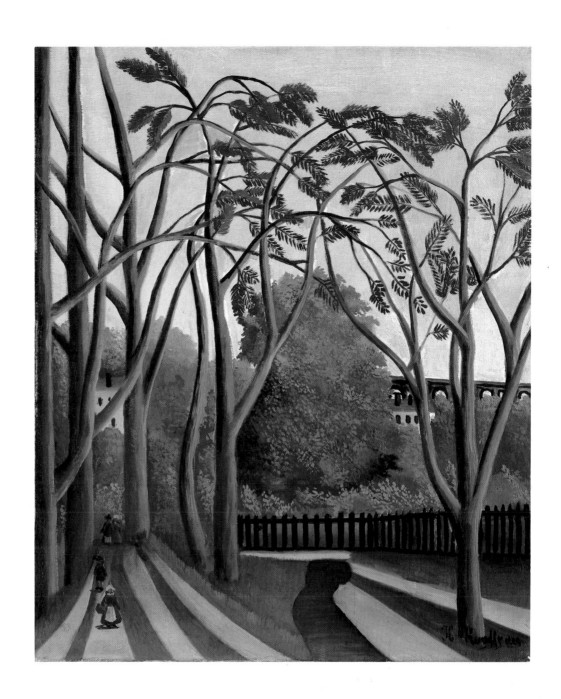

55 Study for View of the Bridge of Austerlitz

1908–09
Oil on cardboard
10⅝ x 8⅝" (27 x 22 cm)
Unsigned
JB 222; DV 231B
Private collection

Without the inscription by Rousseau himself on the back of the final version (private collection, Japan, DV 231A), it would be very difficult to identify this site; the picture exemplifies Rousseau's practice of varying the motifs in his Parisian landscapes, all located on the Left Bank. Here we see the building at the entrance to the Jardin des Plantes where Rousseau often strolled.

 The sketch, which might have been done on the spot, enabled him rapidly to lay in the principal masses. Here again he introduced the form of a Saint Andrew's cross, as he did in the view of the *Avenue, Park of Saint Cloud* (pl. 44). It is a schema that allowed him to give an impression of distance and depth and one that, in fact, he employed with some success.

 As in other examples where we know both sketch and finished picture, there is considerable difference between the two both in workmanship and spirit; the execution of the finished version is precise and detailed. The contrast is made even more striking because the two versions are of approximately the same size.

Provenance
Robert Delaunay, Paris

Bibliography
W. Uhde, 1911, fig. 22; W. Uhde, 1914, repr. pl. 29; C. Zervos, 1927, p. 81; Roch Grey, 1943, repr. no. 86; D. Vallier, 1961, no. 161

Exhibition
Paris, 1911, no. 42

56 Tropical Landscape:
An American Indian Struggling with an Ape

1910
Oil on canvas
44¹¹⁄₁₆ x 63¹⁵⁄₁₆″ (113.6 x 162.5 cm)
Signed and dated lower right: *Henri Rousseau 1910*
JB 229; DV 247
Virginia Museum of Fine Arts, Richmond
Collection Mr. and Mrs. Paul Mellon
New York exhibition only

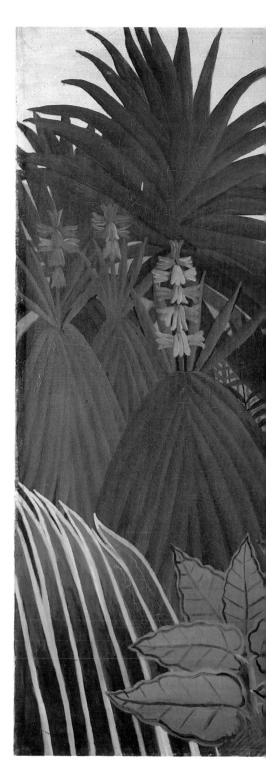

This Jungle painting, to a greater extent than others, reveals Rousseau's working methods. He drew inspiration from illustrations in encyclopedias or botanical books; he may even have traced them and redrawn their outlines on the canvas with the assistance of a pantograph, as Vallier suggests. What is unique in his case and completely invented—aside from the bringing together of species that belong in different habitats—is the manner in which he distributes them on the canvas and the grill-like effect he creates through the interweaving of the branches. Rousseau creates new flora and does not even attempt to describe any plausible landscape. He lays out the elements as his fancy dictates, with changes of scale, "mistakes" in proportion, and completely illogical placement; yet he creates a higher coherence, as did his Surrealist admirer Max Ernst. And, like Max Ernst, his accumulation of vegetation can assume an aspect of wonderment or terror as the painter—or spectator—chooses. Lacking in perspective like the so-called *mille fleurs* tapestries of the late Middle Ages to which they have so often been compared, Rousseau's Jungle paintings have taken on a value that is more poetic than descriptive.

The ape and the Indian here add the needed touch of animation in the form of a combat that, as usual, is indecisive. The character of the Indian, clad in feathers, is drawn from the rich, romantic tradition of the noble savage (see catalogue of the exhibition *L'Amérique vue par l'Europe,* Grand Palais, Paris, 1976, *passim*). At the end of the nineteenth century, it had become a cliché of the circus and theater (Buffalo Bill), illustrated book (e.g., Fenimore Cooper, Mayne Reid, Jules Verne), and even the children's toy. The selection of this "type," which does not appear to recur in any other picture by Rousseau, can perhaps be explained by his desire to vary the characters with which he filled out his compositions.

Provenance
Tetzen Lund, Copenhagen; Leigh Block (?), Chicago;
P. Rosenberg; Wildenstein, New York; Paul Mellon,
Upperville, Virginia

Bibliography
D. Catton Rich, 1942 and 1946, p. 67; D. Vallier, 1961,
repr. no. 157; C. Keay, 1976, repr. no. 78, pp. 168–69;
Y. Le Pichon, 1981, p. 171, repr. col.

Exhibitions
Zurich, 1937, no. 16; Chicago and New York, 1942

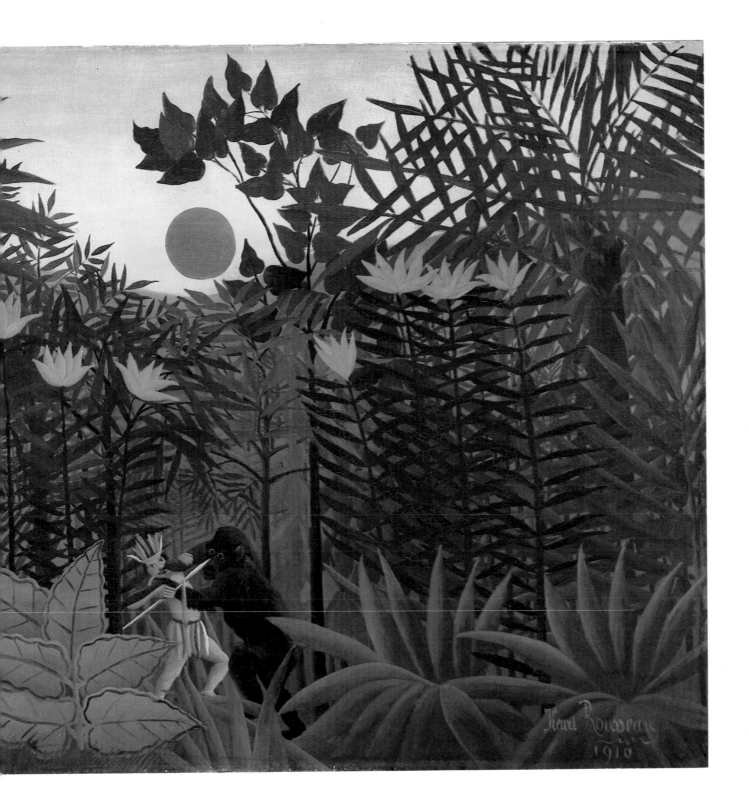

57 Portrait of Joseph Brummer

1909
Oil on canvas
45⅝ x 35⅛" (116 x 89 cm)
Signed and dated lower left: *H. Rousseau 1909*
JB 46; DV 224
Private collection

This portrait, one of Rousseau's last, is striking in its monumentality. It would appear to have been the only one in which the Douanier represented his subject at full length and seated. What we have is a somewhat solemn portrait in a traditional pose—one employed, however, more often by sculptors than by painters, who generally avoid posing their models full face. An exception is Cézanne, whose portrait of Achille Emperaire (fig. 1) had hung at the 1907 Salon d'Automne and whose posterlike style and hasty execution could not have failed to attract Rousseau's attention. Here the dissymmetry of the trees, which differ in hue, mass, and kind, and the detail of the lit cigarette manage to lend a bit of life to this hieratical composition. The features are painted with a meticulous care and application that verge on caricature, as in the *Portrait of Pierre Loti* (pl. 7). The garnet color of the chair introduces the complementary color for the greens. The monumentality of the figure had particular importance for Picasso and Léger.

Joseph Brummer, at the time a young, penniless sculptor, had arrived in Paris from Hungary in 1906. To earn a living he shaped marble for Rodin and worked as a model in various studios. According to Max Weber, he brought

Provenance
J. Brummer, Paris; W. Uhde, Paris; Uhde sale, Paris, 1921, no. 56; Mietshaninoff, Paris

Bibliography
Three letters from Rousseau to Brummer, 1909, reprinted in *Les Soirées de Paris*, January 15, 1914, pp. 50–52; W. Uhde, 1921; H. Kolle, 1922, pl. 2; A. Basler, 1927, pl. 6; C. Zervos, 1927, pl. 95; D. Catton Rich, 1942, pp. 52, 56, 58; Roch Grey, 1943, repr. no. 16; D. Catton Rich, 1946, p. 59; H. Certigny, 1961, pp. 374–75; D. Vallier, 1961, p. 145; S. Leonard, 1970, p. 36; A. Jakovsky, 1971, repr.; L. and O. Bihalji-Merin, 1971, no. 30; P. Descargues, 1972, repr. col. p. 105; C. Keay, 1976, p. 164, no. 75; Y. Le Pichon, 1981, p. 79, repr. col.; H. Leppien, catalogue of exhibition *Der zerbrochene Kopf*, Kunsthalle, Hamburg, December 11, 1981–February 21, 1982, repr. p. 6; E. H. Gombrich, *The Story of Art*, Englewood Cliffs, N.J., 1983, repr. p. 468

Exhibitions
Paris, 1909, no. 1386 (*Portrait [paysage]*); New York, 1931, no. 5; Zurich, 1937, no. 9; Chicago and New York, 1942, unnumbered; New York 1951, no. 22; Paris 1961, no. 63; Paris, 1964, no. 24

Fig. 1.
Cézanne. *Achille Emperaire.* c. 1870
Musée d'Orsay, Paris

Fig. 2.
Constant. *Monsieur Chauchard*
Musée du Louvre, Paris

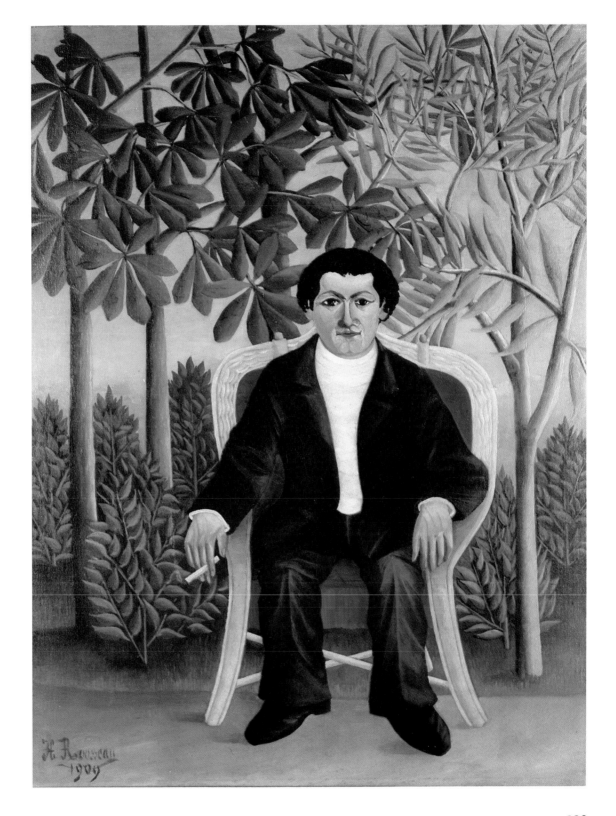

Brummer to Matisse's classes in 1908 (see Sandra E. Leonard, 1970, p. 36). Brummer offered to pose and sweep out the studio to pay for his lessons. It is no surprise that Matisse welcomed him graciously. Brummer was interested in Japanese prints, which he bought and sold, as well as in African sculpture, which he collected. In time he sold off all his holdings and was able to open a shop on the boulevard Raspail. Later, he moved to New York where he became well known as a dealer in antiques and pictures, ending his career with fame and wealth.

Sandra Leonard tells how Max Weber and Brummer met at the Académie de la Grande Chaumière in 1908. Weber had just come from Rousseau's apartment, where the latter had been putting the final touches to *The Jungle: Tiger Attacking a Buffalo* (pl. 50). Their meeting must have occurred in the spring, prior to the opening of the Salon des Indépendants, where that picture was shown. (Weber places their meeting in the autumn of 1908, obviously a lapse of memory.) Brummer, who was very alert when it came to business, wanted to get to know the Douanier, and a short while later Weber set up a meeting. From then on Brummer bought pictures from Rousseau and offered them to his clients, along with Japanese prints and Congolese carvings. According to Adolphe Basler, he met Rousseau at Brummer's before the days of the soirées, which fixes the date of their meeting in the early part of 1908. However, the sculptor Csaky, upon arrival in Paris in August of 1908, stayed with his compatriot Brummer, and Csaky, contradicting Basler, has stated that at the time Brummer had not yet come into contact with Rousseau (cited in H. Certigny, p. 355).

Fig. 3.
Rousseau in front of the *Portrait of Joseph Brummer* (pl. 57) and the second, then unfinished version of *The Muse Inspiring the Poet* (pl. 58)

58 The Muse Inspiring the Poet

1909
Oil on canvas
57½ x 38½" (146 x 97 cm)
Signed and dated lower right: *Henri Rousseau 1909*
JB 44; DV 227B
Oeffentliche Kunstsammlung, Kunstmuseum, Basel

This picture is one of Rousseau's "portrait-landscapes," and is, like *The Present and the Past* (1890–99, p. 26, fig. 4), one of the few with two figures. *The Muse Inspiring the Poet* is a visual token of the friendship between Rousseau and poet Guillaume Apollinaire. Although the poet and painter were acquainted for little more than two or three years, Apollinaire's infectious enthusiasm and the texts and poems he devoted to the Douanier both before and after his death were to link their names solidly.

Rousseau painted two versions of this portrait. When he began, the liaison between Apollinaire and painter Marie Laurencin was in its initial stages: they had met early in 1908, only a few months before. Rousseau placed them in a floral framework in which, as was his habit, he intermingled real and imagined species of plants. To a greater degree than in other portraits, however, the figures are almost deluged with flowers. A garland of pansies encircles the face of Marie Laurencin. She also dominates; her pose and gesture, finger upraised, confer upon her a superior status, suggesting some unidentified John the Baptist or the figure of Plato lecturing to Apollinaire-Aristotle in Raphael's *School of Athens*. Apollinaire, who looks docile and respectful, resembles the image of Schiller in the famous Weimar statue that depicts him alongside Goethe. The large quill pen he is holding is oddly reminiscent of the mane of the steed in *War* (pl. 9).

This highlighting of the female character, obviously the star of the pair and even more so in the first version of the painting (fig. 1), is perhaps tinged with irony. Indeed, there is something caricatural about the work as a whole. Marie Laurencin, graceful and slender, protested when she saw the massive and statuesque creature into which the painter had transformed her. He is said to have replied that Apollinaire was a great poet—he needed a fat Muse.

Both picture and anecdote remind us that Rousseau, somewhat awkward in manner, was far from narrow-minded and was probably cleverer than the "merry pranksters of Montmartre" (X. Tilliette) realized. The drawing of the figures is obviously inferior in quality to that of the foliage, which did not present the same difficulties for him. The floral setting has been greatly altered in this second version. A photograph of Rousseau in front of the unfinished canvas (pl. 57, fig. 3) reveals that he had begun by painting the greenery, while the space for the figures was still merely traced out.

This painting has been celebrated in poetry by the Hungarian Dadaist Lajos Kassak (1887–1967), who had known Apollinaire and Blaise Cendrars in Paris in 1909 (*Die basler Museen,* October 1969, no. 116).

Provenance
G. Apollinaire, Paris; P. Rosenberg, Paris, 1914; P. Mendelssohn-Bartholdy, Berlin, 1914; A. Flechtheim, Dusseldorf, 1922; Comte de Wesdehlen, Geneva

Bibliography
Letter from Apollinaire, published by A. Warnod, *Comoedia,* April 23, 1909, p. 135; *Les Soirées de Paris,* no. 20, January 15, 1914, repr. p. 53; G. Coquiot, *Les Indépendants 1884–1920,* Paris, undated (1920), repr. facing p. 120; W. Uhde, 1920, repr. p. 19; H. Kolle, 1922, pl. 7; A. Basler, 1927, pl. 5; A. Salmon, 1927, no. 37; P. Soupault, 1927, pl. 35; C. Zervos, 1927, pl. 77; F. Olivier, *Picasso et ses amis,* Paris, 1933; Roch Grey, 1943, no. 92; P. Courthion, 1944, pl. XXXI; M. Netter, "Hommage à Rousseau: Kunstmuseum de Bâle," *Schweitzer Museen,* November 1949, p. 101, repr. p. 103; *Schweitzer Radio-Zeitung,* July 2, 1950, p. XXXV; *Histoire de la peinture moderne, de Picasso au Surréalisme,* Geneva, 1950, repr. col. p. 24; D. Cooper, 1951, repr. col., p. 43; "De Holbein à Picasso: Musée de Bâle," *Art et style,* no. 22, Paris, 1952; M. Raynal, *Peinture moderne,* Geneva, 1953, repr. col. p. 130; M. Netter, "Wie erleben Sie die Kunst?," *Ex Libris,* 1954, no. 8; A. Warnod, *Fils de Montmartre,* Paris, 1955, p. 135; C. Gray, "Marie Laurencin and Her Friends," *The Baltimore Museum of Art News,* February 1958, p. 6, repr. p. 1; B. Bilzer, *Europäische Kunstreise durch bedeutende Gemäldegalerie zwischen Stockholm und Rom,* Brunswick, 1958/59, repr. col. p. 50; G. Vergnes, *La Vie passionée de Guillaume Apollinaire,* Paris, 1958, repr. facing p. 8; L. Zahn, *Eine Geschichte der modernen Kunst,* Berlin, 1958, repr. facing p. 80; J. Bouret, 1961, pp. 41–42; G. Ulrich, *Kleine Geschichte der Malerei,* Gütersloh, 1962, repr. p. 150; R. Huyghe and J. Rudel, 1970, repr. col. p. 250; P. Descargues, 1972, repr. col. p. 95; O. Bihalji-Merin, *Henri Rousseau: Leben und werk,* Cologne, 1976, repr. col.; D. Vallier, 1979, repr. col. p. 75; R. Sandell, "Marie Laurencin: Cubist Muse Or More?," *Women's Art Journal,* no. 27, 1980, repr. 1; Y. Le Pichon, 1981, p. 76, repr. col.; "Henri Rousseau: Vater der naiven Malerei," *Pan,* no. 7, Offenburg, 1982; C. Kellerer, "Der Sprung ins Leere," *Objets trouvés, Surrealismus, Zen,* Cologne, 1982, p. 192; W. Rotzler, "Apollinaire und seine Freunde, *DU,* Zurich, no. 3, 1982, repr. col.

Exhibitions
Paris, 1911, no. 43; Paris, 1912, no. 26; Berlin, 1926, no. 5

History

Sometime in the middle of 1908 the idea of painting a double portrait of Guillaume Apollinaire and Marie Laurencin is mentioned in some of Rousseau's letters (published in *Les Soirées de Paris,* no. 20, January 15, 1914). Apollinaire, in recalling the event, was to write: "I posed a number of times for the Douanier, and before beginning he measured my nose, my mouth, my ears, my forehead, my hands, my entire body, and he then transferred those measurements with great exactitude onto his canvas, reducing them to fit its size. In the meantime, since posing is extremely boring, Rousseau entertained me by singing songs of his youth."

Rousseau at once took up the project seriously, and on Wednesday, August 10, 1908, he scheduled the first sitting for "Friday at one p.m." However, the sessions were put off from week to week. In the meantime he went to work on the background (August 31: "For the time being I am going to do a background in the Luxembourg Gardens. I've found a very poetic little nook") and on the gown, although Marie Laurencin was very lax about coming to the studio: on December 27, 1908, Rousseau was to write to Apollinaire: "I am still awaiting the charming Muse to pose for me at least once."

Nothing seems to have been determined with regard to payment for the portrait. Rousseau's first written request dates from March 17, 1909, on the eve of the deadline for submissions to the Salon des Indépendants: "The woodworker is coming tomorrow with the frames, so would you be so kind as to send me a bit of money by return." Finally, on April 28, four days before the Salon was to close, Rousseau made up his mind to suggest—albeit in a rather roundabout way—a precise figure: "It upsets me to have to write this to you … I hope you will be so good as to give me a bit of money in advance for the work on your portrait. Several people have asked me how much I sold it to you for, and I have told them 300 francs, which they seemed to think wasn't expensive; true, it was a price between friends."

A month later, on May 31, Rousseau mentions the portrait again in his letters, but now it is a question of the second version, which was somewhat different in size (Kunstmuseum, Basel). If we are to believe Apollinaire: "thanks to the shaky grasp of science on the part of the botanists in the rue Vercingétorix, the pious and pure painter will still win out over literature and, during my absence, mistaking his flowers the Douanier painted stocks. He redressed his error in the course of that same year by doing another portrait of me with sweet william." [Rousseau undoubtedly knew that the French name for sweet william is *oeillets de poète,* or "eyes of the poet," but the pun in English on Apollinaire's first name was perhaps unintended.] This charming fable may conceal the more prosaic fact that the Douanier, short of funds, had found another buyer—presumably Ambroise Vollard, who sold the first version to the Russian collector Sergei Shchukin.

The history of the second portrait followed more or less the same course as the first, with the difference that Rousseau asked Apollinaire for money on several occasions and that the sittings appear to have been even more rare than before: "I have additional problems because you haven't come to sit again and I have had a lot of trouble with certain tints, but in any case I'll manage to do it from memory" (August 3, 1909). After September 24 the portrait ceases to be mentioned in Rousseau's letters.

Fig. 1.
Rousseau. *The Muse Inspiring the Poet* (first version). 1908–09
The Pushkin State Museum of Fine Arts, Moscow

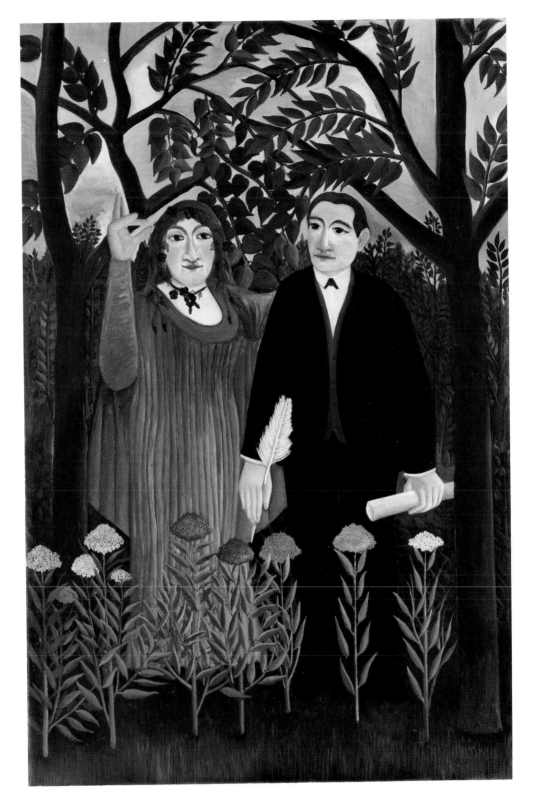

233

59 Study for View of the Ile Saint Louis from the Quay Henry IV

1909
Oil on cardboard
8¾ x 11⅛" (21.9 x 28.2 cm)
JB 218; DV 228B
Private collection

60 Notre Dame: View of the Ile Saint Louis from the Quay Henri IV

1909
Oil on canvas
13 x 16⅛" (33 x 41 cm)
Signed and dated lower left: *H. Rousseau 1909*
JB 45; DV 228A
The Phillips Collection, Washington, D.C.

See,
How lovely always is the scene
Of Paris from afar, sad and merry, mad and wise...

Voyez donc
Comme est joli toujours le paysage
Paris au loin, triste et gai, fol et sage...

Paul Verlaine

Knowledge of Rousseau's working methods can be gathered from a comparison of his preparatory sketch with the finished painting of *Notre Dame: View of the Ile Saint Louis from the Quay Henri IV*. We can presume that the sketch was done outdoors, even if Rousseau had also derived inspiration from a photograph. This site, which has changed in appearance very little since the early part of the century, has undergone considerable interpretation. We sense the artist's striving to achieve a highly organized, well-laid-out composition. The lines of the bridge, the massed trees and houses, the oblique angle of the quay, the triangular shapes of Notre Dame, and the boat on the strongly accented vertical axis form a kind of grid, precise but without the stiffness or clumsiness of some of the other urban landscapes. The interplay of lines, the tiered arrangement of the planes, and the decreasing size of the buildings suggest space and distance, further enhanced by the relationship between the towers of Notre Dame and the houses.

It is tempting to attribute this somewhat unusual ease of execution to acquired experience, since the picture was painted only a year prior to Rousseau's death. However, the arrangement of the right-hand side of the picture (the houses in the background, the bridge viewed head on, the boat and quay viewed at a slant) is almost identical to that in *Myself, Portrait-Landscape* (1890, pl. 5) of twenty years earlier. Robert Delaunay drew upon the left-hand side of

Pl. 59
Provenance
W. Uhde, Paris, 1911; J. H. Weitzner; H. D. Sharpe, Providence, Rhode Island

Bibliography
D. Catton Rich, 1942 and 1946, p. 60; repr.; D. Vallier, 1961, no. 24; H. Certigny, 1961, repr. between pp. 382 and 383

Exhibitions
Paris, 1911, no. 30; Berlin, 1912, no. 222; Chicago and New York, 1942, unnumbered; New York, 1963, no. 57

Pl. 60
Provenance
W. Uhde, Paris; R. and S. Delaunay, Paris; P. Guillaume, Paris

Bibliography
W. Uhde, 1911, fig. 6; W. Uhde, 1914, pl. 29; Roch Grey, 1924, repr.; A. Basler, 1927, pl. 11; A. Salmon, 1927, repr. no. 38; C. Zervos, 1927, pl. 79; P. Soupault, 1927, pl. 34; D. Catton Rich, 1942, p. 61; repr.; Roch Grey, 1943, no. 67, repr.; P. Courthion, 1944, pl. XXXII; D. Catton Rich, 1946, p. 60; *The Phillips Collection, Washington, Catalogue*, 1952, p. 88; H.

the earlier canvas for his *City of Paris* (1910–12, pl. 5, fig. 3). The site, of course, has inspired countless artists, among them Meryon, Signac, Luce, and Marquet. Rousseau set up his easel slightly upstream from the building at 19, quai Saint-Michel, where Matisse and Marquet had moved their studios a short time before.

Is there any significance in the fact that instead of the French flag, which appears so often in his works, Rousseau has here chosen a red flag, the symbol of revolution, but also a danger signal?

Certigny, 1961, repr. between pp. 382 and 383; D. Vallier, 1961, p. 125, repr. col.; L. and O. Bihalji-Merin, 1971, no. 11, repr.; A. Jakovsky, 1971, repr.; P. Descargues, 1972, repr. col. p. 84; Y. Le Pichon, 1981, p. 107, repr. col.

Exhibitions
Paris, 1911, no. 34; Berlin, 1912, *Der Blaue Reiter*; Berlin, 1912, *XXIV. Ausstellung der Berliner Secession*, no. 226; Chicago and New York, 1942, unnumbered; New York, 1951, no. 21; Paris, 1961, no. 67; New York, 1963, no. 58; Rotterdam and Paris, 1964, no. 23

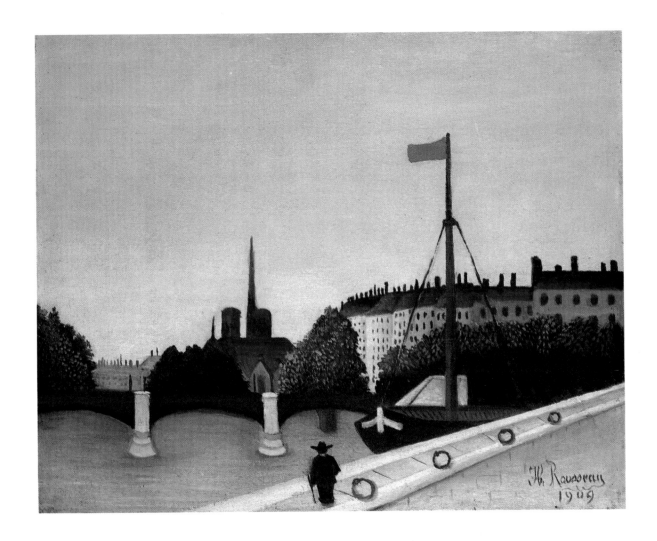

61 Luxembourg Garden

1909
Oil on canvas
14¹⁵⁄₁₆ x 18½″ (33 x 41 cm)
Signed and dated lower right: *H. Rousseau, 1909*
JB 2006; DV 226
Hermitage State Museum, Leningrad

This dated and well-documented picture (it was handed over to Ambroise Vollard as soon as it was finished) is a good example of those works of modest size but beguiling charm that Rousseau made for sale once he had achieved success.

The strollers in their Sunday best promenade in the Luxembourg Garden in the direction of the monument to Frédéric Chopin by Georges Dubois. Rousseau spent a great deal of time in this park and had written to Apollinaire that he had selected "a little nook" of the Luxembourg as background for the writer's portrait (pl. 58). The park is next to the Musée du Luxembourg, in which Rousseau must certainly have dreamed of seeing his work hung. Distance and depth are suggested by the curve of the avenue and by the decreasing size of trees and people. The layout has an odd resemblance to certain pictures Derain (fig. 1) painted in the early days of Fauvism. Although the trees and the characters cast no shadows, Rousseau, by laying in highlights, has suggested that the light is emanating from the right.

Notwithstanding its apparent simplicity and small size, this picture has no lack of significant elements. The traditional theme of strollers in a park (was Rousseau aware that Watteau too had painted in the Luxembourg?) is here transposed into contemporary costume, but, as is often the case in Rousseau's work, each person seems completely alone. Nature is familiar, reassuring, penetrable, and the solitary stroller runs no risk of meeting anything or anyone aside from other solitary strollers. As for the hues selected for the two principal figures, once again we have the three colors of the French flag, which would seem to have sprung spontaneously to Rousseau's brush.

Provenance
A. Vollard, Paris; S. Shchukin, Moscow

Bibliography
Catalogue of the Shchukin Collection, Moscow, 1913, no. 200; Catalogue of Western European Painting in the Hermitage Museum, Leningrad, I, 1958, p. 438; D. Vallier, 1961, p. 117; G. Viatte, *Art de France*, 1962, II, p. 332; L. and O. Bihalji-Merin, 1971, repr. col. no. 17; P. Descargues, 1972, repr. col. p. 94; C. Keay, 1976, p. 160, repr. no. 68; A. Barskaïa and A. Izerghina, *French Painting in the Hermitage Museum*, Leningrad, 1982, no. 73

Fig. 1.
Derain. *Hyde Park*. c. 1906
Musée Pierre Lévy, Troyes, France

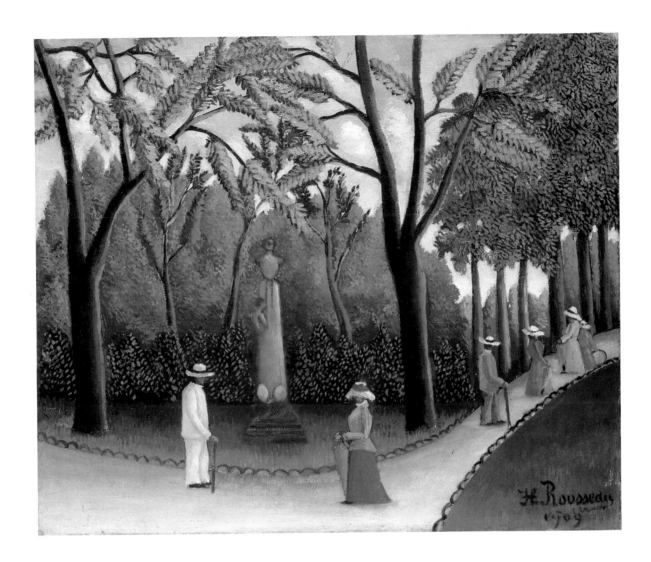

62 Meadowland

1910
Oil on canvas
18¹⁄₁₆ x 21⅝″ (46 x 55 cm)
Signed lower right: *H. Rousseau*
JB 139; DV 255
Bridgestone Museum of Art, Tokyo, Ishibashi Foundation
Paris exhibition only

Meadowland is one of Rousseau's small group of rural landscapes. The Douanier, who in fact took greater pains to vary his subjects than do many artists, occasionally turned to this genre so popular since the mid-nineteenth century. In some instances, using a print, he seems almost to have plagiarized an earlier picture. Here, the simplicity of the composition and its somewhat awkward arrangement would lead us to doubt that he employed a model. The various elements succeed each other from left to right and are juxtaposed without any real connections being made between them. The peaceful charm of this rustic scene is in sharp contrast to the profuse vegetation of the Jungle paintings, which are so often animated by some tragedy. The picture was probably painted fairly quickly to fulfil a commission by Ardengo Soffici and shows heavy cracking.

Rousseau began to derive profit from commissions toward the end of his life. Soffici, a painter and poet, often recounted the story of acquiring *Meadowland*. Having admired the pictures by Rousseau shown at the Salon des Indépendants, he paid him a visit to purchase some and hoped to acquire "the picture showing the copse of trees and cows" (*View of Brittany, Summer,* DV 187). The picture had already been sold to Brummer, and Rousseau told him: "I'll make you an even better one." He then painted this picture for Soffici, and it was brought to Italy by Serge Férat and Roch Grey, with whom Soffici rendezvoused in Venice. He was disappointed:

> Alas, *quantum mutatus!* In a field that looked like a green public square stand two animals that could just as well have been steers as cows; they were being tended, but instead of a shepherd there was a gentleman who looked like a commedia dell'arte character in a scarlet-red cap. Instead of the strong, age-old oak trees standing out among the woods...all I could see was a vegetal black with silvery commas in place of foliage; this tree looked more like a haystack than like the willow it was supposed to be; it was stuck down in front of a row of poplars lined up like soldiers across the background of the picture, and not the slightest trace of a line of woods!
>
> The whole thing wasn't bad, but I was disillusioned because the picture was not at all what I had looked forward to for such a long time" (quoted in Certigny, p. 439).

Provenance
Roch Grey (Baroness d'Oettingen), Paris; private collection, Osaka

Bibliography
Dodici opere di Rousseau, 1914, repr.; letter from S. Jastrebzoff to R. Delaunay, published by B. Dorival, 1977, p. 19; Roch Grey, 1924, repr., and 1943, repr. no. 62; A. Soffici, 1950, cited in H. Certigny, 1961, p. 411; H. Certigny, 1961, repr. facing p. 439; L. and O. Bihalji-Merin, 1971, repr. no. 19; C. Keay, 1976, repr. no. 35, p. 137; Y. Le Pichon, 1981, pp. 126–27, repr. col.

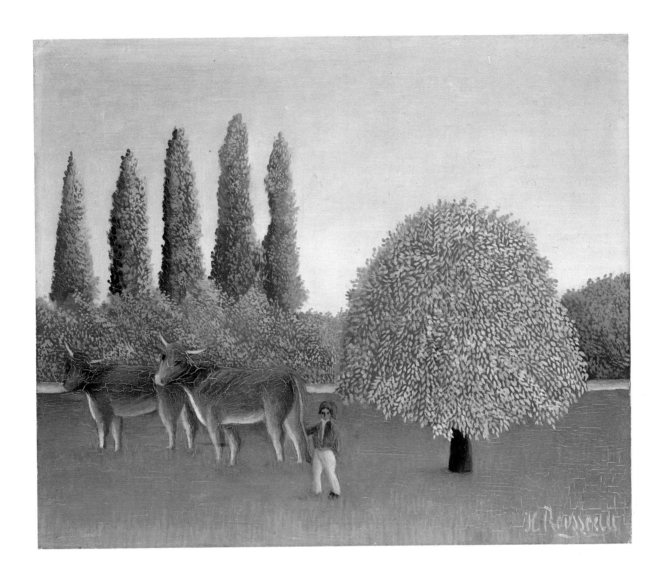

63 Forest Landscape with Setting Sun

c. 1910
Oil on canvas
44⅞ x 64″ (116 x 162.5 cm)
Signed lower right: *Henri Rousseau*
JB 31; DV 249
Oeffentliche Kunstsammlung, Kunstmuseum, Basel

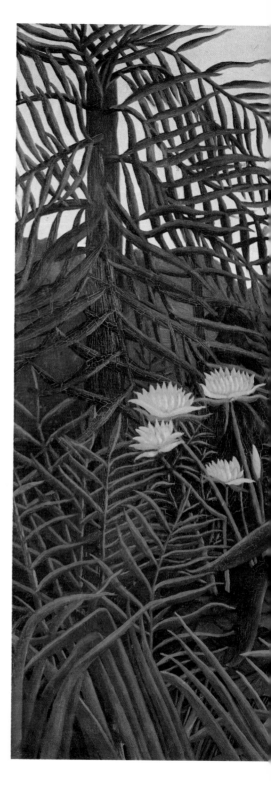

It is rare in the Jungle paintings to find one in which animate creatures (human or animal) play such a small role and in which, by contrast, the vegetation is subject to such precise and complex organization. From top to bottom the succession of planes is suggested on the canvas by an assemblage of plants that are of similar size and design but grow darker in tone. As in other paintings, Rousseau placed flowers at the midpoint of the canvas, their dimensions showing no concern for verisimilitude. Vast yellow and pink blooms frame red cactus flowers, punctuating the center of the canvas. This vertical tier arrangement is echoed by an evident attempt at symmetry; the central axis is marked by the large red sun and the struggling figures. The color scale is dominated by greens, from the yellow-green of the hemp plants on the right (almost identical to those in the same position in *The Snake Charmer,* pl. 36) to very dark tones of other foliage. The darkest portions of the canvas reveal old crackling, indicative of fairly extensive reworkings during the painting's execution.

The jaguar is taken directly from a photograph in the album *Bêtes sauvages* (Galeries Lafayette, c. 1910) in which it is rearing up at its trainer. The man here ducks his head to escape, as does the trainer in the album. With his left hand he stabs at the beast, which is bleeding. Although the man and the beast take up little space within the structure of the picture, their struggle is a reminder of the threat of the natural world with which Rousseau imbues most of his Jungle paintings.

The picture is usually dated near the end of Rousseau's life. In Rousseau's obituary notice written by Ardengo Soffici, who was later to become one of the main supporters of Futurism, reference was made to Rousseau's passion "for the sights and life of exotic lands…that overflowed into his many immense compositions in which the grotesque is joined to the touching.…Cruel struggles occur between blacks and wild beasts amidst the sap-filled grasses of the savannah.…" (*La Voce,* September 15, 1910, reprinted in *Mercure de France,* October 16, 1910).

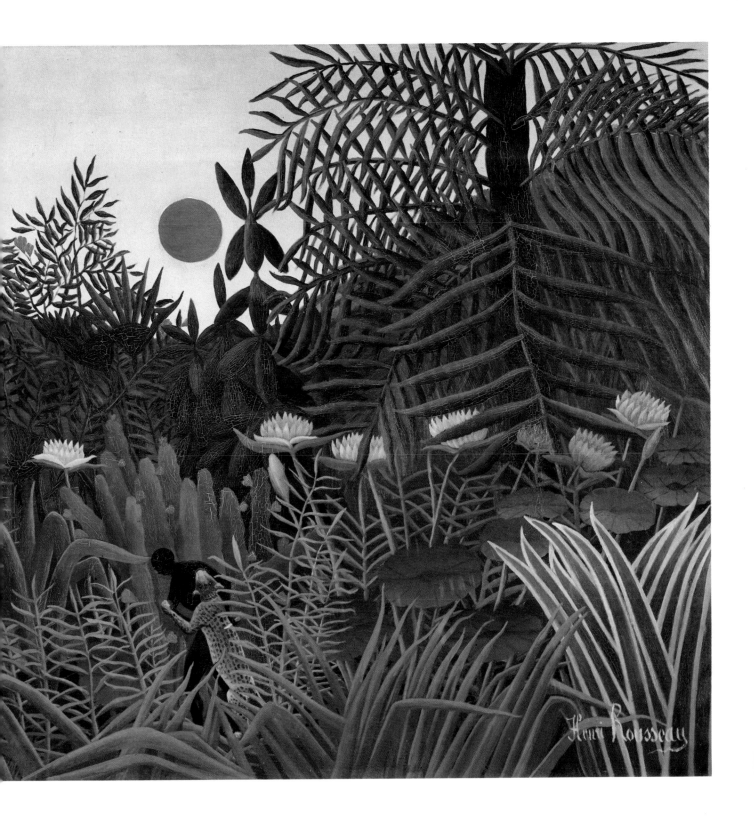

243

Provenance
A. Flechtheim, Dusseldorf; Mendelssohn-Bartholdy, Berlin; Dr. Charles Bernoulli, Basel

Bibliography
W. Uhde, 1914, pl. 43; W. Uhde, 1920, repr. p. 17; Roch Grey, 1924, repr.; C. Zervos, 1927, pl. 75; P. Soupault, 1927, pl. 16; Roch Grey, 1943, repr. no. 117; P. Courthion, 1944, pl. 17; R. Netter, "Hommage à Rousseau," *Schweitzer Museen,* November 1949, pp. 101–03; M. Netter, "Der Neuerwerbungen der oeffentlichen Kunstsammlung Basel 1947–1950," *Werk,* September 1950, p. 283; D. Cooper, 1951, repr. col. p. 59; "Musée de Bâle: De Holbein à Picasso," *Art et style,* no. 22, Paris, 1952, repr. col.; G. Schmidt, "Le Musée des Beaux-Arts à Bâle," *Journal des voyages,* no. 177, January-February 1954, p. 59, repr. 62; M. Netter, "Neuerwerbung einer 'Urwaldlandschaft': Hommage à Rousseau au Kunstmuseum de Bâle," *Musées Suisses,* November 1949, repr. p. 103; P. Mieg, "Kunst in Basel," *Schweitzer Journal,* February 1955, pp. 36–37, repr. p. 36; H. Platte, "Malerei," *Die Kunst des 20. Jahrhunderts,* Munich, 1957, p. 197, repr. pl. 1; G. Schmidt, "Wie kommt ein Bild ins Kunstmuseum?," *Die Ernte,* 1958, p. 257, repr. col.; Y. Le Pichon, "Le secret du Douanier Rousseau," *Elle,* February 10, 1961, p. 57, repr. p. 59; D. Vallier, 1961, no. 167; W. Helwig, "Die Geheimnisse eines Zöllners Henri Rousseau," *Gütersloh,* 1962, repr. col.; R. D. Hohl, "Sonnendarstellungen in der modernen Malerei und Plastik: Die Sonne in der Kunst," *Graphis,* Zurich, June 1962, p. 128, repr. col. no. 2; F. Deuchler, *Geschichte der Malerei von den Anfängen bis zur Gegenwart,* Lucerne, 1968, p. 140; R. Cowley, "The Toll Collector's Riddles," *Horizon,* Winter 1968, pp. 31–43, repr. col. pp. 36–37; L. and O. Bihalji-Merin, 1971, no. 51; C. Keay, 1976, no. 56; R. Alley, *Portrait of a Primitive: The Art of Henri Rousseau,* Oxford, 1978; G. Wirth, "Die naive Kunst," *Tapetenzeitung,* Stuttgart, July-August 1978, repr. col. p. 17; R. Cardinal, *Modern Primitives,* London, 1978, repr. col. no. 26; D. Vallier, 1979, repr. col. p. 91; Y. Le Pichon, 1981, pp. 156–57, repr. col.

Exhibition
Berlin, 1926, no. 28

64 Tropical Forest with Monkeys

1910
Oil on canvas
51 x 64″ (129.5 x 162.6 cm)
Signed and dated lower right: *Henri Rousseau 1910*
JB 48; DV 253
National Gallery of Art, Washington, D.C., The John Hay Whitney Collection 1982

You recall, Rousseau, the Aztec landscape,
The forests where the mango and pineapple grew...

Tu te souviens, Rousseau, du paysage aztèque,
Des forêts où poussaient la mangue et l'ananas...

Guillaume Apollinaire

In addition to those Jungle paintings in which a tragedy is taking place, there are others that are more peaceful. In his obituary of Rousseau, Ardengo Soffici, the Italian Futurist who had known the Douanier well, after noting that the painter already had imitators less valid than he, wrote: "What makes Henri Rousseau different from his popular fellows ... is his tendency to fantasy, and especially his almost nostalgic passion for the sights and life of exotic lands ... that overflowed into many immense compositions in which the grotesque is joined to the touching, the absurd to the magnificent, and totally distorted objects to things undeniably beautiful and poetic" (*La Voce,* September 15, 1910, reprinted in *Mercure de France,* October 16, 1910).

These clever monkeys leaping from tree to tree or standing in the water fishing with poles have sprung straight out of Rousseau's imagination, with help from the album *Bêtes sauvages* of the Galeries Lafayette (see Y. Le Pichon, 1981, p. 165), but that unimaginative collection of photographs could have provided him with little more than shapes. The actions—and particularly fishing, an activity that often figures in his suburban and city landscapes—take us, as in

Provenance
P. Mendelssohn-Bartholdy, Berlin; John Hay Whitney, New York, 1950

Bibliography
W. Uhde, 1911, pl. 41; W. Uhde, 1914, pl. 41; W. Uhde, 1920, repr. p. 18; D. Vallier, 1961, no. 170; Y. Le Pichon, 1981, p. 165, repr. col.

Exhibitions
Berlin, 1926, no. 26 (*Les Singes*); Paris, 1961, no. 79

Fig. 1.
Rousseau. *Cascade.* 1910
The Art Institute of Chicago.
Helen Birch Bartlett Memorial Collection

The Merry Jesters (pl. 33), into an imaginary world. The flowers are monstrous and their leaves disproportionately large, while the monkeys engage in human pursuits. Chardin, the painters of *singeries,* the illustrators of La Fontaine, Grandville, and many others also humanized their animals.

This jungle scene, painted a few months prior to Rousseau's death, is similar in spirit to an *Exotic Landscape* (DV 252, Norton Simon Foundation, Los Angeles) of the same size and in which monkeys are playing with oranges in the trees.

To his usual foliage Rousseau has added a hedge of purple shrubbery like the one that appears in *Cascade* (fig. 1), which dates from the same period and is similar in size.

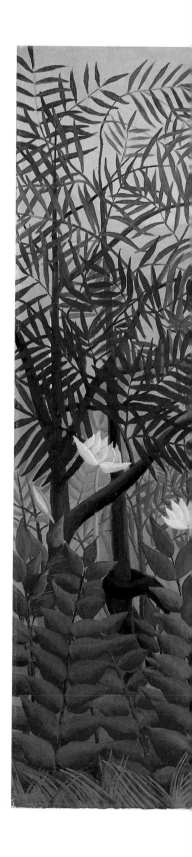

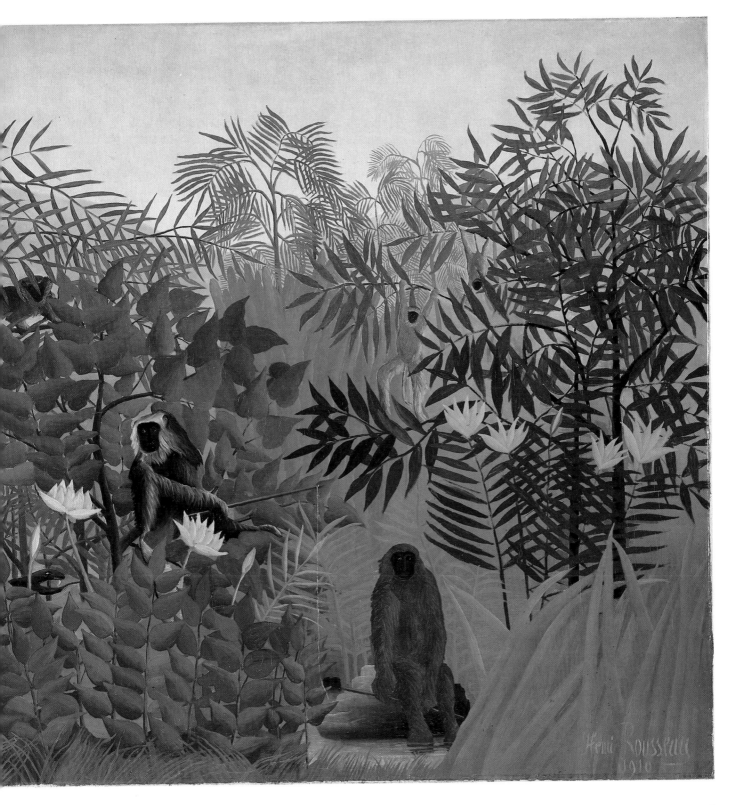

65 Horse Attacked by a Jaguar

1910
Oil on canvas
31¹⁄₁₆ x 45⁵⁄₈" (89 x 116 cm)
Signed lower right: *Henri Rousseau*
JB 223; DV 250
Pushkin State Museum of Fine Arts, Moscow

This is probably one of Rousseau's last Jungle paintings. We again encounter the teeming vegetation, systematic disproportion among flowers, grasses, and trees, and, as usual, a struggle at the focal point of the picture. The virgin forest itself has more animation than in earlier works. Rousseau has varied to a greater degree the shapes, colors (red, orange, violet, and white), and distribution of the flowers. The plants seem to be participating in the combat, and those on the left appear to be bending toward and menacing—like so many blades or snakes— the pair of struggling beasts. The jaguar gripping its prey recalls other wild beasts painted by Rousseau, but the white horse is the more startling. The head with black eyes and flowing mane, seen full front, seems to have been inspired by some heraldic figure, whereas the painter has given the part of its body to the right of the jaguar's paw a female shape.

Vallier believes Rousseau makes reference to this painting in a letter to Ambroise Vollard dated March 5, 1910: "*The Dream* is finished. I am beginning the 50 canvas; the subject will be a fight between a lion and a horse" (catalogue of the Rousseau exhibition, Paris, 1944, pp. 18–19). The 50 format (31¹⁄₁₆ x 45⁵⁄₈") accords with the present picture; the substitution of a jaguar for the lion could very well be explained by the imprecise aspect of the beast as we have it here, or by the fact that Rousseau painted the animals in at the end. There also exists a receipt that almost certainly refers to this picture ("Received from Monsieur Vollard the sum of 100 francs for a picture entitled combat between jaguard [*sic*] and horse. Paris, March 22, 1910, Henri Rousseau," published in G. Viatte, 1962, p. 334). It is unlikely that the picture was painted in seventeen days, but it could have been begun prior to March 3, and Vollard could have paid for it before it was finished.

Provenance
A. Vollard, Paris; S. Shchukin, Moscow

Bibliography
W. Uhde, 1933, p. 191, fig. 239; W. Kuhn, 1938; M. Brown, 1964, L. and O. Bihalji-Merin, 1971, repr. no. 55; C. Keay, 1976, repr. col. no. XXXI; Y. Le Pichon, 1981, p. 149, repr. col.

Exhibitions
New York, 1913, no. 382; Chicago, 1913, no. 359; Boston, 1913, no. 192

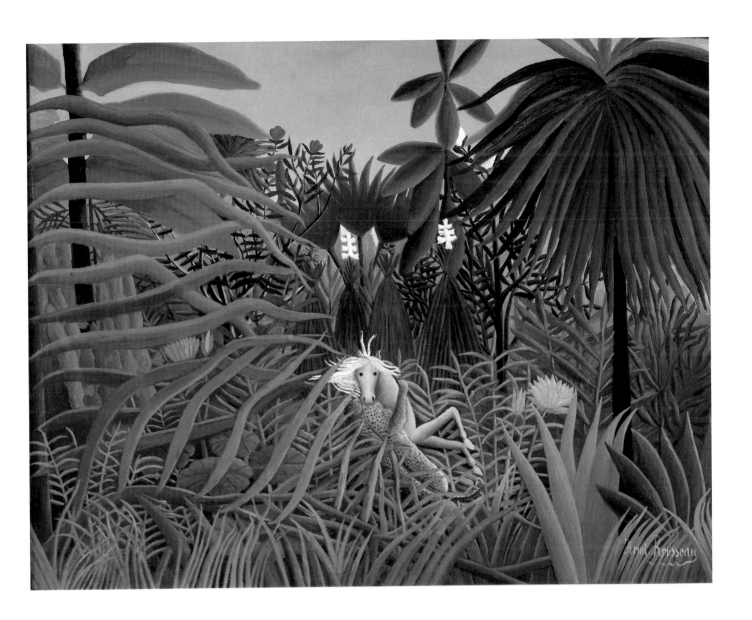

66 The Dream

1910
Oil on canvas
80½ x 117½" (204.5 x 298.5 cm)
Signed and dated lower right: *Henri Rousseau 1910*
JB 47; DV 256
The Museum of Modern Art, New York, gift of Nelson A. Rockefeller, 1954

O hothouse amidst the forest trees
The reveries of a princess.

O serre au milieu des forêts!
Les pensées d'une princesse.

Maeterlinck

The Dream, followed by *The Hungry Lion* (1905, pl. 31), is the largest of Rousseau's pictures. The artist's letter to critic André Dupont deserves quotation: "I am writing in response to your friendly letter to explain to you the reason the couch in question is where it is. This woman asleep on the couch is dreaming she has been transported into the forest, listening to the sounds from the instrument of the enchanter" (April 1, 1910, published in *Les Soirées de Paris,* January 15, 1914). Both the poem and letter are explicit: the incongruity does not arise from the presence of this naked woman on a Louis-Philippe couch in the midst of the jungle, but rather the contrary. The woman is at home, and she dreams she is in a jungle, just as Rousseau dreamed of distant lands in his Paris studio. Here, as in Rousseau's two other dreamlike pictures, *War* (pl. 9) and *The Sleeping Gypsy* (pl. 19), we have what is at least a partial identification of the painter with a female figure.

The woman, Yadwigha—whom Rousseau has given the name of a Polish woman of whom he was fond—finds herself in an *inhabited* jungle vastly different from Rousseau's other Jungles. No other has been so heavily populated: the flute player is surrounded by a lion and lioness, a serpent, an elephant, two birds, and a monkey, perhaps owing to the spell of music. Under the sway of the Tahitian Orpheus, all the animals live in perfect harmony and move about in a lush vegetation that is more easily penetrated than in other Jungles. Instead of the usual wall formed by the plants and the trees, the painter presents a series of planes arranged in tiers. Ambroise Vollard, who was the painting's first owner and who may have commissioned it, remarked upon this and asked: "Look here, Monsieur Rousseau, how did you manage to get so much air among those trees?" "Through the observation of nature," Rousseau responded (A. Vollard, *Recollections of a Picture Dealer,* London, 1936).

Another element unique to *The Dream* is that most of the flowers—which are gigantic—are seen in cross-section in such a way as to show their hearts, a detail that perhaps lends itself too easily to a Freudian interpretation. Rousseau has replaced his usual neutral lighting with moonlight effects, at least

Provenance
A. Vollard, Paris; Knoeder's, New York; Sidney Janis Gallery, New York

Bibliography
F. R. Kemp, "Les Indépendants," *L'Aurore,* March 18, 1910; G. Apollinaire, *L'Intransigéant,* March 18, 1910, reprinted in *Chroniques d'Art 1902–1918,* 1960, p. 76; Santilhac, *Le Soleil,* March 19, 1910; L. Werth, *La Phalange,* April 20, 1910; A. Soffici, 1910; W. Uhde, 1911, fig. 26; W. Uhde, 1914, pl. 5; *Les Soirées de Paris,* no. 20, January 15, 1914, pp. 56–57; G. Coquiot, 1920, pp. 130–33; W. Uhde, 1921, p. 88; P. Soupault, *L'Amour de l'art,* October 1926, p. 335; P. Soupault, 1927, pp. 24, 42; A. Basler, 1927, pl. 20, p. 13; A. Salmon, 1927, pp. 32–37, repr. no. 39; C. Zervos, 1927, pl. 23–27; R. Huyghe, 1933, p. 186; A. Vollard, 1937, p. 241; R. H. Wilenski, 1940, pp. 205–06; D. Catton Rich, 1942 and 1946, pp. 42, 64, 73–79, repr. pp. 68, 70, 71; Roch Grey, 1943, repr. no. 93; P. Courthion, 1944, pl. 26; W. Uhde, 1949, p. 56, repr. p. 69; R. H. Wilenski, 1953, p. 000; H. Perruchot, 1957, pp. 67–68, pl. 12; J. Cassou, 1960, p. 609; D. Vallier, 1961, pp. 95, 118, repr. col. p. 133; H. Certigny, 1961, pp. 406–08; A. Breton, 1965, pp. 52, 293–94; R. Passeron, 1968, repr. no. 16; A. Salmon, *Souvenirs sans fin: 2ème époque,* Paris, 1969, pp. 49–50; R. Huyghe and J. Rudel, 1970, pp. 346–47; L. and O. Bihalji-Merin, 1971, no. 56; A. Jakovsky, 1971, repr.; P. Descargues, 1972, pp. 124–25, repr. col. pp. 122, 125; V. Nezval, 1972, pp. 82–83; *Three Generations of Twentieth-Century Art: The Sidney and Harriet Janis Collection of The Museum of Modern Art,* New York, 1972, pp. 211, 222; H. Franc, 1973, repr. col. p. 80; R. Nacenta, 1973, no. 4, repr. col.; C. Keay, 1976, pl. XXX; W. S. Rubin, undated (1969), p. 128, repr. p. 422; S. Monneret, 1979, p. 214; D. Vallier, 1979, p. 85, repr. col. pp. 84, 86, 87; Y. Le Pichon, 1981, pp. 181–82, 208–11, repr. col.

Exhibitions
Paris, 1910, no. 4468; Chicago and New York, 1942, unnumbered; New York, 1951, no. 23

on certain trees and on the oranges, which are given some feeling of shape. J. Bouret has also noted the triangular elements in the composition: "All the active elements, the flute-player, the tiger, the bird, are inside a triangle pointing down on the right, and the passive element, the recumbent woman, occupies another triangle on the left, pointing up" (1961, p. 50).

Can we find a precise model for this woman, whose figure recalls that of *Eve* (pl. 29)? All the recumbent Venuses of the Renaissance, Goya's Majas, Madame Récamier, and Manet's Olympia can be invoked here (see p. 76, fig. 59). Such a plethora of models only serves to prove that, consciously or not, Rousseau was working in one of the most long-lived traditions of art history. If we must cite a recent precedent let us take the *Models in Repose* of Felix Vallotton (fig. 1), which hung next to *The Hungry Lion* (pl. 31) in the 1905 Salon d'Automne. The resemblances are striking and, further, since Vallotton was one of the first to write a favorable article on Rousseau, the Douanier had reason to notice the work of a well-wishing "colleague."

By 1910 Rousseau was a well-known personality, and the critics had begun to look for his works. This picture, whose size and subject matter could not help but attract attention, did not meet with an indifferent reception. A few days prior to the opening of the Salon, Rousseau wrote to Apollinaire: "I have submitted my large picture; everyone likes it, I hope you will deploy your literary talent and avenge me for all the insults and affronts I have received" (March 11, 1910, published in *Les Soirées de Paris,* January 15, 1914, p. 56). Apollinaire did indeed devote considerable space to his friend's picture, and, after a detailed description, he was to conclude: "In this painting we find beauty that is indisputable.... I don't believe anyone will dare laugh this year.... Ask the painters. They are unanimous: they admire" (*L'Intransigéant,* March 18, 1910).

Another admirer was the Italian Futurist, Ardengo Soffici; he gave a careful description of the picture and commented upon it with greater penetration than had Apollinaire:

> Henry [*sic*] Rousseau, who does not brood but works from the first spurt and according to his own special way of seeing things, has understood this truth, that in art everything is allowable and legitimate if everything concurs in the sincere expression of a state of mind. That couch, that naked body, that moon, those birds, wild beasts and flowers—either because of their color or because of their structure—represented for him images that, independent of any discursive logic, created in his mind a purely artistic unity, and he used them as the elements best able to exteriorize a vision that was wholly personal. In so doing he was following the trend prevalent in the school of modern painting that always attempts to rid art insofar as possible of any logical element in order to yield wholly to the lyric exaltation created by colors and lines viewed and conceived independently of their practical use and their task as delineators and differentiators of bodies and objects. In addition, instead of wondering what those things the painter sees only as images are trying to say, it would be better to see whether from their respective forms and colors the poetic feeling the author has tried to make them express has in fact been elicited ...

Fig. 1.
Vallotton. *Models at Rest.* 1905
Private collection, Switzerland

Having fallen into a gentle sleep
Yadwigha, in a dream,
Heard the sounds of a musette
Played by a benevolent magician.
While the moon shone down
Upon the flowers, the green trees,
The wild serpents listened to
The instrument's merry tunes.

Yadwigha dans un beau rêve
S'étant endormie doucement
Entendait les sons d'une musette
Dont jouait un charmeur bien pensant.
Pendant que la lune reflète
Sur les fleurs, les arbres verdoyants,
Les fauves serpents prêtent l'oreille
Aux airs gais de l'instrument.

(Pamphlet of the Salon des Indépendants,
1910, no. 4468)

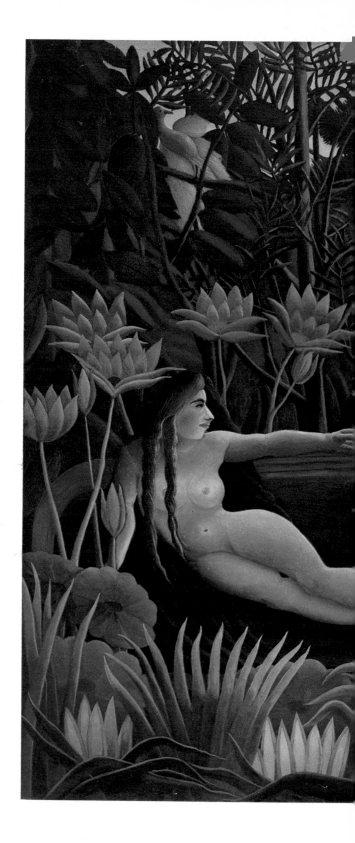

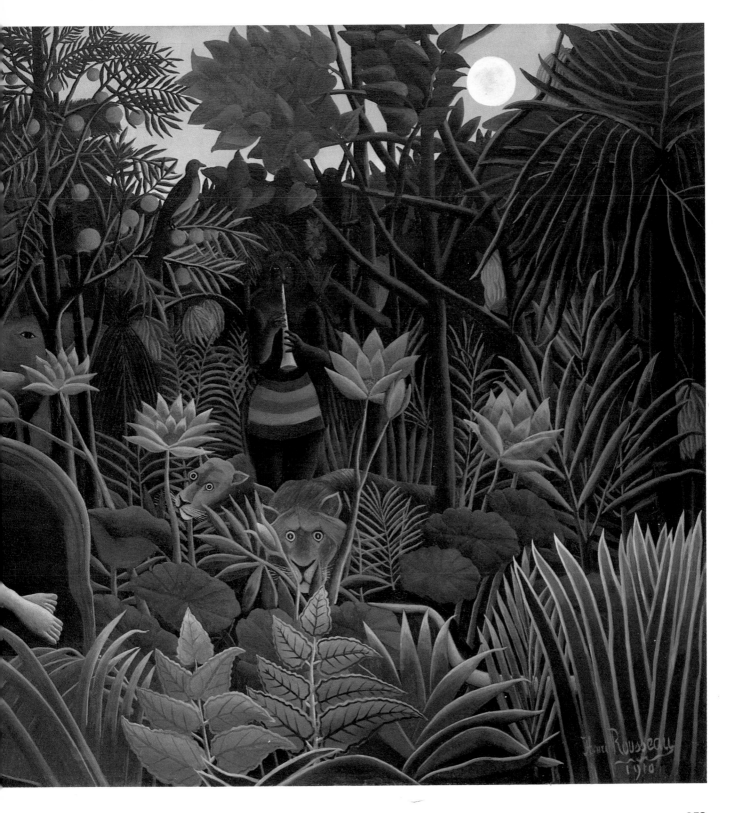

Although Leon Werth and Louis Vauxcelles were also generous, there were many brief or frankly hostile comments. Two, because of the personality of their authors and the positions they represent, should be mentioned: Louis Dimier, who later gained a reputation as one of the great specialists in sixteenth-century painting, was less inspired by Rousseau than he was to be by Clouet: "Rousseau, a fugitive from the customs office, whose failings have not discouraged the gaping art-lover or the clever merchants" *(L'Action Française,* March 19, 1910). As for the phrase of the poet and dramatist Henri Ghéon, albeit no more than a short *mot* ("Rousseau's verdure, so applied, so ridiculous, so decorative..." *Nouvelle Revue Française,* May 1, 1910, p. 685), it reflects the prudent stand taken by that journal with regard to artistic novelty.

Since that time, the work, often reproduced but rarely shown outside New York, has exercised a kind of fascination that was well expressed by André Breton: "I am almost on the point of believing that in this large canvas all the poetry and mysterious gestations of our time are present: none other has for me, in the inexhaustible freshness of its discovery, the feeling of the *sacred.* Like Cimabue's *Maestà* in its time, the day will come when it will be borne in procession through the streets" *(Le Surréalisme et la peinture,* Paris, 1965, pp. 293–94, text written in 1942).

The poem attached to the picture has attracted the attention of one of the masters of contemporary linguistic theory, Roman Jakobson, who has noted its highly coherent internal structure. It has all the charm of a folk song or childhood counting-out game. The play of sonorities within the poem, supposes a mastery of the language that strengthens the hypothesis—which Jakobson does not mention—that Apollinaire is the actual author of the lines ("On the Verbal Art of William Blake and Other Poet-Painters," *Linguistic Inquiry,* January 1970).

À Monsieur Le Président de La République.

Le soussigné, Henri Rousseau, a l'honneur de s'adresser à vous, Monsieur Le Président, pour vous prier de vouloir bien l'aider afin qu'il puisse arriver à un emploi de professeur dans un des Établissements de l'État, pour le dessin et la peinture. Ayant rendu vingt-neuf ans de service à l'État et à la Ville de Paris, tant comme militaire que comme Employé d'Octroi, petit-fils d'officiers ayant combattu sous les ordres de votre ancêtre, il aurait pour plusieurs motifs le désir que vous ayez la bonté de vouloir bien lui venir en aide. Déjà vous l'avez vu et suivi dans plusieurs Expositions et vous l'avez remarqué, il

Autobiographical Note

Rousseau compiled these notes in July 1895 for an unpublished work, "Portraits for the Coming Century" ("Portraits du prochain siècle")

Born at Laval in the year 1844, was at first forced, owing to his parents' lack of fortune, to pursue a career different from that to which his artistic tastes called him.

It was therefore not until 1885 that he made his entry into Art, after many reversals, alone, with no Master other than nature and bits of advice culled from Gérôme and Clément. His first two works to be shown were submitted to the Salon des Champs-Elysées: they were entitled *An Italian Dance* and *A Sunset*.

Next year he painted *Carnival Evening* and *A Thunderbolt*. Followed by *Expectation, A Poor Fellow, After the Feast, Departure, Picnic, The Suicide, For my Father, Myself, Portrait-Landscape of the Artist, Tiger Chasing Explorers, A Hundred Years of Independence, Liberty, The Last of the 41st, War,* a genre portrait of the man-of-letters A. J.... and some 200 drawings, both pen and ink and pencil, along with some landscapes of Paris and environs.

After many difficult trials he managed to make a name for himself among some of the artists of the day. He continued to improve his mastery of the original genre he had developed and is now on the way to becoming one of our best realist painters.

His appearance is notable because of his bushy beard and he has long been a member of the Indépendants, believing as he does that complete freedom to produce must be granted to the innovator whose thought is elevated toward the beautiful and the good.

He will never forget those members of the Press who understood him and supported him in his moments of discouragement and who assisted him in achieving his goals.

Paris, July 10, 95
Henri Rousseau

Letters by Henri Rousseau

To the Minister for Public Education and Fine Arts

Mr. Minister,
Pardon me, Mr. Minister, for being so bold as to write these few lines to you. I am led to do so by the paragraph in your speech at the awards ceremonies for the Salon, in which you made mention of a hitherto neglected painter. That has greatly touched and moved me; please do believe this, Mr. Minister, for although I learned only a bit of drawing when I was young, I nonetheless created a picture for the Exhibition. I had submitted it to the triennial Exhibition, which I had felt would not be too difficult to get into, with the full realization that my picture was not free from defects, only I was eager to have some precise opinion with regard to my work. Whereupon I was rejected, since which time I have reworked and tried to overcome the problems with which I had to deal. Unfortunately I was too late for the Salon, having counted on having until the end of March; I did not finish it until approximately the 20th, and when I went to turn it in it was too late. Thus my disappointment, and allow me to assure you, Mr. Minister, I was sorely disheartened since it was for me a cruel let-down after so many sacrifices and such submission. Last year I wrote a note to your predecessor, and as my picture had been rejected I no longer hoped for any solution. Finally, and most fortunately for me, my work was seen and appreciated by Monsieur Gérôme, the famous contemporary painter, by Monsieur Clément, winner of the Prix de Rome, and by Monsieur Pélissier, Professor of Drawing. All these celebrated men were in agreement in saying I should persevere and that notwithstanding my being forty years old it was still not too late. Thus my spirits have been replenished. Mr. Minister, and your paragraph, which I have read over and over again with keen pleasure and for which I sincerely thank you, will give me even greater courage and I shall not abandon hope of arriving at my goal. I shall therefore continue to rework with an even greater ardor, despite lack of time and resources, in view of the fact that I am only a low-ranking employee. If, as I believe, you are disposed to abet and encourage goodwill and a craving to achieve

great things, please be good enough to take into account this sincere statement, which comes from a soul devoted to Art. I shall be sincerely grateful to you. My work is being shown along with several others I have since done [and which are] in the hands of persons who have been so good as to concern themselves with my case, and as all those gentlemen stated, I need to be launched by someone so that I can devote myself totally to my Art and to bringing out my ideas. I shall finally have attained my goal, after so much poverty and suffering, and if I have not produced [anything] before this it is because I was unsure of whether I could do so, and because I have already experienced a number of setbacks that have kept me from working. Now, therefore, I am counting solely on luck to find someone of means with a noble and generous spirit who will, by acquiring my works, be kind enough to look after my well-being, thus enabling me to continue on a large scale and to be in a position, dare I hope, to present my work to your eyes, Mr. Minister.

In such a hope, please accept, Mr. Minister, my respectful salutations and the sincere thanks of one who is an artist through and through and who seeks only to do good work and to give pleasure to those kind enough to show him their concern. It is an honor to salute you.

H. Rousseau
Rue de Sèvres, no. 135
Paris, 25 June 1884

Archives Nationales, Paris, F21 4338

To the President of the Republic

Mr. President,
The Undersigned, Henri Rousseau, is honored to address himself to you, Mr. President, to beseech you to be so good as to assist him in obtaining employment as an instructor in one of the State institutions for drawing and painting. Having rendered Twenty-nine years of service to the State and to the City of Paris, both as soldier and employee of the Toll Service, as the grandson of officers who fought under the Command of your forefather, he has a number of grounds for hoping that you will be so good as to come to his aid. You have already noticed him and have seen [his work] in several Exhibitions and you have seen that his achievements have even attracted enemies; and only this year an attempt has been made to prevent him from exhibiting as has been his wont. Nevertheless he worked very hard to complete his two entries, a patriotic one entitled: *The Last of the 51st* and the other: *Work on Liberty*. In both cases he failed to encounter the usual ill will. Please understand, Mr. President, that all those bad turns, which are intended to belittle him and to give him considerable pain, since he has but one desire and that is to seriously continue along the artistic path upon which he has been engaged for eight years now, and on the advice of the Inspector of Fine Arts himself... he must persevere and make his style known, one that is very economical, and be of use to his country. Within the span of Eighteen months he has received two honorable mentions and 1 silver medal, a mention at the 91 champs [sic] de Mars competition and a silver medal at the Exhibition des Alcools, which included a painting section, and in a competition held under the patronage of Monsieur Hattat. Thus you can see, Mr. President, that he has but one goal, that of striving to achieve an honorable post for himself, to continue to raise his family, and to provide a good upbringing for his children. The first steps in Art are hard ones; above all when Fortune has not smiled upon you; and he has been loaded down with many burdens. He would also be pleased were you, Mr. President, to alleviate his troubles, to see to the acquisition of one of the pictures that have been shown and that have met with Success. I can assure you that he would be proud and grateful for anything you could do for him. Please be good enough to excuse his having been so bold as to write to you; but he is doing so in the firm hope that in you, Mr. President, he may find someone who will be so kind as to alleviate the sufferings that others seem bent upon inflicting and making him bear.

He would be happy too were you to be good enough to grant him an interview in order that he might better expatiate on the subjects he has raised herein.

I dare hope that for the sake of my forebears and in light of the services he himself has rendered his country you will be so good as to take action on his behalf, for which he will be eternally grateful to you and begs you to accept his respectful civilities.

Henri Rousseau
Avenue du Maine 44
Paris, 7 June 1893

Archives Nationales F21 4338

257

À Monsieur Le Ministre de
L'Instruction publique et des Beaux
-Arts

Monsieur Le Ministre,

Le Soussigné, Henri Rousseau
Artiste peintre; a l'honneur de solliciter de la
bienveillance de Monsieur Le Ministre,
l'achat de l'un ou de ses tableaux exposés cette
année au Salon des Artistes Indépendants
sis dans les Grandes Serres de l'Exposition
universelle.

Ses Tableaux au nombre de Sept
sont intitulés:

Nos du Catalogue

1° Mauvaise surprise 867
2° Au printemps 868
3° Route allant au fort de Vincennes. 870
4° Lac Daumesnil (Effet d'Orage) 871
5° Lac Daumesnil (Coucher de Soleil) 872
6° Vue du Bois de Vincennes 873
 à Droite de la Route de Paris

A Concourru pour la Décoration Des Mairies
de Bagnolet, de Vincennes et d'Asnières,
est porté pour la Légion d'honneur.

Dans L'Espoir, Monsieur Le Ministre
que vous voudrez bien faire droit à sa Demande,
il vous prie de recevoir l'assurance de sa consi
dération distinguée.

Henri Rousseau
36 rue Gassendi

Paris, le 21 Avril 1901.

To the Minister of Public Instruction and Fine Arts

Mr. Minister,
The undersigned, Henri Rousseau Artist-Painter, has the honor to request that in his benevolence the Minister purchase one or more of his pictures being exhibited this year at the Salon des Indépendants being held in the Great Hall at the World's Fair.

Those pictures, seven in number, are entitled:

	Catalogue no.
1. *Unwelcome Surprise*	867
2. *In Spring*	868
3. *Road leading to the Fort of Vincennes*	870
4. *Lake Daumesnil (Storm Effect)*	871
5. *Lake Daumesnil (Sunset)*	872
6. *View of the Forest of Vincennes right hand side of road to Paris*	873

Took part in the competition to decorate the Mairies [City Halls] of Bagnolet, Vincennes, and Asnières; nominated for the Legion of HONOR.

In the hope, Mr. Minister, that you will accede to his request, he begs you to accept his assurance of his distinguished regard.

Henri Rousseau
36, rue Gassendi
Paris, 21 April 1901

Archives Nationales F21 4338

RÉPUBLIQUE FRANÇAISE
Liberté Egalité Fraternité

To the Director of Fine Arts

Mr. Director,
The undersigned, Henri Julien Rousseau, has the honor to request that you, Mr. Director, be so good as to purchase for the State his picture entitled: *Arab Scouts attacked by a Tiger* exhibited this year at the Salon des Indépendants as Number 2025. and measuring including frame 2 meters in width and 1.60 in height.

In the Hope, Mr. Director, that you will be so kind as to accede to his request, which will make him happy, being in straits following the long illness of his wife; and beseeching you to accept the assurance of his distinguished regard,

H. J. Rousseau
Artist painter professor at the Philotechnic Assn.
36, rue Gassendi
Paris 10/3 1904

Archives Nationales F21 4338

Paris, October 16, 1905

The Under-Secretary of State (for the Fine Arts)

Sir,
Excuse me for taking the liberty to write you these few lines to tell you that I greatly regret I am a bit late for the opening of the Salon d'Automne. Based on what my colleagues have told me you were not adverse to my picture, *The Hungry Lion*. I thank you: however, it would please me very much if the State were to acquire it having had some very serious setbacks I am in great need to improve my condition and return to work on other important canvases: having the firm intention of becoming a worthy Frenchman eager to do honor to his country. I should also like to remind you, Sir, of my receiving the *Palmes* of an officer of the Academy for which I had rendered a report and had been highly recommended by Monsieur Messimy, my deputy, by Monsieur Pennenlier, my Municipal Councillor, by the Phylotechnic association where I have been a teacher for four years. In addition I rendered 32 years of service to the State and city as a soldier and employee of the octroi. I have also composed many musical works, one of which has been printed and published.

In the hope, Sir, that you will do all in your power to assist me, I beg you to accept the assurance of my high regard.

Henri Rousseau, Artist painter
Professor at the association phylotechnic
Atelier 2 bis, rue Peyrel, Plaisance,
14th Arrondissement

Archives Nationales, Paris, FR21 4103

To the Under-Secretary of State for Fine Arts

Sir,
I have the honor to request that you be so kind as to grant me an interview with regard to the purchase of my Picture of a Lion that is in the Salon d'Automne. I came to call on you, I am sorry I was unable to see you.

In the hope of a favorable reply, please accept, Mr. Under-Secretary of State, the assurance of my distinguished regard.

Henri Rousseau
artist painter
44, rue Daguerre
Paris 23 October 1905

Archives Nationales F21 4103

REPUBLIQUE FRANÇAISE
Liberté Egalité Fraternité

To the Under-Secretary of State for Fine Arts

Mr. Under-Secretary,
The Undersigned, Henri Julien Rousseau, has the honor to request your beneficence in causing the State to purchase the Picture entitled *Liberty Inviting Artists to Take Part in the Twenty-second Exhibition of the Société des Indépendants* which he is exhibiting this year at the Salon of the aforementioned Society to which he has belonged since the year 1884.

In the hope, Mr. Under-Secretary of State, that you will be so good as to do all you can with regard to the above matter, please accept the assurance of his distinguished regard.

Henri J. Rousseau
2 bis, rue Perrel
Paris, 15/3 1906

Archives Nationales F21 4338

REPUBLIQUE FRANÇAISE
Liberté Egalité Fraternité

To the Under-Secretary of State for Fine Arts

Mr. Under-Secretary of State,
The undersigned Henri Julien Rousseau has the honor to request that you be so kind, Mr. Under-Secretary of State, as to purchase for the State the Picture entitled *The Merry Jesters* at present being exhibited at the Salon d'Automne, Grand Palais, and which is his work.

In the Hope, Mr. Under-Secretary of State, of your Acceding to his request, he begs that you accept the assurance of his distinguished regard as well as his gratitude.

H. J. Rousseau
artist painter
Professor at the Phylotechnic Association (free course)
2 bis, rue Perrel

Undated letter; register number 7132 from 13 October 1906. Archives Nationales F21 4338

REPUBLIQUE FRANÇAISE
Liberté Egalité Fraternité

To the Under-Secretary of State for Fine Arts,

Mr. Under-Secretary of State,
The Undersigned, Henri Julien Rousseau, has the honor to request that you be so kind as to purchase one of his four pictures being exhibited at the Salon d'Automne.

In the Hope that this time you will be good enough to accede to his request, he begs you to accept the assurance of his distinguished regard.

Henri Julien Rousseau
2 bis, rue Perrel
14th Arrond.

Pictures exhibited:
1. *The Snake Charmer*
 (possible sale being negotiated)

260

2. *Landscape near Asnières*
3. *Banana Vendors*
4. *The Basket Weaver*

} exotic landscapes

Paris the 24 7ème 1907

Archives Nationales F21 4338

Letter from Henri Rousseau to the President of the Arts Orphanage

Paris, 14/6/1910

Madame President,

I am pleased to be able to write you these few lines to give you my precise ideas on the subject of the 2 very family-like festivities I attended. Being a father myself and unfortunately having lost almost all of them I experienced some unhappy feelings as well as joy. All those children that are under your guidance and who, from a social and humanitarian point of view, could be your own, as your friend Monsieur Jean Richepin expressed it in the speech he made as benefactor and godfather—tears came to my eyes. It would have given me great pleasure to shake his hand as I did yours, Madame, because I felt our Hearts were one. I would have come to see you today, it being the day you receive in Courbevoie, but it is very difficult for me to get away because of my work which at the moment is going well. A Sunday would be easier for me. If you could find a moment on any day at all I would be happy to have you honor me with a visit. I am at home to guests from 9 to 11 in the morning and from 2:30 to 5:30 after lunch in my studio, an unpretentious and simple working man; but a sincere one. Many many thanks also to your charming violinist teacher who played with such tender feeling and such fleet fingers; as well as to the other artists who lent their gracious support.

Dear Madame, I give small evening parties from time to time, literary, musical and above all informal, if it should please you to honor them with your friendly presence you have only to tell me so that I can send you an invitation to the next one that will take place at the end of this month. I conclude, Madame President, by wishing you perfect health and extending to you very sincere and fraternal handshakes.

Henri Rousseau
artist painter
2 bis, rue Perrel
unpublished

Private collection

Notes on Early Devotees of Henri Rousseau

GUILLAUME APOLLINAIRE (1880–1918) was, both in verse and in prose, by far the most brilliant commentator on and effective propagandist for Rousseau. In 1914 he prepared a special Rousseau number of *Les Soirées de Paris,* assembling documentary evidence for the future understanding of a personality around which more than one legend had already begun to form. At the same time, although probably acting in good faith, he unwittingly certified and spread the unfounded rumor of Rousseau's having taken part in the 1860s French expedition to Mexico. The abundance and enthusiasm of Apollinaire's writings on Rousseau would lead one to believe that he had known the painter well. It appears, however, that he did not become acquainted with Rousseau's works until 1907 and that he did not begin to spend time with the artist until 1908–09, when the two versions of *The Muse Inspiring the Poet* (pl. 58, second version) were being painted; it is believed that this portrait of Apollinaire and his companion Marie Laurencin was one neither model much liked.

ROBERT DELAUNAY (1885–1941) was one of the Douanier Rousseau's greatest admirers and most fervent defenders. At the age of twenty-two he began to collect Rousseau's works, eventually owning twenty of them; he introduced the Douanier to his mother, and she commissioned *The Snake Charmer* (pl. 36) from him; Delaunay also introduced the Douanier to Wilhelm Uhde. Delaunay was one of the few to attend Rousseau's funeral and made an effort to salvage his papers and drawings after his death. He was also a propagandist for his works, particularly with regard to Kandinsky (see "Henri Rousseau and Modernism"). Delaunay inserted a "quotation" from Rousseau's self-portrait (pl. 5) into his own picture, *The City of Paris,* painted shortly after the Douanier's death in 1910.

In the 1920s, Delaunay, then going through a difficult period in his life, sold the works of Rousseau in his possession; when selling *The Snake Charmer* to collector Jacques Doucet, he stipulated that Doucet bequeath it to The Louvre, Paris, which he did. Delaunay amassed documentation on Rousseau and planned to write a book about him; although the book was never issued, he published an excerpt from it, "Henri Rousseau, Le Douanier," in *L'Amour de l'art* (1920); other excerpts appeared posthumously.

SONIA DELAUNAY-TERK (1885–1979) met Rousseau through her first husband, Wilhelm Uhde, and later shared the enthusiastic admiration of her second husband, Robert Delaunay, for the Douanier. In his epitaph, Apollinaire mentions her, along with Delaunay, as one of the few persons present at Rousseau's funeral. Sonia Delaunay, without in any way denying her feelings of admiration and sympathy for the man whose honesty she took pains to stress, believed that there was a distance separating Rousseau's art from the experiments of the avant-garde. In 1952 *Les Lettres françaises* published her article on Rousseau forgeries, as well as an excerpt from her late husband's memoirs of Rousseau.

SERGE FÉRAT (1881–1958), a painter of Russian descent (whose real name was Serge Jastrebzoff), settled in Paris in 1902 and became one of the leading figures in the Cubist movement. Owner of the review *Les Soirées de Paris,* he entrusted the editorship to Guillaume Apollinaire, who was to invite Férat to create the scenery and costumes for his play *Les Mamelles de Tirésias* (1917). Férat purchased about ten paintings directly from Rousseau, including *Myself, Portrait-Landscape* (pl. 5), and also gave him commissions. Férat was forced to sell his collection after the 1917 October Revolution in Russia cut off his income.

His sister, Baroness d'Oettingen, who used a number of pseudonyms (among them Roch Grey and Leonard Pieux), shared her brother's tastes and wrote several articles on Rousseau (see Roch Grey, Bibliography).

ALFRED FLECHTHEIM (1878–1937), the German dealer and collector, was introduced to the new trends in painting by his compatriots Wilhelm Uhde and D. H. Kahnweiler. Flechtheim was one of the organizers of the exhibition *Sonderbund*, Cologne (1912), in which innovative European—and especially French—painting was widely represented; Rousseau, however, was not included, except in an advertisement for *Der Blaue Reiter* almanac (1912), which appeared in the catalogue. In 1913 Flechtheim opened a gallery in Dusseldorf in which he showed the work of contemporary German and French artists. He soon owned galleries in several German cities and was instrumental in bringing French painting to Germany prior to 1914. Among the ten or so works by Rousseau that passed through his hands were *A Hundred Years of Independence* (DV 54), *Happy Quartet* (pl. 22), and *Forest Landscape with Setting Sun* (pl. 63).

PAUL GUILLAUME (1891–1934) was a dealer and collector who during his lifetime owned some twenty pictures by Rousseau, most of which were purchased from Ambroise Vollard and Serge Férat. Too young to have known the Douanier Rousseau, Guillaume probably heard about him from Apollinaire and Delaunay. Several paintings from his collection, among them *The Wedding* (pl. 28) and *Old Junier's Cart* (pl. 39), today hang in the Musée de l'Orangerie, Paris, as part of the Jean Walter—Paul Guillaume Collection. (See Introduction, catalogue of the collection, Musée de l'Orangerie, Paris, 1984.)

ALFRED JARRY (1873–1907), like Rousseau, was born in Laval. Poet, playwright, and critic, Jarry was a nonconformist in his tastes as well as in his writings, and was one of the first to speak out on behalf of his countryman, which he did as early as 1894 (see note for *War*, pl. 9). It was upon Jarry's urging that Rémy de Gourmont published Rousseau's only lithograph (pl. 10) in *L'Ymagier* (January 1895). Jarry lived in Rousseau's studio for several months in 1897. The relationships between Jarry's work and that of Rousseau are set forth in more detail in Henri Béhar, "Jarry, Rousseau, and Popular Tradition."

WASSILY KANDINSKY (1866–1944), the Russian painter, who worked in Germany and France, may have learned of Rousseau during his stay in Paris in 1906–07, but his marked interest in the Douanier came later, in 1911–12, when he was preparing *Der Blaue Reiter* (published in 1912); he had received a copy of Wilhelm Uhde's recent book on Rousseau, which reproduced a number of paintings owned by Robert Delaunay.

In a letter to Delaunay, dated October 28, 1911, Kandinsky describes himself as "struck by the expressive force of the great poet." *Der Blaue Reiter* reproduced seven works by Rousseau, and Kandinsky acquired two paintings through Delaunay's intervention.

PABLO PICASSO (1881–1973) purchased the large *Portrait of a Woman* (pl. 12) from Père Soulier, the secondhand dealer, c. 1908, and it hung in a prominent place in Picasso's Bateau-Lavoir studio at the famous Rousseau banquet that year. Later, Picasso was to purchase three other pictures by Rousseau (pls. 23, 24, 35). The relationship between Picasso and Rousseau is analyzed at length in Carolyn Lanchner and William Rubin, "Henri Rousseau and Modernism."

HANS PURRMANN (1880–1966), a German painter who came to Paris in 1905 to see the Manet exhibition at the Salon d'Automne, discovered the work of the young French painters and later became the disciple and friend of Henri Matisse. He remained in Paris until the outbreak of the First World War in 1914. He acquired one work by Rousseau, *The Quarry* (pl. 16), but the date of acquisition is unknown.

SERGEI SHCHUKIN (1854–1936) was a Moscow businessman famous for the great collection of French Impressionist and modernist paintings he began to amass in 1890. By 1914 it included 221 pictures, today divided for the most part between the Pushkin State Museum of Fine Arts, Moscow, and The Hermitage State Museum, Leningrad. He owned seven of the Douanier's works, purchased from the dealer Ambroise Vollard. Four of them are included here (pls. 41, 51, 61, 65). Morosov, another great Moscow collector of French paintings, does not seem to have purchased any of Rousseau's works.

WILHELM UHDE (1874–1947), writer, art-lover and dealer, settled in Paris in 1904 and became a supporter of the young French painters, particularly the Fauves, whose works he saw at the Salon d'Automne and at Berthe Weill's. He first purchased works of Georges Braque, André Derain, Raoul Dufy, Jean Metzinger, and Pablo Picasso. He became friendly with Robert Delaunay, who introduced him to Rousseau, then at work on *The Snake Charmer* (pl. 36), commissioned by Delaunay's mother. Delaunay "brought me to [Rousseau's] house and there, on the easel, I saw this marvelous picture....It was seeing Rousseau's concern for the unity and balance of this large composition and his asking me if he ought not adopt a more somber or a clearer

color, remove or add something or other, that I understood, even then, that the legend of his artistic naïveté was completely without foundation" (W. Uhde, *Von Bismarck bis Picasso,* Zurich, 1938, p. 150). He organized the Douanier's first exhibition in 1908 but neglected to include the address of the gallery on the invitation. Uhde was married to Sonia Terk, later the wife of Robert Delaunay; she was also to become one of Rousseau's most active admirers. Along with Delaunay and Vollard, Uhde was one of Rousseau's earliest supporters, in 1911 publishing the first monograph on him and organizing a retrospective at the Indépendants, and in 1912, organizing the first large retrospective exhibition of Rousseau, at the Galerie Bernheim-Jeune, Paris.

ANTOINE VILLARD (1867–1934), a landscape painter who is little known today, showed regularly at the Salon des Indépendants, of which he was a strong supporter (*Bulletin de la vie artistique,* November 15, 1921). He had an opportunity to see works by Rousseau there, as well as at the Salon d'Automne. It would appear that he acquired from, among others, Serge Férat and Wilhelm Uhde a collection of ten or so canvases by Rousseau, several of which are of prime importance: *Old Junier's Cart* (pl. 39) and *The Past and the Present* (DV 87).

AMBROISE VOLLARD (1868–1939) entered the art business around 1890. Alive to everything new and endowed with an exceptional flair, he probably discerned Rousseau's importance on his own, and there is no need to presume that one or another of the artists in his "stable" had to bring the painter to his attention. He was Rousseau's principal client at the end of the Douanier's life, and many of his pictures passed through Vollard's hands.

MAX WEBER (1881–1961), an American artist born in Russia, went to Paris in 1906 and studied painting at the Académie Julien, Académie Colarossi, Académie de la Grande Chaumière, and, finally, Matisse's studio, where he worked until 1908. At the 1907 Salon d'Automne, Rousseau showed *The Snake Charmer* (pl. 36), which belonged to Robert Delaunay's mother. It was at her home that Max Weber met the Douanier, sometime around the middle of October of that year. He was twenty-six years of age, Rousseau sixty-three. It was the beginning of a good friendship. They exchanged pictures, and Weber also purchased some of the older man's works (pl. 26) and introduced him to Joseph Brummer (see pl. 57).

Max Weber often lent his tenor voice to the soirees at the rue Perrel. Before he returned to the United States in December 1908, Rousseau presented him with the Study for *The View of Malakoff* (pl. 46) and gave him a farewell banquet.

One of the first to collect Rousseau's work, Weber returned to New York with drawings and five pictures, all of which were part of the commemorative exhibition held at the Alfred Stieglitz Little Galleries of the Photo-Secession in 1910. The works were again exhibited, with others, at the Armory Show (1913).

BERTHE WEILL (active 1900–30) owned a tiny gallery in Paris on the rue Victor Massé where she was one of the earliest defenders of the Fauves. She wrote in her memoirs: "Henri Rousseau, so celebrated by Picasso, Apollinaire, and that whole crowd...after many difficulties (the poor man! people had taken advantage of his naïveté to get him to sign his name to papers that he didn't know were libelous) died....A very short time before his death I had arranged with him to put on a show of his works....His friends dissuaded him...perhaps they had motives I am unaware of....The absence of his name leaves a gap in my list of exhibitors" (*Pan dans l'oeil,* Paris, 1933, p. 158).

Bibliography

The number of books and articles on the Douanier Rousseau has become so large and references to him in general works so frequent that we have not attempted to present an exhaustive bibliography. The list that follows contains the works or articles most frequently referred to in the notes to the plates. An attempt has been made to cite contemporary sources and those that contribute new information or judgments. The Douanier Rousseau's paintings and his personality have been the subject of exhaustive research in recent years, particularly on the part of Dora Vallier and Henry Certigny. We have relied heavily on their studies. There are two *catalogues raisonnés* of Rousseau's works, one by Jean Bouret and the other by Vallier. Reference is made to them in the headings to each note using the abbreviations JB and DV.

Writings by the Douanier Rousseau

Rousseau, Henri, "Le Douanier." *Une Visite à l'Exposition de 1889 (A Visit to the 1889 World's Fair),* 1889. Preface by Tristan Tzara. Geneva, 1947; excerpts repr. in *Bulletin de la vie artistique,* no. 8 (April 15, 1922), and no. 9 (May 1, 1922)

———. *La Vengeance d'une orpheline russe* (The Revenge of a Russian Orphan), c. 1899. Geneva, 1947; excerpts published by Tristan Tzara, *Orbes,* nos. 2–4 (1929–33). An edition of the two plays by Rousseau, with introduction by Noël Arnaud, Paris: Christian Bourgois, 1984

———. "Clémence," waltz, with introduction for violin and mandolin, Paris, 1904

———. *L'Etudiant en goguette* (The Merry Student), n.d. Unpublished manuscript

———. Three poems published in *Les Soirées de Paris,* no. 20 (January 15, 1914)

Writings on the Douanier Rousseau

Ajalbert, Jean. "La Leçon du Douanier," *Beaux-Arts* (October 5, 1937)

Alexandre, Arsène. "Le Salon des Indépendants," *Comoedia* (April 3, 1909)

———. "La Vie et l'oeuvre d'Henri Rousseau, peintre et ancien employé de l'octroi," *Comoedia* (March 19, 1910)

———. *Le Figaro* (October 18, 1922)

Apollinaire, Guillaume. "Les Indépendants," *L'Intransigéant* (April 20, 1911)

———. "Les Peintres cubistes," *Les Soirées de Paris,* no. 15 (April 15, 1913)

———. *Les Soirées de Paris,* no. 18 (November 15, 1913)

———. *Les Soirées de Paris,* no. 20 (January 15, 1914)

———. *Il y a,* Paris, 1925

———. *Chroniques d'art (1902–1918),* edited by L.-C. Breunig, Paris, 1960

Arp, Hans. *Neue französische Malerei,* Leipzig, 1913

Barnes, Albert C. *The Art in Painting,* New York, 1925

Basler, Adolphe. "Parise Chronik," *Der Cicerone,* no. 15 (1923)

———. "Le Douanier Henri Rousseau," *L'Art vivant* (October 15, 1926)

———. "Recollections of Henri Rousseau," *The Arts,* no. 11 (June 1927)

———. *Henri Rousseau,* Paris, 1927

———. "Les Peintres français nouveaux," *Henri Rousseau* (Paris), no. 34 (1929)

Bazin, Germain. " 'La Guerre' du Douanier Rousseau," *Bulletin des Musées de France,* no. 2 (1946)

———. *Le Message de l'absolu: De l'aube au crépuscule des images,* Paris, 1964

Bell, Clive. *Since Cézanne,* New York, 1923

Bernard-Rousseau, Jeanne. "La Petite Fille de Rousseau raconte la vie de son grand-père," *Arts* (October 17, 1947)

———. "Révélé par Jeanne, sa petite fille, le secret du Douanier Rousseau," *Elle* (February 10, 1961)

Bernier, Georges. *L'Art et l'argent,* Paris, 1977

Berthoud, Dorette. *La Peinture française d'aujourd'hui,* Paris, 1937

Bertram, Anthony. "Henri Rousseau," *The Studio,* London, 1936

Bihalji-Merin, Oto. *Les Peintres naïfs,* Cologne, 1959; Paris, 1960

———. *Modern Primitives,* London, 1961; reprinted London, 1978

———. *Le Monde des Naïfs,* preface to the catalogue of the exhibition, Musée National d'Art Moderne, Paris, 1964

———. *Die Kunst der Naiven,* Zurich, 1975

Bihalji-Merin, Lise and Oto. *Henri Rousseau,* Dresden, 1971

Bouret, Jean. *Henri Rousseau,* Neuchâtel, 1961; *catalogue raisonné*

Breton, André. *Le Surréalisme et la peinture,* Paris, 1965

Brown, Milton. *The Story of the Armory Show,* New York, 1964

Bryars, Davin. "Berners, Rousseau, Satie (3 peintres musiciens)," *Studio International,* vol. 192, no. 984 (November–December 1976)

Bryen, Camille, and Gheerbrant, Alain. *Anthologie de la poésie naturelle,* Paris, 1949

Cabanne, Pierre. "Le Procès en mystification d'un naïf de génie," *Arts* (February 15–21, 1961)

———. *Le Siècle de Picasso,* Paris, 1975; English trans., *Picasso: His Life and Times,* New York, 1977

Camera Work (New York), no. 32 (October 1910); no. 33 (January 1911)

Cann, Louise Gebhard. "An Artist of the People," *Studio International,* no. 81 (July 1925)

Carrà, Carlo. *Pittura Metafisica,* Milan, 1919

Cassou, Jean. *Panorama des arts plastiques contemporains,* Paris, 1960

———. Langui, Emile, and Pevsner, Nicholas. *Les Sources du XXe siècle,* Paris, 1961

Cendrars, Blaise. "Le Douanier Henri Rousseau," *Der Sturm,* no. 178–79 (September 1913)

Certigny, Henry. *La Vérité sur le Douanier Rousseau,* Paris, 1961; addendum no. 1, Paris, 1966; addendum no. 2, Lausanne and Paris, 1971

———. *Le Douanier Rousseau et Frumence Biche,* Lausanne and Paris, 1973

———. "Aspects inconnus du Douanier Rousseau," *Galerie des Arts,* no. 57 (October 1968)

———. "Une Source inconnue du Douanier Rousseau," *L'Oeil,* no. 291 (October 1979)

———. "Le Douanier Rousseau et la source du 'Centenaire de l'Indépendance,'" *L'Oeil,* no. 309 (April 1981)

Chassé, Charles. "Les Fausses Gloires: D'Ubu Roi au Douanier Rousseau," *La Grande Revue*, no. 111 (April 1923)

———. "Les Défenseurs des fausses gloires: Les Amis du Douanier Rousseau," *La Grande Revue*, no. 114 (May 1924)

Combe, Jacques. "Un Douanier Rousseau au XVIIe siècle: Franz Post (1612–1680)," *L'Amour de l'art*, no. 12 (December 1931)

Cooper, Douglas. *Rousseau*, Paris, 1951

Coquiot, Gustave. *Les Indépendants 1884–1920*, Paris, 1920

Courthion, Pierre. *Henri Rousseau le Douanier*, Geneva, 1944

———. *Henri Rousseau*, Paris, 1956

———. *Paris, des temps nouveaux*, Geneva, 1957

———. "Henri Rousseau," *L'Oeil*, no. 46 (October 1958)

Crespelle, Jean-Paul. *Montparnasse vivant*, Paris, 1962

Delaunay, Robert. "Henri Rousseau Le Douanier," *L'Amour de l'art*, no. 7 (November 1920)

———. "Mon Ami Rousseau," *Les Lettres françaises* (August–September 1952)

———. *Les Cahiers inédits de Robert Delaunay: Du cubisme à l'art abstrait*, Paris, 1957

Delaunay, Sonia. "Images inédites du Douanier," *Les Lettres françaises* (August 1, 1952)

Descargues, Pierre. *Le Douanier Rousseau*, Geneva, 1972

Dodici opere di Rousseau, Florence, 1914

Dorival, Bernard. "Robert Delaunay et l'oeuvre du Douanier Rousseau," *L'Oeil*, no. 267 (October 1977)

Eddy, Arthur Jerome. *Cubists and Post-Impressionists*, Chicago, 1914

Egger, Carl. "Der Stil Henri Rousseau: Zur Erinnerung und die Ausstellung in der basler Kunsthalle im März 1933," *Basler Kunstverein Jahresberichtet*, 1932

———. "Henri Rousseau: Austellung in der basler Kunsthalle," *Die Kunst*, no. 67 (May 1933)

Eichmann, Ingeborg. "Five Sketches by Henri Rousseau," *Burlington Magazine*, no. 72 (June 1938)

Elderfield, John. *European Master Paintings from Swiss Collections: Post-Impressionism to World War II*, New York, 1976

Elgar, Frank. *Rousseau*, Paris, 1980

Fellion, Gaston. "Le Douanier Rousseau et le mythe de la peinture naive," *The Lion*, no. 294 (July 1980)

Fels, Florent. "Notes on the Rousseau Exhibition at the Marie Harriman Gallery," *Formes*, no. 11 (January 1931)

Forges, Marie-Thérèse de. "Une Source du Douanier Rousseau," *Art de France*, no. 4 (1964)

———. *Donation Picasso*, Paris, 1978; catalogue of the Picasso Bequest Musée du Louvre

———. and Allemand, G. "La Collection Paul Guillaume, Jean Walter," *Revue du Louvre*, no. 1 (1966)

Franc, Helen M. *An Invitation to See*, New York, 1973

Frederick, James Gregg. "Letting in the Light," *Harper's Weekly* (February 15, 1913); repr. in the catalogue for the fiftieth anniversary of the Armory Show

Galeries Lafayette. *Bêtes sauvages*, approx. 200 illustrations of animal life, with educational texts, Paris, n.d. (c. 1900)

Gallego, Julian. "De Rousseau à Dubuffet, o La ingenuidad perdida," *Bellas Artes* (Madrid), no. 32 (April 1974)

Garçon, Maurice. *Le Douanier Rousseau, accusé naïf*, Paris, 1953

Gauthier, Maximilien. "La Maison natale du Douanier Rousseau: L'Association des amis d'Henri Rousseau," *Beaux-Arts* (December 3, 1937)

———. "Henri Rousseau et Alfred Jarry," *Beaux-Arts* (February 11, 1938)

———. *Henri Rousseau*, Paris, 1949

———. *Rousseau*, Paris, 1956

George, Waldemar. "Le Miracle de Rousseau," *Les Arts à Paris*, no. 18 (July 1931)

Georges-Michel, Michel. *De Renoir à Picasso: Les Peintres que j'ai connus*, Paris, 1954

Goldwater, Robert J. *Primitivism in Modern Painting*, London and New York, 1938

Goodrich, Lloyd. *Max Weber*, New York, 1949

Gordon, Donald E. *Modern Art Exhibitions 1900–1916*, Munich, 1974

Gordon, Jan. *Modern French Painters*, New York, 1923

Gourmont, Rémy de. *Mercure de France* (October 16, 1910)

———. *La France* (December 1, 1912)

———. *Le Puits de vérité*, Paris, 1922

Haftmann, Werner. *Malerei in 20. Jahrhundert*, Munich, 1957; English trans., *Painting in the 20th Century*, London, 1965

Hoog, Michel. "La Direction des Beaux-Arts et les Fauves, 1903–1905," *Art de France*, no. 3 (1963)

———. " 'La Ville de Paris' de Robert Delaunay: Sources et développement," *Revue du Louvre*, no. 1 (1965)

———. *Robert Delaunay*, Paris, 1975

Huyghe, René. "La Peinture d'instinct," *L'Amour de l'art*, no. 7 (July 1933)

———. *Les Contemporains*, Paris, 1939

———. *Sens et destin de l'art*, Paris, 1967

———. and Rudel, Jean. *L'Art et le monde moderne*, Paris, 1970

Jakovsky, Anatole. *La Peinture naïve*, Paris, 1949

———. *Les Peintres naïfs*, Paris, 1956

———. "Le Douanier et les contrebandiers," *Jardin des arts*, no. 79 (June 1961)

———. "Le Douanier Rousseau savait-il peindre?," *Médecine de France*, no. 218 (1971)

———. *Lexique universel des peintres naïfs*, Basel, 1976

Jarry, Alfred. "Minutes d'arts," *L'Art littéraire*, no. 5–6 (May–June 1894)

———. "Les Indépendants," *Les Essais d'art libre* (June–July 1894)

Kahnweiler, Daniel-Henry. *Confessions esthétiques*, Paris, 1963

Kandinsky, Wassily. *Der Blaue Reiter*, "Ueber die Formfrage," Munich, 1912; French trans., *L'Almanach du "Blaue Reiter,"* Paris, 1931; reprinted in English trans., New York, 1975, and in *Kandinsky: Complete Writings on Art*, vol. 1 (1901–1921), ed. by Kenneth C. Lindsay and Peter Vergo, Boston, 1983

———. "Malerei als reine Kunst," *Der Sturm*, no. 178–79 (September 1913); reprinted in *Kandinsky: Complete Writings on Art*, Boston, 1983

———. *Regards sur le passé et autres textes, 1912–1922*, Paris, 1974

Keay, Carolyn. *Henri Rousseau*, London, 1976

Kolle, Helmut. *Henri Rousseau*, Leipzig, 1922

Kousnetsova, Irina. *La Peinture française au Musée Pouchkine*, Leningrad, 1980

Kuhn, Walt. *The Story of the Armory Show*, New York, 1938

Larkin, David. *Rousseau*, Paris, 1975

Le Diberder, Yves. "Rousseau s'inspirait-il des photos et des gravures?," *Arts* (December 26, 1947)

Leonard, Sandra E. *Henri Rousseau and Max Weber*, New York, 1970

Le Pichon, Yann. "Les Sources de Rousseau révélées," *Arts*, no. 809 (February 15–21, 1961)

———. *Le Monde du douanier Rousseau*, Paris, 1981; English trans., *The World of Henri Rousseau*, New York, 1982

Lhote, Andre. "Exposition Henri Rousseau," *Nouvelle Revue française* (November 1, 1923)

———. "L'Art populaire," *Nouvelle Revue française* (August 1, 1929)

———. "La Peinture, le coeur et l'esprit," 1923; repr. in *Ecrits sur la peinture*, Brussels, 1946

Lo Duca. *Henri Rousseau dit le Douanier*, Paris, 1951

Masters of Popular Painting: Modern Primitives of Europe and America, catalogue of the exhibition, The Museum of Modern Art, New York, 1938

Michailow, Nikola. "Zur Begriffsbestimmung der Laienmalerei," *Zeitschrift für Kunstgeschichte*, no. 5–6 (1935)

Monneret, Sophie. *L'Impressionnisme et son époque*, vol. 2, Paris, 1979

Morariu, Modest. *Henri Rousseau le Douanier*, Paris and Bucharest, 1975

Myagawa, Atsushi. "Rousseau," *L'Art moderne du monde* (Tokyo), no. 10 (1971)

Nacenta, Raymond. *Les Naïfs*, Paris, 1973

Nezval, Viteszlav. *Henri Rousseau*, Prague, 1937

———. "Rousseau," *Insita*, no. 4 (1972)

Niggli, Ida. *Naive Art Yesterday and Today*, Niederteufen, 1976

Olivier, Fernande. *Picasso et ses amis*, Paris, 1933

Passeron, René. *Histoire de la peinture surréaliste,* Paris, 1968

Payro, Julio E. *Rousseau el Adouanero,* Buenos Aires, 1944

Penrose, Roland. *Picasso: His Life and Work,* London, 1958; reprinted New York, 1971

Perruchot, Henri. *Le Douanier Rousseau,* Paris, 1957

Raboff, Ernest. *Henri Rousseau: L'Art pour les enfants,* Geneva, 1971

Raynal, Maurice. "Le Banquet Rousseau," *Les Soirées de Paris,* no. 20 (January 15, 1914)

_____. *Histoire de la peinture moderne,* Geneva, 1950

Rewald, John. *Post-Impressionism: From van Gogh to Gauguin,* 3d ed., New York, 1978

Reyer, Georges. "Un Photographe retrouve le Douanier Rousseau," *Paris-Match* (April 16, 1960)

Rich, Daniel Catton. *Henri Rousseau,* New York, 1942; rev. ed., 1946

Richter, Irma A. "Henri Rousseau," *College Art Journal* (May 1942)

Roch Grey (pseudonym of Baroness d'Oettingen). "Souvenirs de Rousseau," *Les Soirées de Paris,* no. 20 (January 15, 1914)

_____. *Henri Rousseau,* Rome, 1922

_____. *Henri Rousseau,* Rome, 1924

_____. *Henri Rousseau,* Paris, 1943

Roh, Franz. "Ein neuer Henri Rousseau: Zur kunstgeschichtlichen Stellung des Meisters," *Der Cicerone,* no. 16 (July 1924)

_____. "Henri Rousseau: Bildform und Bedeutung für die Gegenwart," *Die Kunst,* no. 55 (January 1927)

Roy, Louis. "Un Isolé: Henri Rousseau," *Le Mercure de France* (March 1895)

Rubin, William S. *Dada and Surrealist Art,* New York, 1969, and London, 1970; French trans., *L'Art dada et surréaliste,* Paris, [1977]

Rudenstine, Angelica. *The Guggenheim Museum Collection: Paintings 1880–1945,* vol. 2, New York, 1976

Salmon, André. *Revue de France* (December 1, 1922)

_____. *Propos d'atelier,* Paris, 1922

_____. *Henri Rousseau dit le Douanier,* Paris, 1927

_____. *Henri Rousseau,* Paris, 1962

Shattuck, Roger. *The Banquet Years,* New York, 1955; French trans., *Les Primitifs de l'avant-garde,* Paris, 1974

Soffici, Ardengo. *La Voce,* no. 40 (September 15, 1910)

_____. "La France jugée a l'étranger: Le Peintre Henri Rousseau," *Le Mercure de France* (October 16, 1910)

_____. *Trenta artisti moderni italiani e stranieri,* Florence, 1950

Soupault, Philippe. *Feuilles libres* (August–September 1922)

_____. "La Légende du Douanier Rousseau," *L'Amour de l'art,* vol. 7, no. 10 (October 1926)

_____. *Henri Rousseau, le Douanier,* Paris, 1927

_____. *Henri Rousseau, le Douanier,* Paris, 1949

Stein, Gertrude. *The Autobiography of Alice B. Toklas,* New York, 1933; French trans.: *Autobiographie d'Alice B. Toklas,* Paris, 1933

Sterling, Charles, and Salinger, Margaretta M. *French Paintings; A Catalogue of the Collection of The Metropolitan Museum of Art,* vol. 3, New York, 1967

Sweeney, James J. "Henri Rousseau," *College Art Journal,* vol. 1, no. 4 (May 1942)

Szittya, Emil. *Henri Rousseau,* Hamburg, 1924

Tharaud, Jérôme and Jean. *Le Gentil Douanier et un artiste maudit,* Paris, 1929

Tilliette, Xavier. "Inspection du Douanier," *Etudes* (May 1961)

Trohel, Jules. "Origines mayennaises du Douanier Rousseau: Notes et documents artistiques," *Le Mercure de France,* no. 723 (August 1, 1928)

_____. "Alfred Jarry et les huissiers," *Le Mercure de France* (July 1, 1934)

Tzara, Tristan. "Le Rôle du temps et de l'espace dans l'oeuvre du Douanier Rousseau," *Art de France,* no. 2 (1962)

_____. Preface to the catalogue of the exhibition *Henri Rousseau,* Sidney Janis Gallery, New York, 1951

Uhde, Wilhelm. *Henri Rousseau,* Paris, 1911

_____. *Henri Rousseau,* Dusseldorf, 1914

_____. "Henri Rousseau," *Deutsche Kunst und Dekoration,* no. 47 (October–November 1920)

_____. *Henri Rousseau,* Dresden, 1921

_____. *Henri Rousseau,* Berlin and Dresden, 1923

_____. *Picasso et la tradition française,* Paris, 1929

_____. "Henri Rousseau et les Primitifs modernes," in R. Huyghe, *Histoire de l'art contemporain: La Peinture,* Paris, 1935

_____. *Von Bismarck bis Picasso: Erinnerungen und Bekenntnisse,* Zurich, 1938

_____. *Rousseau (Le Douanier),* Lausanne, 1948

_____. *Five Primitive Masters,* translated by Ralph Thompson, New York, 1949; Zurich, 1947

Vallier, Dora. *Henri Rousseau,* Paris, 1961

_____. "Le Canapé rouge du Douanier," *XXe siècle,* no. 25 (June 1965)

_____. "L'Emploi du pantographe dans l'oeuvre du Douanier Rousseau," *Revue de l'art,* no. 7 (1970)

_____. *Tout l'Oeuvre peint de Henri Rousseau,* Paris, 1970; rev. ed., 1982

_____. *Henri Rousseau,* Paris, 1979

Venturi, Lionello. *Pour comprendre la peinture de Giotto à Chagall,* Paris, 1950

Viatte, Germain. "Henri Rousseau dit le Douanier," *Art de France,* no. 2 (1962)

Vierny, Dina. *Le Monde merveilleux des Naïfs: Hommage à Wilhelm Uhde,* Paris, 1974

Vlaminck, Maurice de. *Portraits avant décès,* Paris, 1943

Vollard, Ambroise. *Auguste Renoir,* Paris, 1920

_____. *Recollections of a Picture Dealer,* London, Boston, 1936; Paris, 1937

Warnod, André. *Les Berceaux de la jeune peinture,* Paris, 1925

Weber, Max. Preface to the catalogue of the exhibition *Henri Rousseau* at the Little Galleries of the Photo-Secession ("291"), New York, 1910

_____. "Rousseau as I Knew Him," *Art News,* vol. 41 (February 15, 1942)

_____. Unpublished writings quoted in Leonard and in Rich, *op. cit.*

Wilenski, R. H. *Modern French Painters,* London, 1940

_____. *Rousseau,* Paris, 1953

Zervos, Christian. "Henri Rousseau et le sentiment poétique," *Cahiers d'art,* vol. 1, no. 9 (1926)

_____. *Rousseau,* Paris, 1927

_____. *Histoire de l'art contemporain,* Paris, 1938

Exhibitions

We have not attempted to draw up a complete list of exhibitions in which works of the Douanier Rousseau have appeared. Such a list would have required the enumeration of countless shows devoted to primitive or naive painters and to general exhibitions of the art of the twentieth century, and would have burdened the catalogue unnecessarily.

We have cited all exhibitions held prior to 1914 of which we have found evidence; post 1914 one-man exhibitions of the Douanier Rousseau; exhibitions of naive or primitive painting that included a particularly important group of his works.

1885
Paris, Salon libre des Beaux-Arts (?)

1886–1910
Paris, IId–XXVIth Salon des Artistes Indépendants, with the exception of 1899 and 1900

1905
Paris, IIId Salon d'Automne

1906
Paris, IVth Salon d'Automne

1907
Paris, Vth Salon d'Automne

1908
Paris, first Rousseau exhibition organized by W. Uhde; however, the address having been omitted from the invitation, no one came

1909
Budapest, and Mücsarnok; watercolors, pastels, and drawings
Odessa, Salon 2: International Art Exhibition

1910
Kiev, Salon 2: International Art Exhibition
Saint Petersburg, Salon 2: International Art Exhibition
Riga, Salon 2: International Art Exhibition
Leipzig, Exhibition of French Art of the 18th, 19th, and 20th Centuries
New York, Little Galleries of the Photo-Secession, 291 Fifth Avenue, collection of Max Weber

1911
Paris, XXVIIth Salon des Artistes Indépendants; posthumous exhibition, Rousseau room
Munich, Galerie Thannhauser, Der Blaue Reiter

1912
Cologne, Gereons Club, Der Blaue Reiter

Berlin, Der Sturm, Der Blaue Reiter
Paris, Galerie Bernheim-Jeune, Henri Rousseau; 50 paintings and drawings
Berlin, Secession Ausstellungshaus, XXIV. Ausstellung der Berliner Secession
London, Grafton Galleries, Second Post-Impressionist Exhibition

1913
Moscow, Jack of Diamonds
New York, Armory Show
Chicago, The Art Institute of Chicago, Armory Show
Boston, Copley Hall, Armory Show
Munich, Hans Goltz, II. Gesamtausstellung
Berlin, Der Sturm, Erster deutscher Herbstsalon
Budapest, Ernst Museum, A XIX. Szazad Nagy Francia Mesterei
Dusseldorf, Galerie A. Flechtheim, XIX. Jahrhundert

1914
Paris, Galerie Bernheim-Jeune, Exposition de la collection de peinture moderne Herbert Kuhlmann

1923
Paris, Galerie Paul Rosenberg

1925
Paris, La Grande Maison de Blanc

1926
Berlin, Galerie A. Flechtheim; 32 paintings, catalogue preface by W. Uhde
London, Lefebvre Gallery; exhibition organized by Roch Grey

1931
New York, Marie Harriman Gallery; 31 paintings

1933
Basel, Kunsthalle, Henri Rousseau; first large retrospective, 56 paintings, 8 drawings

1937
Paris, Galerie Paul Rosenberg; 22 paintings
Paris, Salle Royale, and Zurich, Kunsthalle, Les Maîtres populaires de la réalité; exhibition organized by the Musée de Grenoble

1938
New York, The Museum of Modern Art, Masters of Popular Painting: Modern Primitives of Europe and America; in conjunction with the Musée de Grenoble

1942
New York, The Museum of Modern Art, Henri

Rousseau; exhibition organized by Daniel Catton Rich; traveled to:
Chicago, The Art Institute of Chicago
Boston, Institute of Modern Art
Pittsburgh, Carnegie Institute
Toronto, Art Gallery of Toronto
Cincinnati, Cincinnati Modern Art Society
St. Louis, City Art Museum
Manchester, New Hampshire, Currier Gallery of Art

1944
Paris, Musée d'Art Moderne de la Ville de Paris, Henri Rousseau Le Douanier; 20 paintings

1945
Paris, LVIth Salon des Artistes Indépendants; Rousseau room

1950
Venice, XXVth Biennale; Rousseau room

1951
New York, Sidney Janis Gallery; 23 paintings

1961
Paris, Galerie Charpentier, Henri Rousseau dit le Douanier; exhibition commemorating the fiftieth anniversary of his death

1963
New York, Wildenstein Gallery, Loan Exhibition: Henri Rousseau, 23 paintings

1964
Rotterdam, Museum Boymans-van Beuningen, De Lusthof des Naïeven
Paris, Musée National d'Art Moderne, Le Monde des naïfs; 26 paintings

Index to Plates

Photo Credits

Photographs have been provided in most cases by the owners or custodians of the works reproduced. The following list applies to those for which a separate acknowledgment is due. Individual works of art may be additionally protected by copyright in the United States of America or abroad and may not be reproduced in any form or medium without the permission of the copyright owners.

Colorplates:

Blauel-Artothek, Frankfurt, 44
Colorphoto Hinz, Allschwil-Basel, 55, 58, 63
Fine Arts Photography, Mount Airy, Maryland, 27
Al Freni, 20
Gerhard Howald, Bern, 47
Kate Keller, Staff Photographer, The Museum of
 Modern Art, New York, 19
Ralph Kleinhempel, Hamburg, 29
Frank Lerner, 22
Mates-Katz Inc., 14, 38
The Metropolitan Museum of Art, New York, all rights
 reserved, 49, 54
Mali Olatunji, Staff Photographer, The Museum of
 Modern Art, New York, 66
Eric Pollitzer, New York, 30, 37, 48, 53
Réunion des Musées Nationaux de France, 8, 9, 12, 15,
 17, 18, 23, 24, 34–36, 39, 43

Documentary photographs:

Frontispiece:
Réunion des Musées Nationaux de France

Text by Roger Shattuck:
Bibliothèque Nationale, Paris, figs. 3, 4, 6
Paris-Match/Izis, fig. 5

Text by Henri Béhar:
Copyright© 1984 The Barnes Foundation, Merion,
 Pennsylvania, fig. 4
Réunion des Musées Nationaux de France, figs. 2, 3

Text by Michel Hoog:
Réunion des Musées Nationaux de France,
 figs. 1–3, 7, 8

Text by Carolyn Lanchner and William Rubin:
Art Institute of Chicago, figs. 2, 5
Oliver Baker, New York, fig. 48
Copyright © 1984 ADAGP, Paris, fig. 43
Copyright © 1984 The Barnes Foundation, Merion,
 Pennsylvania, figs. 12, 57
Dr. Stanley Jernow, fig. 20
John Lindsay Ltd., fig. 14
Pierre Matisse Gallery, New York, fig. 75
The Metropolitan Museum of Art, New York, all rights
 reserved, figs. 4, 8
Réunion des Musées Nationaux de France, figs. 1, 9,
 15–17, 21, 32, 39, 41, 42, 58, 59
Rheinisches Bildarchiv, Cologne, figs. 47, 53
A. J. Wyatt, Staff Photographer, Philadelphia Museum
 of Art, fig. 25
Yan, Toulouse, fig. 24

Plates:
Bibliothèque Nationale, Paris, 9–1, 51–1, 57–1
Brassaï, 12–1
Caisse Nationale des Monuments Historiques, Paris,
 fig. 32–2
Giraudon, Paris, 22–2, 22–3, 32–1
Illustration/Sygma, Paris, 29–1, 31–1
Musées de la Ville de Paris, 8–1
Réunion des Musées Nationaux de France, 4–1, 5–1,
 5–2, 5–3, 18–1, 22–1, 26–1, 37–1, 45–1, 57–2,
 57–3, 58–1, 61–1
Roger Viollet, Paris, 20–1

**Trustees of
the Museum of Modern Art**

William S. Paley
Chairman of the Board

Mrs. Henry Ives Cobb
David Rockefeller
Vice Chairmen

Mrs. John D. Rockefeller 3rd
President

Mrs. Frank Y. Larkin
Donald B. Marron
John Parkinson III
Vice Presidents

John Parkinson III
Treasurer

Mrs. L. vA. Auchincloss
Edward Larrabee Barnes
Mrs. Armand P. Bartos
Sid Richardson Bass
Gordon Bunshaft
Shirley C. Burden
William A. M. Burden
Thomas S. Carroll
Frank T. Cary
Anne Cox Chambers
Ivan Chermayeff
Gardner Cowles*
Gianluigi Gabetti
Paul Gottlieb
Mrs. Melville Wakeman Hall
George Heard Hamilton*
Mrs. Barbara Jakobson
Sidney Janis**
Philip Johnson
Ronald S. Lauder
John L. Loeb*
Ranald H. Macdonald*
Dorothy C. Miller**
Mrs. G. Macculloch Miller*
J. Irwin Miller*
S. I. Newhouse, Jr.
Stavros S. Niarchos
Richard E. Oldenburg
Peter G. Peterson
Gifford Phillips
John Rewald**
David Rockefeller, Jr.
Mrs. Agnes Gund Saalfield
Mrs. Wolfgang Schoenborn*
Mrs. Constantine Sidamon-Eristoff
Mrs. Bertram Smith
Jerry I. Speyer
Mrs. Alfred R. Stern
Mrs. Donald B. Straus
Walter N. Thayer
R. L. B. Tobin
Edward M. M. Warburg*
Mrs. Clifton R. Wharton, Jr.
Monroe Wheeler*
Richard S. Zeisler

*Trustee Emeritus
**Honorary Trustee

Ex Officio Trustees

Edward I. Koch
Mayor of the City of New York

Harrison J. Goldin
*Comptroller of the
City of New York*